BEHOLDING PARADISE

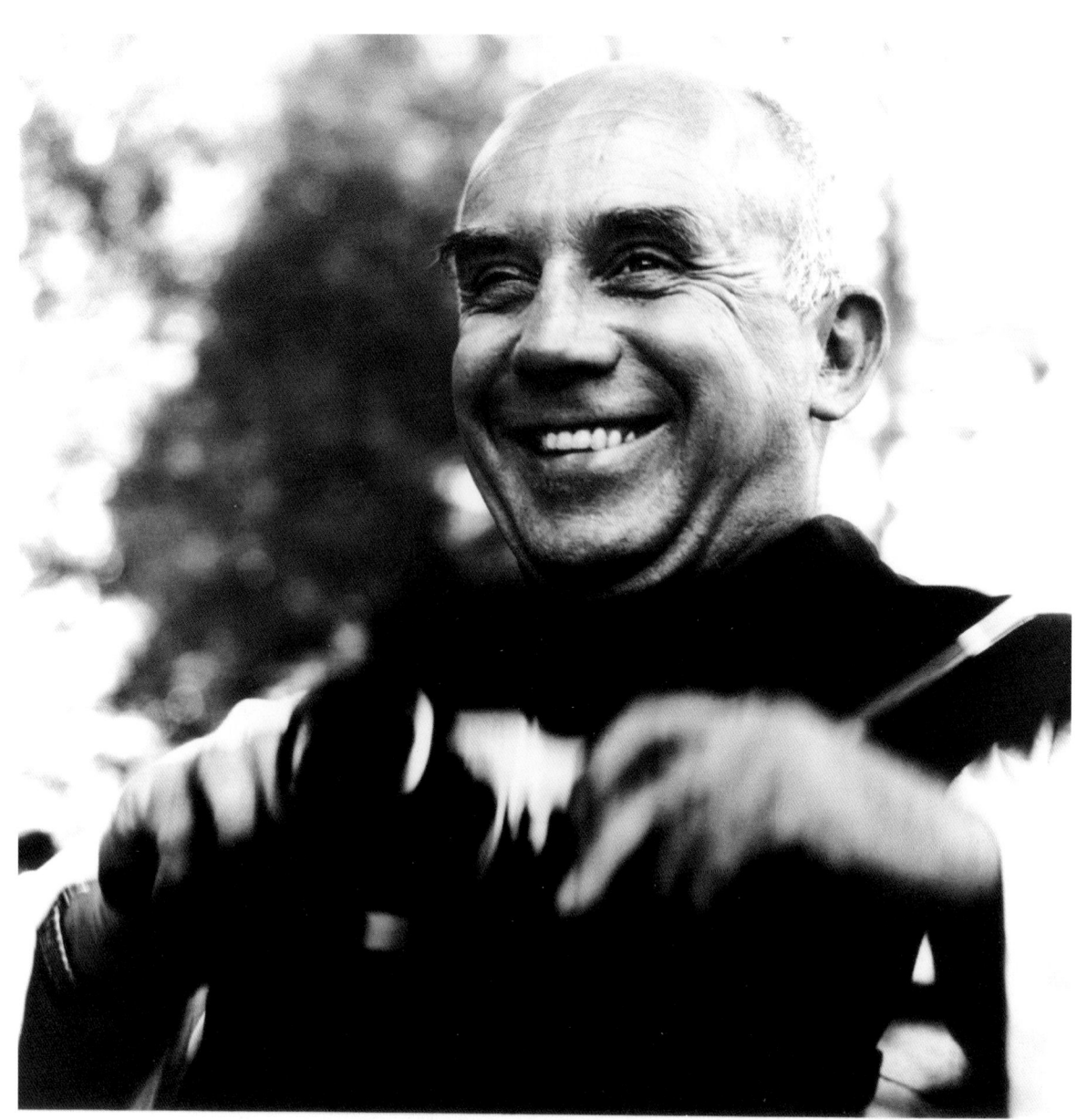

BEHOLDING PARADISE

THE PHOTOGRAPHS OF THOMAS MERTON

EDITED BY PAUL M. PEARSON

PAULIST PRESS

NEW YORK / MAHWAH, NJ

For my Mother, Eileen M. Pearson,
and my Aunt and Godmother, Roseline A. Salter

Permission granted to reproduce figure 13 on p. xvi, figures 14 and 15 on p. xvii, and photograph on p. 233, copyright © The Estate of Ralph Eugene Meatyard, courtesy Fraenkel Gallery, San Francisco.

Excerpts from "In Silence," "Sacred Heart 2," "Three Postcards from the Monastery," "Elias – Variations on a Theme," "The Sowing of Meanings," "Song: If You Seek…," "Two Desert Fathers," and "The Night of Destiny" by Thomas Merton, from THE COLLECTED POEMS OF THOMAS MERTON, copyright © 1946, 1947 by New Directions Publishing Corp. Copyright 1944, 1949 by Our Lady of Gethsemani Monastery. Copyright © 1964 by The Abbey of Gethsemani. Copyright © 1952, 1954, 1955, 1956, 1957, 1961, 1962, 1967, 1968 by The Abbey of Gethsemani, Inc. Copyright © 1968 by Thomas Merton. Copyright © 1961, 1963, 1965, 1966, 1967, 1968, 1969, 1970, 1971, 1976, 1977 by the Trustees of the Merton Legacy Trust. Copyright © 1977 by William Davis. Reprinted by permission of New Directions Publishing Corp.

Excerpts from THE ASIAN JOURNALS OF THOMAS MERTON, copyright © 1975 by The Trustees of the Merton Legacy Trust. Reprinted by permission of New Directions Publishing Corp.

Merton Photographs Copyright © 2020 by The Merton Legacy Trust

Text Copyright © 2020 by Paul M. Pearson

Cover and Book Design by Amy C. King

All rights reserved. No part of this publication may be reproduced, stored in a retrieval system, or transmitted in any form or by any means, electronic, mechanical, photocopying, recording, scanning, or otherwise, except as permitted under Section 107 or 108 of the 1976 United States Copyright Act, without the prior written permission of the Publisher. Requests to the Publisher for permission should be addressed to the Permissions Department, Paulist Press, 997 Macarthur Boulevard, Mahwah, NJ 07430, (201) 825-7300, fax (201) 825-8345, or online at www.paulistpress.com.

Library of Congress Control Number: 2019949812

ISBN 978-0-8091-0625-7 (hardcover)

ISBN 978-1-58768-574-3 (e-book)

Published by Paulist Press
997 Macarthur Boulevard
Mahwah, New Jersey 07430

www.paulistpress.com

Printed and bound in Spain

CONTENTS

Introduction VI

I THE PARADOX OF PLACE: *Gethsemani and Pleasant Hill*
1

II A HIDDEN WHOLENESS: *Zen Photography*
51

III SHINING LIKE THE SUN: *Friends and Faces Radiating the Spark in the Soul*
131

IV WOODS, SHORE, DESERT, EAST: *The Pilgrim*
165

V THE JOYFUL FACE BEHIND THE CAMERA: *Images of Merton*
217

Notes 235

INTRODUCTION

THOMAS MERTON'S artistic worldview was no doubt inherited from his parents, Owen and Ruth Merton (see fig. 1). They had met in Paris where they were both pursuing artistic careers; Ruth was interested in interior decoration and design, and Owen was a New Zealand artist who had already had a number of exhibitions. Thomas Merton described his father in the opening pages of *The Seven Storey Mountain*, saying,

> *His vision of the world was sane, full of balance, full of veneration for structure, for the relations of masses and for the circumstances that impress an individual identity on each created thing. His vision was religious and clean, and therefore his paintings were without decoration or superfluous comment, since a religious man respects the power of God's creation to bear witness for itself.*[1]

In speaking of his father Owen in this quotation, penned in the mid-1940s at Gethsemani, Thomas Merton points to some trends he perceived as present in his father's art work, trends that were present in Thomas Merton's own drawings, which he was already creating at the Abbey of Gethsemani at this time, and which then would also surface in Merton's photographs over a decade later.

The obituary of Owen in the London *Times* described him as "a water-colour painter of distinction, who, had he lived longer, would have earned a wide reputation." It continued,

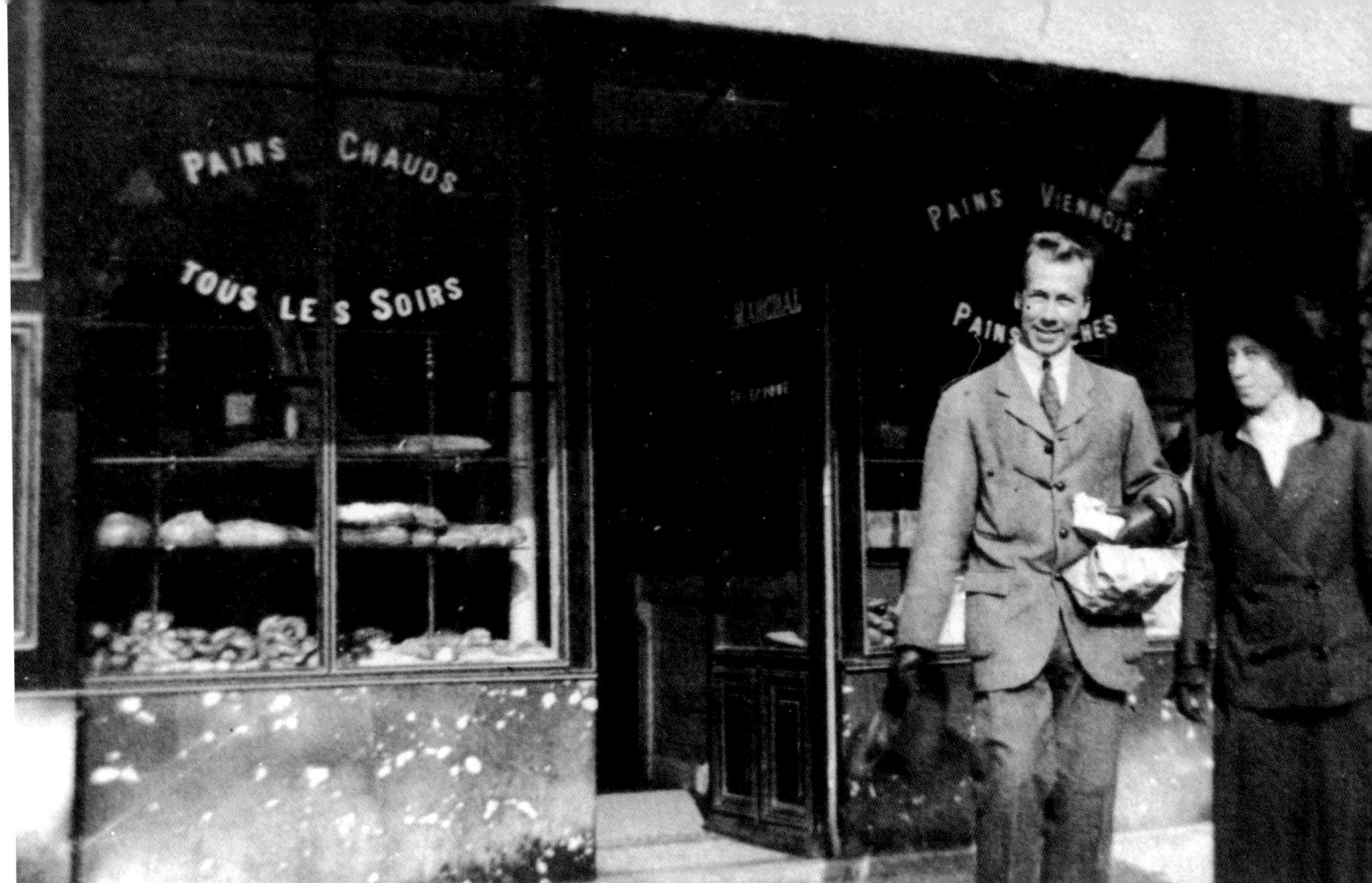

» *fig. 1*

His pictures displayed a sense of design and a delicacy of colour which reflected his love of the Chinese masters, together with a strength and individuality which bore witness to the originality and power of the artist's mind….His love of landscape and his passion for painting enabled him to inspire all those who came in contact with him, and many other painters owe much to his helpful enthusiasm.[2]

It was inevitable that Thomas Merton should try his own hand at art. On the reverse of an early photograph of him from 1918 or 1919, his mother had written, "Tom making a drawing of an aeroplane"[3] (see fig. 2). His earliest surviving images were drawings he made to illustrate stories that he was writing in his early teens, and *The Haunted Castle*,[4] "profusely illustrated in pen and ink," is the earliest such manuscript, followed a few years later by his first drawings to be published, appearing in the school magazine at Oakham.

Introduction ||| vii

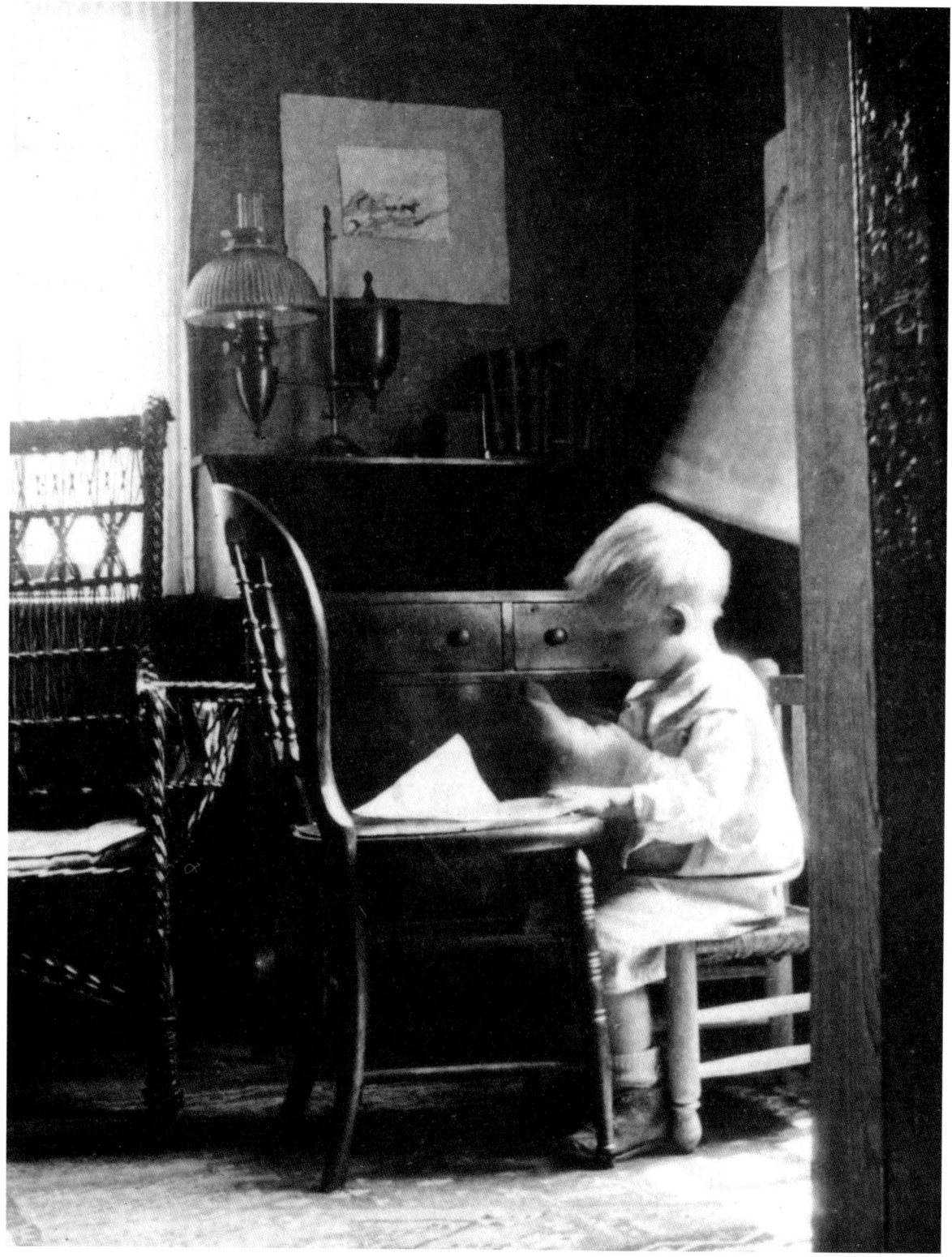

» fig. 2

The next known images date from Merton's time at Columbia University—cartoons published in *The Jester*, the humorous magazine on campus of which Merton was the art editor in his senior year (see fig. 3). On Merton's "Declaration of Intention" for permanent residence in the United States, completed in 1938, his stated occupation was "cartoonist and writer."[5] After his conversion to Catholicism in November 1938, the subjects of his drawings changed, and religious images came to dominate his artistic output.

At Gethsemani, through the 1940s and '50s, Merton would continue to draw. His images from this period were traditional images of saints, prophets, angels, the cross, and Christ crucified; most notably, a large collection of groups of the crucifixion, St. John of the Cross, and female saints—in particular the Blessed Virgin Mary, St. Therese, and Mary Magdalene (see fig. 4). But, in the late 1950s, as Thomas Merton moved from the world-denying monk of the forties and early fifties to the world-embracing monk of the sixties, his drawings, like

"Don't leave him alone or he'll kick hell out of the cat."

» fig. 3

Thomas Merton, Photographer

Merton showed little interest in photography until the final years of his life. On a visit to Germany as a teenager, he had bought his first camera, a Zeiss, which he subsequently pawned as his debts grew at Cambridge University in the early thirties.[7] In October 1939, he records in his personal journal a visit with friends to an exhibit of Charles Sheeler's at the Museum of Modern Art in New York City. But he records that he and his friends were disappointed with the exhibit, which he described as "completely uninteresting" and "dull."[8]

In his early years at Gethsemani, he contin-

» fig. 4

his prose and poetry, would change dramatically. In an entry contained in his personal journal for October 28, 1960, Merton records a marked change in his style of drawing, writing, "...tried some abstract-looking art this week,"[6] and just a few entries later, he records, "Spending some work time on abstract drawings for a possible experimental book." Some of these drawings, which Merton would begin calling *calligraphies*, were semi-representational, but the majority were completely abstract (see fig. 5).

» fig. 5

x ||| INTRODUCTION

ued to draw and even give some classes to his students on art, classes he would later work up into his unpublished manuscript "Art and Worship." Yet, he makes only passing references to photographs and photography, and these are made mostly as he records a number of opportunities to browse books of photographs, mostly from other monasteries. In December 1947, writing of one such book commemorating the canonization of St. Nicholas de Flue, Merton says,

> *I have never seen such magnificent layouts, and the photographs themselves are wonderful. The pictures are not merely grouped: they are orchestrated. I have never seen such smart work, such variations, spacing, bleed-outs, etc.*[9]

From the late fifties onward, however, Merton had contact with some eminent North American photographers, beginning with Shirley Burden. Contact with these photographers would stimulate his own interest in photography as well as influence the style and the subjects of the photographs he would begin to take in the years that followed. Looking at Merton's contact with these photographers, we can gain an insight into his own developing vision of photography.

Shirley Burden (see fig. 6) had provided photographs for a postulant's guide, *Monas-*

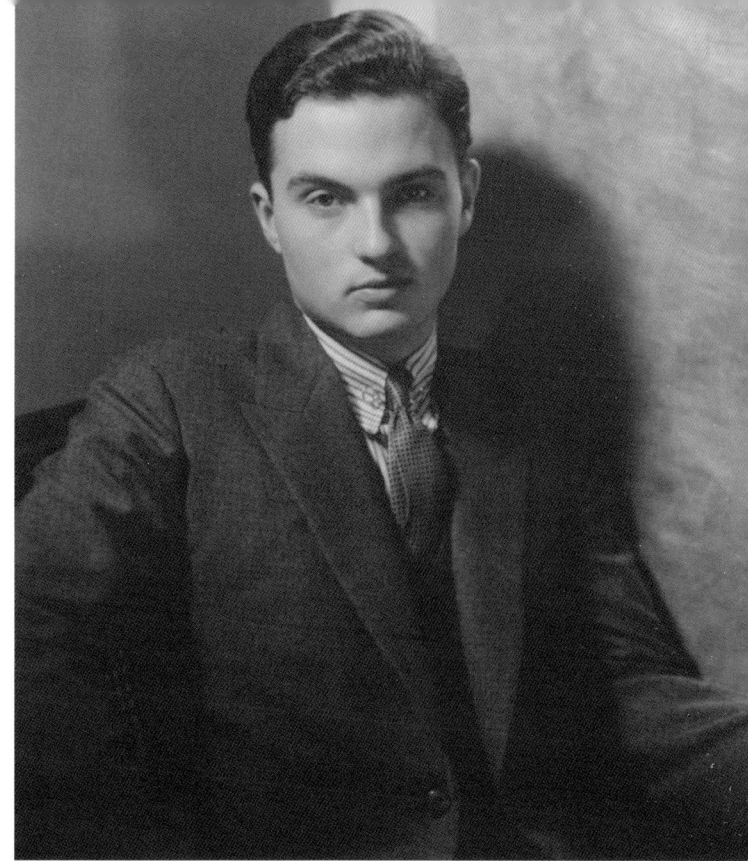

» *fig. 6*

tic Peace;[10] for the cover of Merton's *Selected Poems*[11] (see fig. 7); and had undertaken a photographic study of the monks at the Abbey of Gethsemani, *God Is My Life*,[12] for which Merton wrote the introduction. While working with Burden on this book and going over his photographs, Merton had noted that Burden had "a very fine spontaneous sense of symbolism."[13] However, when the published book arrived a few months later, Merton found it "disappointing,"[14] though the journal entry in which Merton notes this suggests that it might have been more the sentimental captions for the photographs, rather than the photographs themselves, that elicited this reaction, along with a fear that

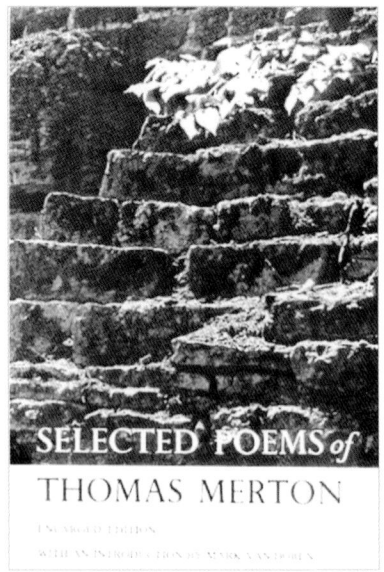

» fig. 7

their sentimentality would be blamed on him, even though he only wrote the "deliberately dry preface."[15] This theory would be supported by the fact that when Merton was considering a photographic study of the Shakers[16] in the early sixties, it would be to Shirley Burden that he initially turned. Or again, it is interesting to see the similarity between some of Merton's subsequent work and the photo by Shirley Burden that was used on the cover of Merton's *Selected Poems*.

In a journal entry for March 19, 1958, Merton records that on a visit to Louisville, he bought "for a few pennies" *The Family of Man*, the book accompanying Edward Steichen's exhibition of photographs at the Museum of Modern Art. Merton goes on to describe it in his journal entry as "fabulous" writing, continuing,

> *No refinements and no explanations are necessary! How scandalized some would be if I said that this whole book is to me a picture of Christ, and yet that is the Truth.*[17]

For many readers of Thomas Merton, the journal entry from which this quotation is taken will be familiar for another reason—it is in the same entry in his personal journal that Merton records his famous "Louisville epiphany."

> *In Louisville, at the corner of Fourth and Walnut, in the Center of the shopping district, I was suddenly overwhelmed with the realization that I loved all those people, that they were mine and I theirs, that we could not be alien to one another even though we were total strangers….There is no way of telling people that they are all walking around shining like the sun.*[18]

Merton's experience of oneness with other people on that street corner in Louisville is mirrored in his experience of the photographs in Steichen's book, where Merton sees all the images as "a picture of Christ."

The following year, in September 1959, Sibylle Akers (see fig. 8), whom Merton would describe in his personal journal as "a very gifted photographer,"[19] visited Merton at Gethsemani.

Akers took a number of official photographs of Thomas Merton and also left him with some of her own photographs of "Indian women sitting with candles on the graves" for the feast of All Souls on the Island of Juntzio.[20] Although Merton would later describe himself as "incurably camera shy" and is critical of the "awful instantaneous snapshot of pose, of falsity, eternalized,"[21] the pictures Sibylle Akers took of Merton are some of the best formal photographs of him, and he himself records that they kept him awake at night pondering to whom he should send copies![22] (see fig. 9).

In 1963, John Howard Griffin (see fig. 10), with whom Merton had already had contact in relation to the issues of war and peace and the Civil Rights movement—Griffin being most famous for his book *Black Like Me*—wrote to Gethsemani requesting permission to "begin a photographic archive of Merton's life and activities." When Griffin visited Merton to photograph him, he recalls, "Tom watched with interest, wanting an explanation of the cameras—a Leica and an Alpa." According to Griffin, Merton remarked on his friendship with Shirley Burden and also with Edward Rice, a friend from his days at Columbia and an extremely competent photographer, before saying to Griffin "I don't know anything about photography, but

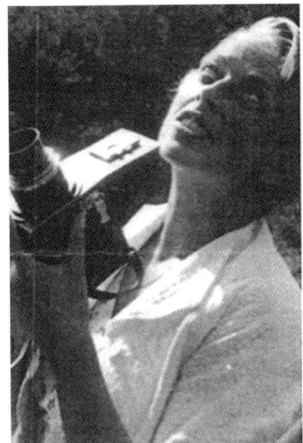

» fig. 8

it fascinates me."[23] The journal *Jubilee*, which Edward Rice (see fig. 11) edited, was frequently lavishly illustrated by Rice's photographs. Similarly, his biography of Merton, *The Man in the Sycamore Tree*, contains many memorable images of Merton. Also some of Thomas Merton's earliest published photographs would be published by Rice in *Jubilee* to illustrate an article Merton had written on the Shakers: "The Shakers: American Celibates and Craftsmen who 'Danced' in the Glory of God."[24]

In January 1967, Thomas Merton began to develop a friendship with another, more local, photographer, Ralph Eugene Meatyard (see fig. 12), who, through his photographs, has left us an intriguing photographic record of Merton. In his personal journal, Merton recorded the visit of Jonathan Williams, Guy Davenport, and Meatyard—"three kings all from Lexington"[25]—

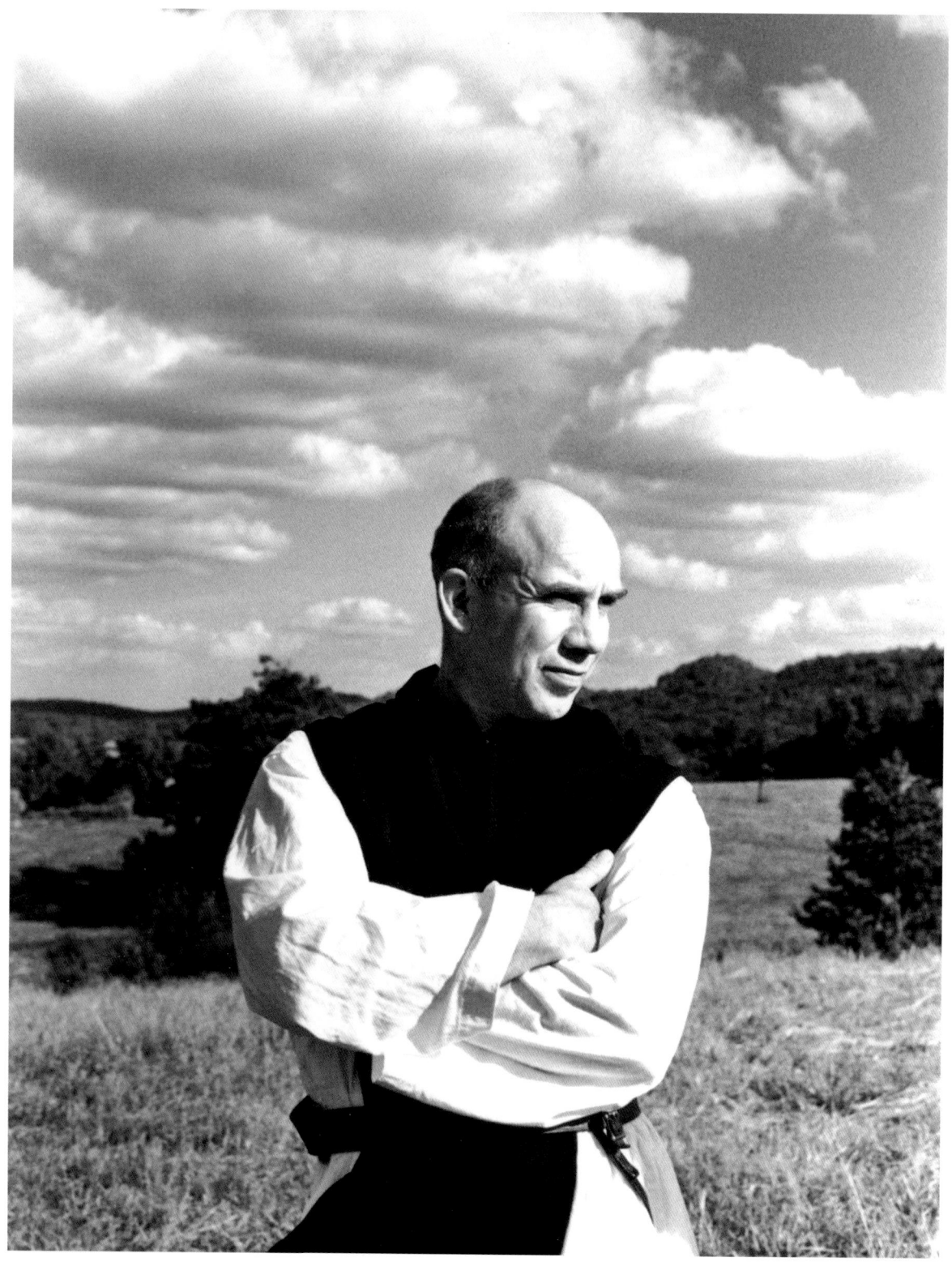

» *fig. 9*

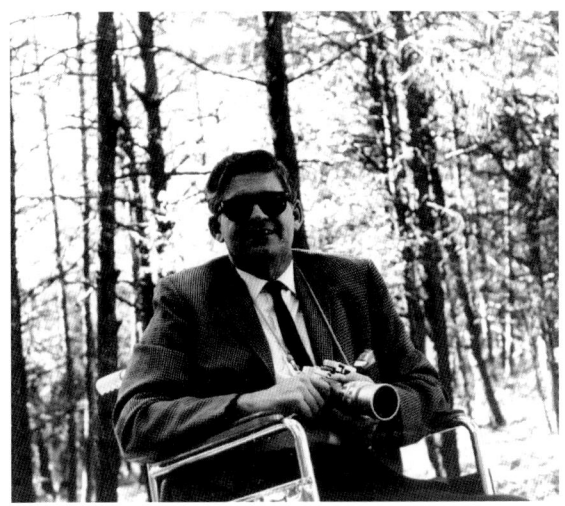

» fig. 10

and, in particular, his excitement at Meatyard's work:

> *The one who made the greatest impression on me as artist was Gene Meatyard, the photographer—does marvelous arresting visionary things, most haunting and suggestive, mythical, photography I ever saw. I felt that here was someone really going somewhere.*[26]

Later writing about Merton and Meatyard, Davenport described Meatyard as "one of the most distinguished of American photographers,"[27] part of the Lexington Camera Club with members such as Van Deren Coke, Guy Mendes, James Baker Hall, and Robert C. May. Meatyard was a professional optician who bought his first camera to photograph his young son in 1950. In 1956, his photographs were exhibited with those of Ansel Adams, Aaron Siskind, Henry Callaghan, and other modern masters. That same year, he attended a photography workshop where, working with Henry Holmes Smith and Minor White,[28] he became interested in Zen.[29]

From their meeting in January 1967 until Merton's death the following year, Merton met Gene Meatyard numerous times and exchanged a brief but steady correspondence of over sixteen letters. During this time, Meatyard took over one hundred photographs of Merton (see figs. 13 and 14), some of the most

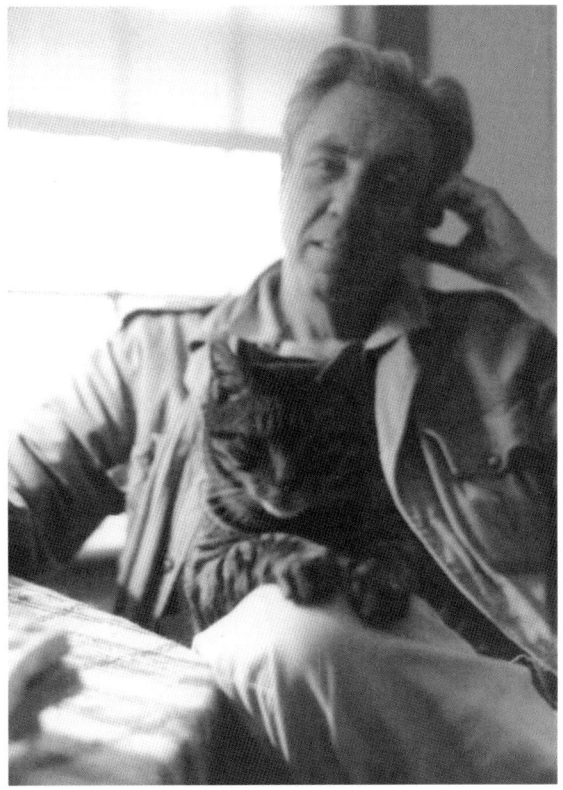

» fig. 11

INTRODUCTION ||| xv

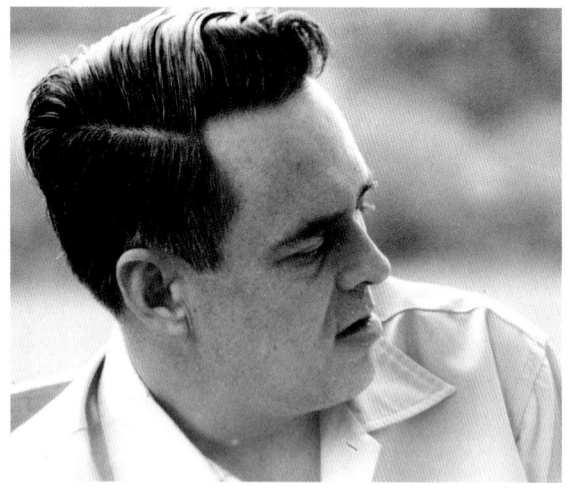

» fig. 12

enigmatic taken—photographs Merton would describe simply as "strange and good."[30] These photographs capture both the paradox of Merton and Meatyard's unique artistic vision: by having his subjects in motion, or by his frequent use of masks in his photographs, most noticeably in the collection *The Family Album of Lucybelle Crater*[31] (see fig. 15).

In his introduction to *Father Louie*, Davenport describes Meatyard's work in the following terms: "...primarily an intricate symmetry of light and shadow. He liked deep shadows of considerable weight, and he liked light that was decisive and clean,"[32] words that could just as well be applied to many of Thomas Merton's own photographs. John Howard Griffin had made reference to this trait in Merton's photographs too in a letter to Merton of January 13, 1967, writing, "They will be difficult for your darkroom to print because of that extraordinary range between light and shadow."[33] Similarly, in a letter of September 17, 1967, Griffin wrote of a test print of a photograph of Merton's that his son Gregory had abandoned "because the blacks were insufficiently rich when it dried."[34]

"Love Affair with Camera"

It is a little unclear when Thomas Merton began taking photographs himself at the Abbey of Gethsemani. The earliest reference I am aware of was on October 10, 1961, when Merton records having taken "half a roll of Kodacolor at the hermitage" (see fig. 16), and in his journal

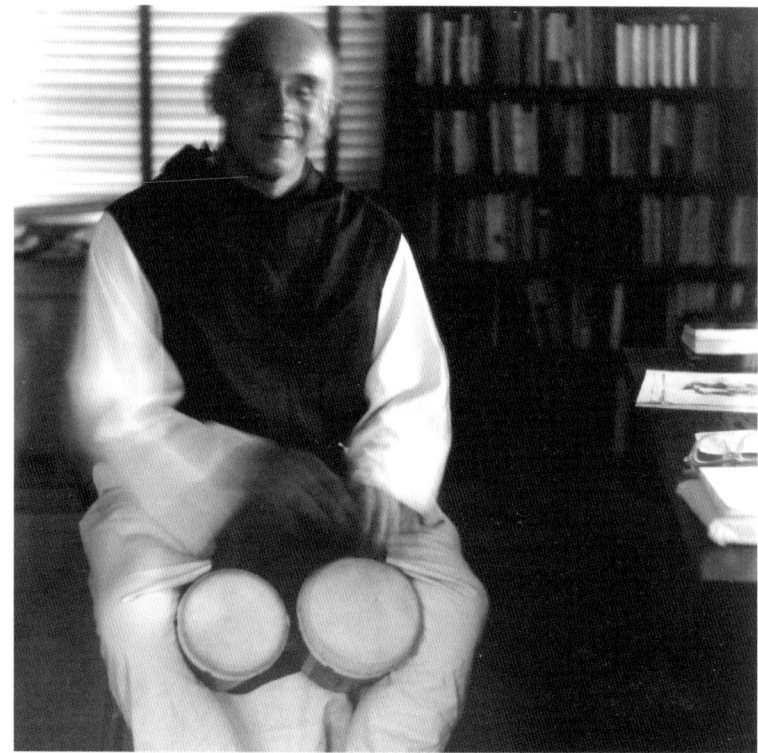

» fig. 13

entry, wonders to himself "what earthly reason is there for taking color photographs?...or any photographs at all"—though, as is so often the way with Merton, he immediately goes on to provide one possible answer, writing, "To send pictures to Loretto and to the Carmelites" as "Mother Luke cannot come to the place and see it herself."³⁵

Certainly, by January 1962, Merton records taking photographs at Pleasant Hill, the Shaker village close to Gethsemani, finding there "some marvelous subjects"³⁶ (see fig. 17).

> *Marvelous, silent, vast spaces around the old buildings. Cold, pure light, and some grand trees....How the blank side of a frame house can be so completely beautiful I cannot imagine. A completely miraculous achievement of forms.*³⁷

Merton was obviously pleased with his results that day as in a later journal entry, he says he is planning to have enlargements made of some of these photographs, describing it as "very satisfying."³⁸ Merton's description here of the buildings he was photographing at Pleasant Hill provides a good starting point for understanding his attraction to photography—insights that go beyond the surface of the frame house and trees, and uncover within them "an inner

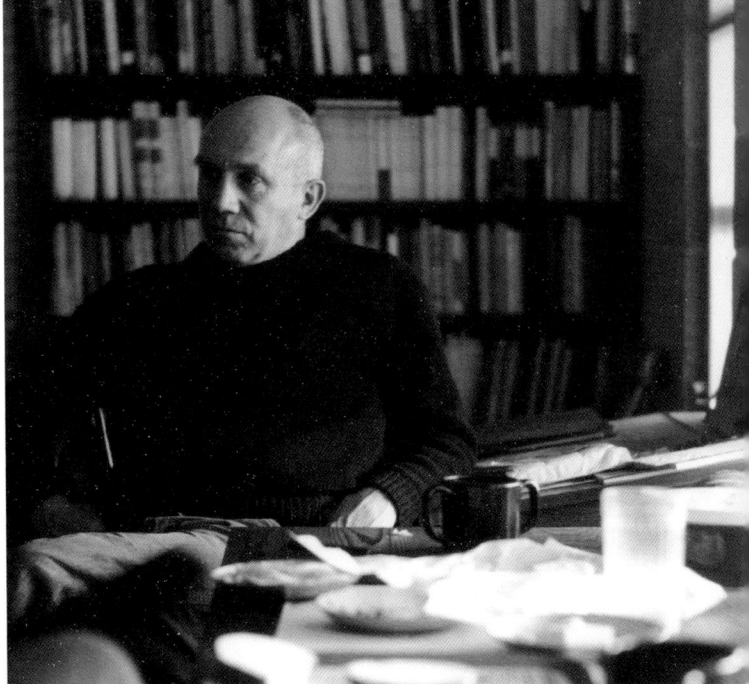

» *fig. 14*

radiance of Being." As Merton's study of the Shakers developed, he wrote in mimeographed notes for one of his lectures to the novices that "the simplicity and austerity demanded by their way of life enabled an unconscious spiritual

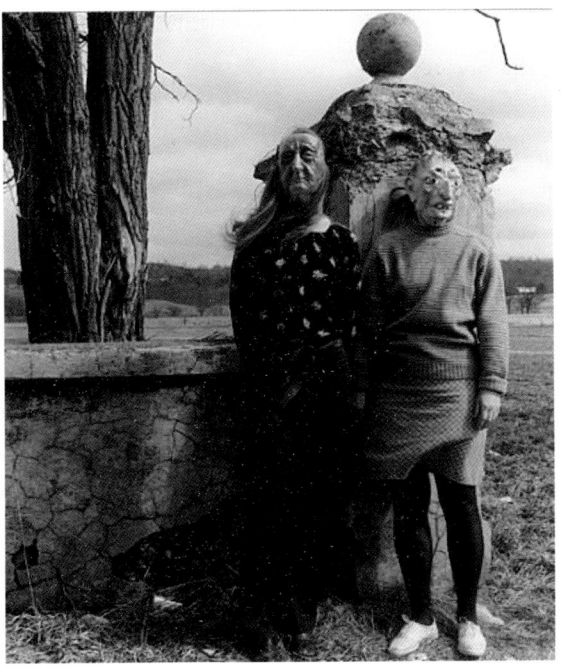

» *fig. 15*

INTRODUCTION ||| *xvii*

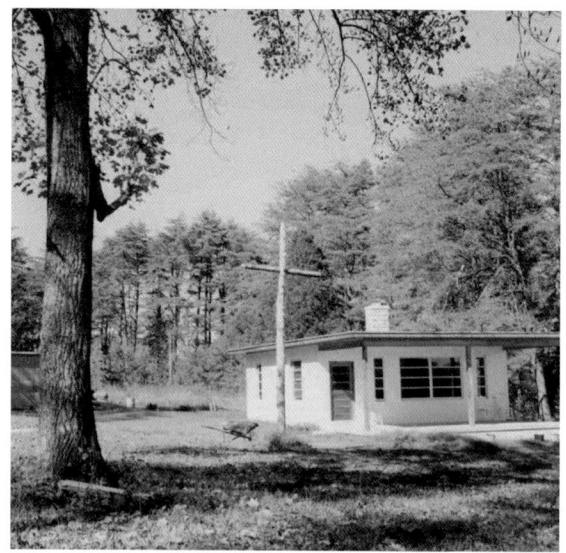

» *fig. 16*

purity to manifest itself in full clarity. Shaker handicrafts are then a real *epiphany of logoi*. Characterized by *spiritual* light."³⁹

We see this spiritual light—this vision—I would suggest, in many of Merton's photographs where ordinary objects could portray an extraordinary, unexpected beauty, reflecting a deep encounter between the craftsman, artist, poet, or photographer, and their subject—a Zen-like awareness. This is reminiscent of the "inscape" of Gerard Manley Hopkins or the "inseeing" of Rainer Maria Rilke, two of Merton's favorite poets—seeing what the photographer Edward Weston would call "the quintessence of the thing itself."⁴⁰

This vision is not limited to religious subjects, for just a few months later, in April 1962, Merton records, in a similar vein, taking photographs with a visiting friend, W. H. "Ping" Ferry, at Dant Station (see fig. 18), an old ruined whiskey distillery, close to the Abbey. He writes of it saying,

> *The long red warehouses, and the wonderful proportion of spaces in the wall, broken up with an interesting low line of narrow windows. Other side, down the road to the creek, windows and doors broken open and Dant labels lying all over the road in hundreds.*⁴¹

These words are reminiscent of those Merton had written in his autobiography about his father's art, describing it as "full of balance, full of veneration for structure, for the relations of masses."⁴²

By September 22, 1964, Merton certainly

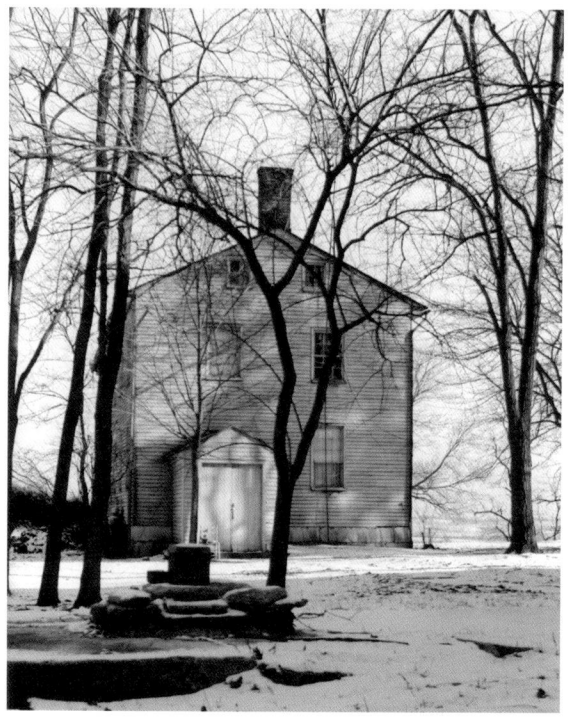

» *fig. 17*

xviii ||| INTRODUCTION

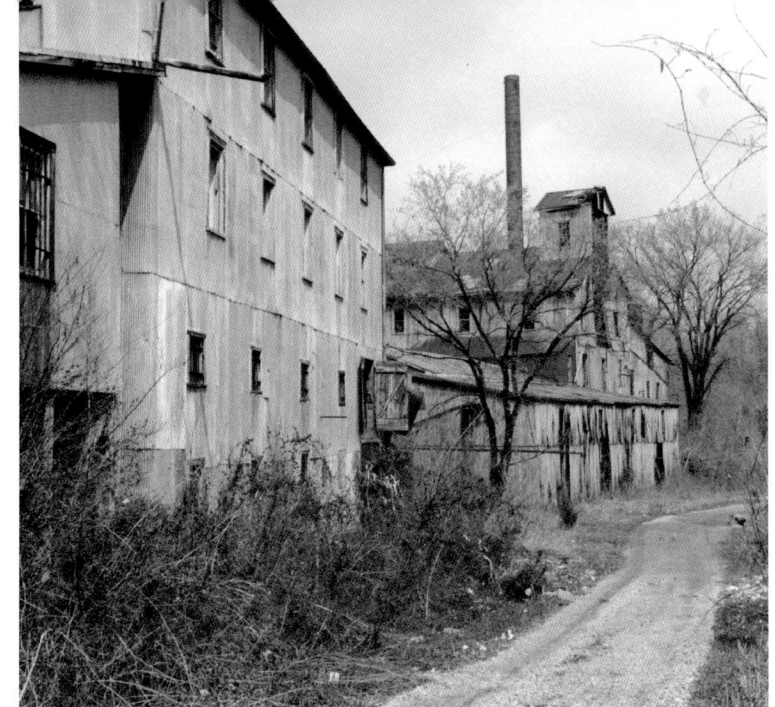

» fig. 18

had regular access to a camera at the Abbey of Gethsemani, recording in his personal journal,

> Brother Ephrem has fitted me out with a camera (Kodak Instamatic) to help take pictures for a book Dom James wants done. So far I have been photographing a fascinating old cedar root I have on the porch. I am not sure what this baby can do. The lens does not look like much—but it changes the film by itself and sets the aperture, etc. Very nice.[43] (see fig. 19)

But two days later, Merton writes that "the dream camera suddenly misbehaved" and that "this marvel of technology and design would not close. The back would not lock shut."[44] The camera is sent into town to be repaired and two days later, he writes again,

> Camera back. Love affair with camera. Darling camera, so glad to have you back! Monarch! XXX. It will I think be a bright day again today.[45]

In his journals, Merton records occasional access to a variety of cameras belonging to his visitors: Naomi Burton Stone's Nikon;[46] John Howard Griffin's Alpa[47]—a camera Merton called "the Picasso camera"[48] as it was the same model used by David Douglas Duncan for his lavish book *Picasso's Picassos*; even on one occasion, a "Japanese movie camera" that he described as "a beautiful thing."[49] One of Merton's most famous photographs was taken using Naomi Burton Stone's Nikon, a view across the rolling monastery fields toward the nearby Kentucky knobs with a hook in the top center of the photograph,

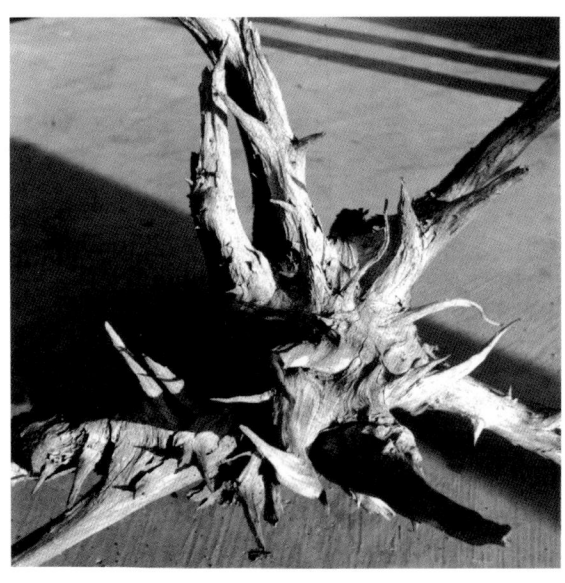

» fig. 19

INTRODUCTION ||| xix

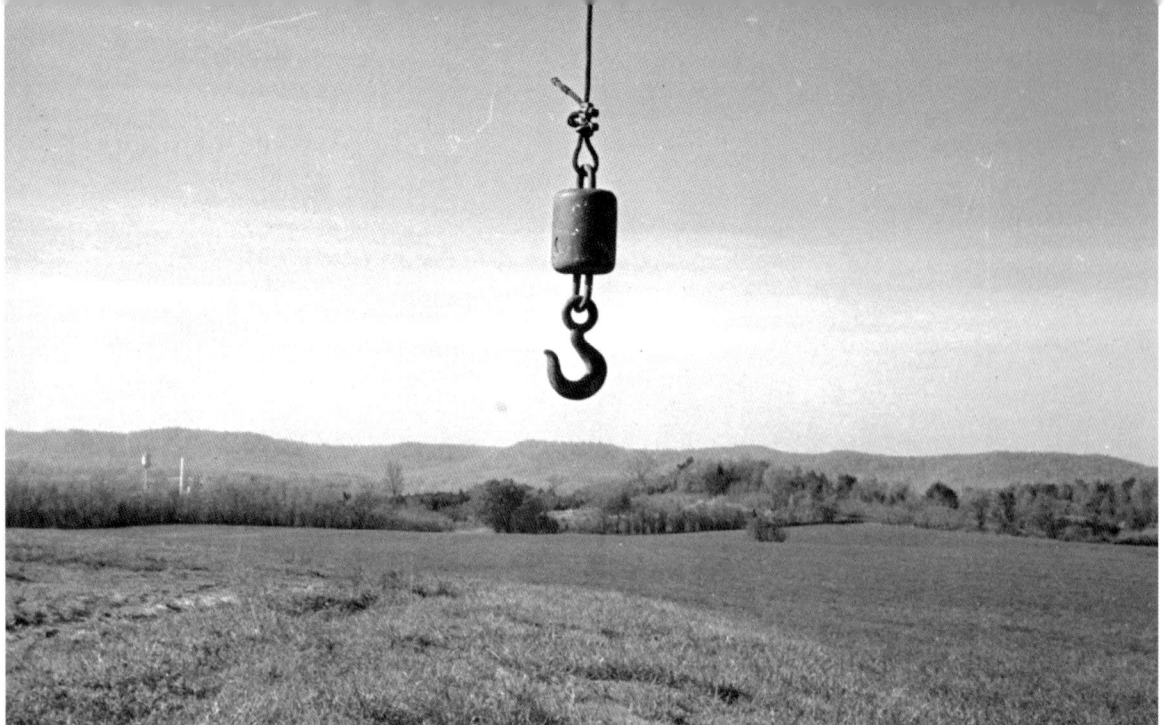

» fig. 20

as if hanging down from the sky itself. It is one of the few photographs to which Merton ever gave a title—two titles in fact—calling it in one place "The Sky Hook" and elsewhere "The Only Known Photograph of God" (see fig. 20).

In August 1967, Merton refers in passing to taking some pictures of roots, this time with a Rolleiflex belonging to the monastery.[50] In January 1968, Merton fell and suspected he might have broken the Rolleiflex so that the back was letting in light. He immediately wrote to his friend and correspondent John Howard Griffin to take up an offer Griffin had made to loan a camera. In his letter, Merton describes the kind of camera he would need; the specifications he outlines give an indication of Merton's own expectations of his photography:

Obviously I am not covering the Kentucky Derby etc. But I do like a chance at fast funny out of the way stuff too. The possibility of it in case. But as I see it I am going to be on roots, sides of barns, tall weeds, mudpuddles, and junkpiles until Kingdom come. A built-in exposure meter might be a help.[51]

In response, John Howard Griffin loaned Merton a Canon F-X (see fig. 21) that Merton, in writing to thank Griffin, described as "fabulous" and "a joy to work with."

The camera is the most eager and helpful of beings, all full of happy suggestions: 'Try this! Do it that way!' Reminding me of things I have overlooked, and cooperating in the creation of new worlds.[52]

Roots, sides of barns and whiskey distilleries, windows and doorways, tall weeds and paint cans, are just some of the subjects in photographs Merton took in the environs of the Abbey of Gethsemani. It has frequently been said that many famous photographers will take a thousand photographs to achieve the one they are looking for. Merton, with the limited resources available to him at the Abbey of Gethsemani, produced many superlative photographs in the limited numbers he took. Later, during his travels of 1968, Merton seems to have had easier access to film as indicated in his journal where he writes that he quickly ran out of film when he visited the Jantar Mantar observatory near Delhi in November of 1968, and then, the following month in Bangkok, he writes of having dropped off nine rolls of film for developing.[53]

In his letters, especially to John Howard Griffin, Merton is self-effacing about his own photographic skills. For example, after Griffin sends him what he describes as some "magnificent...really splendid" enlargements of his photographs of roots, Merton writes, "I find myself wondering if I took such pictures."[54] Or again, after the visit of Jacques Maritain, Merton describes one picture as "a lucky accident." Griffin's reaction to this letter clearly shows the respect he had for Merton's work. Griffin wrote,

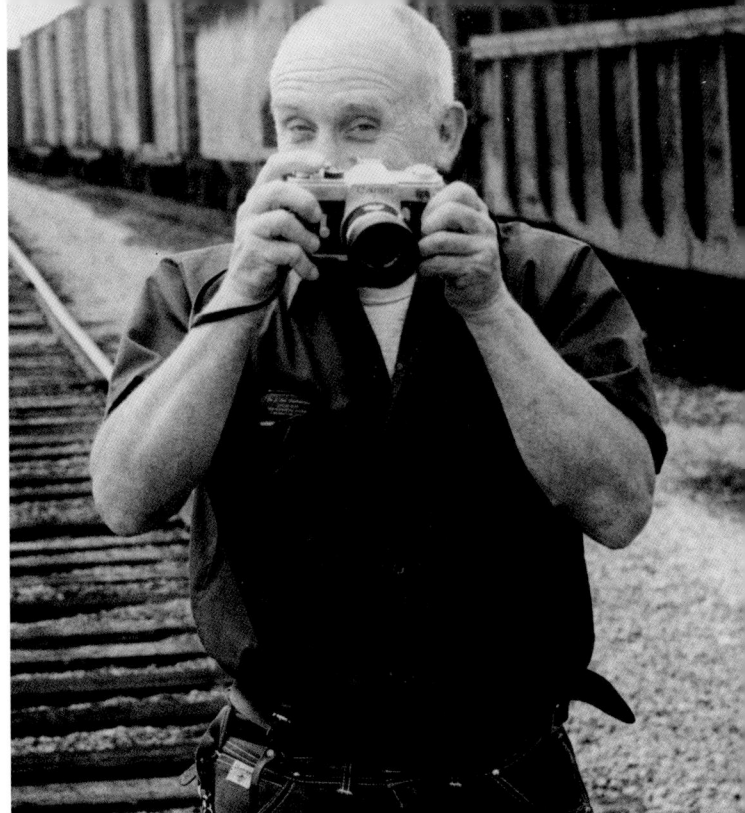

» *fig. 21*

These are not really "lucky accidents" however. It takes an eye and it takes a lot more and your photographs consistently show these deeper things (any fool can develop negatives)....Few pros have what you have in the way of vision, photographic vision, I mean; and your work has a freshness and quality I have seldom seen. These are the real things in photography.[55]

Griffin even goes on to suggest to Merton that he should think about exhibiting his photographs, but Merton refuses, saying,

I'm no pro...just because I happened to press the shutter release accidentally, when the thing was pointing at an interesting object.[56]

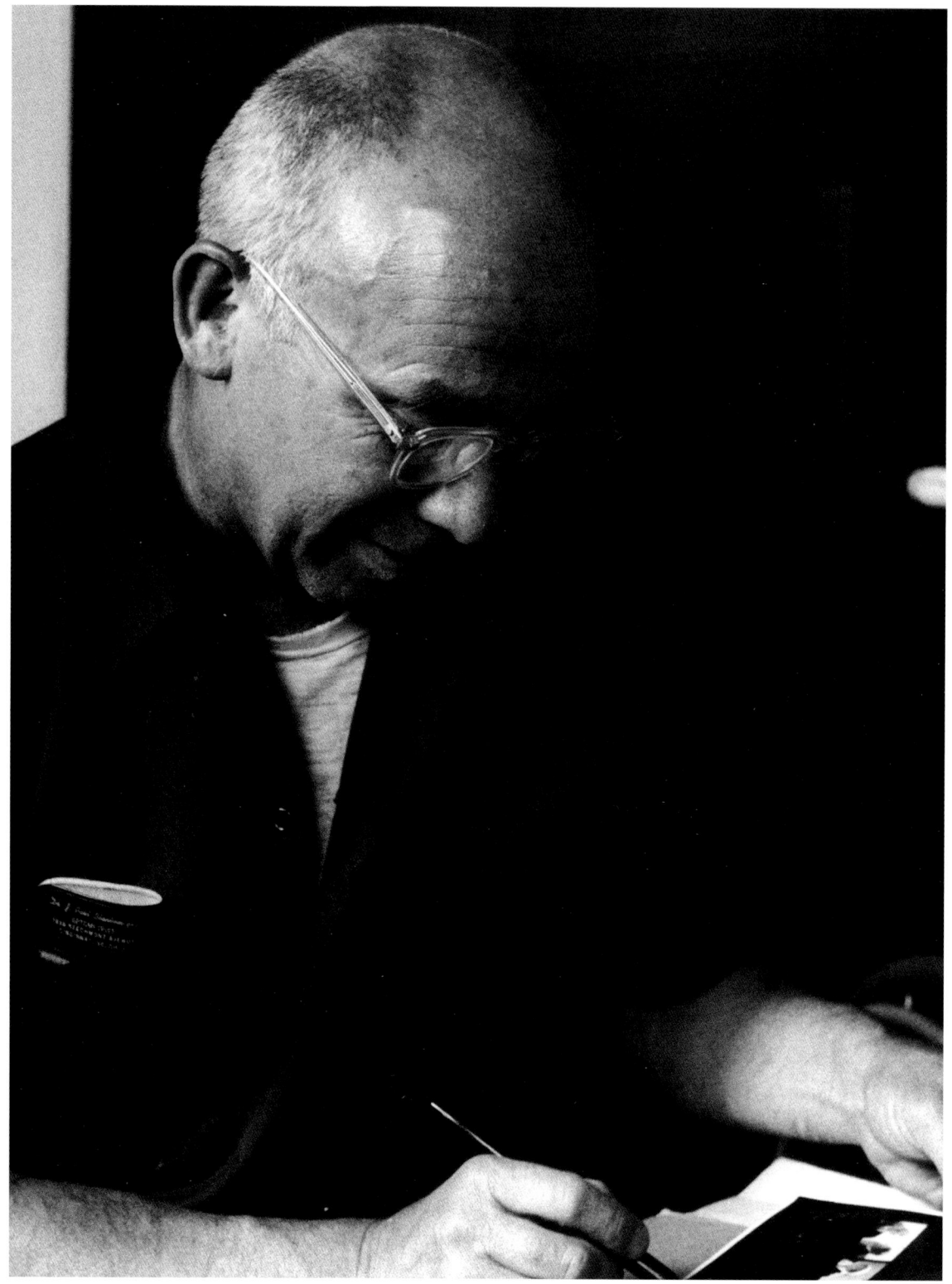

» *fig. 22*

Generally, Merton's preferred photographic medium was black and white, though a number of photographs in the collections at the Thomas Merton Center at Bellarmine University are in color.[57] Merton never did his own developing or printing. This was usually done for him either by Griffin, Griffin's son Gregory, or by other friends. Merton also makes reference to some of his work being done at the Abbey, and in one of Griffin's letters to Merton, he refers to the fact that (much to Griffin's horror) Merton had even had film developed at a nearby drugstore. Griffin writes saying how he and his Gregory both "shivered at the thought of someone sending your negatives for drugstore processing" and instructs Merton never to allow this to happen again.[58]

Thomas Merton's knowledge of the technical aspects of photography was certainly limited. In a letter from January 1968 to Griffin, Merton says that he doesn't "especially like Kodaks or Leicas,"[59] and Griffin quickly reprimands him, "Dear God, don't bracket Leicas and Kodaks in the same sentence—or even the same paragraph."[60] In another letter, Merton admits to knowing nothing about "such mysteries as ASA speeds" and to "never [using] a meter."[61]

After Merton's death, John Howard Griffin recalled that he and his son were frequently bewildered by the pictures Merton selected from contact sheets to be enlarged (see fig. 22). "He ignored many superlative photographs while marking others," wrote Griffin.

> *We thought he had not yet learned to judge photographs well enough to select consistently the best frames. We wrote and offered advice about the quality of some of the ignored frames. He went right on marking what he wanted rather than what we thought he should want. Then, more and more often, he would send a contact sheet with a certain frame marked and his excited notation: 'At last—this is what I have been aiming for.'*[62]

Sadly, none of those original contact sheets seem to have survived.[63] They would have provided a fascinating insight into the images Merton himself thought were worth having printed and enlarged. In the absence of these contact sheets, the best indication of Merton's preference for his own photographs come from those he submitted for publication along with those he himself published in 1968 in his *avant-garde* journal, *Monk's Pond*.[64]

However, that description by Griffin written in his book *A Hidden Wholeness*, published two years after Merton's death, is far more circumspect than Griffin's letters written at the

INTRODUCTION ||| *xxiii*

actual time that he and Gregory were working with Merton's contact sheets. These letters contain no hint of what he would later describe as their "bewilderment," but instead, just their excitement and wonder at the images they were enlarging, images that Merton himself had chosen, not the images Griffin and his son "thought he should want." So, in October 1967, Griffin writes,

> *Each photo of yours seeming more beautiful and exciting…the atmosphere in that darkroom is electric and I wish you could have been here to experience the extreme excitement of [Gregory] and those negatives, which are supremely beautiful.[65]*

The next day Griffin would write in a similar vein to their mutual friend Robert Bonazzi,

> *These are some of the most eloquent and beautiful statements I have ever seen in photography. I am…trying to understand what Merton does with his eye and his camera.[66]*

In *A Hidden Wholeness*, Griffin describes Merton's photography, getting right to the heart of his particular photographic genius, to its simplicity, like the Zen masters and the desert mothers and fathers Merton so admired:

> *His vision was more often attracted to the movement of wheat in the wind, the textures of snow, paint-spattered cans, stone, crocuses blossoming through weeds—or again, the woods in all their hours, from the first fog of morning, through noonday stillness, to evening quiet.*
>
> *In his photography, he focused on the images of his contemplation, as they were and not as he wanted them to be. He took his camera on his walks and, with his special way of seeing, photographed what moved or excited him—whatsoever responded to that inner orientation.*
>
> *His concept of aesthetic beauty differed from that of most men. Most would pass by dead tree roots in search of a rose. Merton photographed the dead tree root or the texture of wood or whatever crossed his path. In these works, he photographed the natural, unarranged, unpossessed objects of his contemplation, seeking not to alter their life but to preserve it in his emulsions.*
>
> *In a certain sense, then, these photographs do not need to be studied, they need to be contemplated if they are to carry their full impact.[67]*

From these comments by Griffin, by tracing Merton's development as a photographer, and through looking at Merton's photographs, it is clear that Thomas Merton used his camera as a contemplative instrument, and he photographed the things he contemplated. Through his photography, as with his writing, he breaks through the debris that so frequently obscures our vision of the world around us. The simplicity, directness, transparency of Merton's photographs allows God to shine through.

In these photographs, we can see Merton's utter awakeness to the "isness" of reality. As Thomas Merton discovered in Zen a "good clean blade" to "cut right through all the knots,"[68] so, we too, in contemplating Merton's photographs, can learn how to *see*, can learn how to go "beyond the shadow and the disguise" to the reality that is immediately in front of us, and to discover what Merton calls the "cosmic dance which...beats in our very blood."[69]

Thomas Merton's photographs invite us to break through the media hype, the technobabble, and the torrent of images we are constantly bombarded with to that inner radiance of being, that consciousness of paradise within each and every one of us, to that image of God in which we were created.

These images serve as question marks, asking us to pause and to reflect on what we are seeing (for example, fig. 23). The words of his poem "In Silence," serve to illustrate this well:

Be still
Listen to the stones of the wall.
Be silent, they try
To speak your

Name....

...The whole
World is secretly on fire. The
stones
Burn, even the stones
They burn me. How can a man
be still or
Listen to all things burning?
How can he dare
To sit with them when
All their silence
Is on fire?"[70]

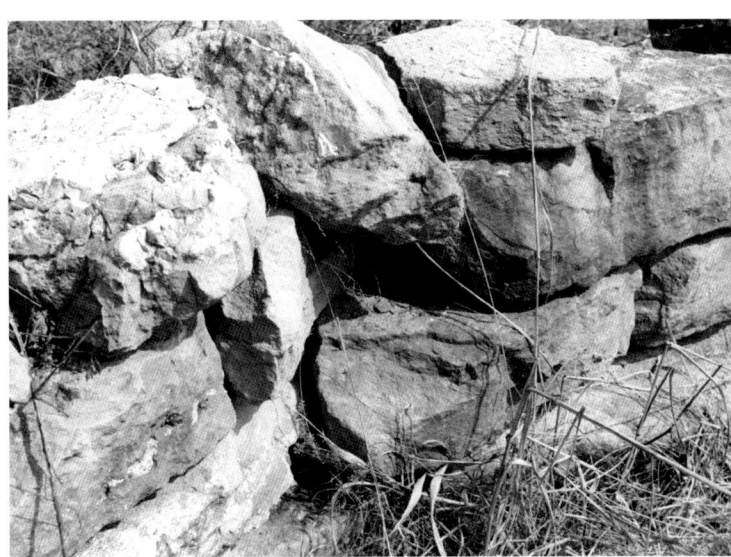

» *fig. 23*

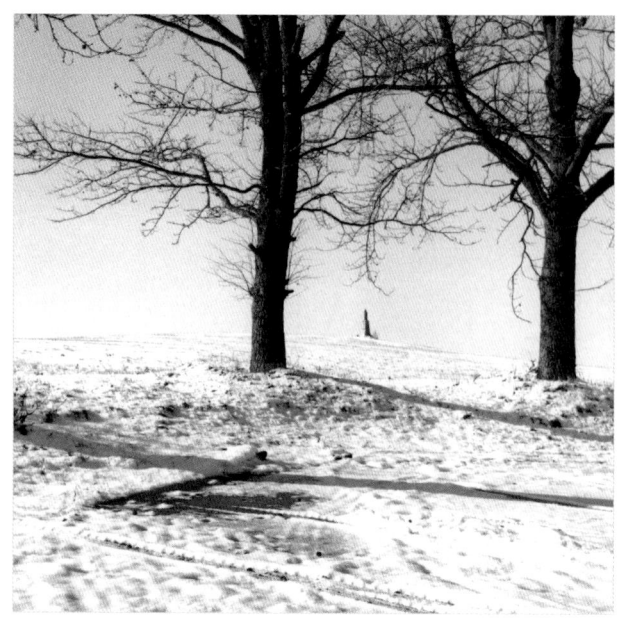

I

THE PARADOX OF PLACE

GETHSEMANI AND PLEASANT HILL

THOMAS MERTON could never be accused of being indifferent to place. As Michael Mott says, "It would be hard to exaggerate the importance of place for Thomas Merton."[1] The story of Merton's life that he recorded so meticulously is the record of a journey characterized by place—St. Antonin, Oakham, Rome, Cambridge, New York, Cuba, Olean, Kentucky.

Within the Christian Tradition, there have been two prominent themes frequently used for describing the Christian life—*pilgrimage* and *plantation*. They were themes clearly evident in Merton's life and writings: entering a community with vows of stability to one place and obedience to an abbot, yet all the while seeking to travel further and further on his journey toward God. His early life was marked by journeys and instability, his years at Gethsemani by stability of place, though rarely by stability of heart except that which he found in seeking God.

The wandering of his early life, which he described as having given him a "terrific sense of geography," nonetheless lacked a reassuring constancy. He imagined that with his entry to Gethsemani in 1941, his geography would be limited to the "four walls" of the monastic enclosure:

> *There will be no more future—not in the world, not in geography, not in travel...new work, new problems in writing, new friends, none of that: but a far better progress, all interior and quiet!!!*[2]

These emotions are similar to those he expressed in a poem likely written about this time, where he said:

> *Geography comes to an end,*
> *Compass has lost all earthly north,*
> *Horizons have no meaning*
> *Nor roads an explanation.*[3]

As Merton's wanderings stopped in the limited enclosure of the novitiate, an enclosure within the enclosure, he began for almost the first time in his life to put down roots and notice the world around him. Monica Furlong says of him that Gethsemani

> *began to feel like home, a deeply consoling experience to a man who had not really belonged anywhere since he was six years old; enclosure and stability were the antithesis of the wandering that had taken up so much of his young life.*[4]

The stability of place Merton found at Gethsemani, especially compared to the sense of homelessness and exile of his youth, were essential to his development as a person. The Cistercian writer Charles Cummings has pointed out how important a sense of groundedness is for people, saying that "reaching one's full human and spiritual potential seems to be facilitated by some degree of stability in a peaceful place where one can be at ease, sort things out, and develop a feeling of being a fully existing, unique individual."[5] Over the course of *Conjectures of a Guilty Bystander*, it is possible to see Merton's growing sense of having discovered that "stability in a peaceful place" and the effect this had of making him increasingly aware of both his surroundings and the natural life he shared with those surroundings. James McMurry describes this same experience in the following terms:

> *A man can never really come to know himself, and in that knowledge know God, unless he dwells for long periods in one place among familiar, congenial surroundings. Without stability he cannot confront the basic questions of life: Who am I, Where am I, Whence have I come, Where am I going?*[6]

In one entry contained in the pivotal section of *Conjectures* titled "The Night Spirit and the Dawn Air," dating from the very early sixties, Merton begins by describing "the 'way' up

through the woods" and how he "appreciate[s] the beauty and the solemnity" of it, going on to describe the sunrise before stating, "It is essential to experience all the times and moods of one good place. No one will ever be able to say how essential, how truly part of a genuine life this is"[7]—"to experience all the times and moods of one good place."

Merton's statement about "one good place" seems to be brought about by the effect his natural surroundings had upon him and by being allowed to spend a limited amount of time in solitude at the hermitage. The influence of these two factors can be seen in an entry in his personal journal from December 1960, in which he records one of the first evenings he spent at the hermitage:

> *Lit candles in the dusk. Haec requies mea in saeculum saeculi [This is my resting place forever]—the sense of a journey ended, of wandering at an end. The first time in my life I ever really felt I had come home and that my waiting and looking were ended.*
>
> *A burst of sun through the window. Wind in the pines. Fire in the grate. Silence over the whole valley.*[8]

In this quotation, Merton combines the natural surroundings and the solitude of the hermitage with his feeling of having, at last, found a place where he belonged. Merton's vow of stability allowed him to notice the physical space around him, space that, as he said elsewhere, he never noticed when he was in the world and more mobile. Dwelling "for long periods in one place among familiar, congenial surroundings"[9] was essential for Merton to come to know God and to know himself; it was integral to his spiritual quest.

In September 1962, after returning to the monastery after a spell in the hospital, Merton records his feelings toward Gethsemani:

> *Once again I get the strange sense that one has when he comes back to a place that has been chosen for him by Providence. I belong to this parcel of land with rocky rills around it, with pine trees on it. These are the woods and fields that I have worked in, and in which I have encountered the deepest mystery of my own life. And in a sense I never chose this place for myself, it was chosen for me.*[10]

His reflection here is very much in line with Cummings's comments on the effect of "stability in a peaceful place" and the way it enables a person to "be at ease, sort things out, and develop a feeling of being a fully existing, unique individual."[11]

Sacramental Visions of the World

Among Merton's wide and varied interests when he became interested in photography, it would seem that the Shakers attracted him in particular because of their own emphasis on nature and place.

Kentucky was the farthest west the Shakers spread in the United States, and the Shaker settlement nearest to Gethsemani was Pleasant Hill. The last members of the community had long since died, but their buildings were still there and a restoration project was about to begin. On a visit to Pleasant Hill in January 1962, Merton found their buildings "indescribably beautiful." In the snow, Merton took in the "cold, pure light" and "some great old trees" and enjoyed a "few moments of eloquent silence in the snow;" moments, he said, that "stay with me, follow me home, do not go away."[12]

The Shakers, like the early Cistercians, appreciated the importance of place. They carefully chose sites for their communities, and often the place and their religious aspirations were reflected in the names they gave their communities—Pleasant Hill, New Lebanon and Sabbathday Lake, for example. There are also many other similarities between the Shakers and the Cistercians, especially with their emphasis on work, rhythm of life, simplicity, architecture, and lifestyle.[13] Merton, in writing to the renowned Shaker scholar Edward Demming Andrews, points clearly to some of the similarities, saying both groups "originally had the same kind of idea of honesty, simplicity, good work, for a spiritual motive," and in his letter, notes that "a Cistercian ought to be in a good position to understand the Shaker spirit."[14] In *The Waters of Siloe*, Merton described how

> *Cistercian architecture is famous for its energy and simplicity and purity, for its originality and technical brilliance. It was the Cistercians who effected the transition from the massive, ponderous Norman style to the thirteenth-century Gothic, with its genius for poising masses of stone in mid-air, and making masonry fly and hover over the low earth with the self-assurance of an angel.[15]*
>
> *The typical Cistercian church, with its low elevation, its plain, bare walls, lighted by few windows and without stained glass, achieved its effect by the balance of masses and austere, powerful, round or pointed arches and mighty vaulting. These buildings filled anyone who entered them with peace and restfulness and disposed the soul for contemplation in an atmosphere of simplicity and poverty.[16]*

These descriptions could be applied equally well to certain aspects of Shaker architecture.

Writing many years later about the Shakers after having visited Pleasant Hill, Merton commented on the "extraordinary, unforgettable beauty" of their buildings and furniture brought about, like the Cistercians, through their attempts to "build honest buildings and to make honest sturdy pieces of furniture."[17] Merton also refers to this in his unpublished notes: "See also their buildings, barns especially, high, this highly mystical quality, capaciousness and dignity, solidity, permanence—*logos* of a barn."[18] In introducing Edward Demming Andrew's book *Religion in Wood*, Merton noted that "neither the Shakers nor Blake would be disturbed at the thought that a work-a-day bench, cupboard, or table might also and at the same time be furniture in and for heaven."[19] Later in the same piece, Merton says, "The peculiar grace of a Shaker chair is due to the fact that it was made by someone capable of believing that an angel might come and sit on it."[20] This description can equally be applied to Shaker and Cistercian architecture.

There is a great contrast between the travels of Merton's early years and those he undertook in the final year of his life. His early travels were an aimless wandering from place to place, unlike his travels of 1968, which were a part of his journey into solitude, his spiritual pilgrimage in search of the next stage on his spiritual journey. The major difference between Merton's early travels and those of 1968 is that by the latter, Merton had attained an inner stability and a sense of home, of rootedness, which allowed him to travel in a new way:

> *It was because he had by now found a home that he was ready to go out. He knew that he belonged at Gethsemani, and that this rootedness gave him a place from which to set out and to which to return.*[21]

This chapter reflects one side of this paradoxical pole in Merton's life and writing, images of the places associated with his monastic life, the minute things he observed around him every day at the Abbey of Gethsemani in the rural Kentucky countryside, images that in his photographs became prayers. Chapter 4 will then highlight the other pole with images from his travels of 1968, images of California, New Mexico, Alaska and Asia—images of places very different to his monastery, yet still seen with the same eye that captured those images of Gethsemani.

Railroad Station near Gethsemani

We were begotten in the tunnels of
December rain,

Born from the wombs of news and
tribulation,

By night, by wakeful rosary:

Such was my birth, my resurrection
from the freezing east,

The night we cleared you, Cincinnati,
in a maze of lights.[1]

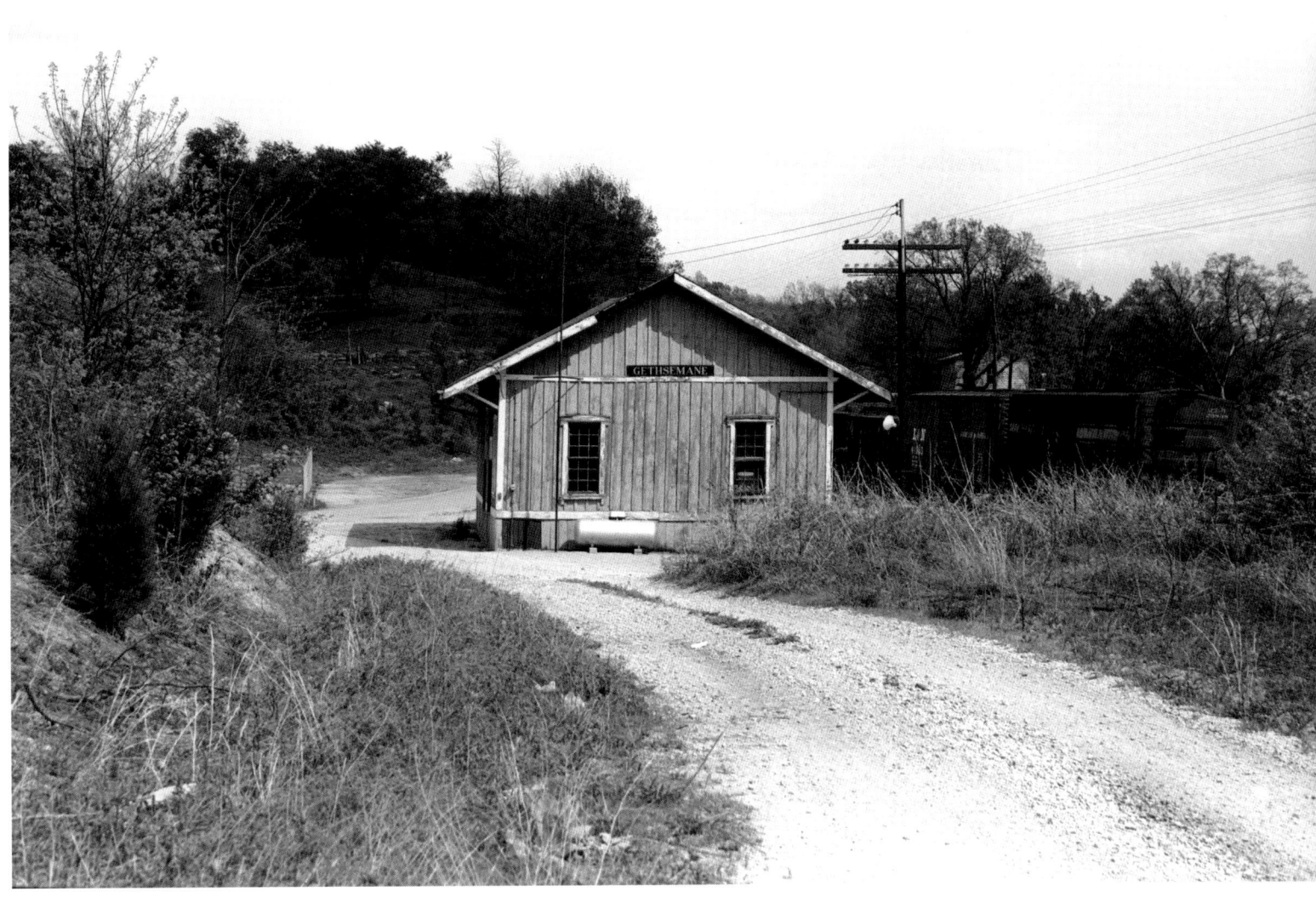

Della Robbia, Alcove Shrine, Gethsemani

Solitude is not found so much by looking outside the boundaries of your dwelling, as by staying within. Solitude is not something you must hope for in the future. Rather, it is a deepening of the present, and unless you look for it in the present you will never find it.[2]

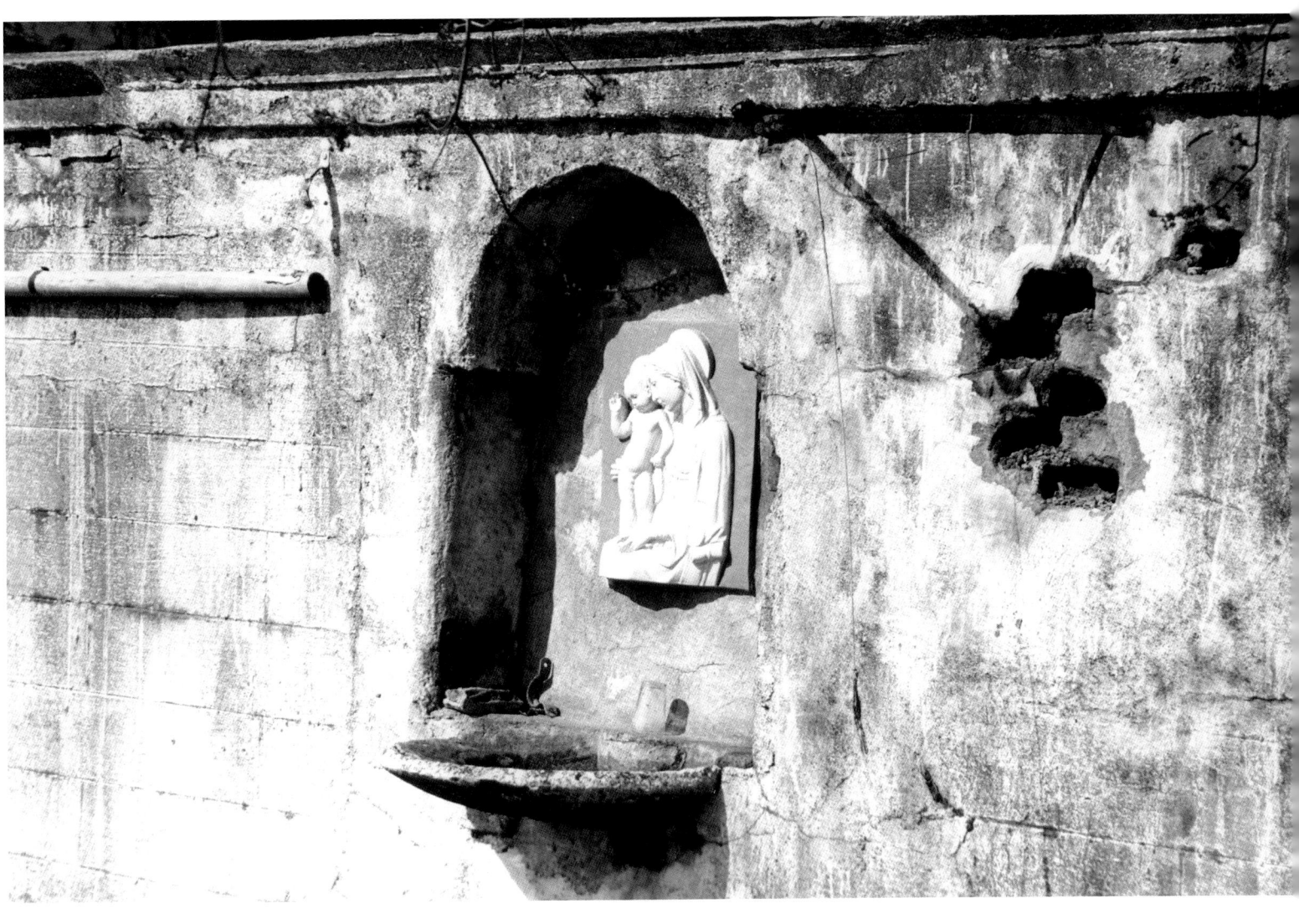

Woods in Snow, Gethsemani

I belong to this parcel of land with rocky rills around it, with pine trees on it. These are the woods and fields that I have worked in, and in which I have encountered the deepest mystery of my own life. And in a sense I never chose this place for myself, it was chosen for me.[3]

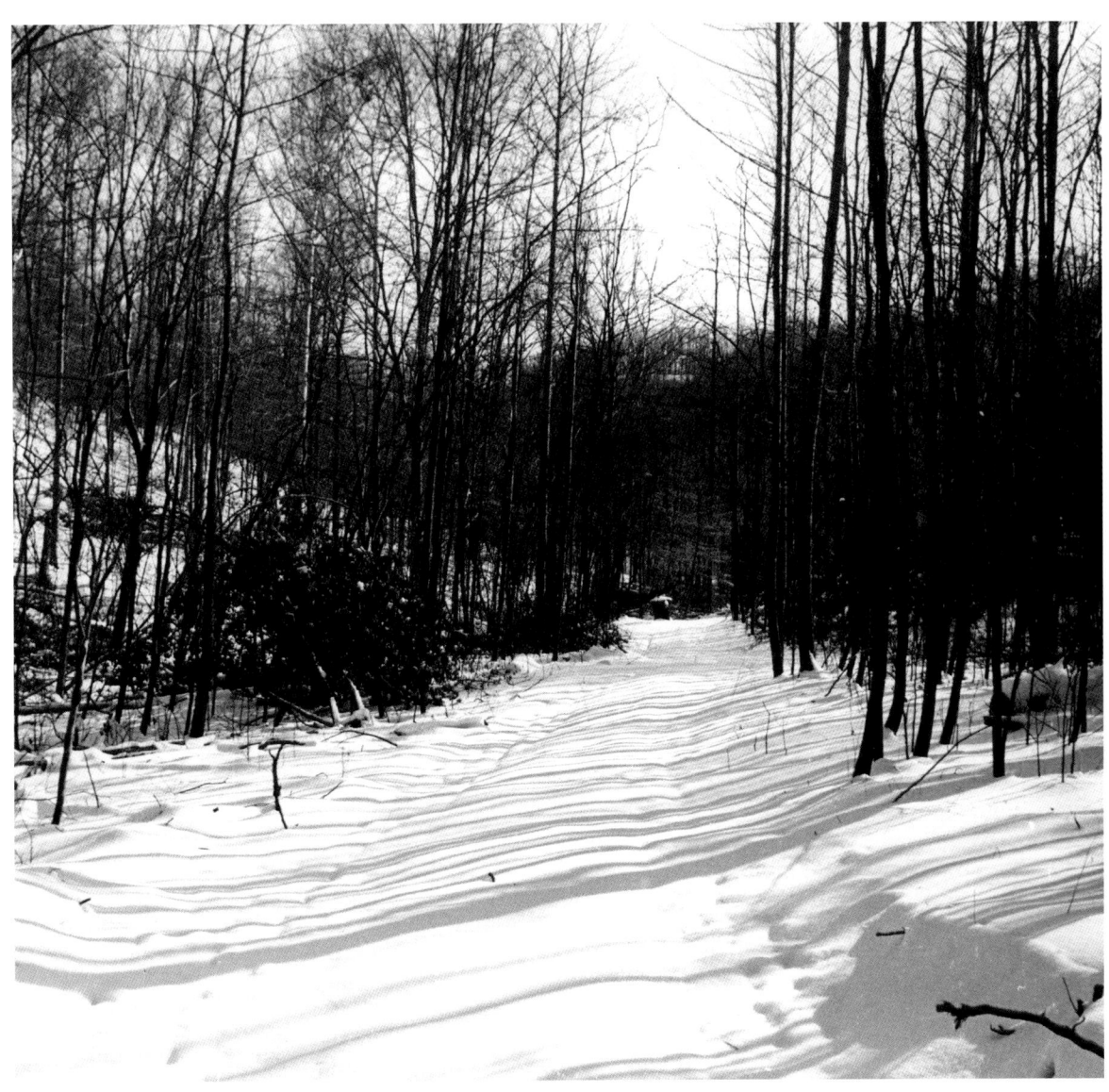

Tree Trunks near Hermitage, Gethsemani

I live in the trees...and the woods cultivate me with their silences, and all day long even in choir and at Mass I seem to be in the forest.[4]

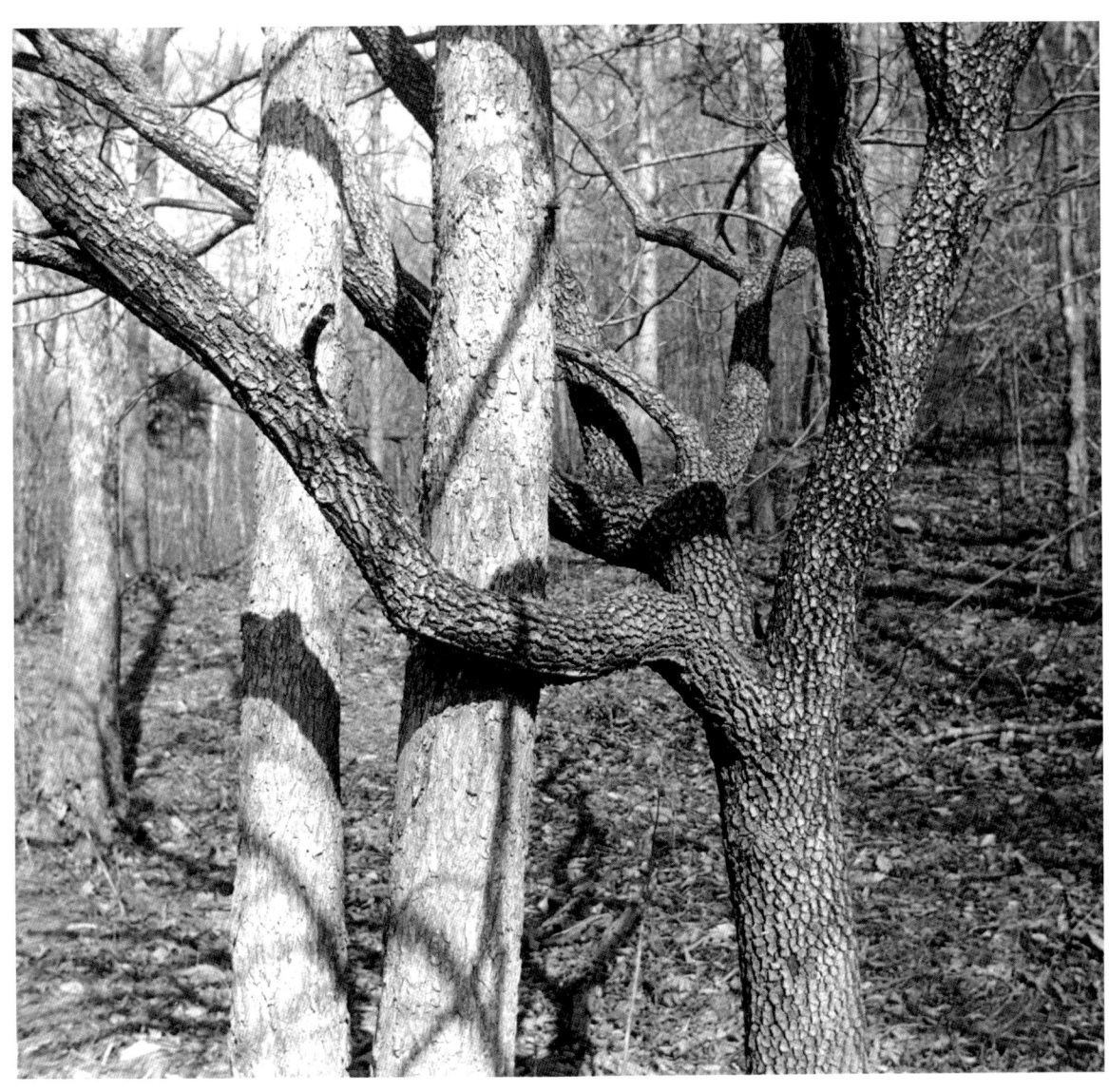

Tree Trunk

This is my place and yet I have never felt so strongly that I have "no place" as I have felt here since becoming fully reconciled to this as "my place." My place is in reality no place, and I hesitate to act as if I were anything but a stranger anywhere, but especially here.[5]

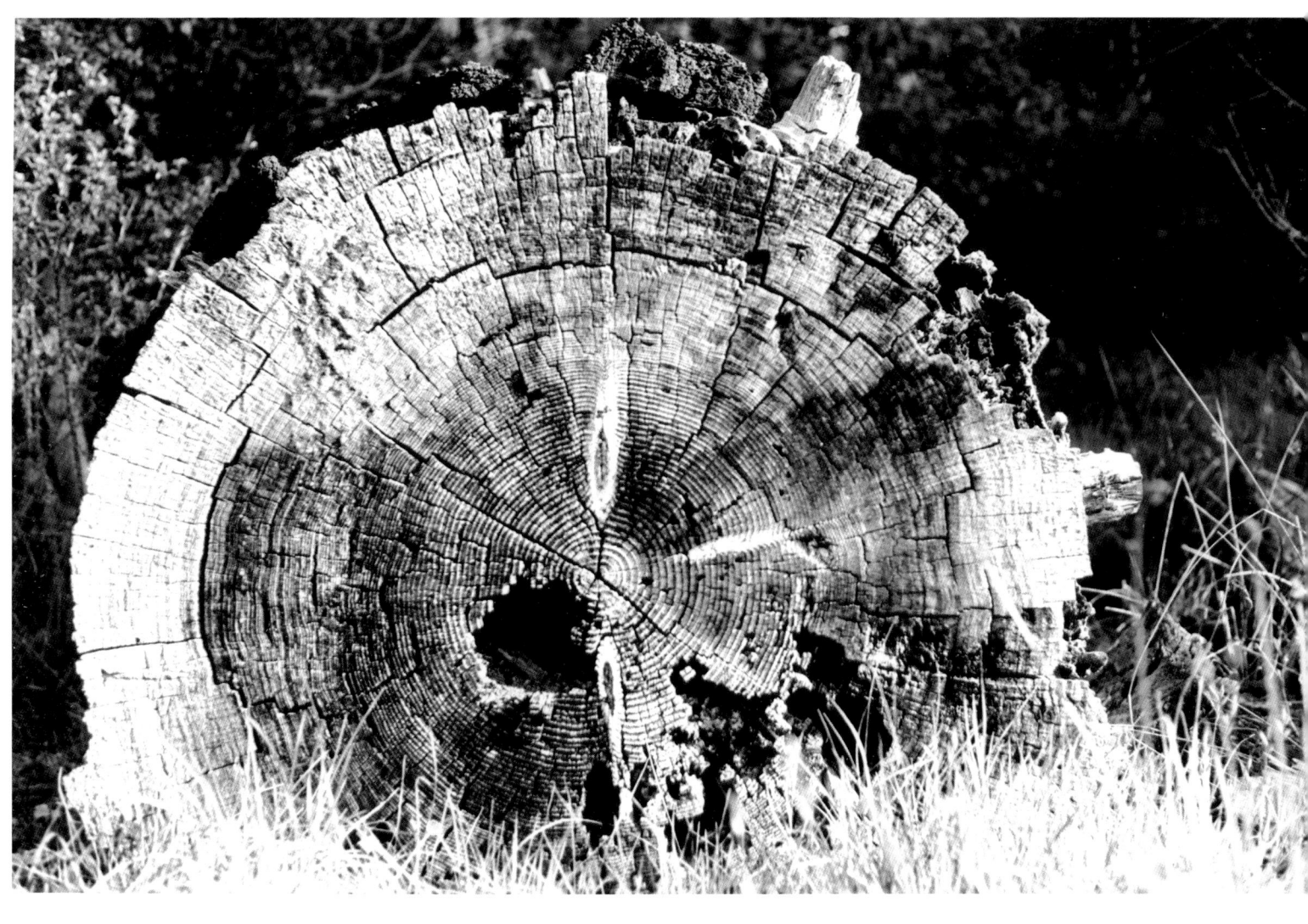

Root, Gethsemani

In the silence of the countryside and the forest, in the cloistered solitude of my monastery, I have discovered the whole Western Hemisphere. Here I have been able, through the grace of God, to explore the New World.[6]

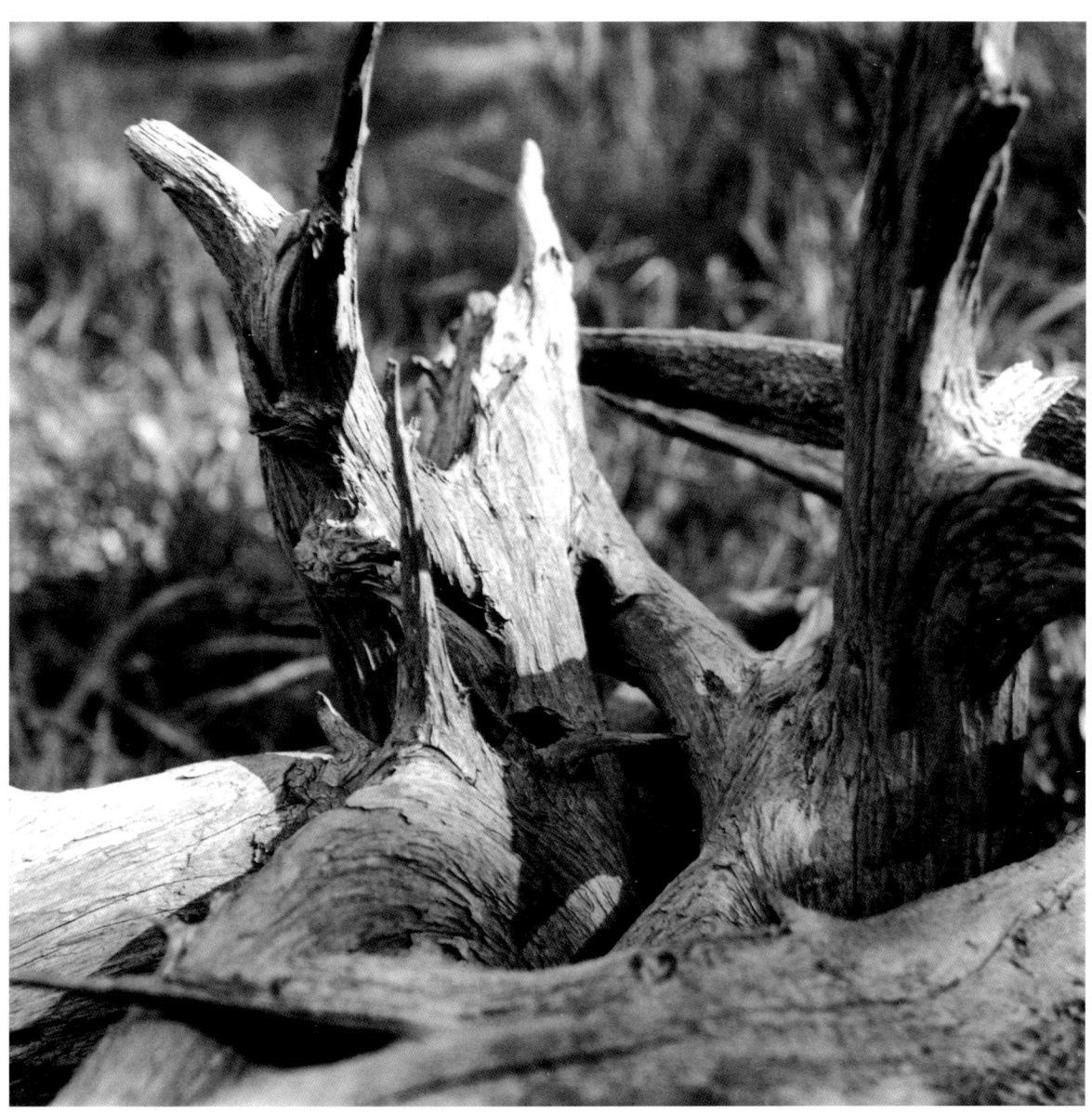

Creek in Woods, near Monks Pond, Gethsemani

Listen, Elias,

To the southern wind...

Live beneath this pine

In wind and rain.

Listen to the woods.[7]

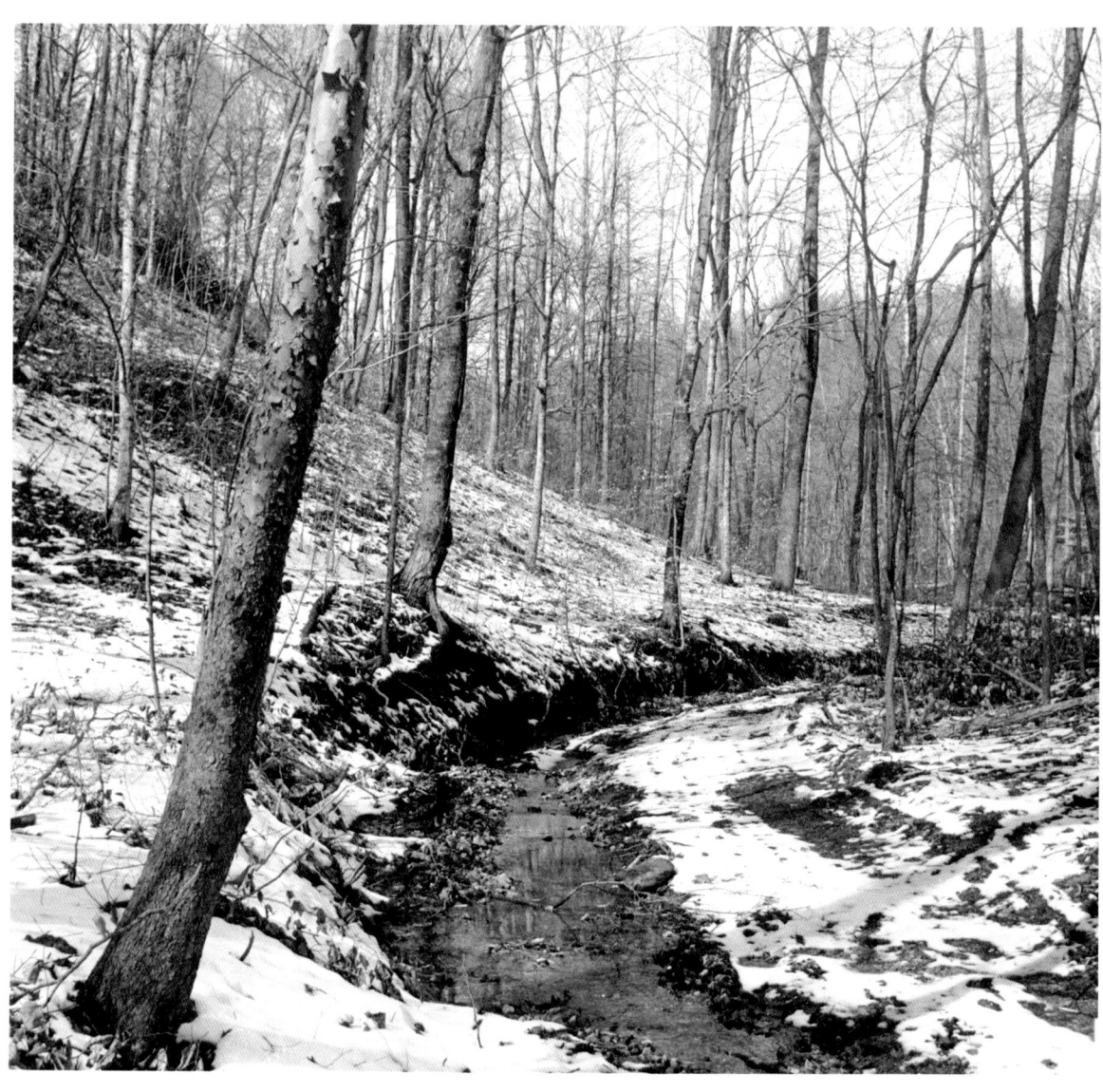

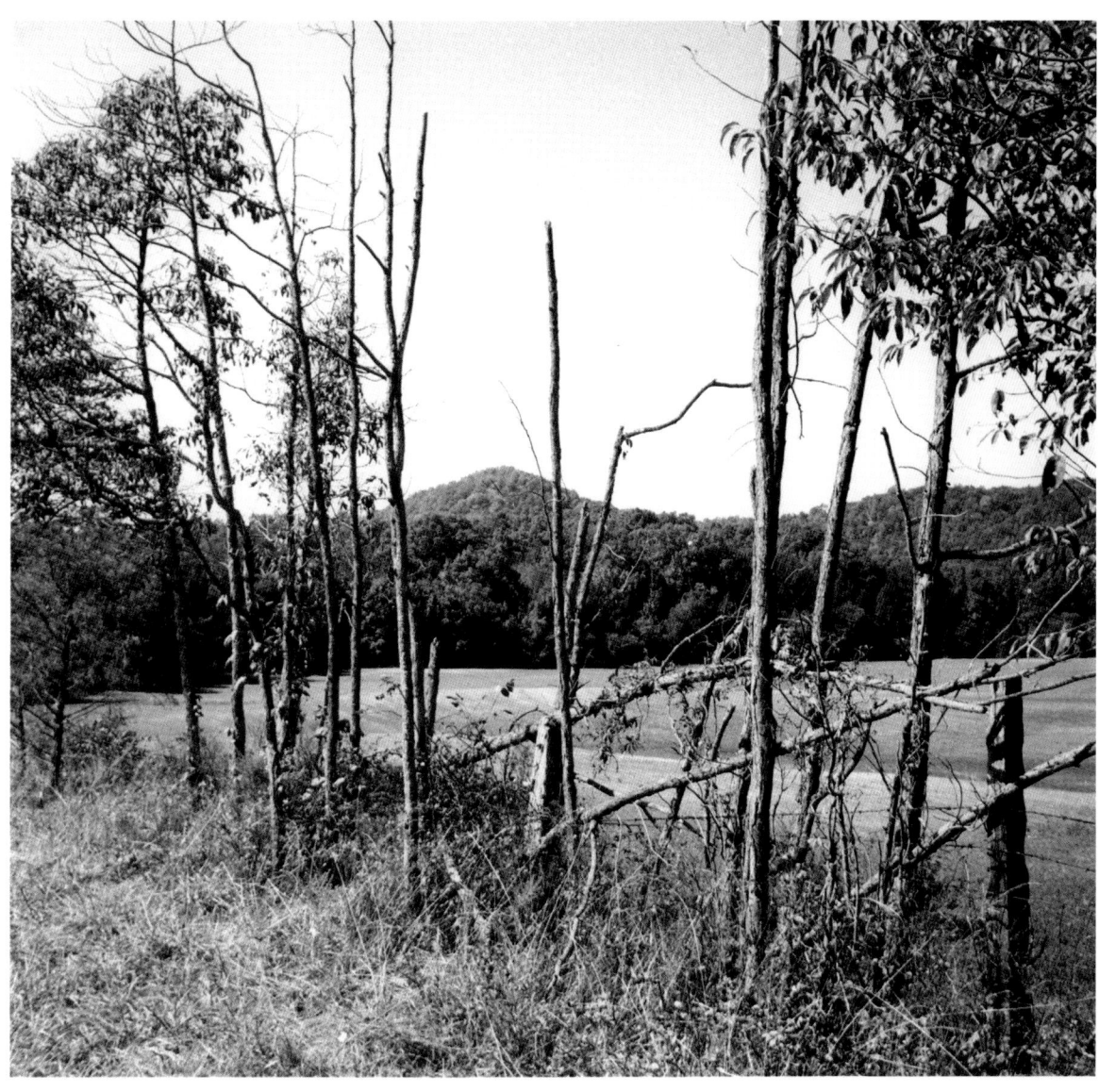

Statue of St. Joseph, Gethsemani

Look where the landscape,
 like a white Cistercian,

Puts on the ample winter like a cowl.[8]

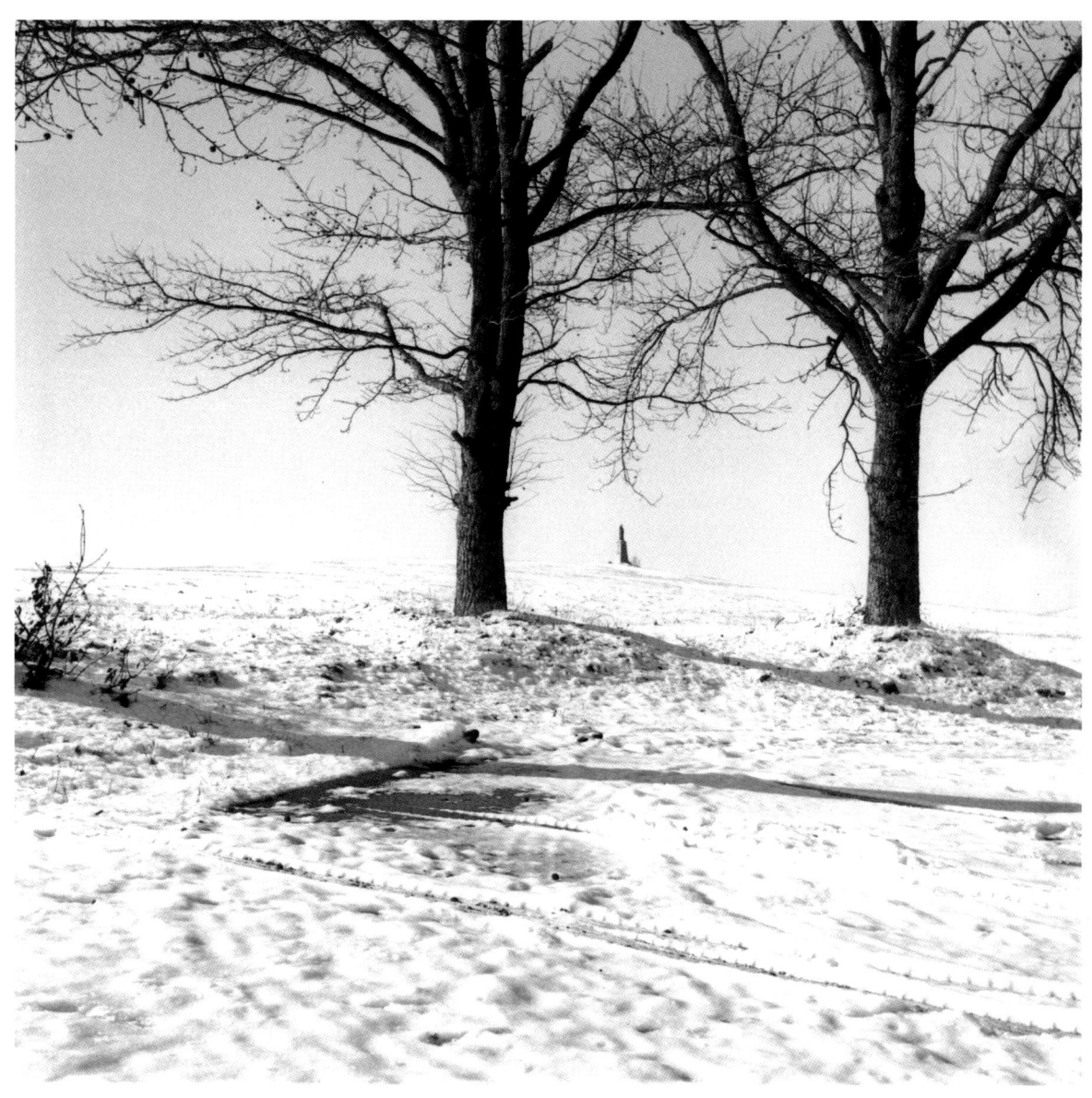

Shops Building, Gethsemani

Cutting wood, clearing ground, cutting grass, cooking soup, drinking fruit juice, sweating, washing, making fire, smelling smoke, sweeping, etc. This is religion. The further one gets away from this, the more one sinks in the mud of words and gestures. The flies gather.[9]

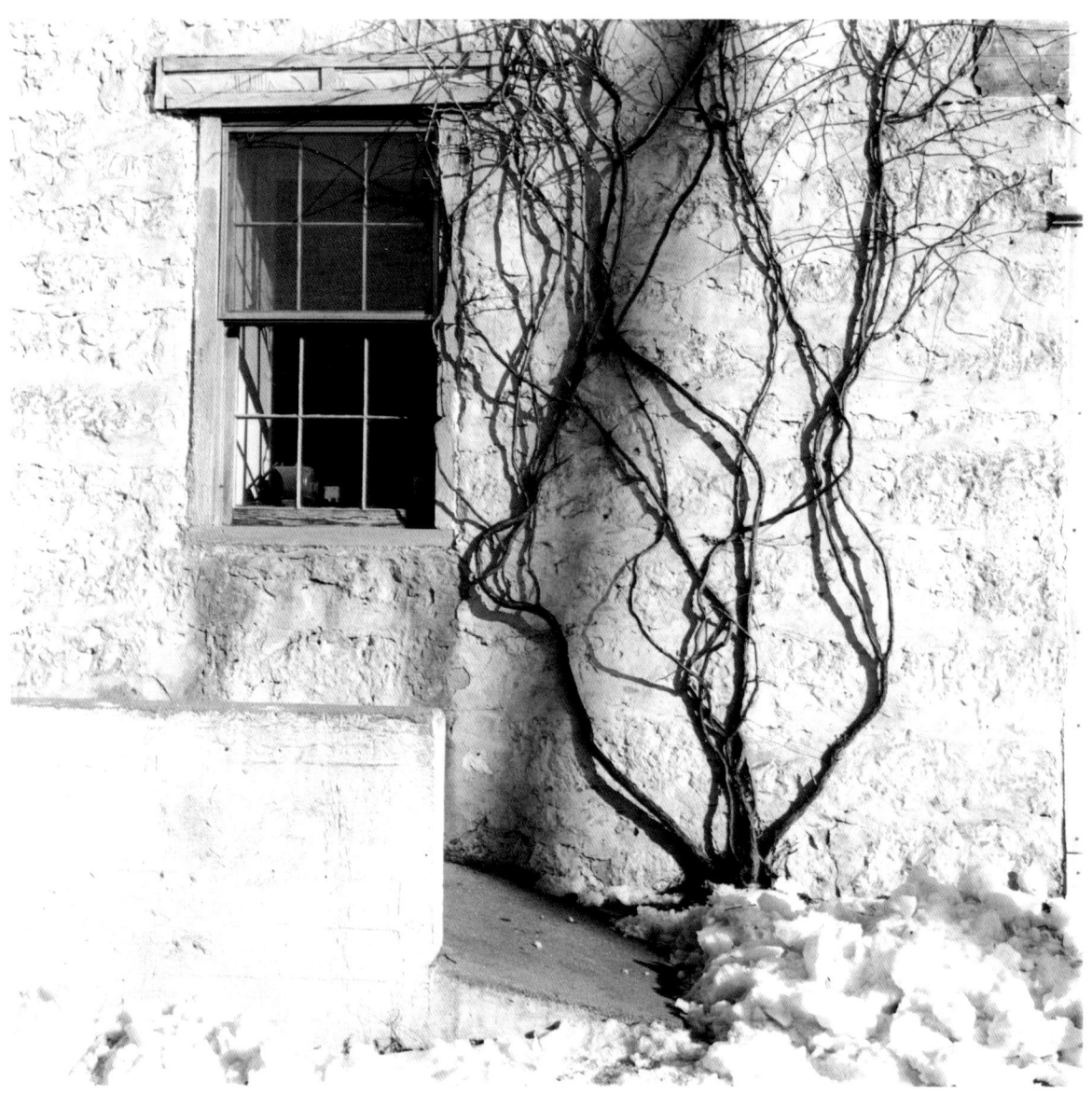

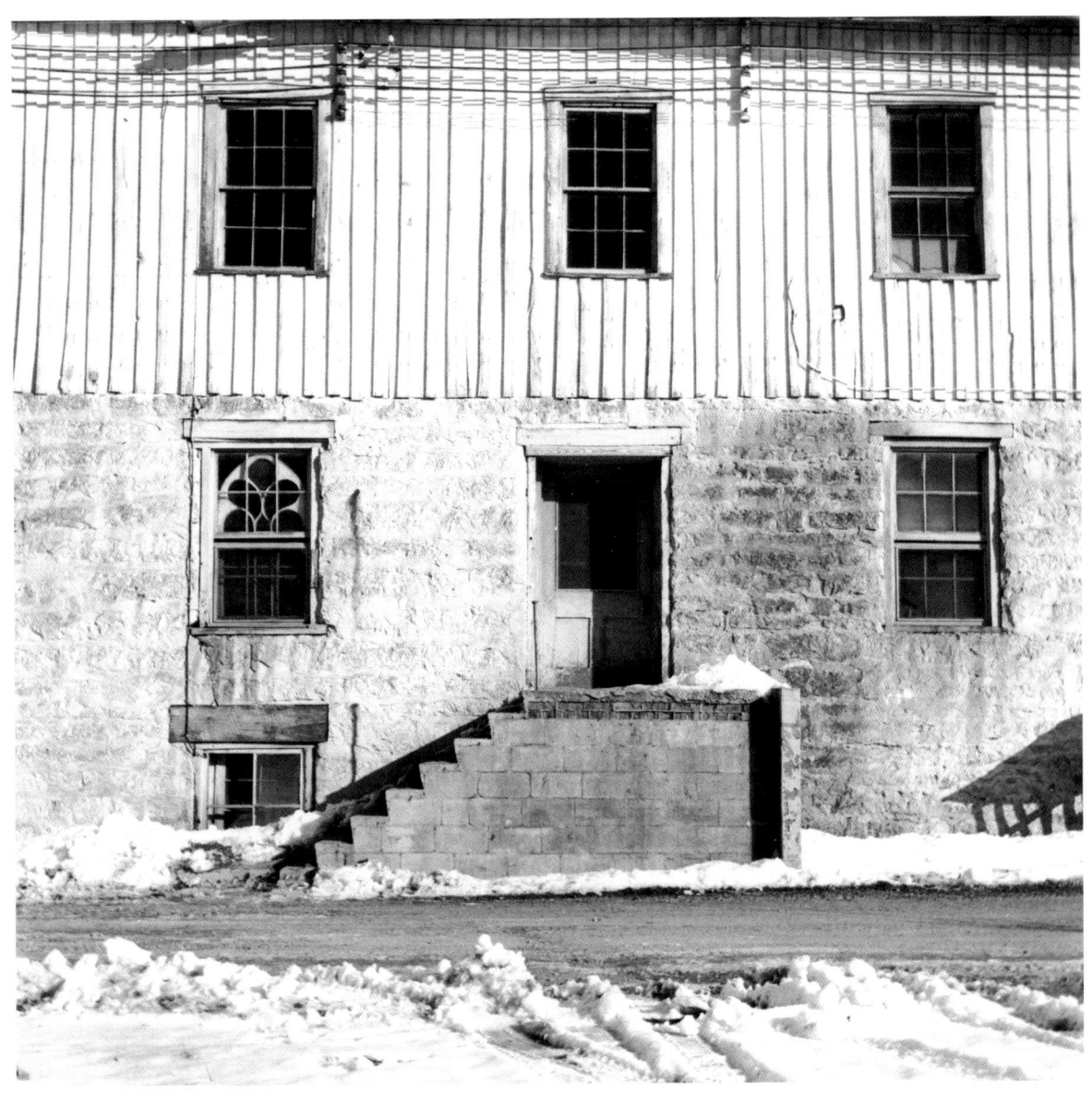

Distillery Buildings, Kentucky

For the world and time are the dance of the Lord in emptiness. The silence of the spheres is the music of a wedding feast...no despair of ours can alter the reality of things, or stain the joy of the cosmic dance which is always there. Indeed, we are in the midst of it, and it is in the midst of us, for it beats in our very blood, whether we want it to or not.

Yet the fact remains that we are invited to forget ourselves on purpose, cast our awful solemnity to the winds and join in the general dance.[10]

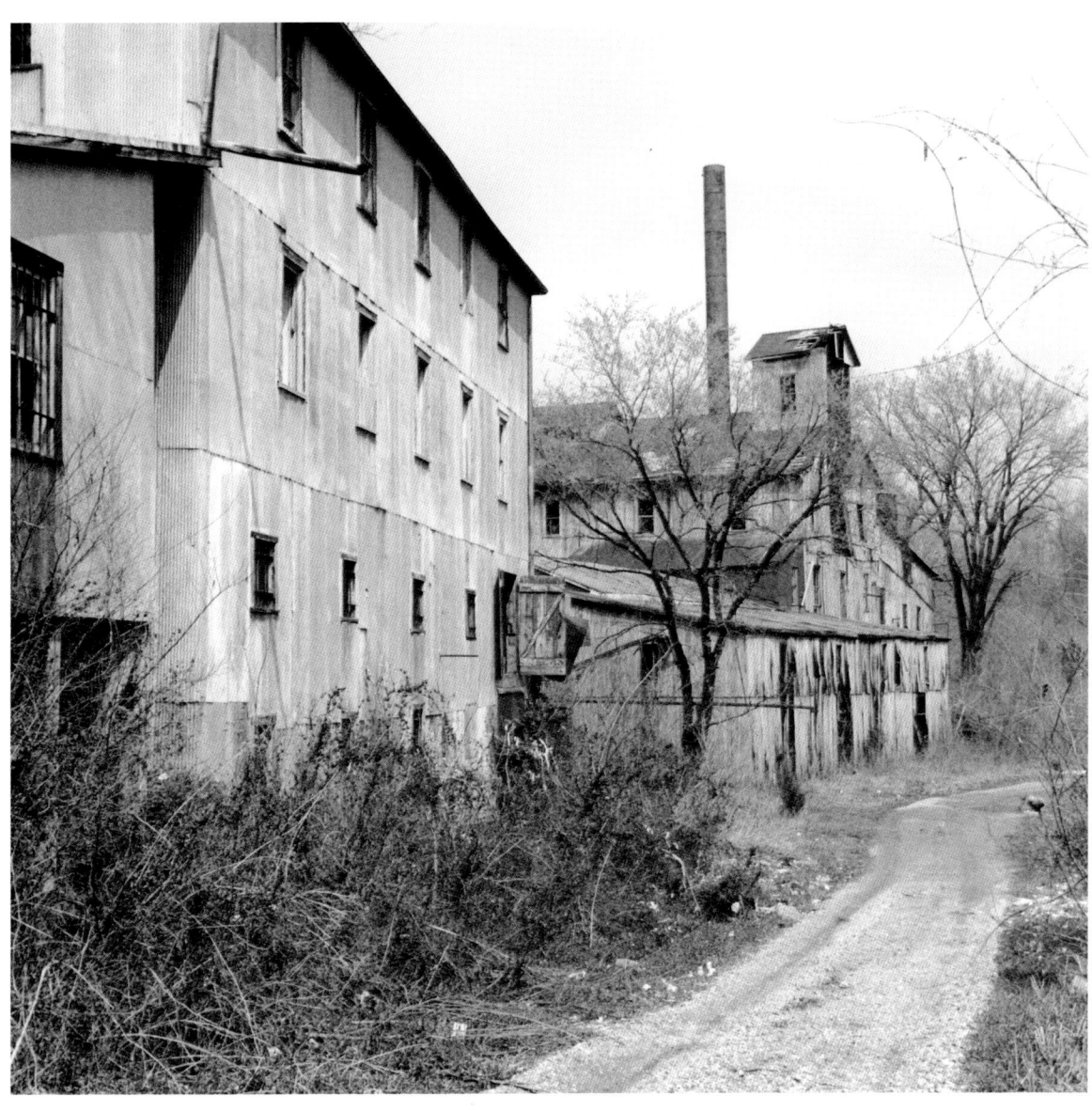

Distillery Buildings, Kentucky

One has to be in the same place every day, watch the dawn from the same window or porch, hear the selfsame birds each morning to realize how inexhaustibly rich and diverse is this 'sameness.' The blessing of stability is not fully evident until you experience it in a hermitage.[11]

Shaker Village, Pleasant Hill

I cannot help seeing Shakertown in a very special light, that of my own vocation. There is a lot of Shakertown in Gethsemani. The two contemporary communities had much in common, were born of the same Spirit. If Shakertown had survived it would probably have evolved much as we have evolved.[12]

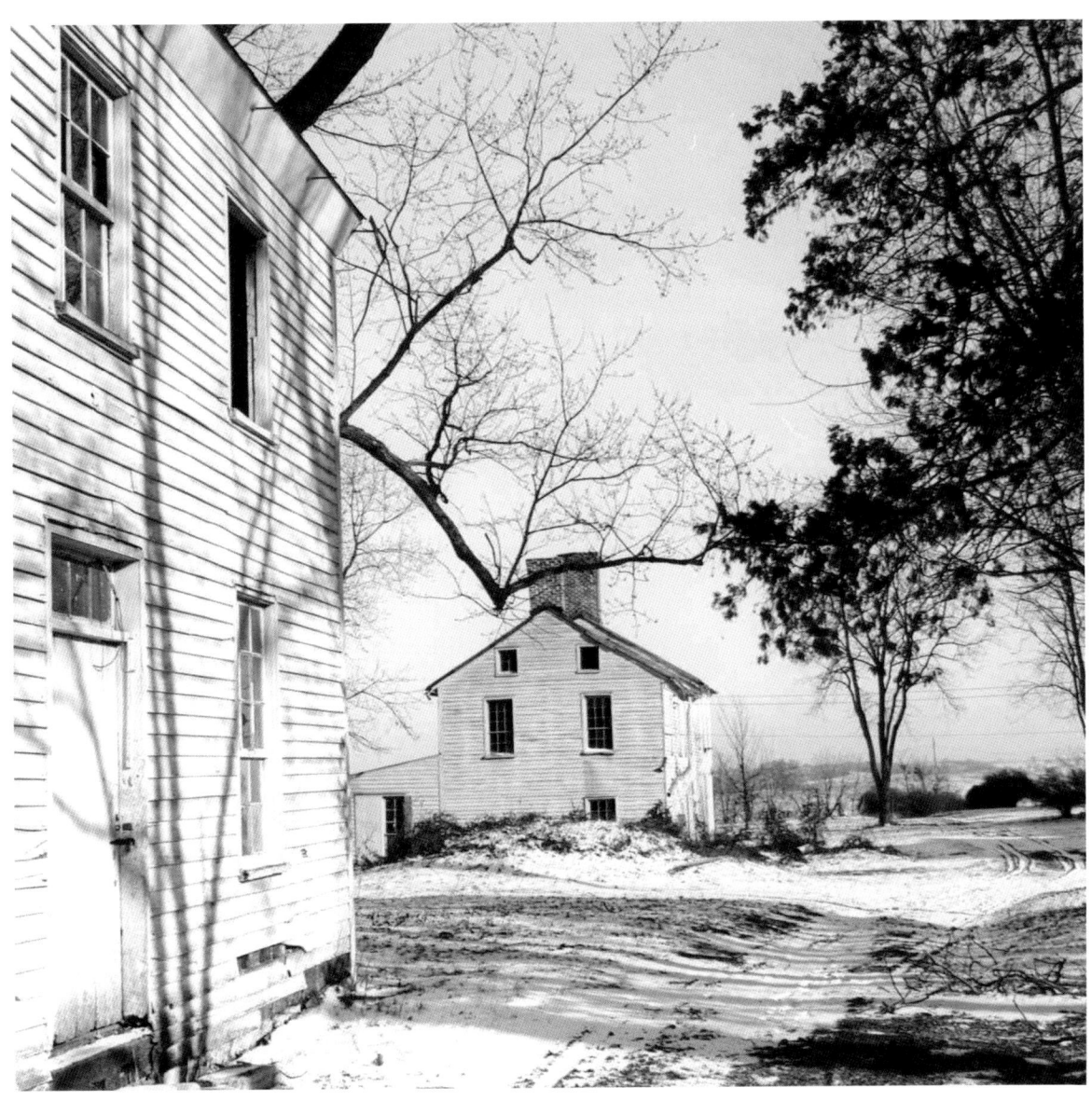

Shaker Village, Pleasant Hill

Marvelous, silent, vast spaces around the old buildings. Cold, pure light, and some grand trees...some marvelous subjects.
How the blank side of a frame house can be so completely beautiful I cannot imagine. A completely miraculous achievement of forms.[13]

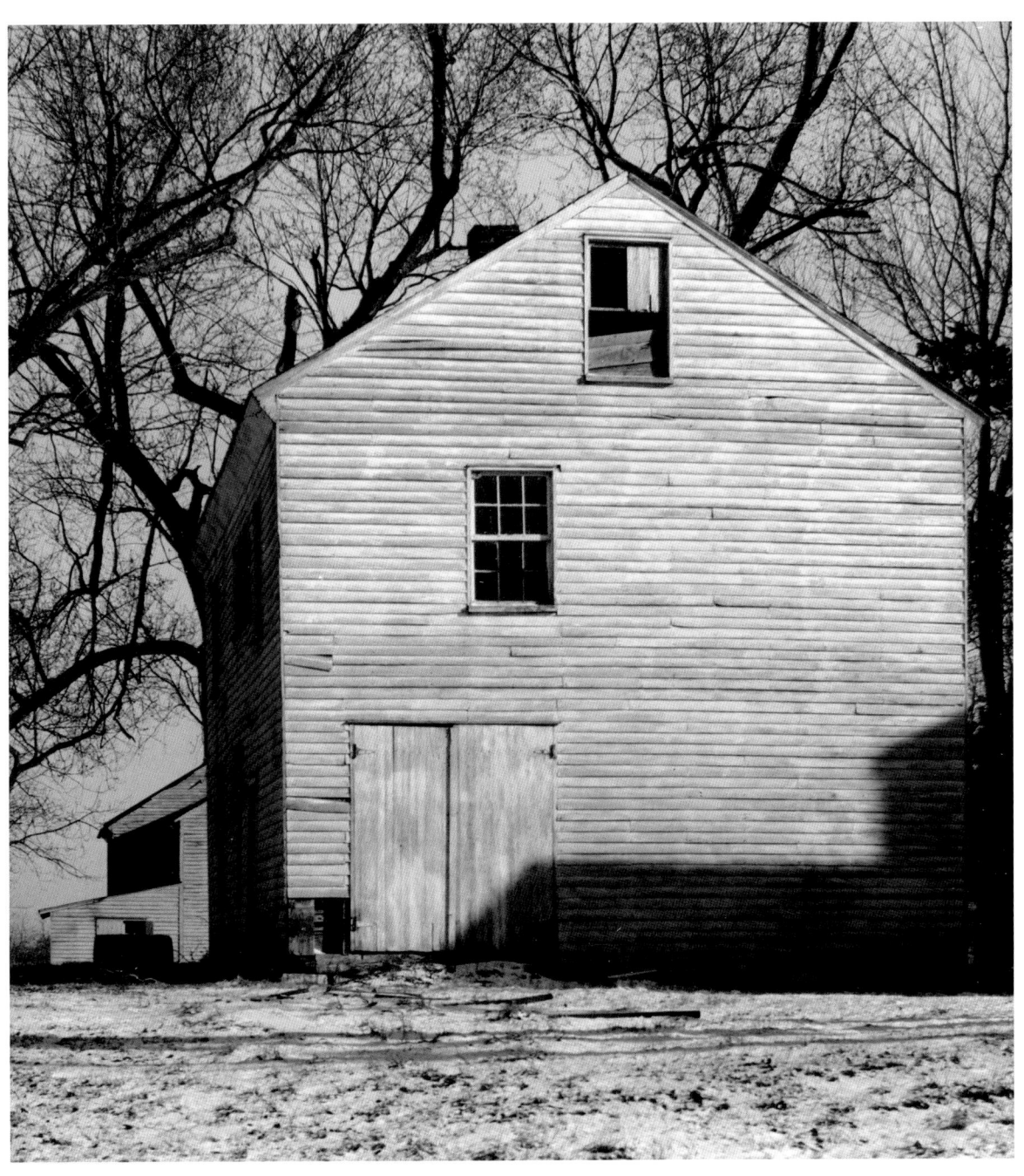

Shaker Village, Pleasant Hill

The empty fields, the big trees—
how I would love to explore those houses
and listen to that silence.[14]

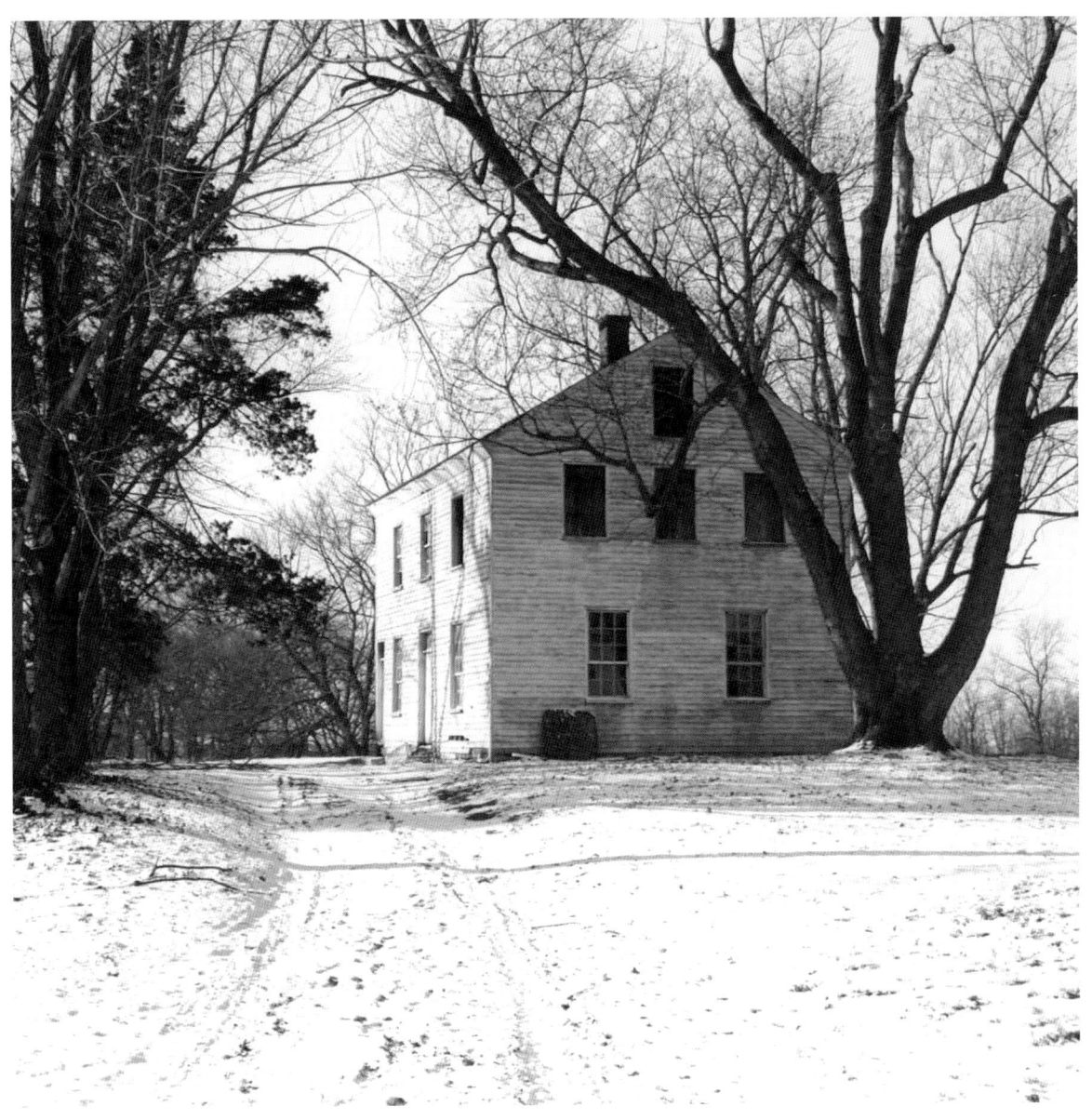

Shaker Dining Table, Pleasant Hill

There is no question in my mind that one of the finest and most genuine religious expressions of the nineteenth century is in the silent eloquence of Shaker craftsmanship.[15]

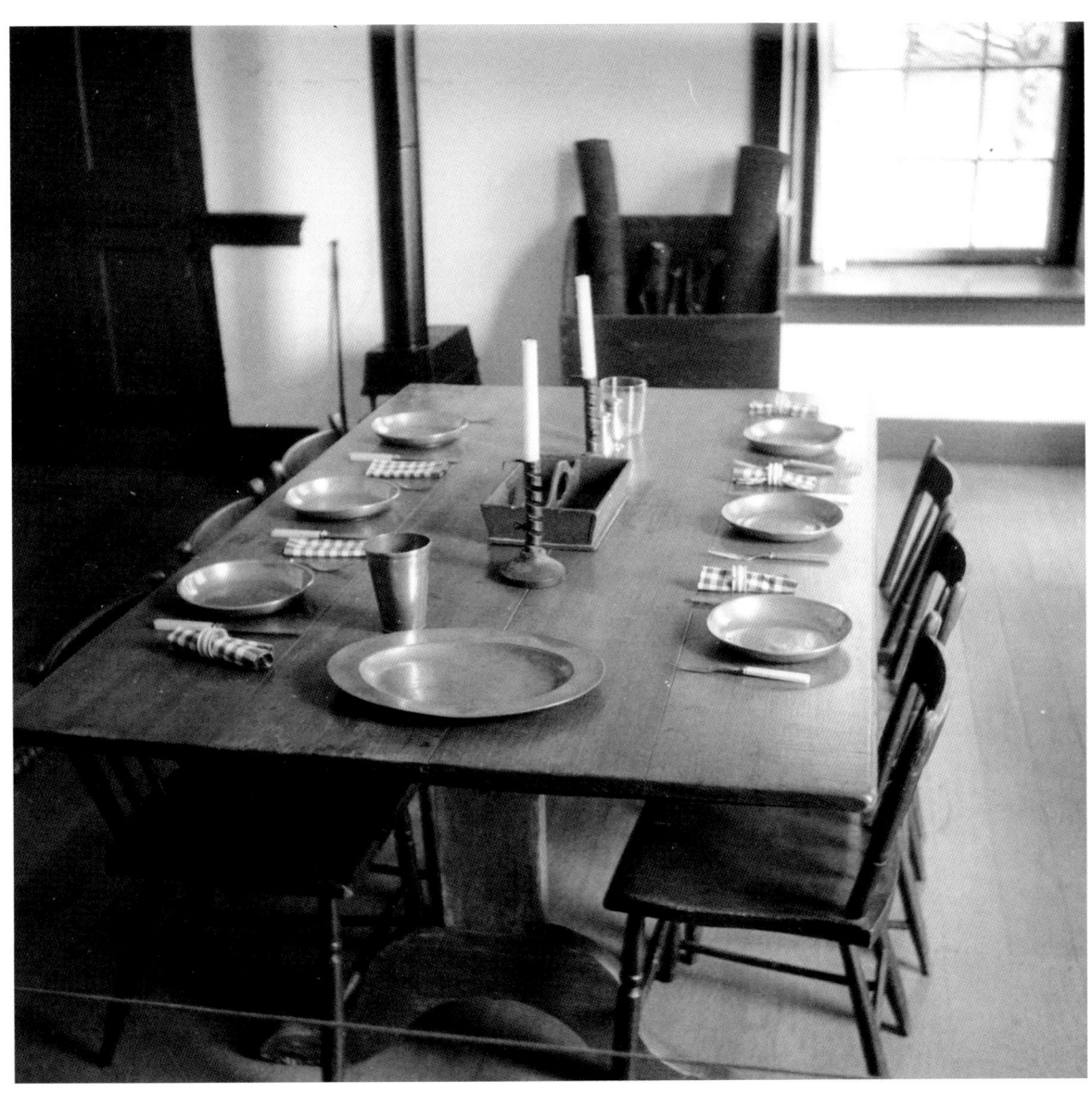

Shaker Chair, Pleasant Hill

The peculiar grace of a Shaker chair is due to the fact that it was made by someone capable of believing that an angel might come and sit on it.[16]

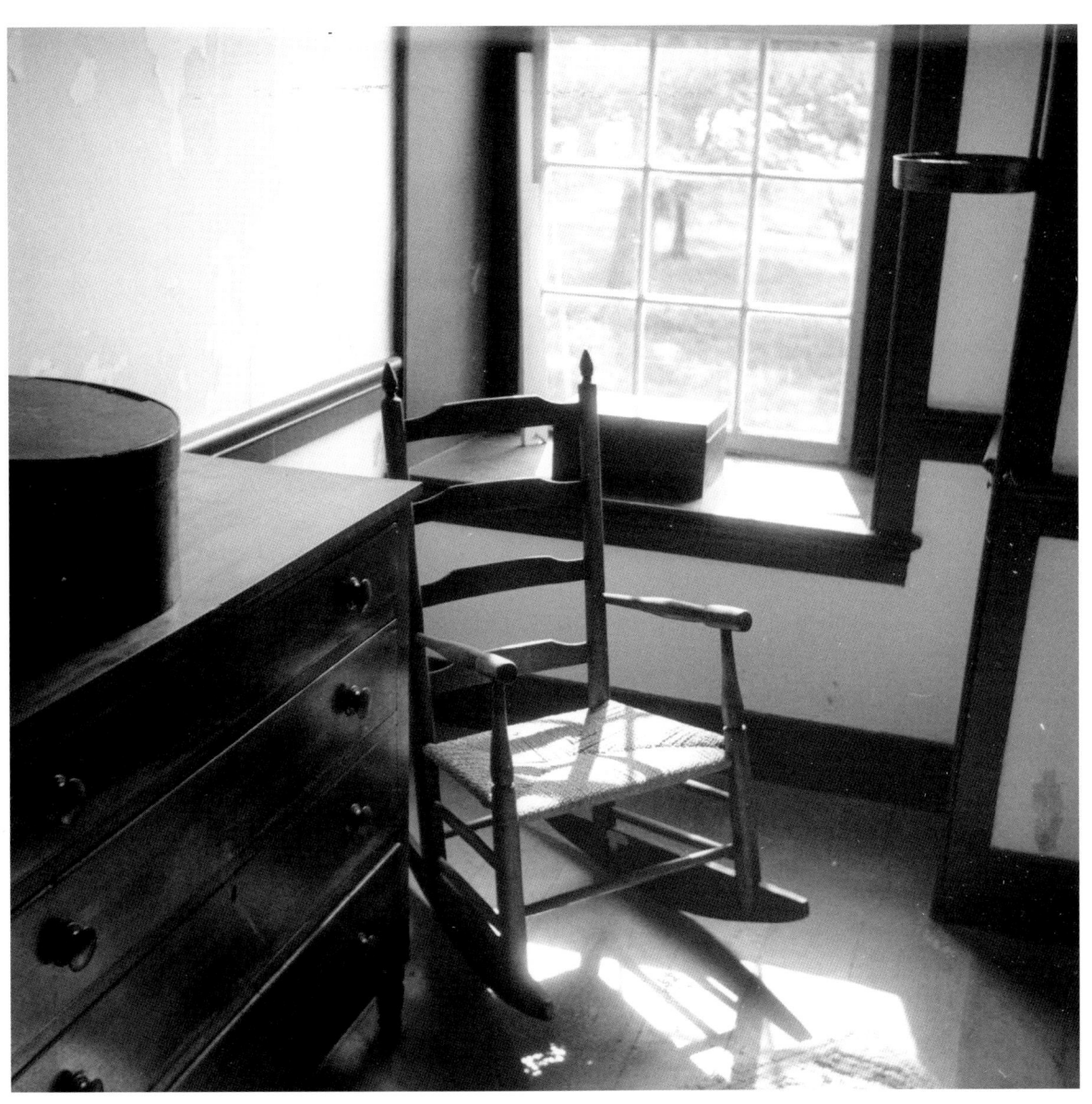

Wheel, Hermitage, Gethsemani

My ideas are always changing, always moving around one center, and I am always seeing that center from somewhere else.

Hence, I will always be accused of inconsistency. But I will no longer be there to hear the accusation.[17]

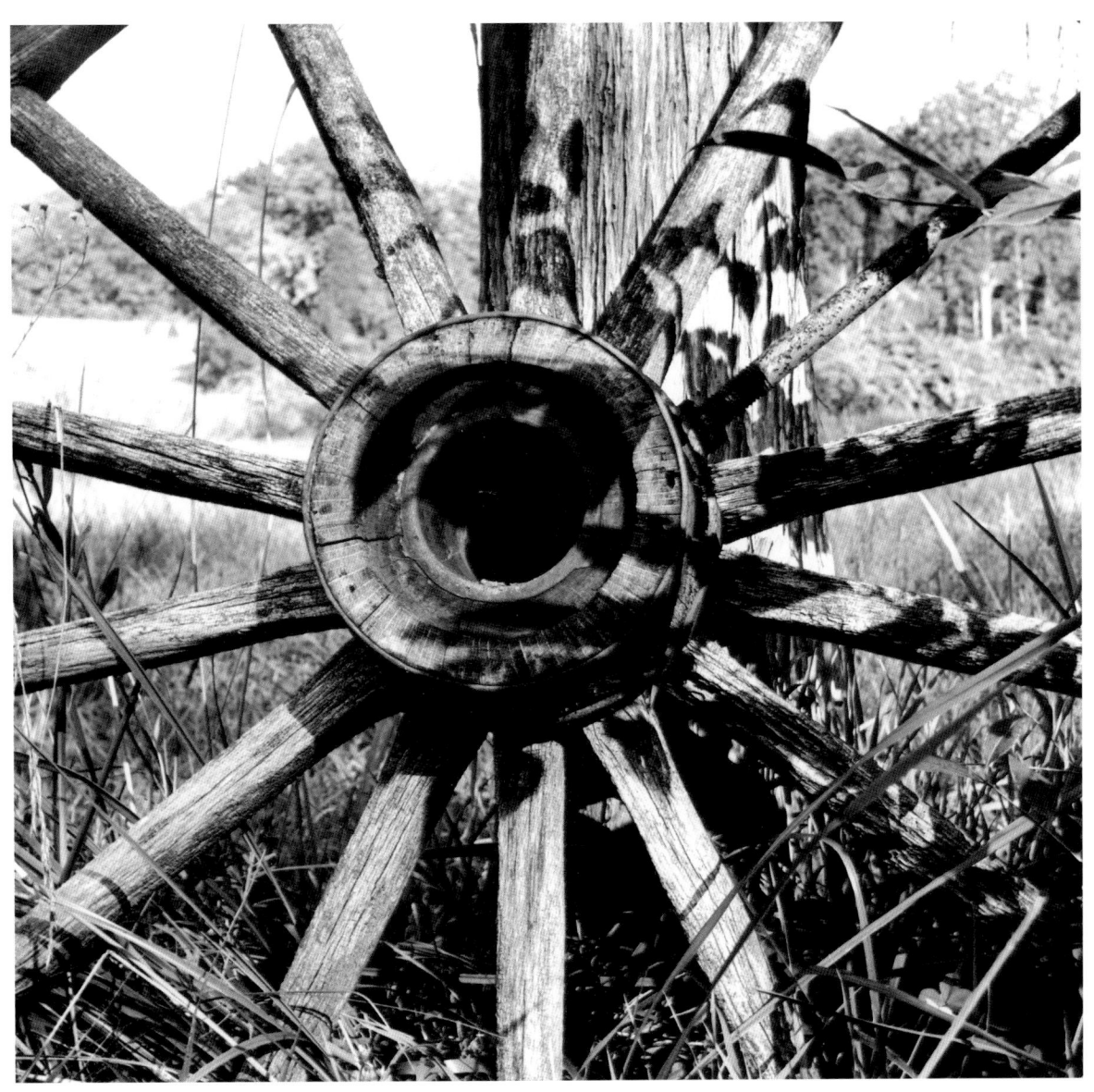

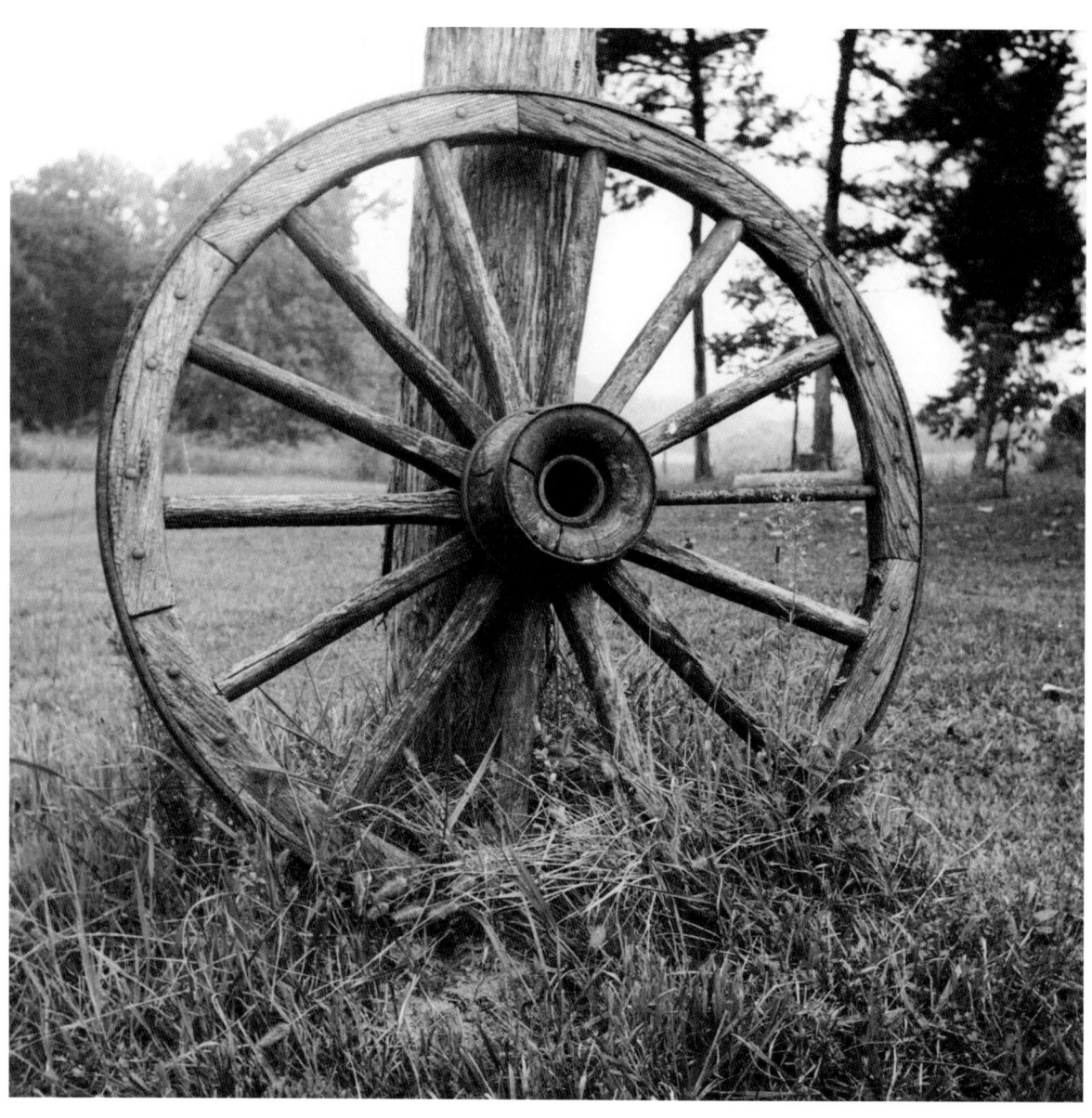

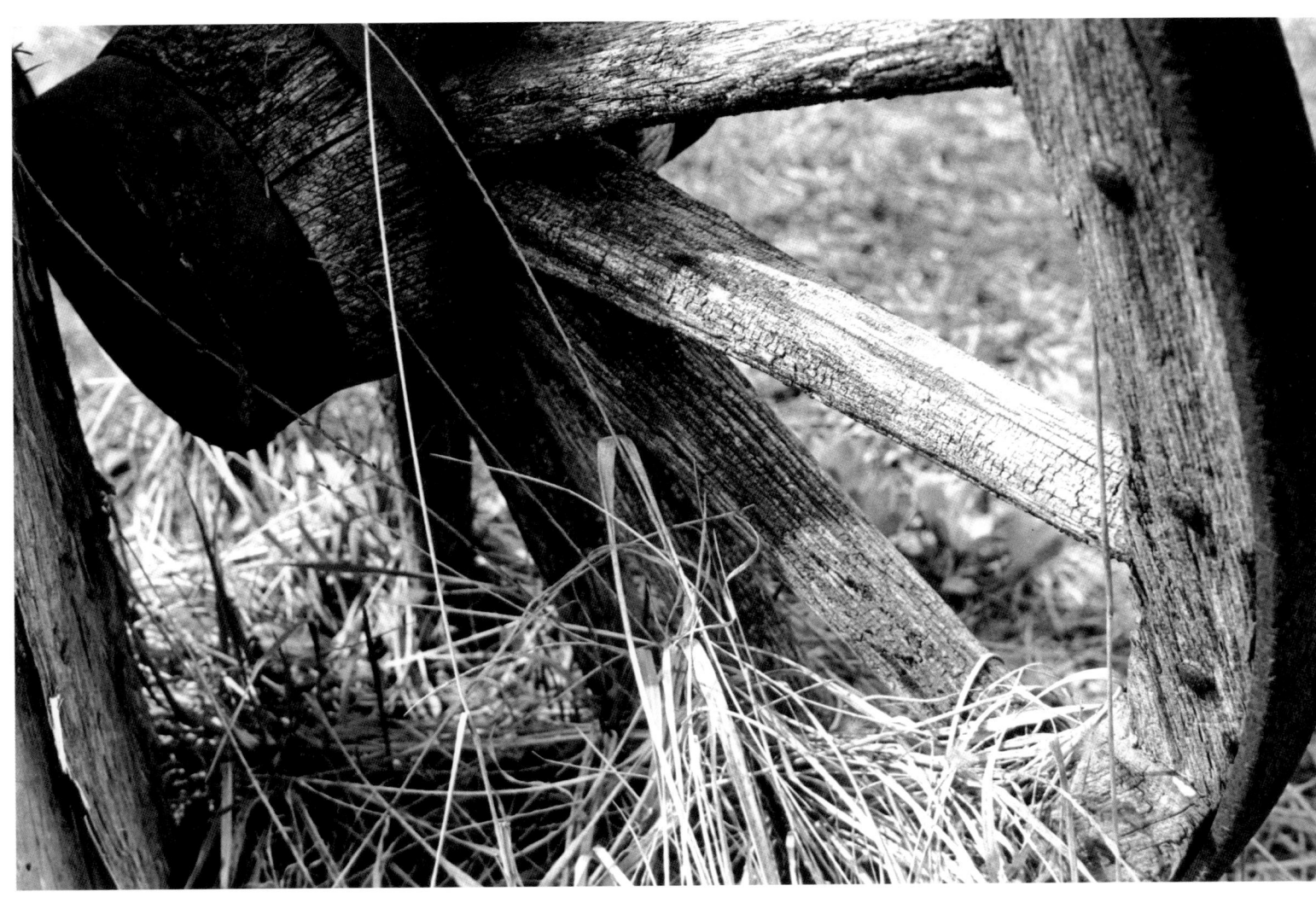

Hermitage, Gethsemani

Vanaprastha. The forest life. My present life. A life of privacy and of quasiretirement. Is there one more stage? Yes. *Sanyasa.* Total renunciation.[18]

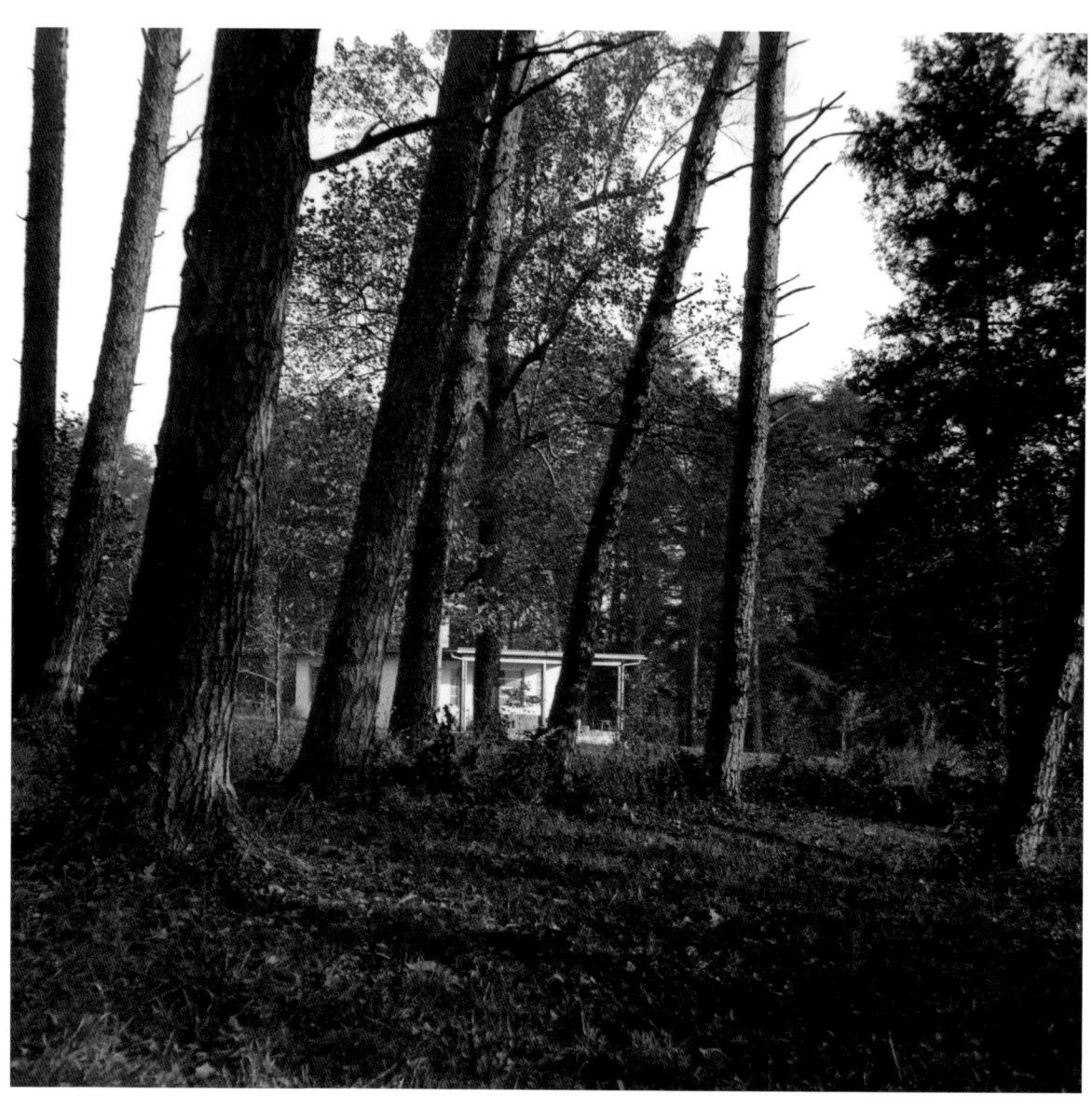

42 ||| *Beholding Paradise*

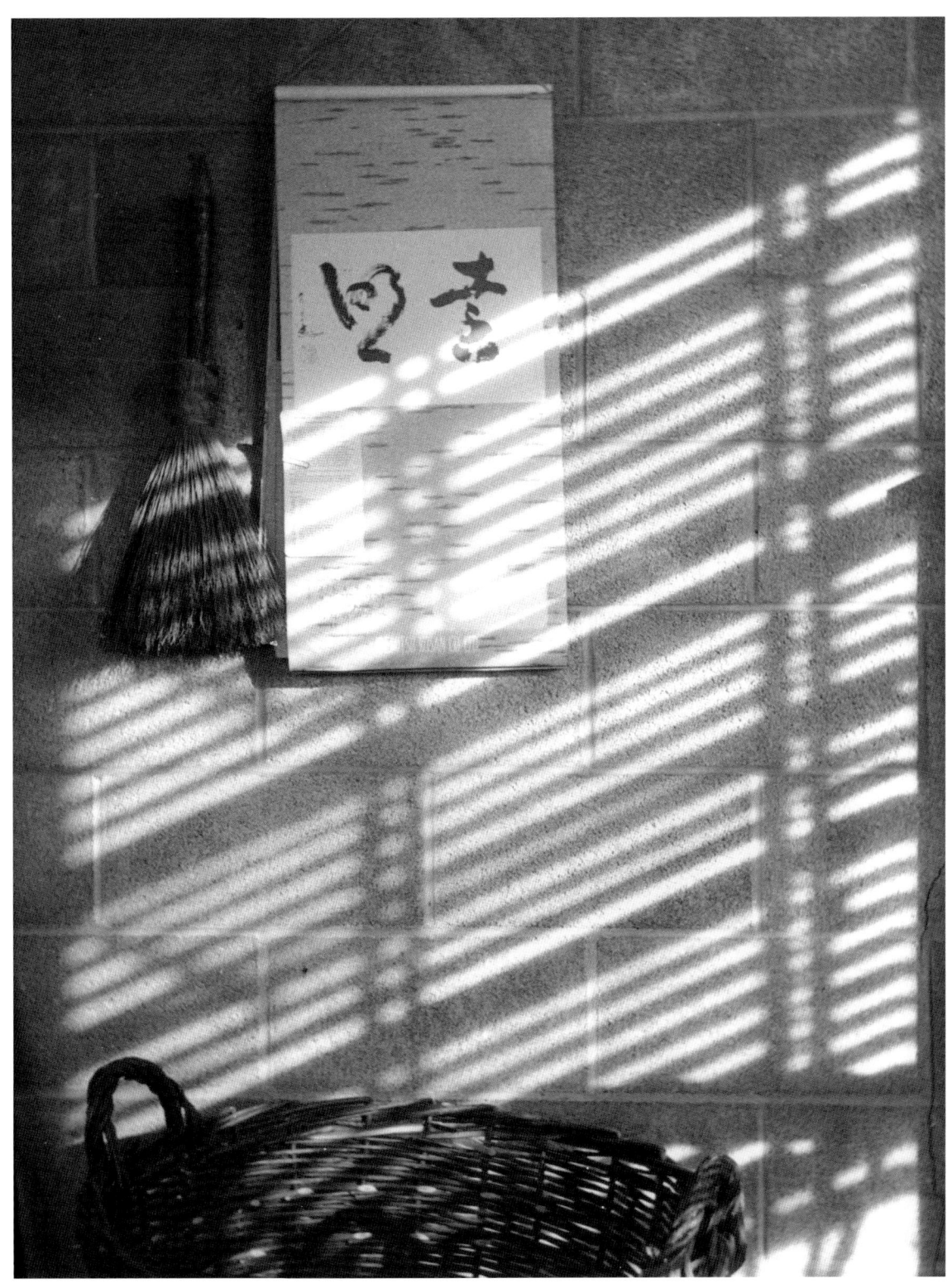

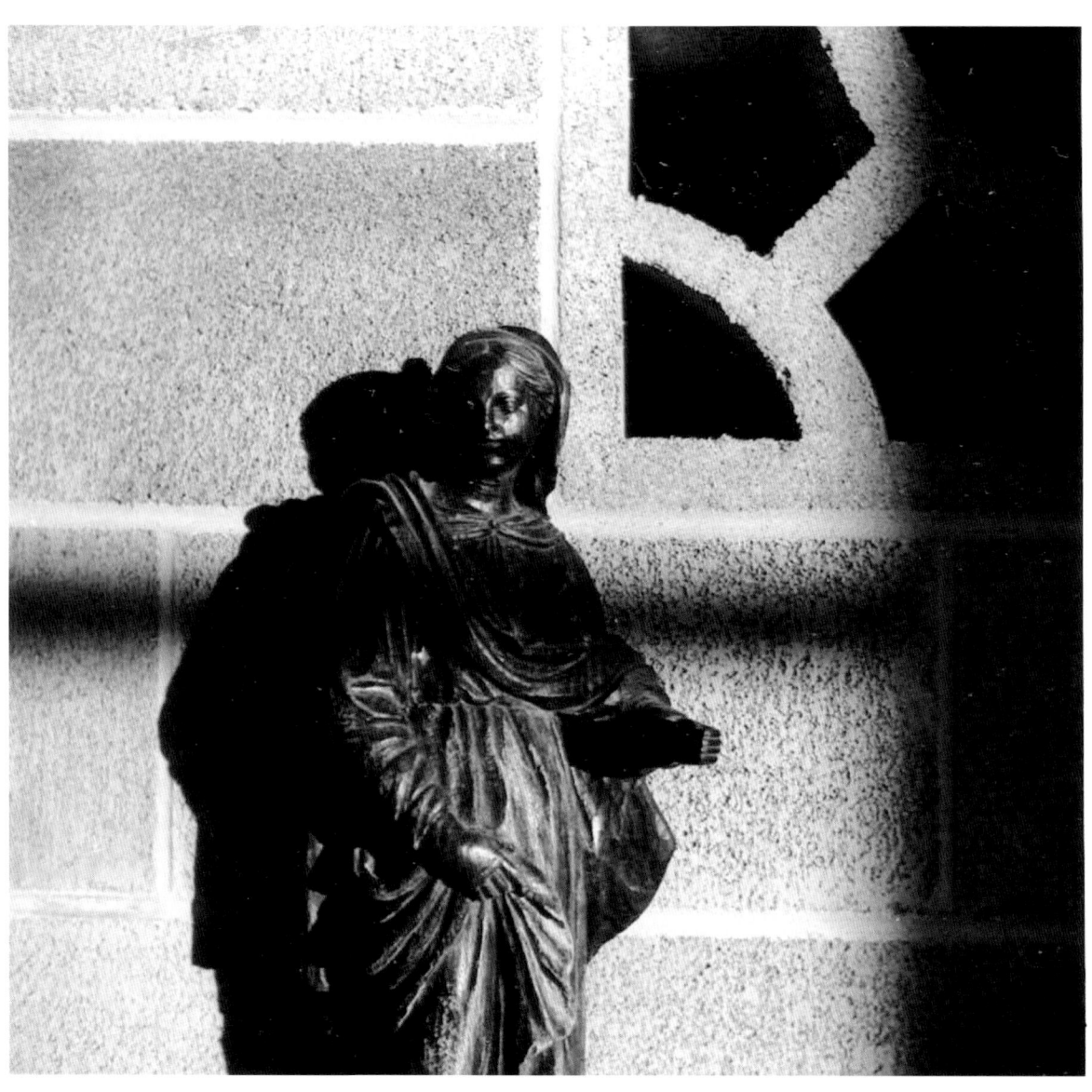

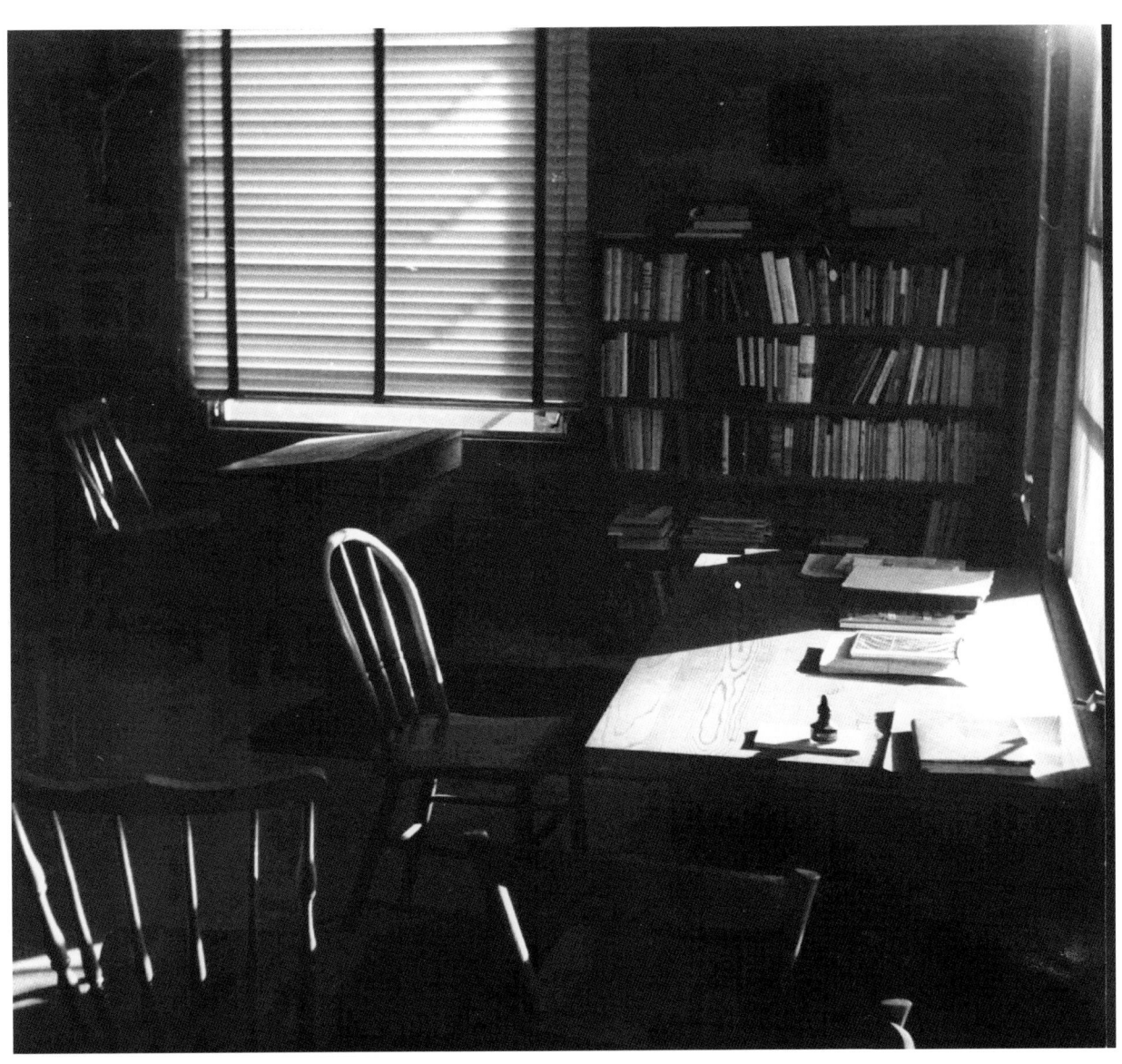

Old Church Pew, Gethsemani

Who

Are you?[19]

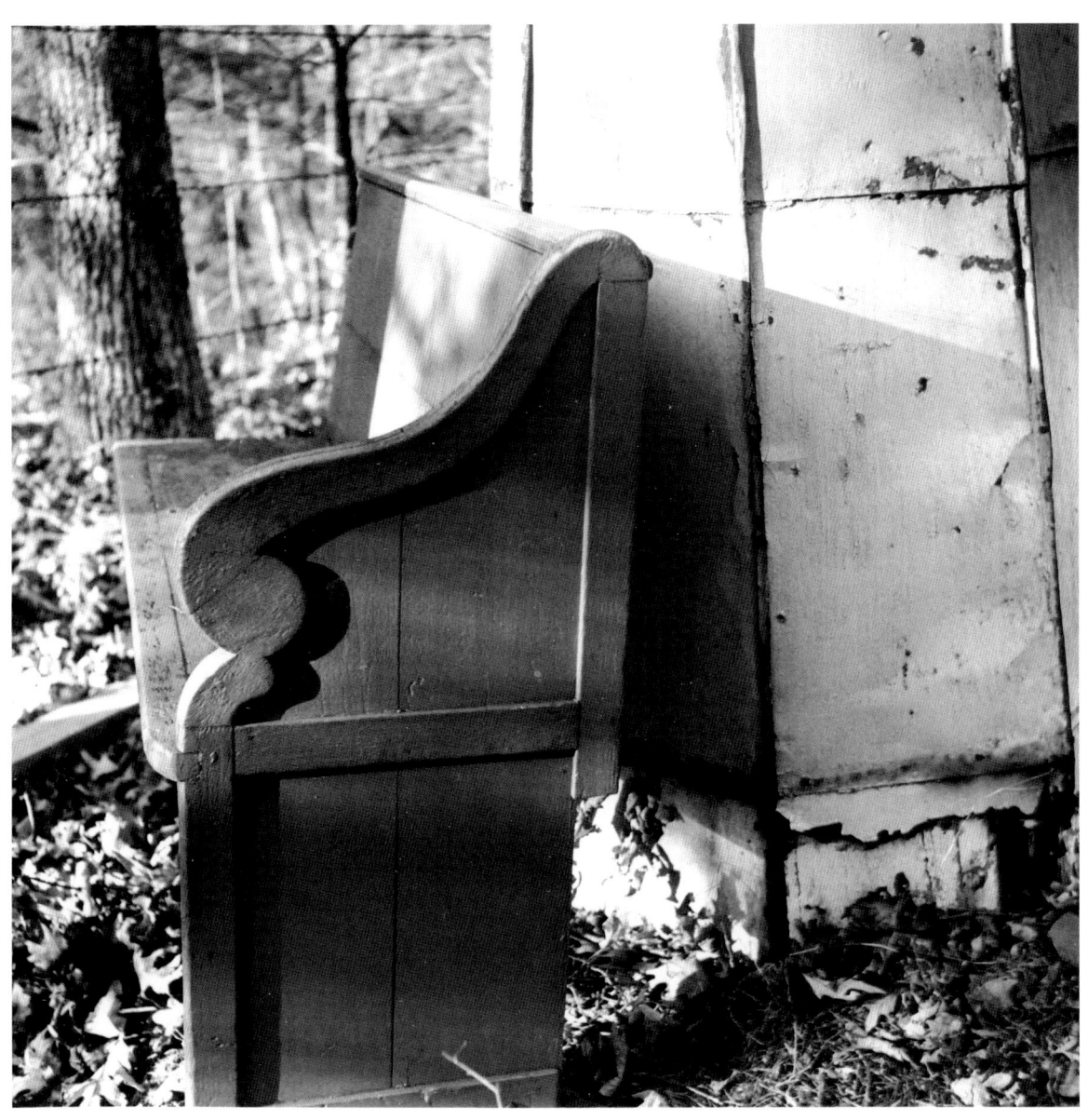

THE PARADOX OF PLACE ||| 47

Zen Garden, Gethsemani

Whose

Silence are you?[20]

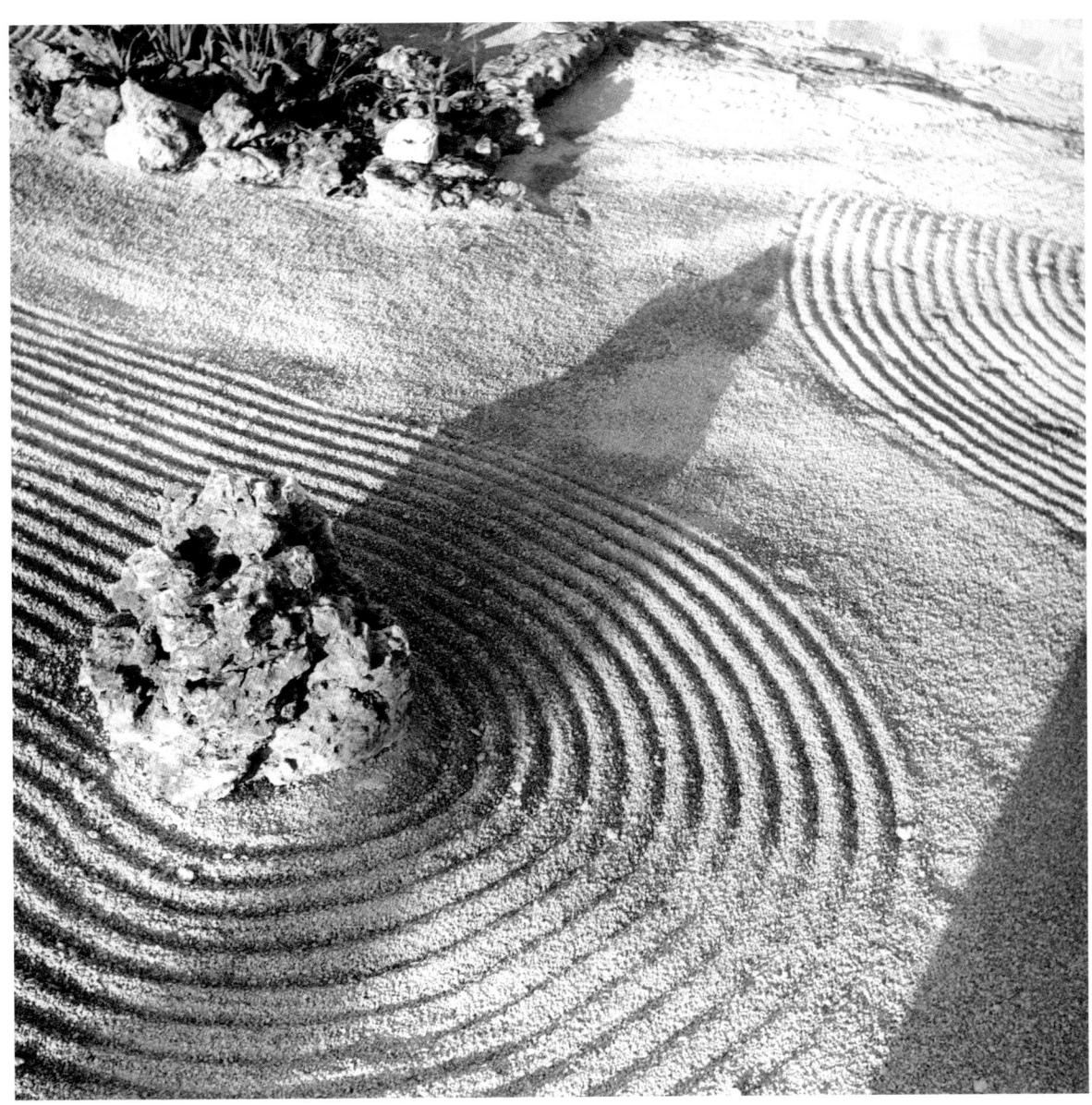

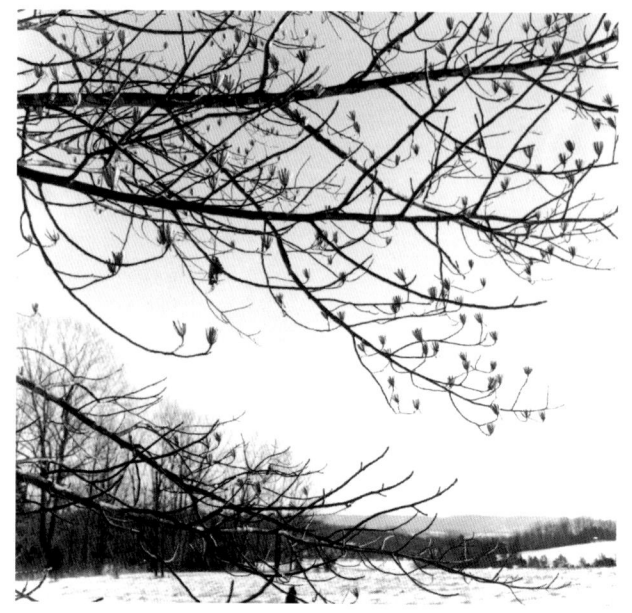

II

A HIDDEN WHOLENESS

ZEN PHOTOGRAPHY

IN ZEN, Thomas Merton had discovered many things that he found missing in Catholicism and monasticism in the middle of the twentieth century, but which belonged to the Christian Tradition. Zen offered an experiential approach to contemplation and a world-affirming spirituality that appealed to Merton, qualities he also discovered in the Church fathers and the great Christian mystics. Zen provided Merton with a terminology to describe both his experience of God and of contemplation. Zen writings on enlightenment also complimented Merton's thinking on the true self.

In the sixties, as Merton's interest in photography developed, he began to refer to what he called "Zen photography"—a term you can now frequently find in photography books, but Thomas Merton was one of the first, if not the first, to coin that phrase. So I

want to explore Merton's growing interest in photography, and to tease out what he meant by the term *Zen photography*.

Merton refers to Zen photography for the first time in an entry in his personal journal for September 22, 1964:

> *After dinner I was distracted by the dream camera, and instead of seriously reading the Zen anthology I got from the Louisville Library, kept seeing curious things to shoot, especially a mad window in the old tool room of the woodshed. The whole place is full of fantastic and strange subjects—a mine of Zen photography.[1]*

His next reference to Zen photography comes in 1968 after John Howard Griffin had loaned Merton a Canon F-X. Merton writes to Griffin thanking him for the camera and saying,

> *The camera is the most eager and helpful of beings, all full of happy suggestions: "Try this! Do it that way!" Reminding me of things I have overlooked, and cooperating in the creation of new worlds. So simply. This is a Zen camera.[2]*

What Merton Means by "Zen Photography"

One definition of *Zen* suggests that its purpose is to make us wonder and to answer that wondering with the deepest expression of our own nature. To learn to see the extraordinary in the ordinary, what Thich Nhat Hanh would call "the miracle of mindfulness." Learning to appreciate the present moment, to appreciate what is right in front of us, rather than always having our mind on results or on the next thing we have to do. The art of photography demands such awareness, such mindfulness from the photographer. "For the camera, the creative moment is brief—a compelling, ephemeral collision of event and artist. Extreme awareness combined with unobtrusiveness," writes Ken Ruth, "becomes the context the photographer must work within."[3] Merton's friend, the poet Ron Seitz, recalls that Merton said to him at one point when they were out together photographing that he needed to "stop looking" and to "start seeing"—looking implies you already have something in mind, whereas seeing is "being open and receptive to what comes to the eye; your vision total and not targeted."[4]

Instead of looking for God in the spectacular sunset, the breathtaking view, in a sacred space, or in some preconceived way, we have to stop and see God in the ordinary, everyday things of our life; we have to learn to see God in the present moment. The Rule of St. Benedict teaches the monk to find God in the ordinary and commonplace, in the monotony of life. Benedict instructs his monks to treat all the property of the monastery as if they are the sacred vessels of the altar and, I would suggest, the whole world around us. The Church fathers called this intuition of the Divine through the reflection of God in nature "natural contemplation"— *theoria physike*. The mindfulness to see in this way allows us to discover the hidden wholeness, the spark of God in creation.

Merton's Zen photographs can help us learn to see, to find the Divine exactly where we are. To see, as he says in *New Seeds of Contemplation*, that "a tree gives glory to God by being a tree"—a root by being a root, a paint can by being a paint can. Zen photography helps us to open our eyes; it calls out from us "the importance, the urgency of seeing, fully aware, experiencing what is *here*... what is given by God and hidden by society."[5]

Solitary Chair

The urgency of seeing, fully aware, experiencing what is *here*: not what is given by men, by society, but what is given by God and hidden by society.[1]

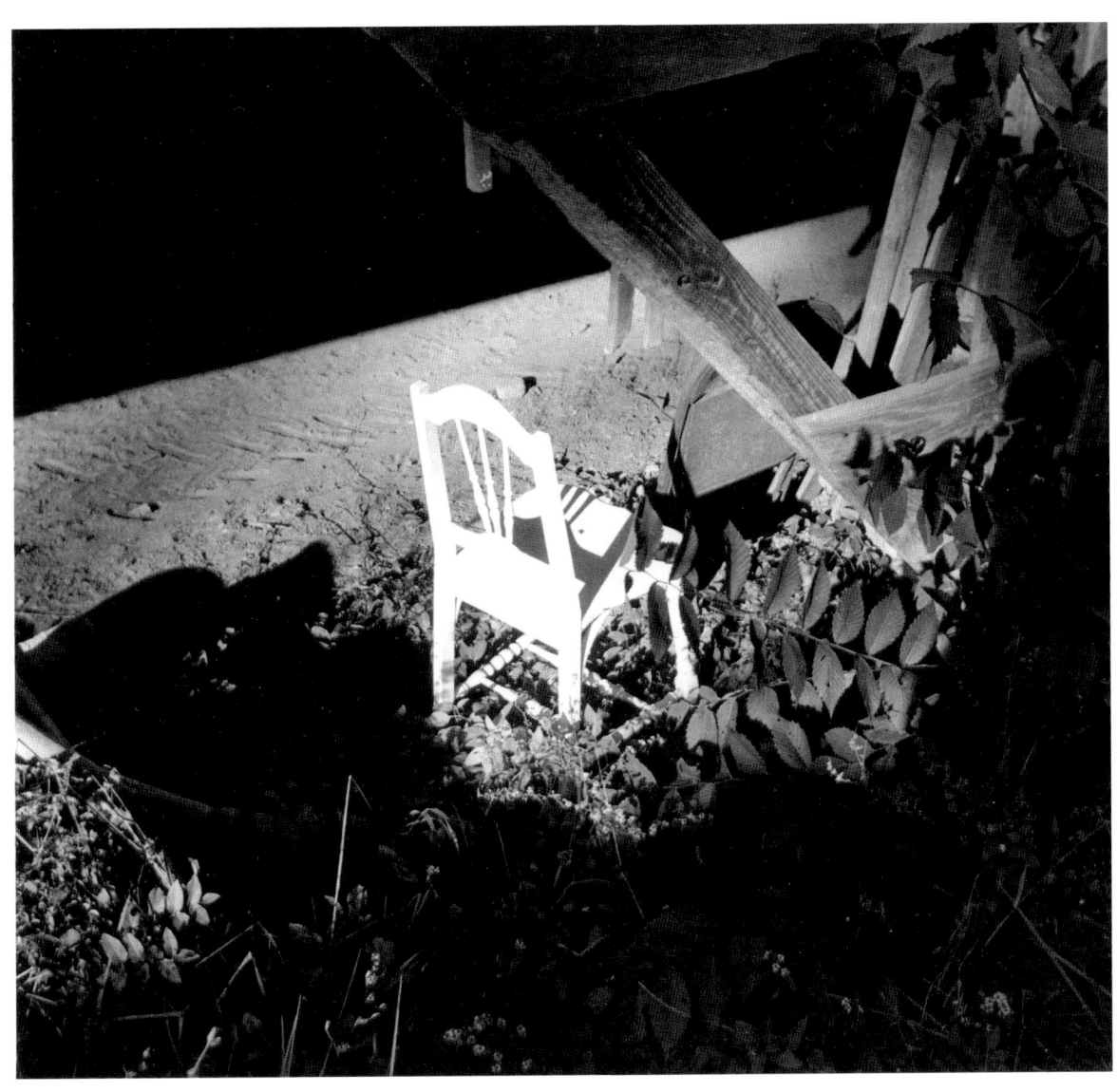

Branch and Leaves

It is in the deepest darkness that we most fully possess God on earth, because it is then that our minds are most truly liberated from the weak, created lights that are darkness in comparison to Him; it is then that we are filled with His infinite Light which seems pure darkness to our reason.[2]

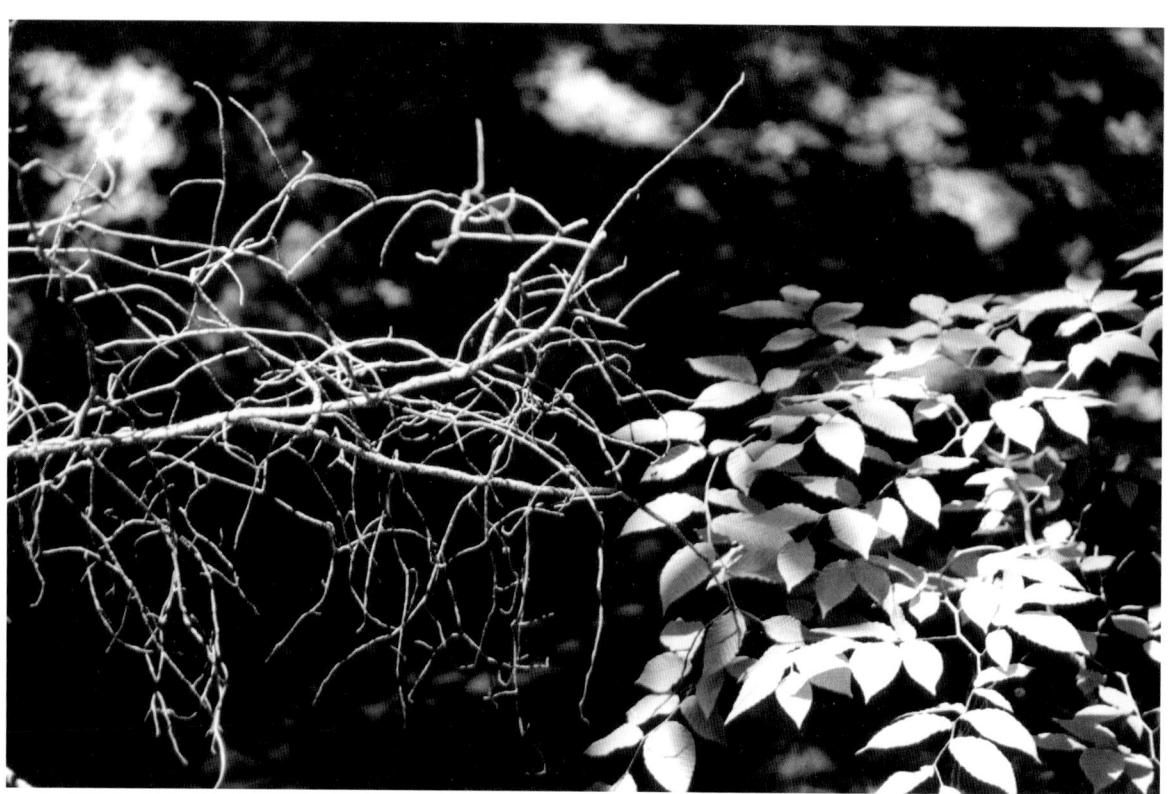

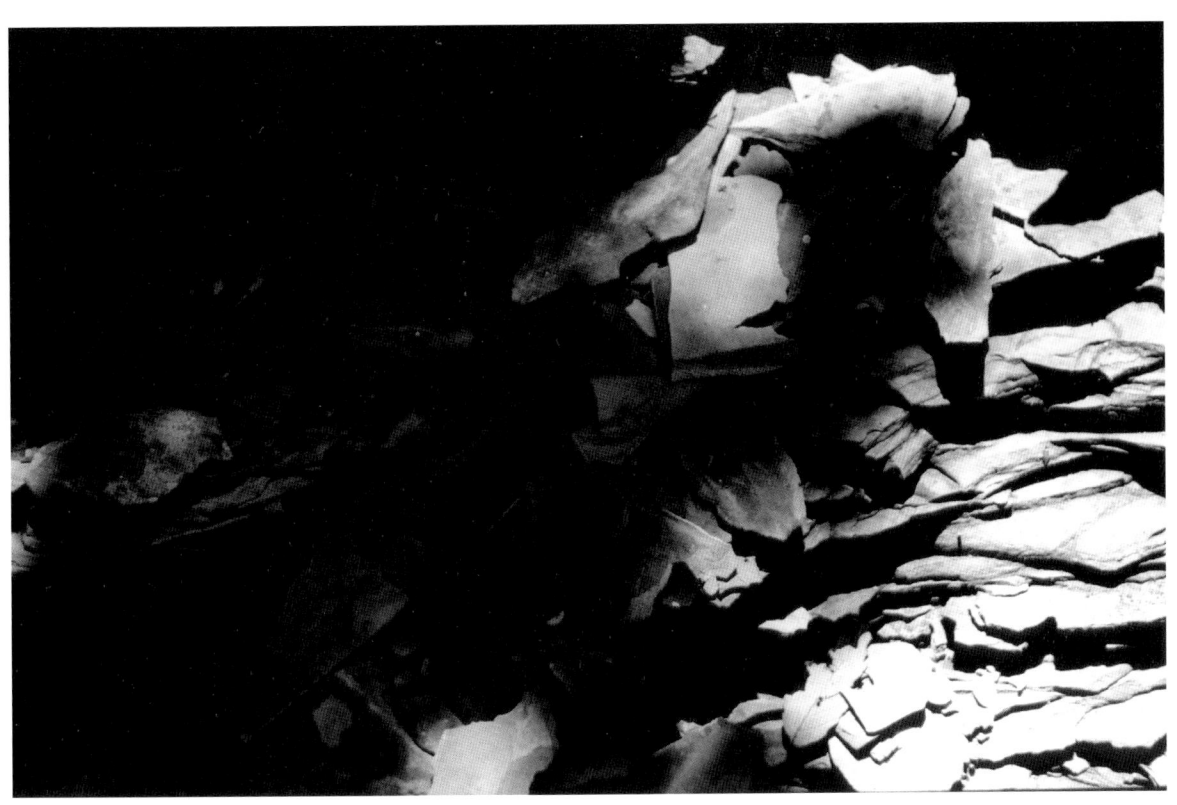

Bark

I am silence, I am poverty, I am solitude, for I have renounced spirituality to find God.[3]

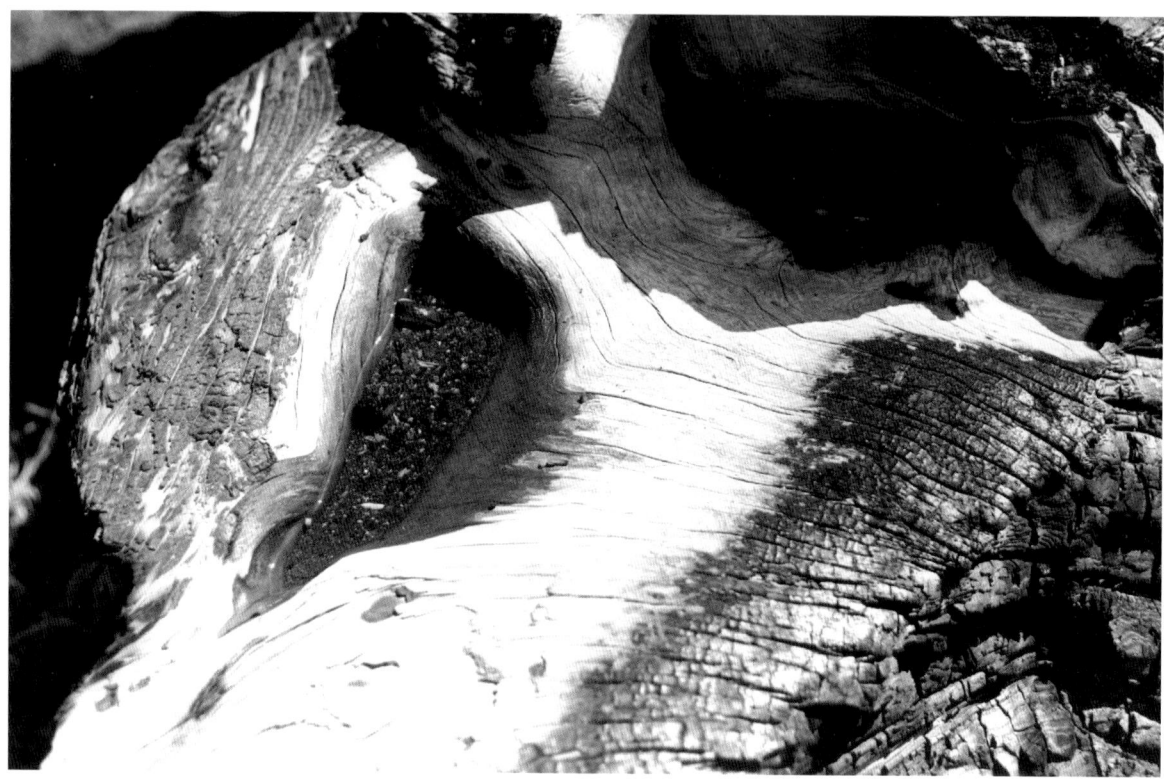

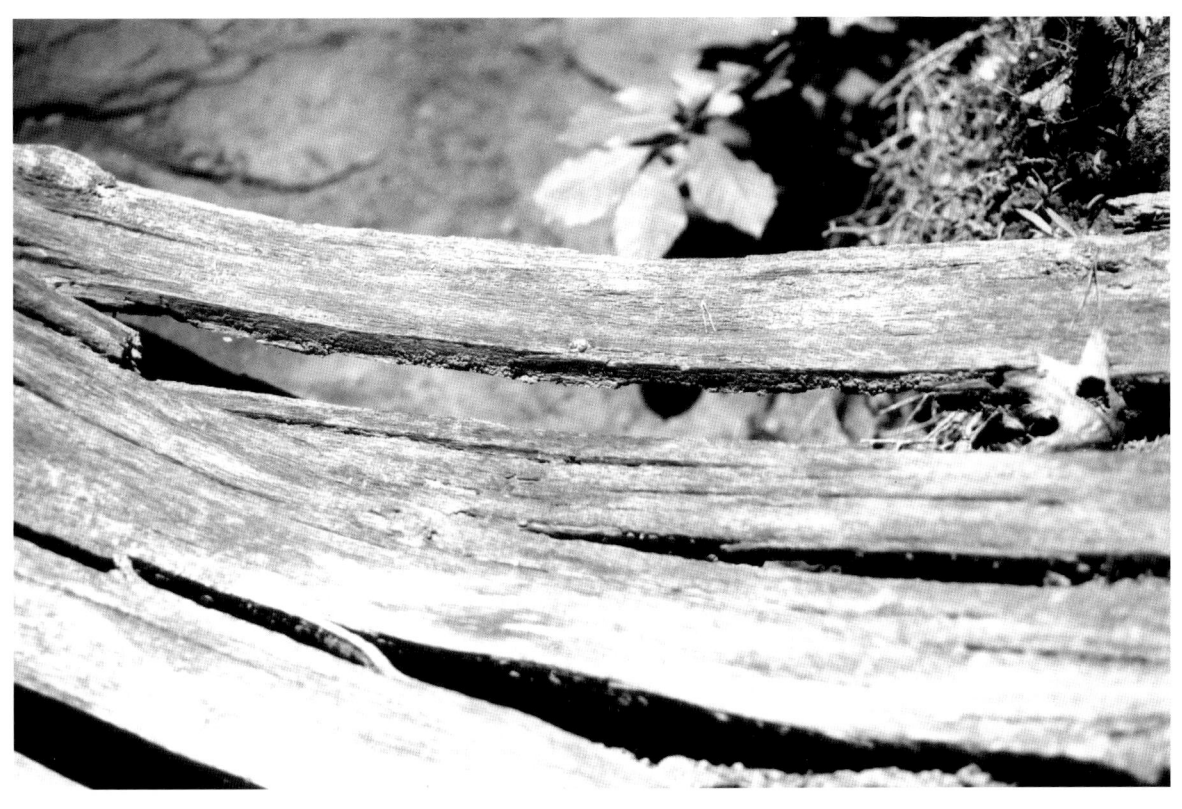

Bare Branch and Rock

Waste. Emptiness. Total poverty of the Creator: yet from this poverty springs *everything*. The waste is inexhaustible. Infinite Zero. Everything comes from this desert. Nothing. Everything wants to return to it and cannot. For who can return "nowhere?"[4]

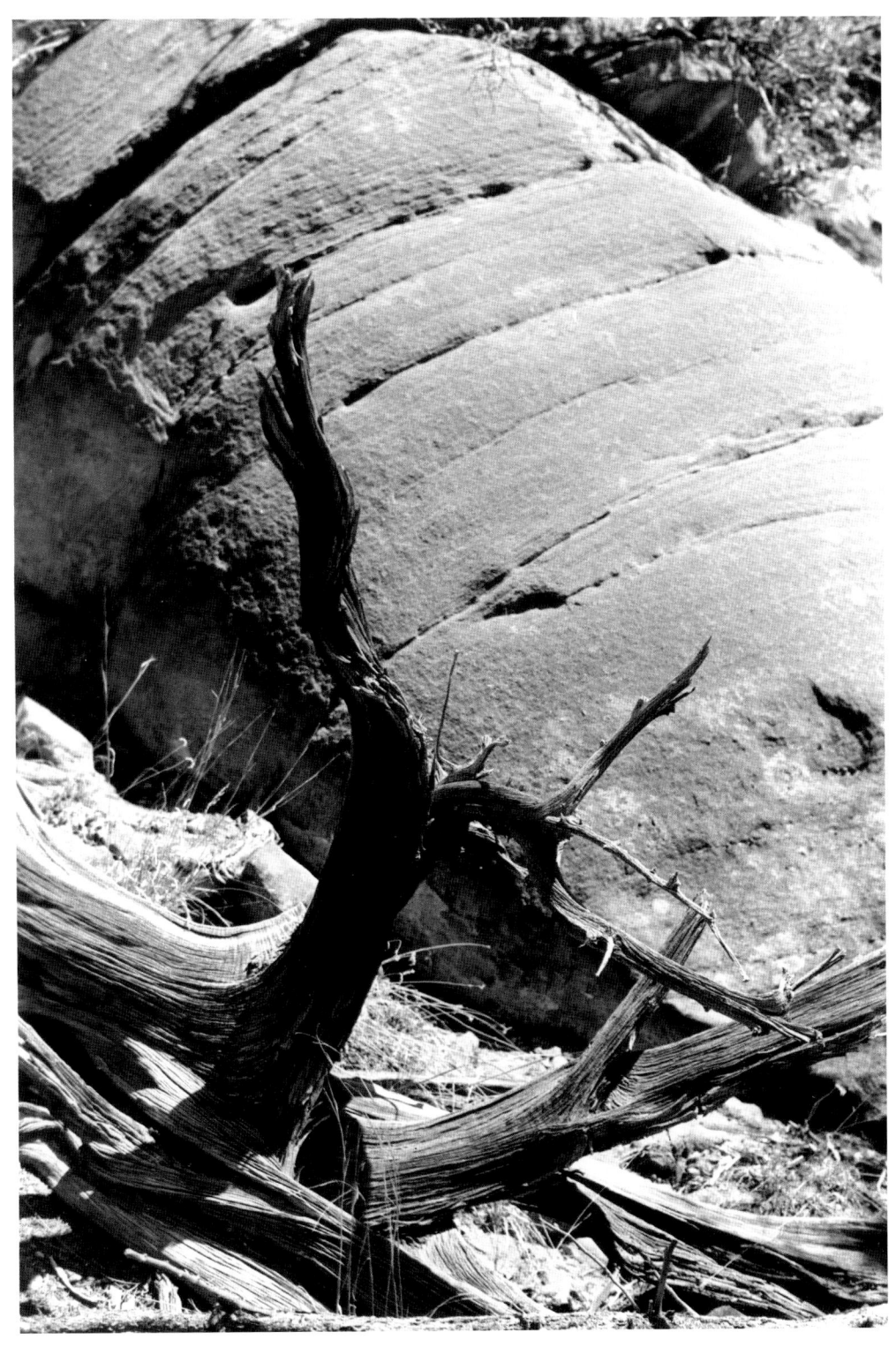

Rock with Shadows

Either you look at the universe as a very poor creation out of which no one can make anything or you look at your own life and your own part in the universe as infinitely rich full of inexhaustible interest opening out into infinite further possibilities for study and contemplation and interest and praise. Beyond all and in all is God.[5]

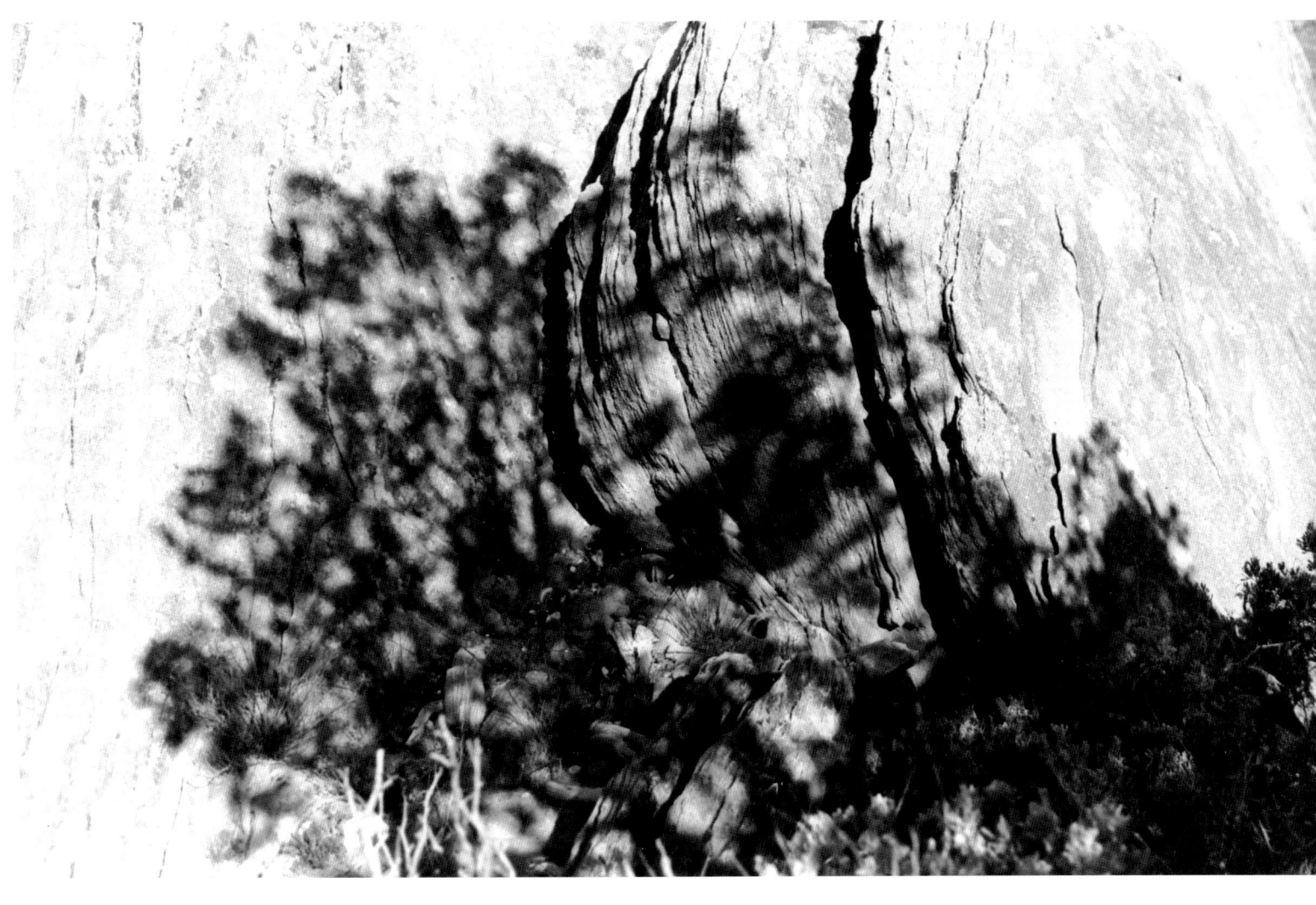

Open Barn Door

In contemplation we know by "unknowing."
Or better, we know *beyond* all knowing
or "unknowing."[6]

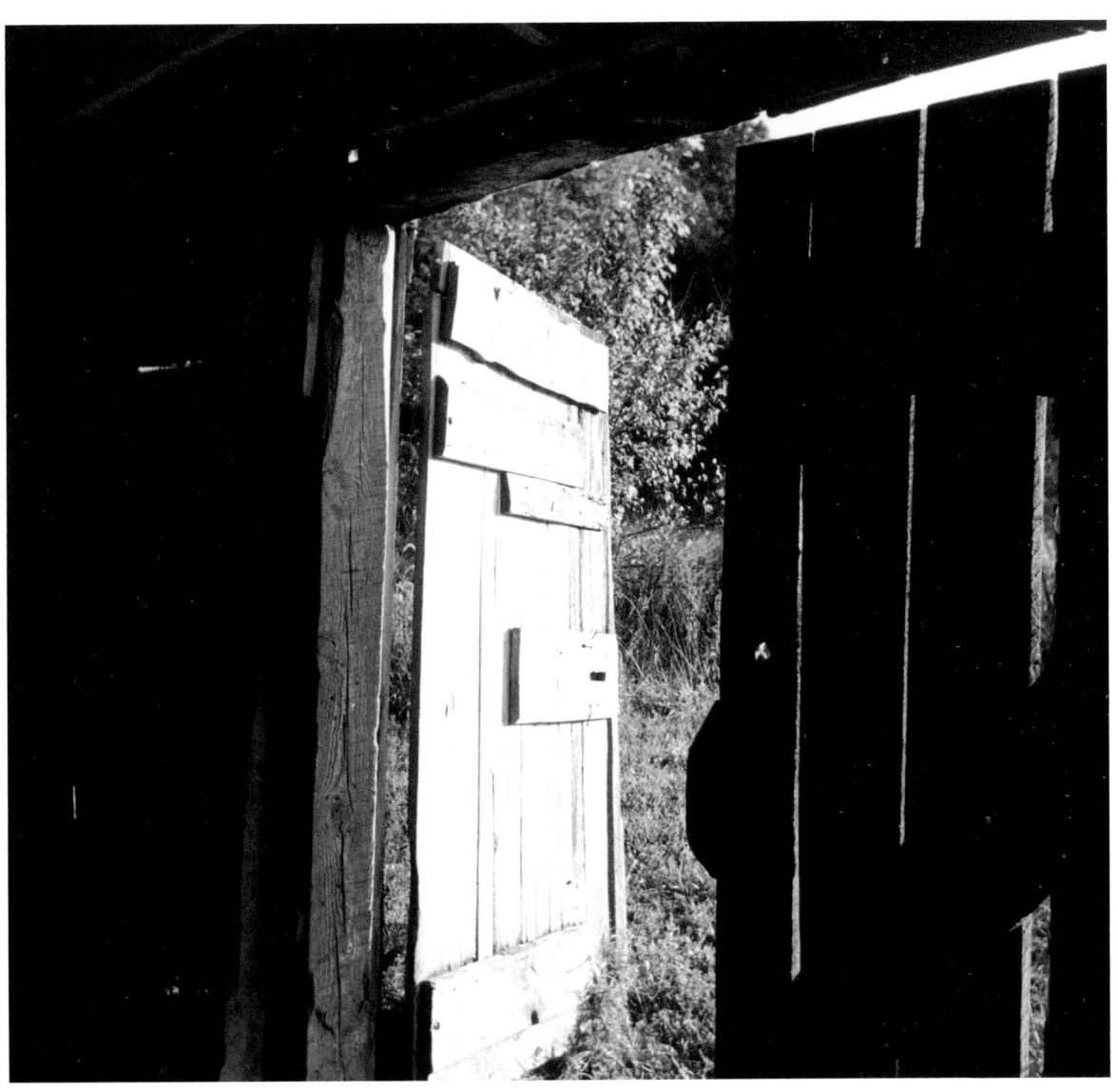

Trees

It is a strange awakening to find the sky inside you and beneath you and above you and all around you so that your spirit is one with the sky, and all is positive night.[7]

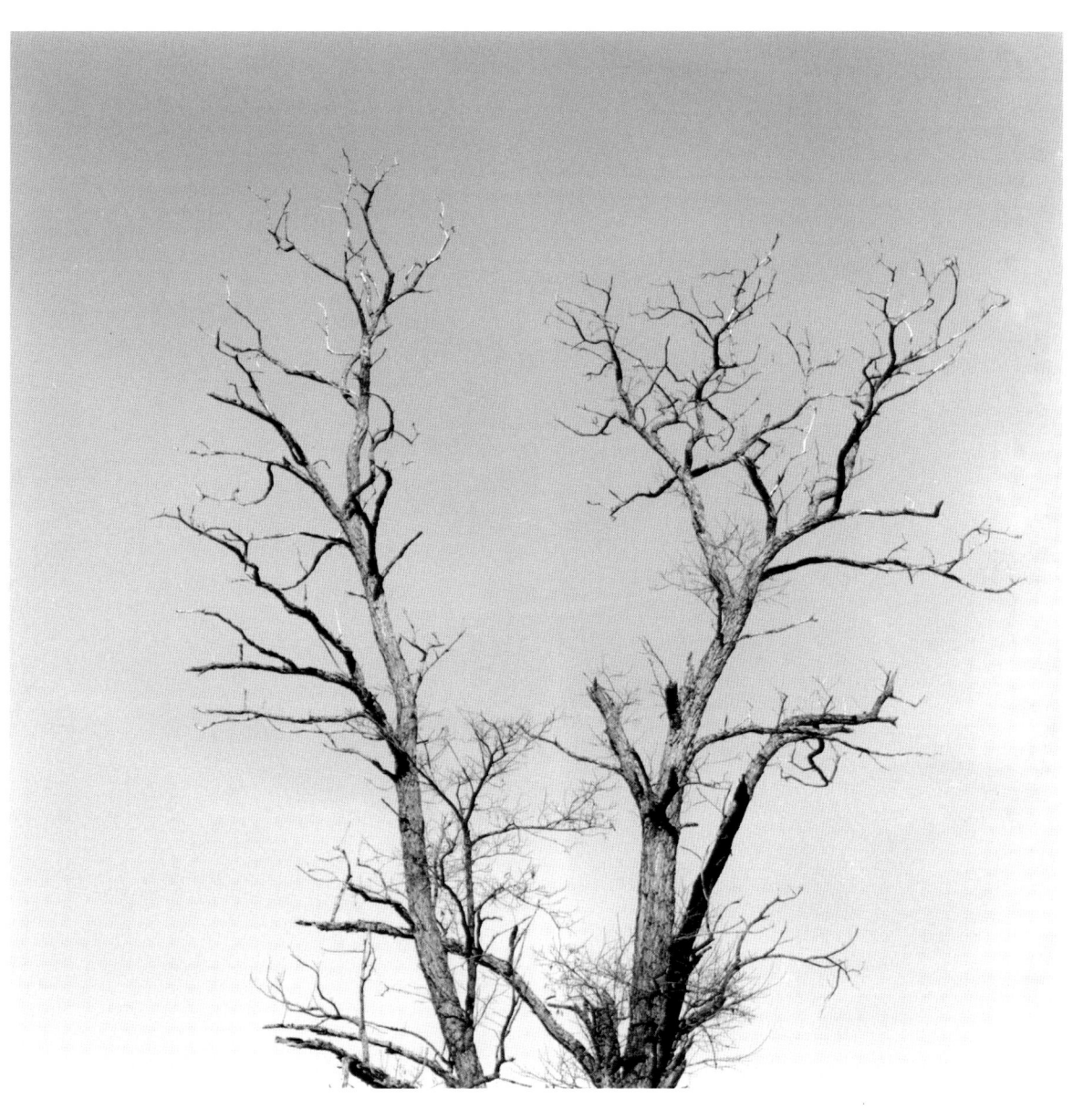

Tree in Winter

Real spring weather—these are the precise days when everything changes. All the trees are fast beginning to be in leaf and the first green freshness of a new summer is all over the hills. Irreplaceable purity of these few days chosen by God as His sign![8]

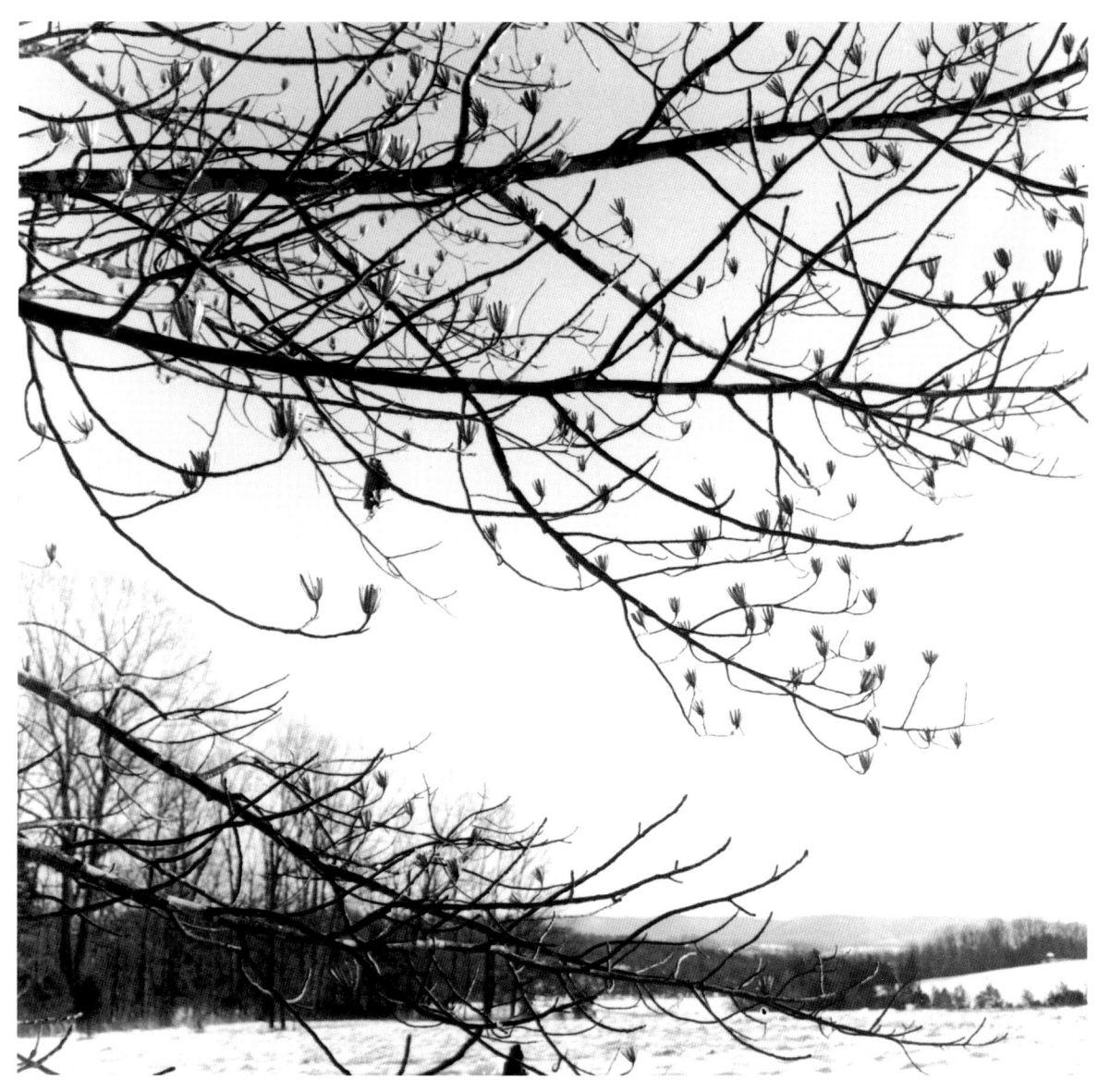

Barn Doors and Weeds

Paradise is all around us and we do not understand…"wisdom," cries the dawn deacon, but we do not attend.[9]

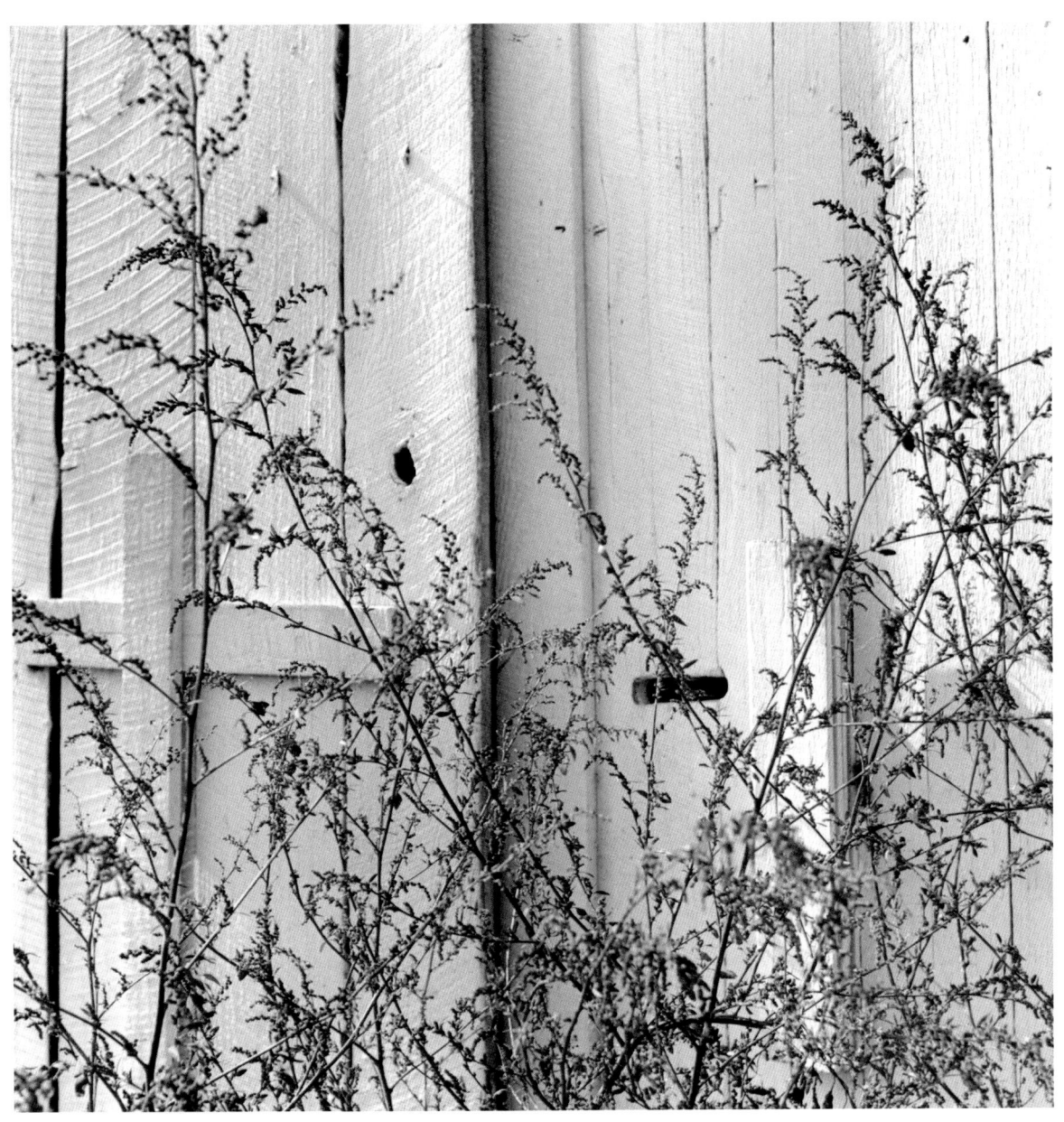

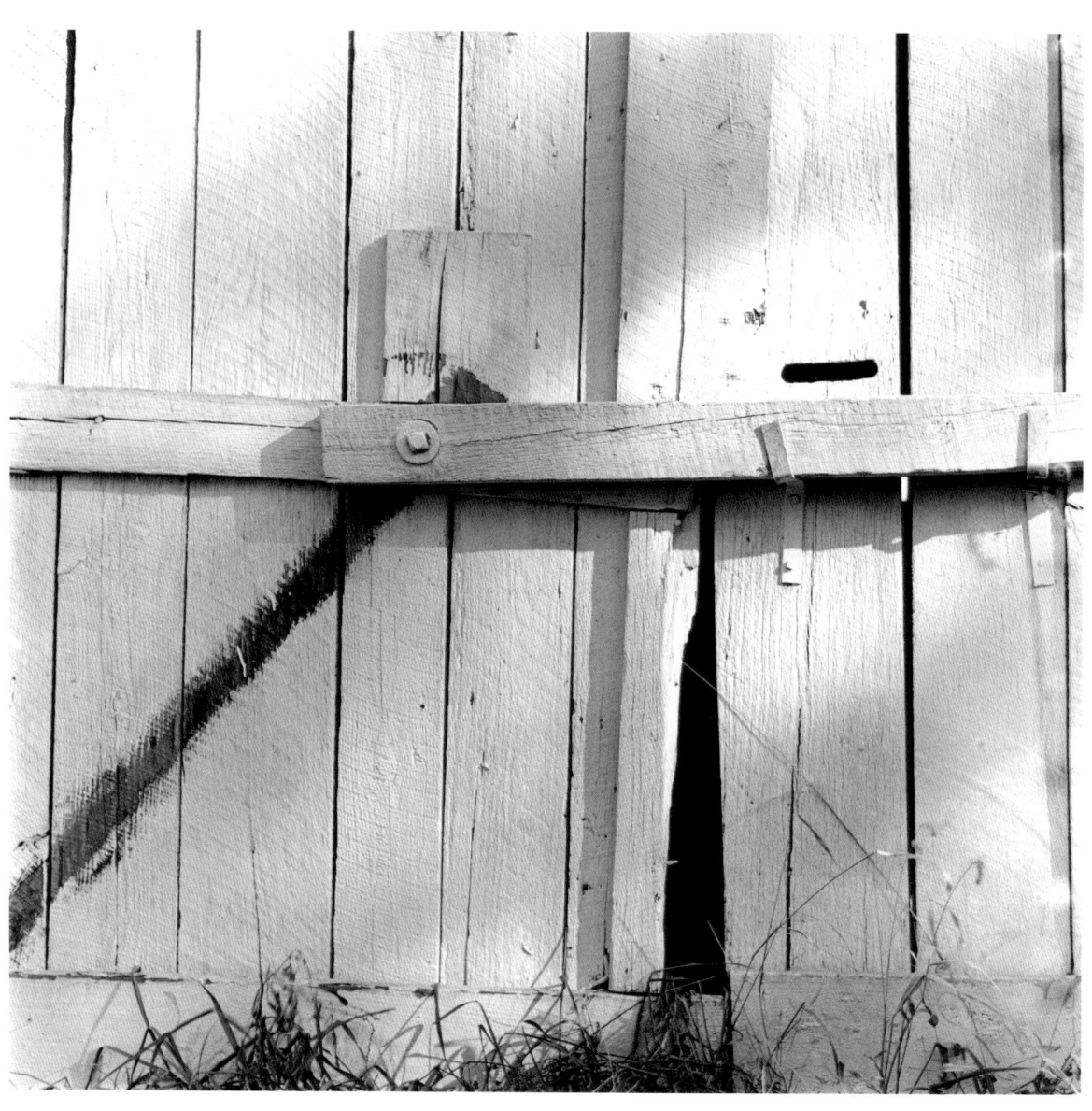

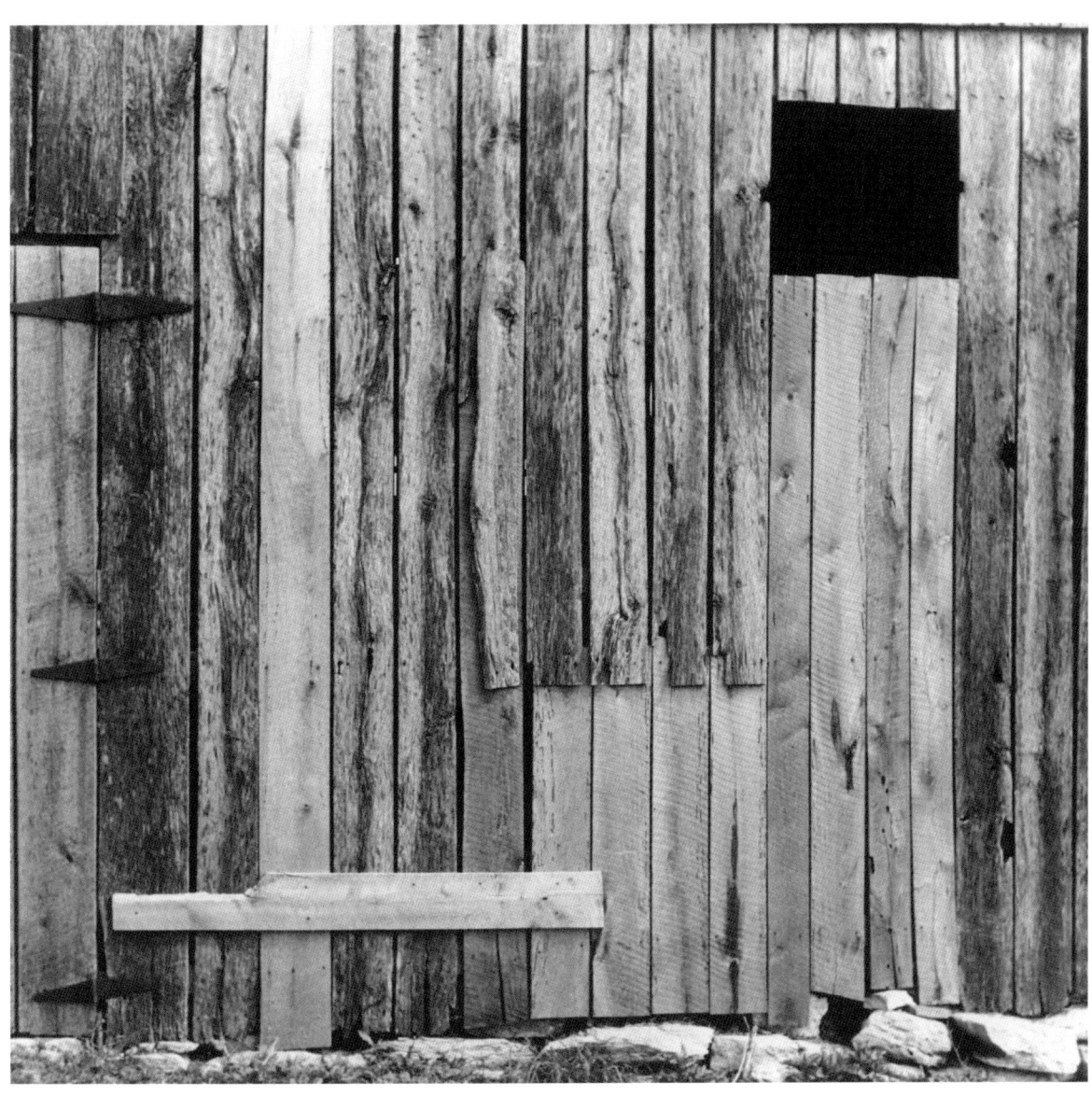

Branches

My Zen is in the slow swinging tops of sixteen pine trees.[10]

Winter Branches

For, like a grain of fire

Smouldering in the heart of every
living essence

God plants His undivided power—

Buries His thought too vast for worlds

In seed and root and blade and flower,

Until, in the amazing shadowlights

Of windy, cloudy April,

Surcharging the religious silence of the spring

Creation finds the pressure of its
everlasting secret

Too terrible to bear.[11]

Monastery Window

The eye wherein I see God is the same eye
wherein God sees me.[12]

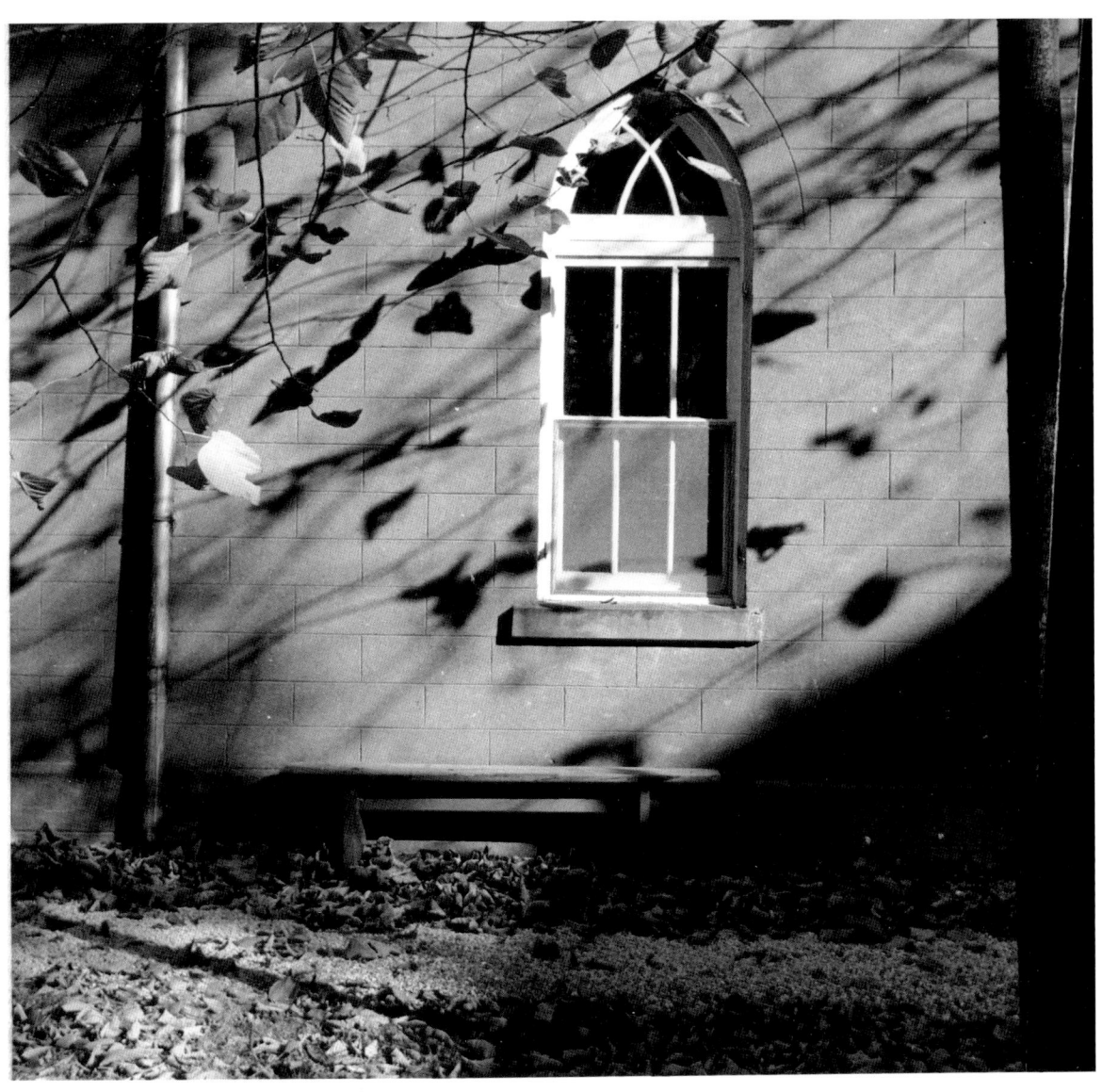

Silhouetted Tree

I looked up at the clear sky and the tops of the leafless trees shining in the sun and it was a moment of angelic lucidity. I said the Psalms of Tierce with great joy, overflowing joy, as if the land and woods and spring were all praising God through me. Again the sense of angelic transparency of everything: of pure, simple and total light.[13]

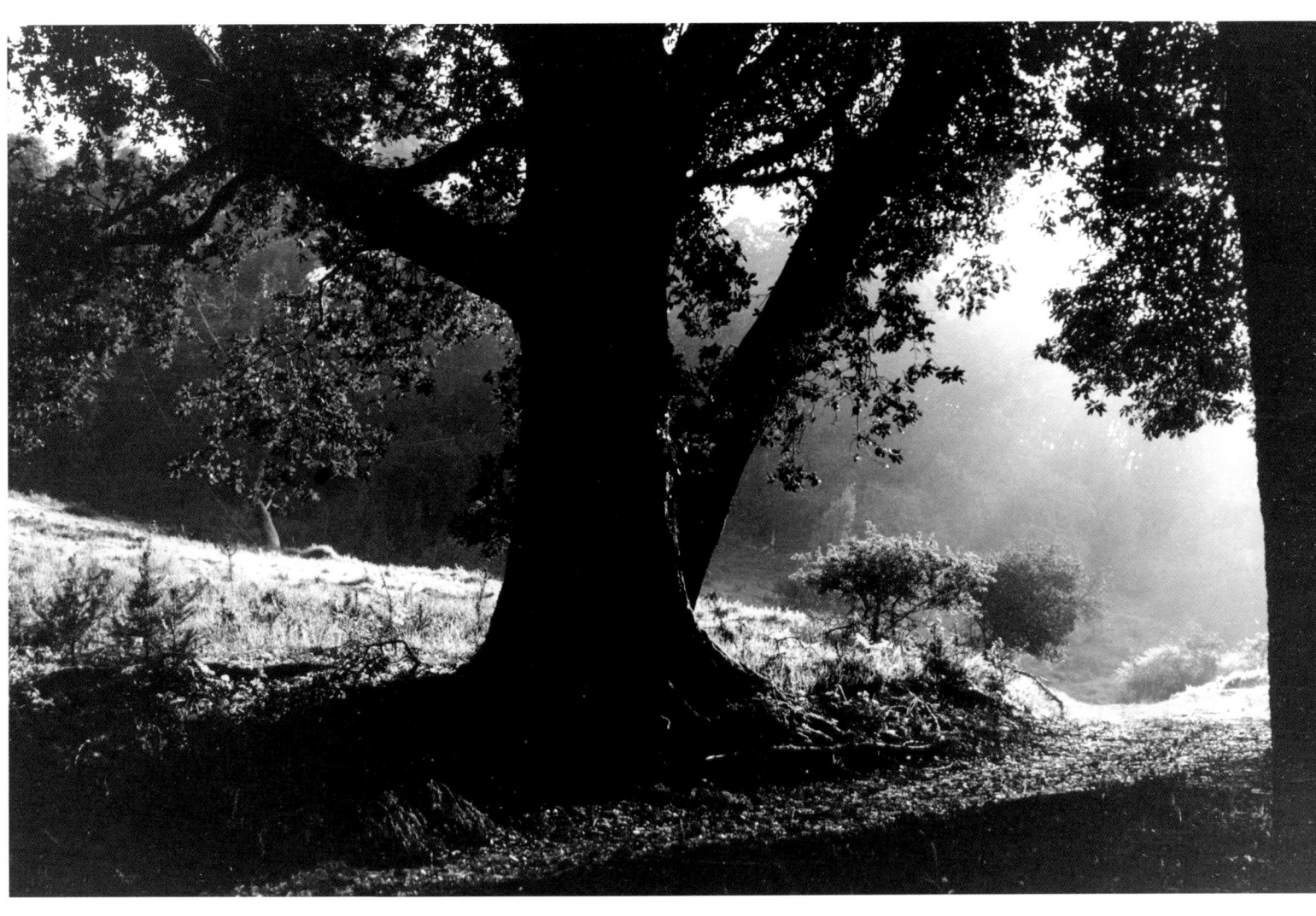

Silhouetted Tree Trunk

The landscape has been splendidly serious.
I love the strength of our woods, in this bleak
weather. And it is bleak weather. Yes there is
warmth in it like the presence of God in
aridity of spirit, when He comes closer
to us than in consolation.[14]

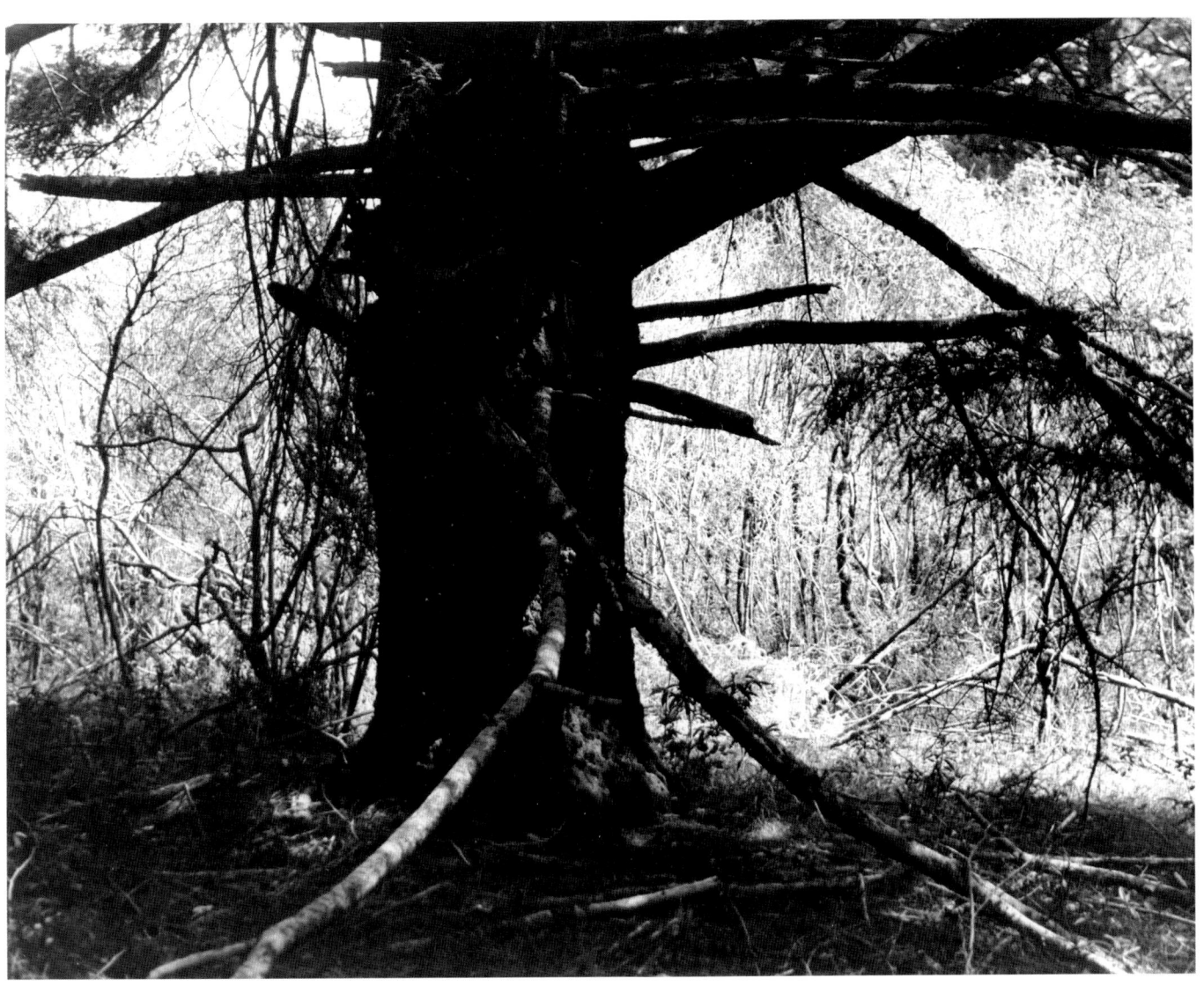

Bare Woods

Out here in the woods I can think of nothing except God and it is not so much that I think of Him either. I am as aware of Him as of the sun and the clouds and the blue sky and the thin cedar trees. When I first came out here, I was sleepy but I read a few lines from the Desert Fathers and then, after that, my whole being was full of serenity and vigilance.[15]

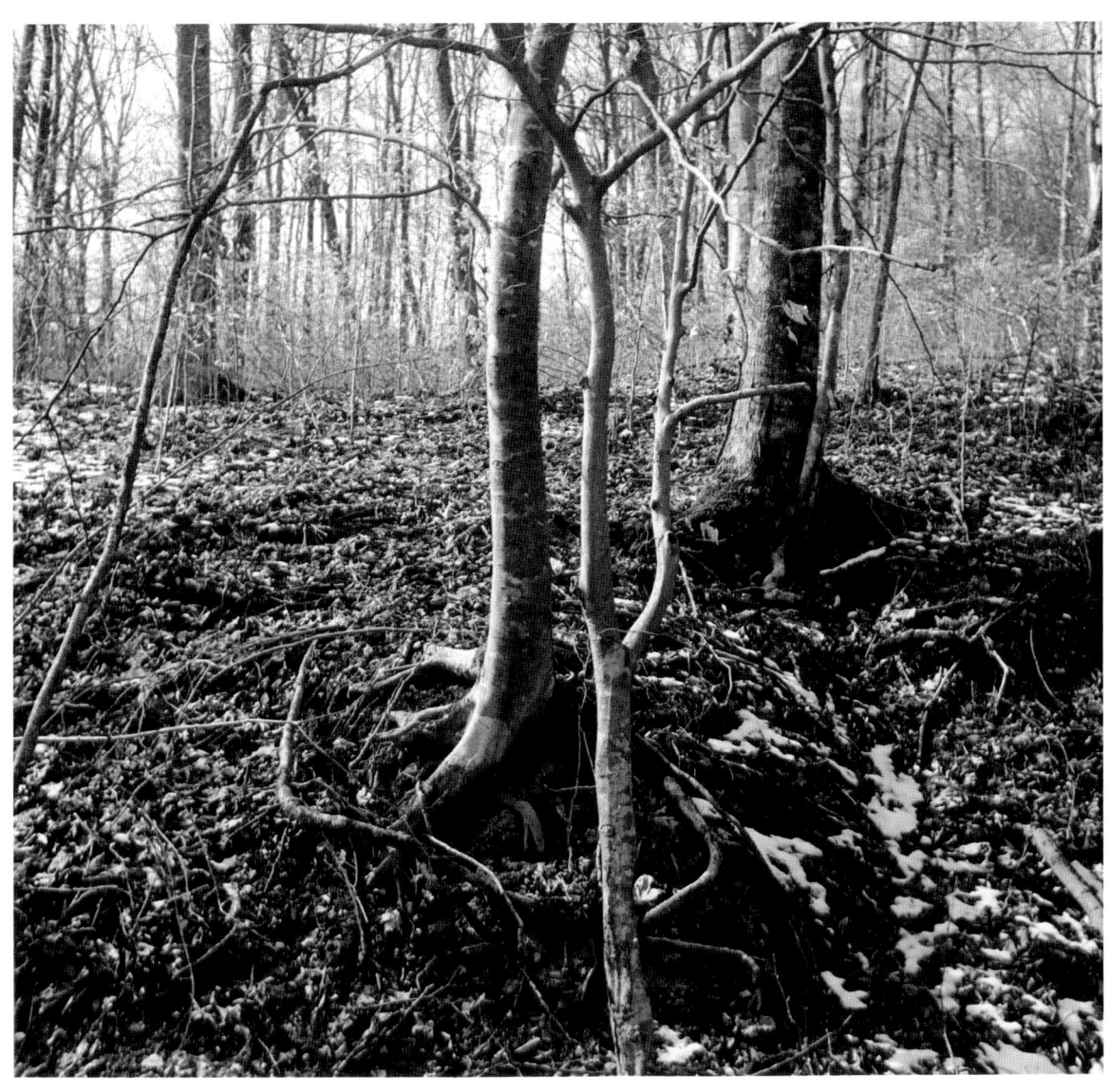

Wooded Glade

Up here in the woods is seen the
New Testament: that is to say, the wind comes
through the trees and you
breathe it.[16]

Solitary Tree on Hillside

I looked at all this in great tranquility, with my soul and spirit quiet. For me landscape seems to be important for contemplation; anyway, I have no scruples about loving it.[17]

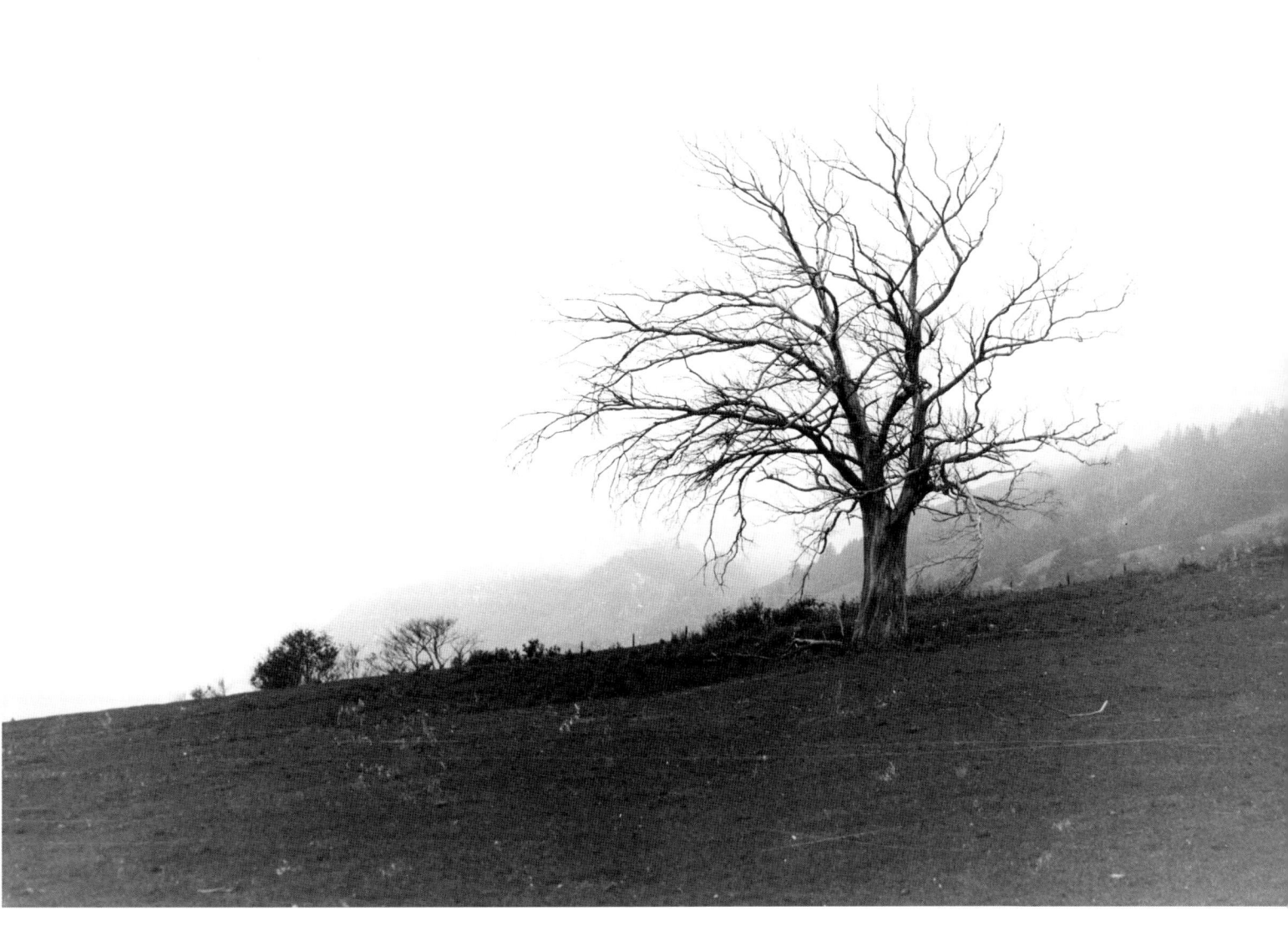

Window Frame

For I, Solitude, am thine own self:

 I, Nothingness, am thy All.

 I, Silence, am thy Amen![18]

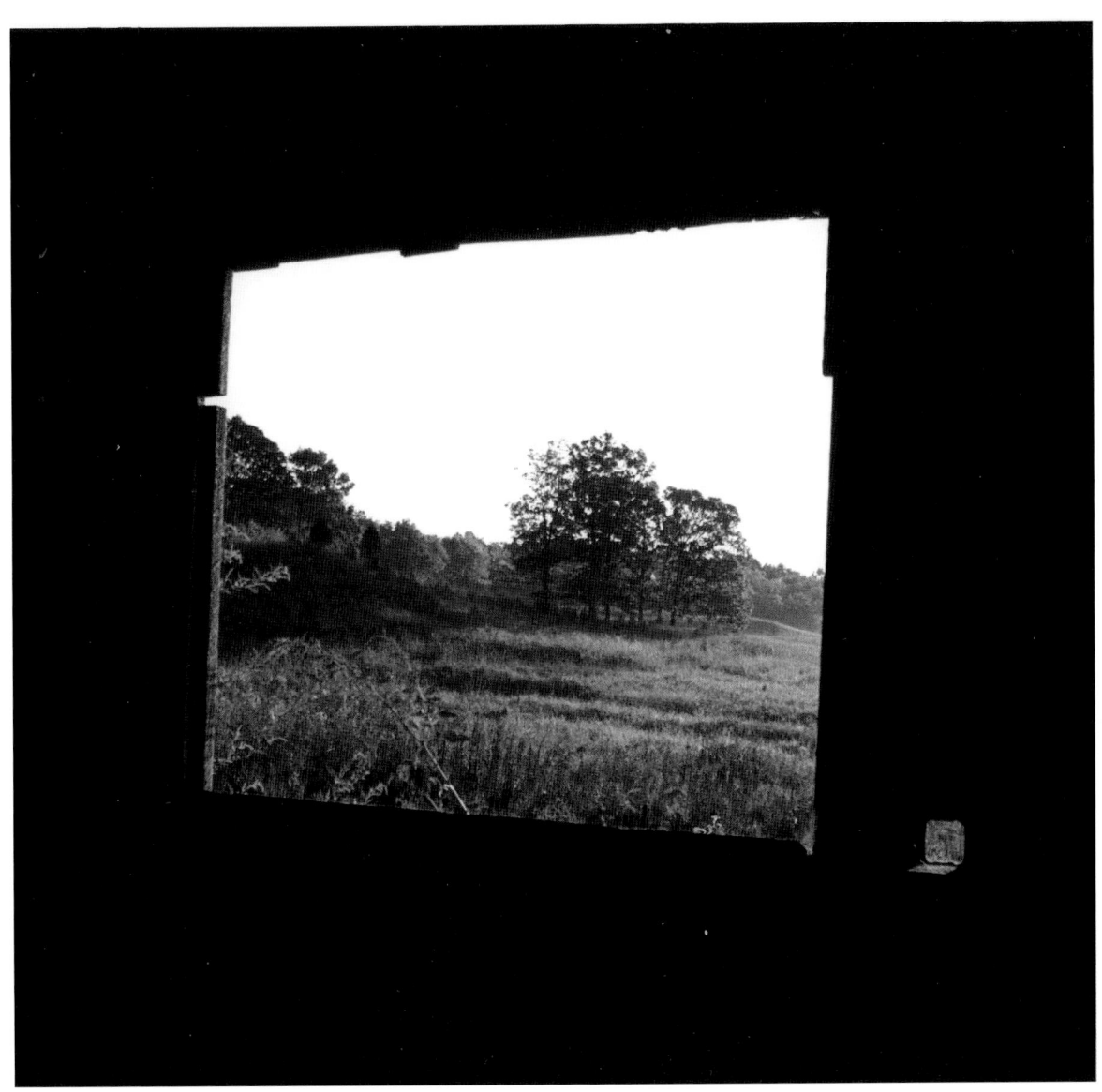

Basket and Tree Root

Zen explains nothing. It just sees.
Sees what? Not an Absolute Object but
Absolute Seeing.[19]

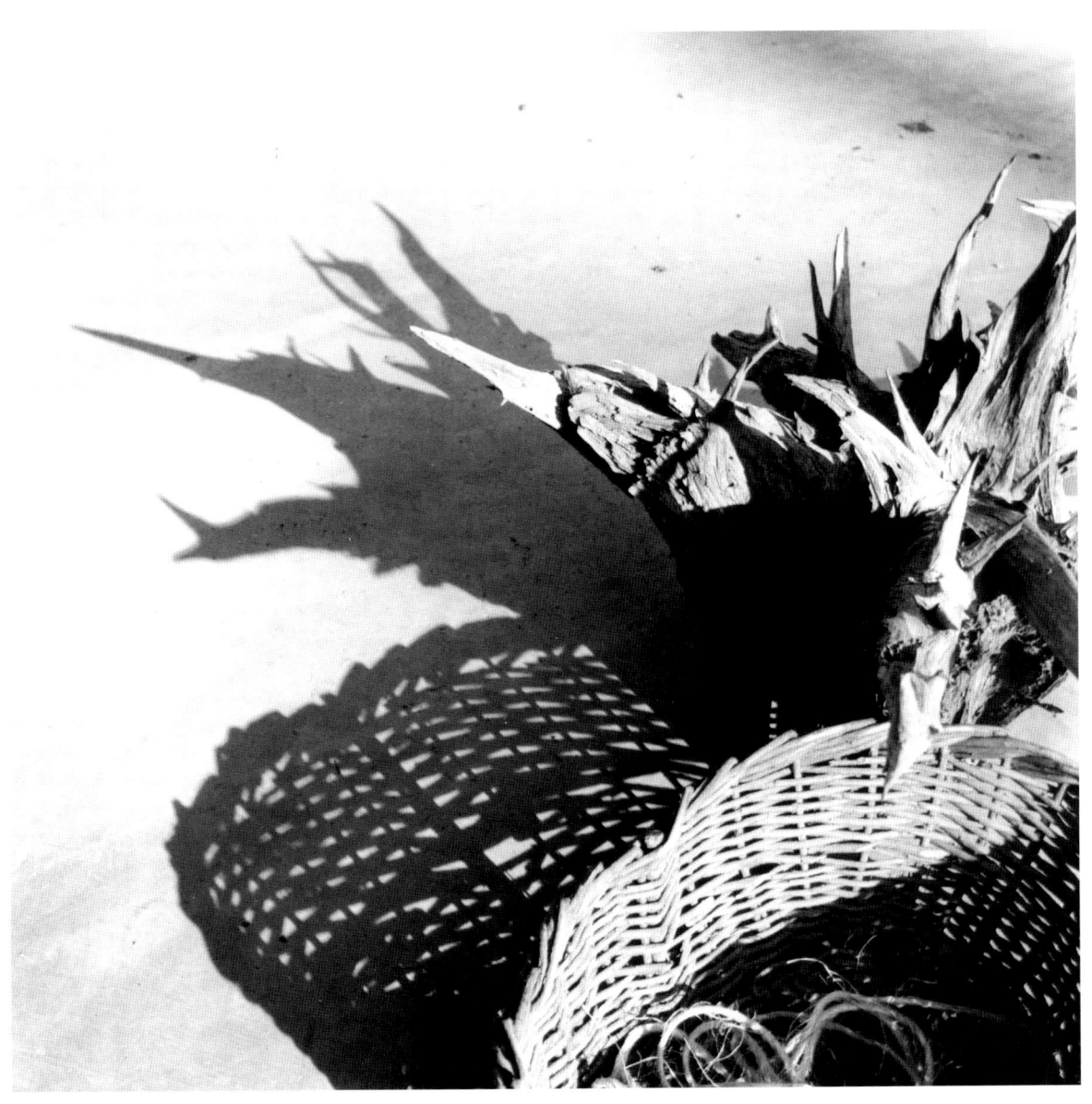

Basket

Each particular being, in its individuality, its concrete nature and entity, with all its own characteristics and its private qualities and its own inviolable identity, gives glory to God by being precisely what He wants it to be here and now, in the circumstances ordained for it by His Love and His infinite Art.[20]

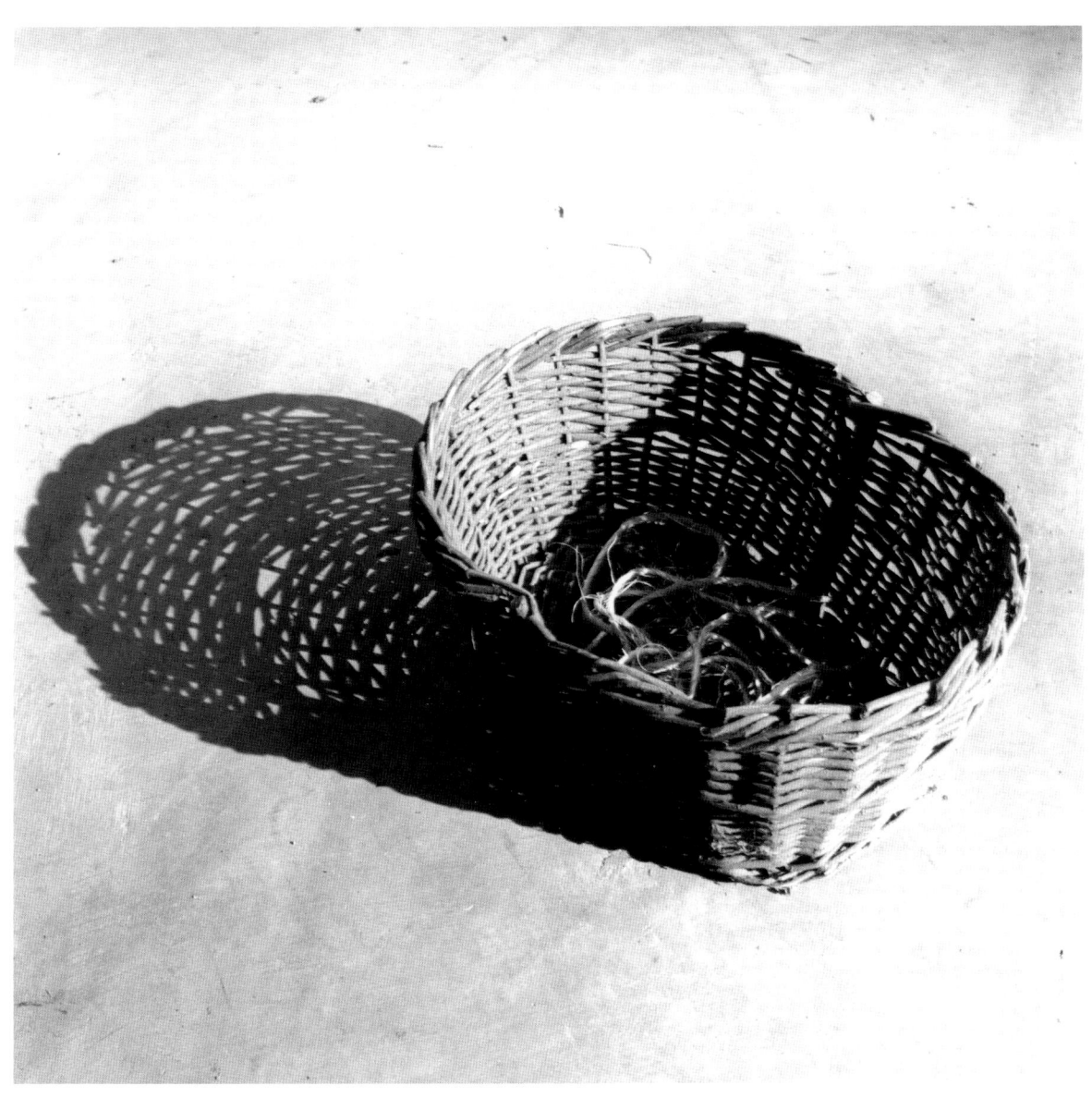

Basket (Detail)

The forms and individual characters of living and growing things, of inanimate beings, of animals and flowers and all nature, constitute their holiness in the sight of God.

Their inscape is their sanctity. It is the imprint of His wisdom and His reality in them.[21]

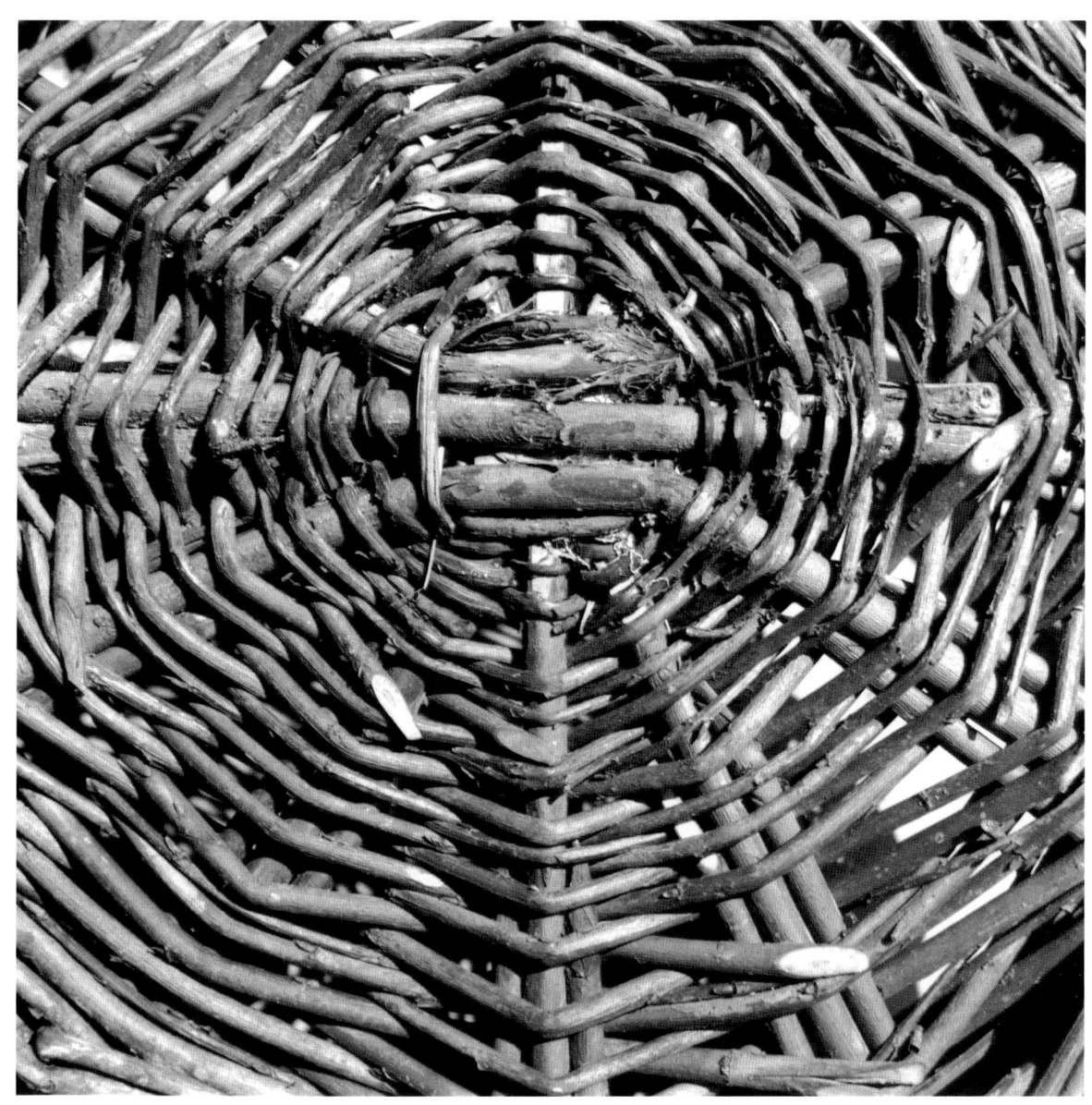

Basket (Detail)

Solitude is not found so much by looking outside the boundaries of your dwelling, as by staying within. Solitude is not something you must hope for in the future. Rather, it is a deepening of the present, and unless you look for it in the present you will never find it.[22]

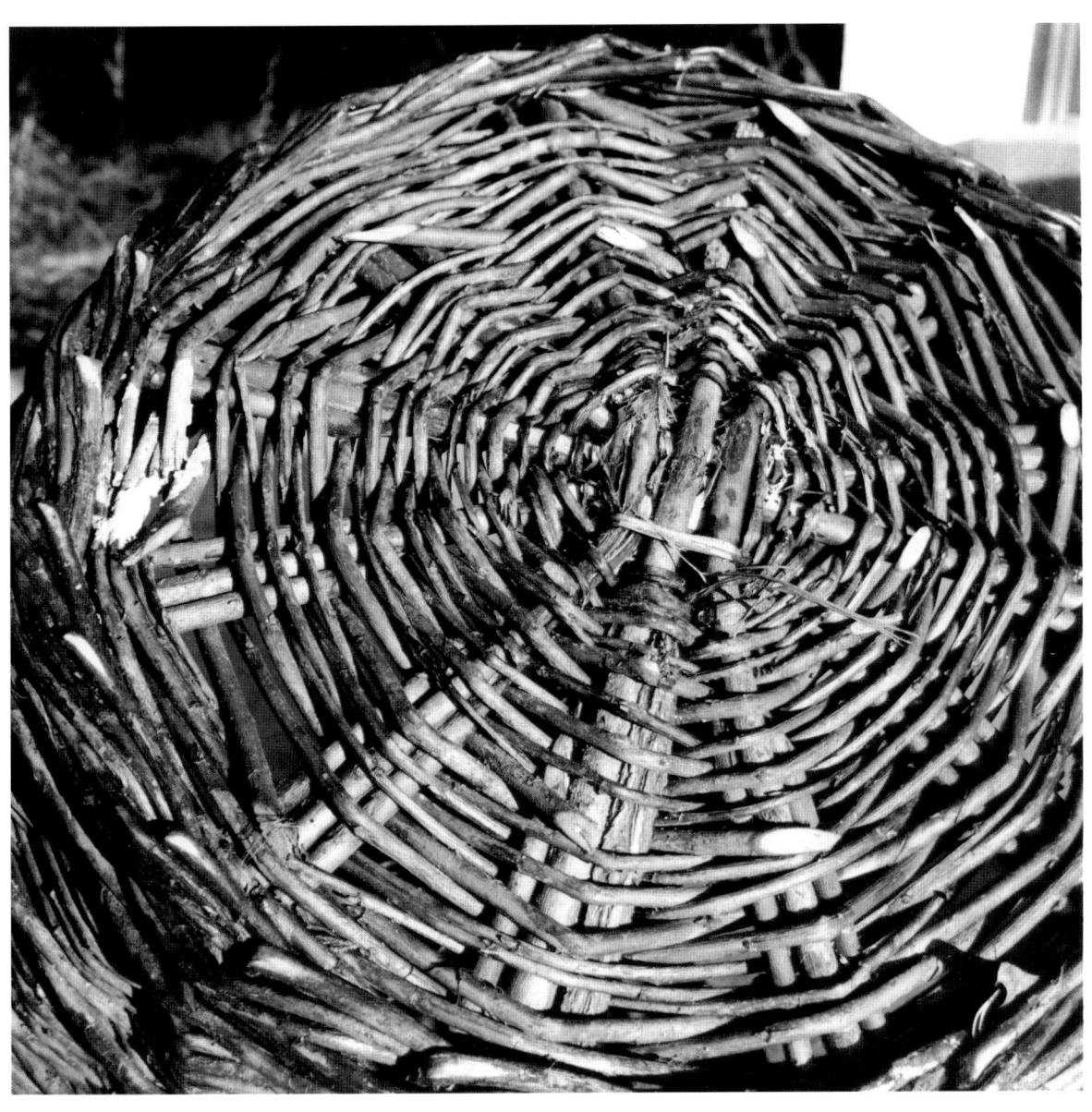

Basket

The light is itself. The silence is itself.
I am myself.[23]

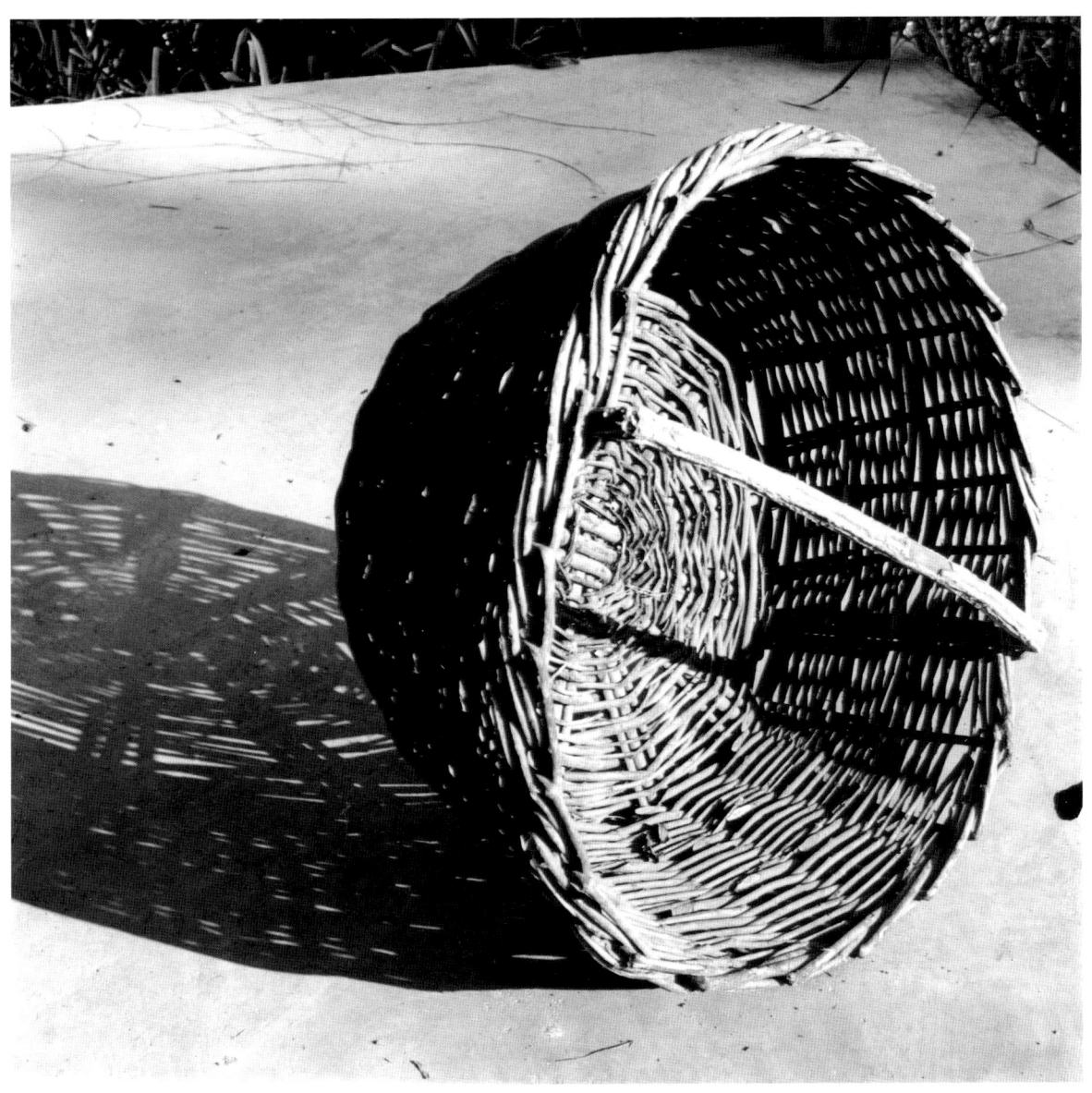

Window

He who is infinite light is so tremendous in His evidence that our minds only see Him as darkness. *Lux in tenebris lucet et tenebrae eam non comprehenderunt.*[24]

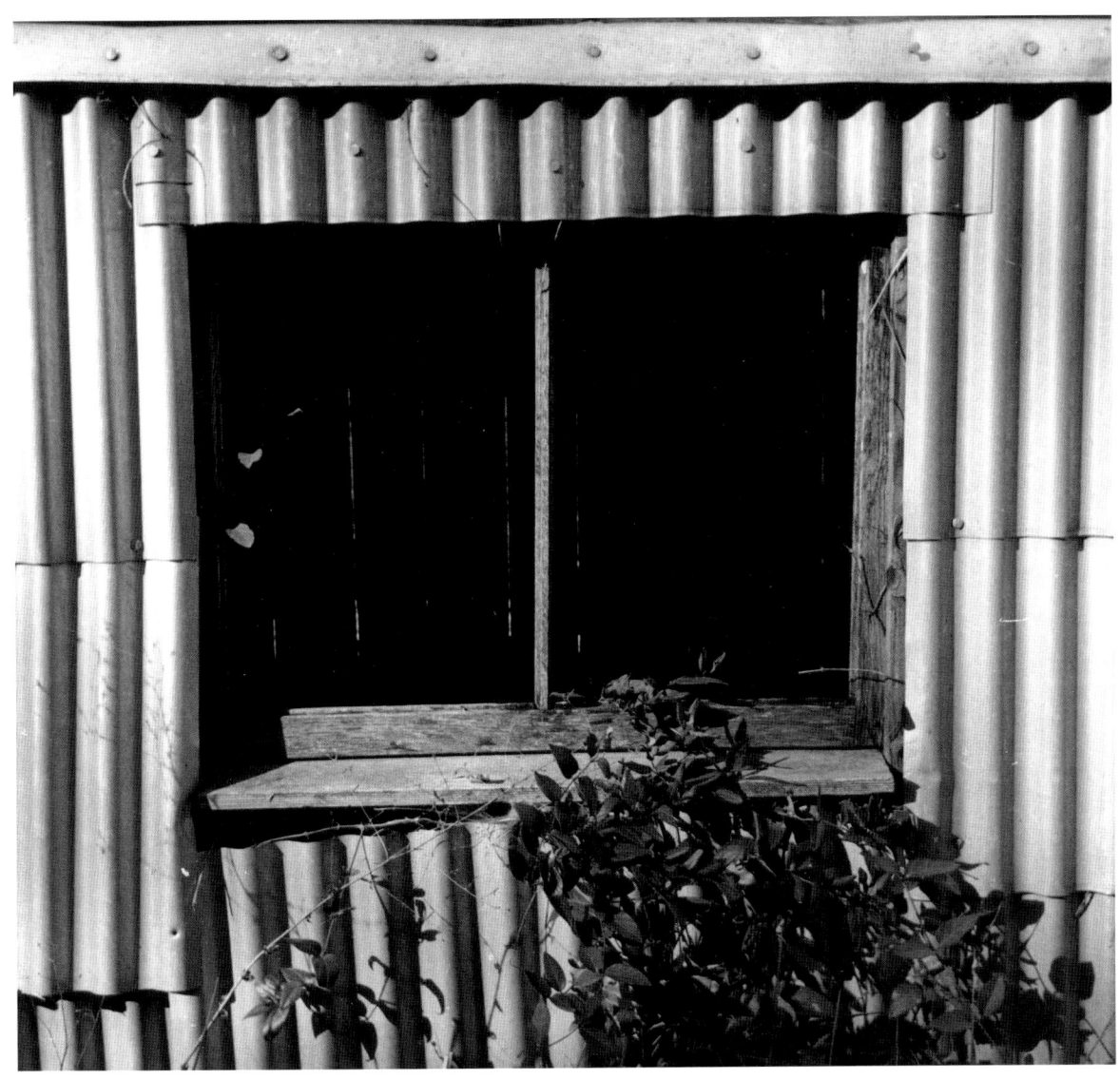

Rock and Shoots

This is a country whose center is everywhere and whose circumference is nowhere. You do not find it by traveling but by standing still.[25]

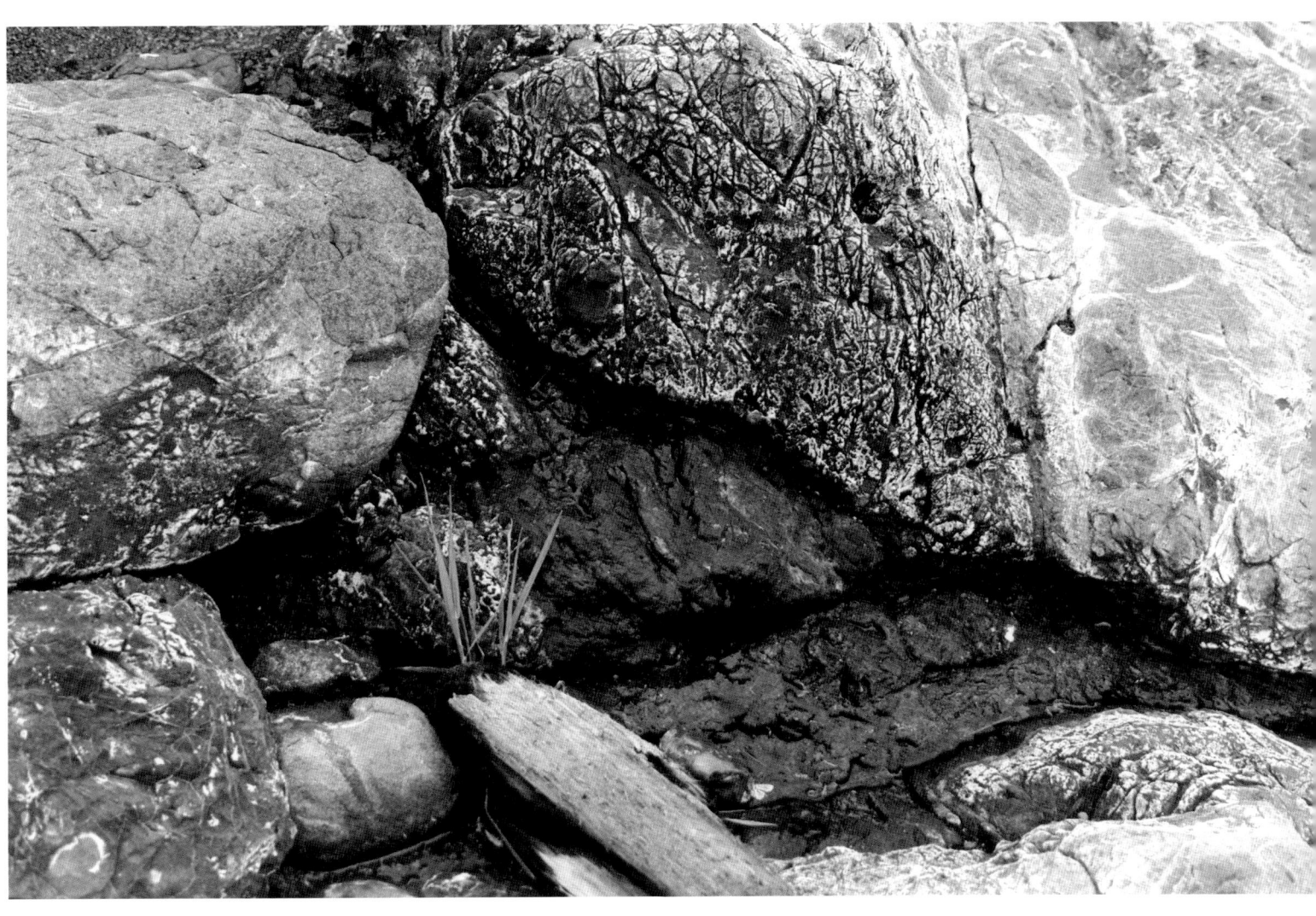

Rock and Water

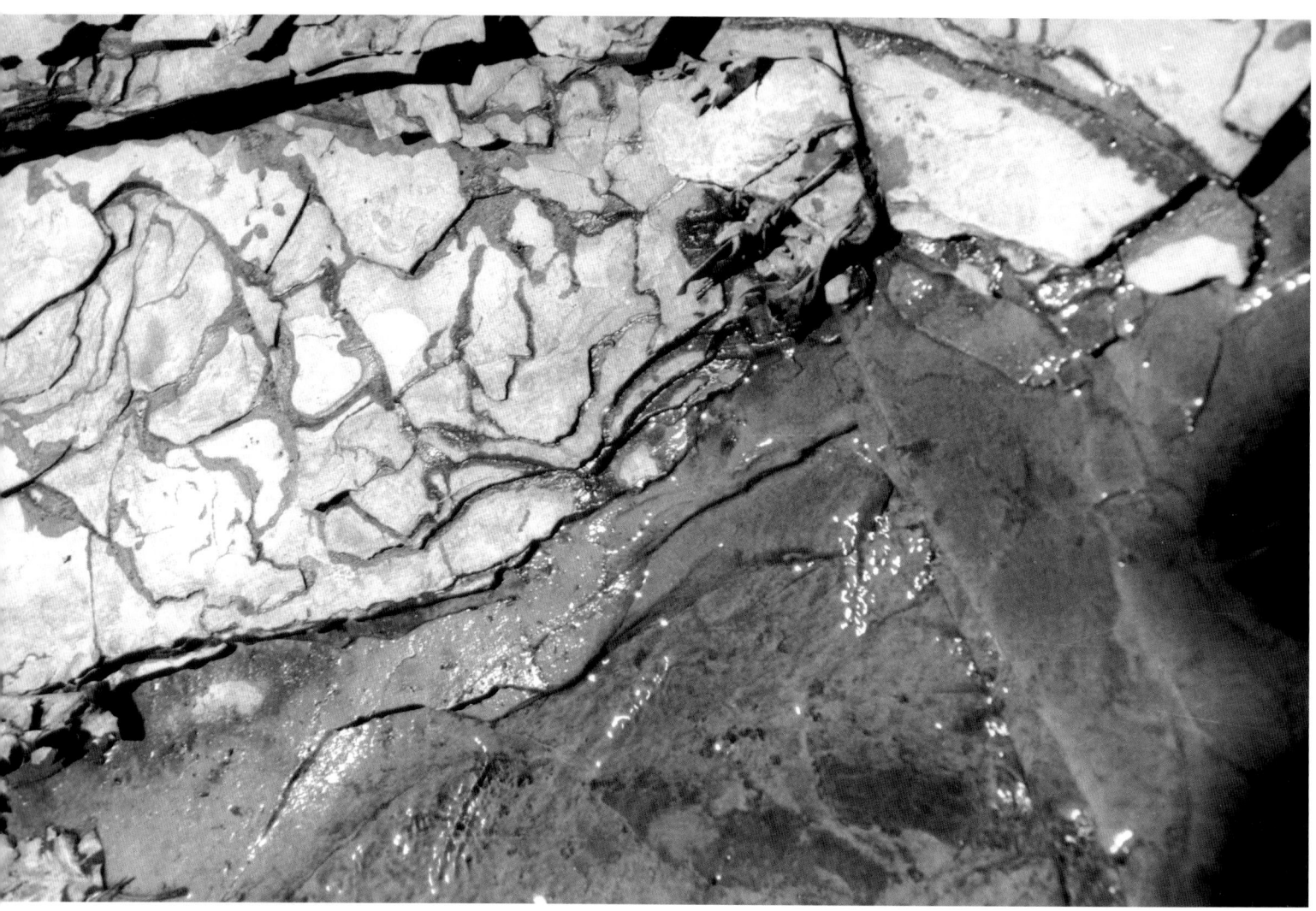

Water

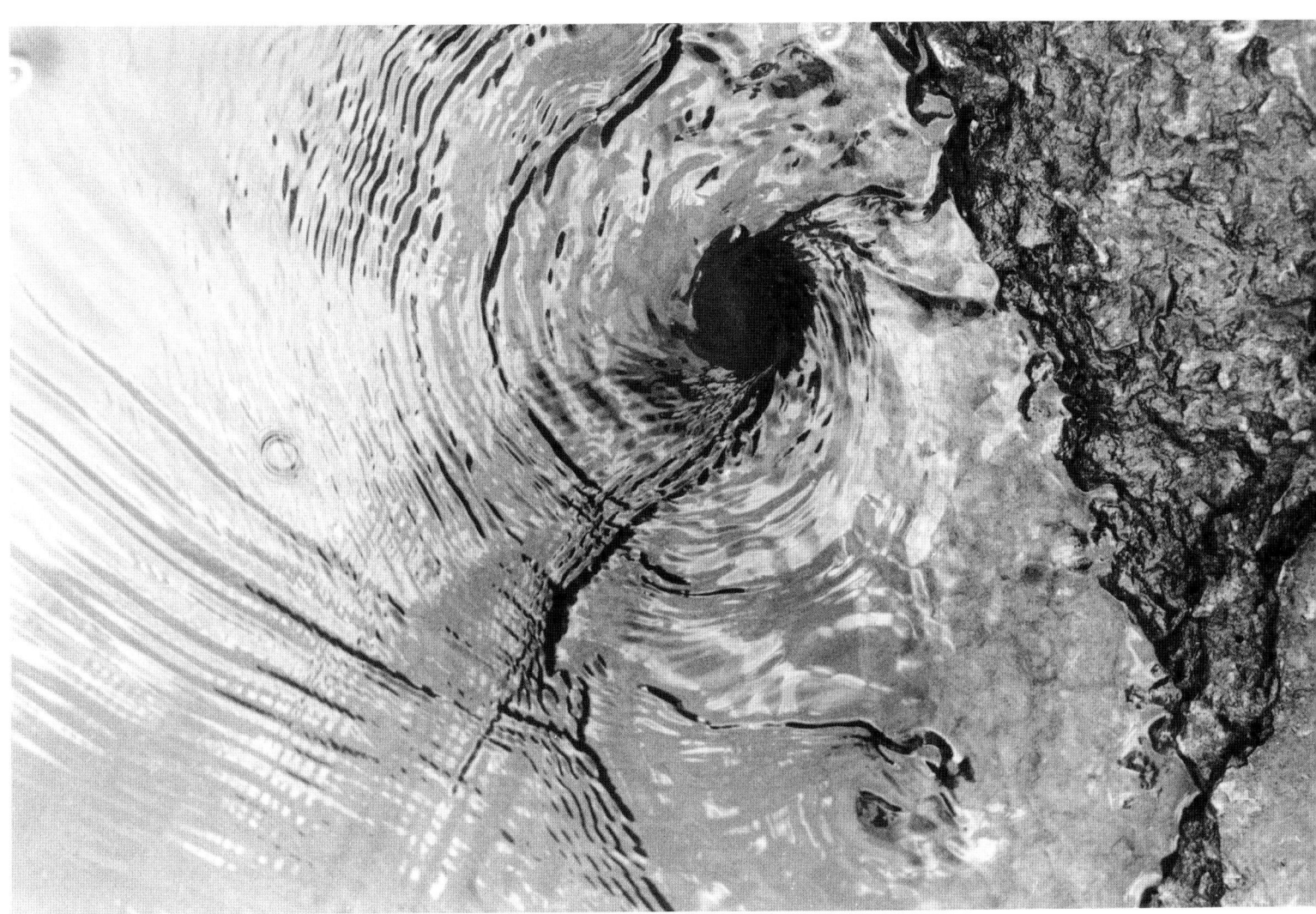

Broken Rock and Grass

Because God, God

The One I hunt and never capture,

Opened His door, and lo, His loneliness invaded you.[26]

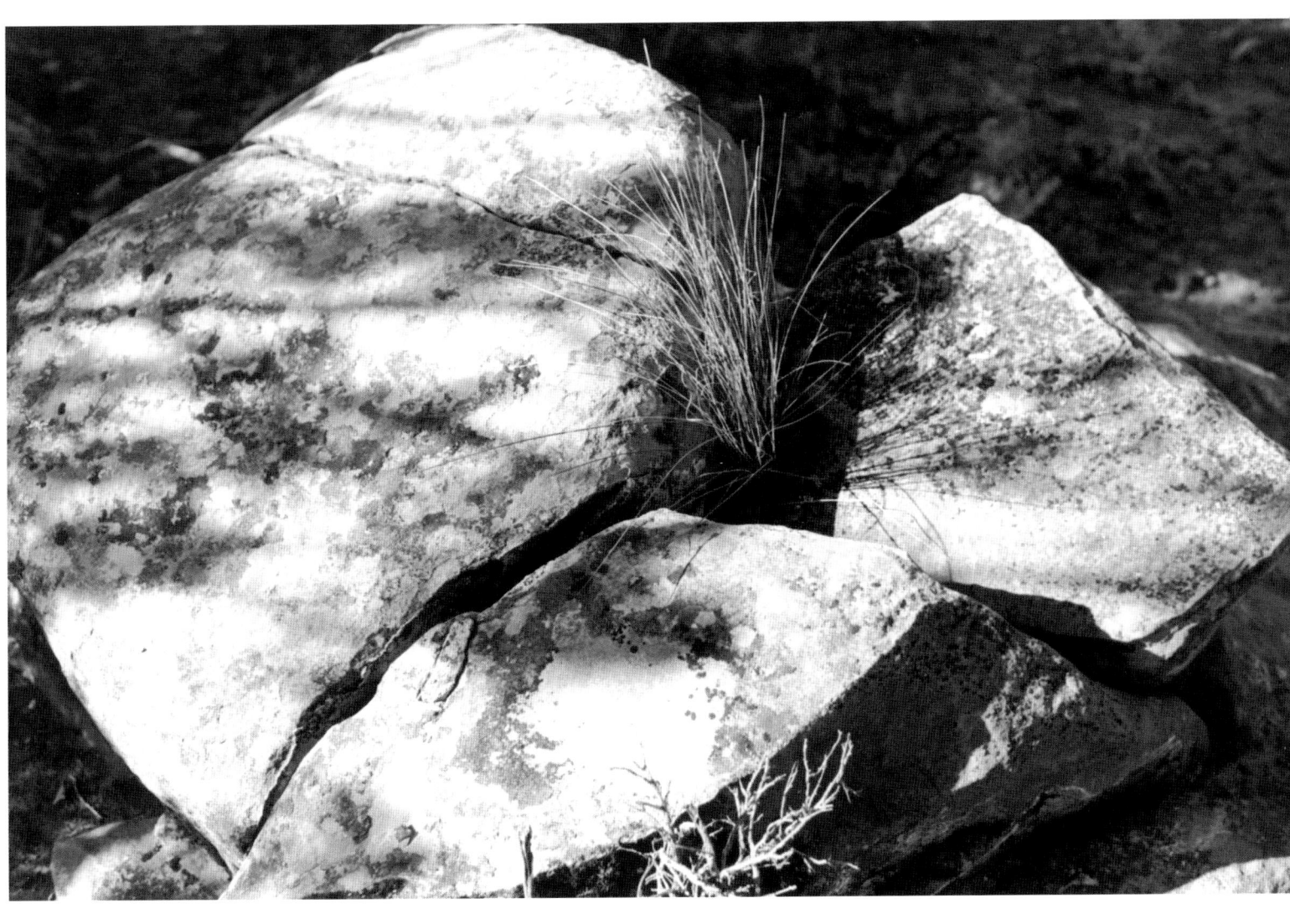

Rocks and Root

The meaning of life is found in openness to being and "being present" in full awareness.[27]

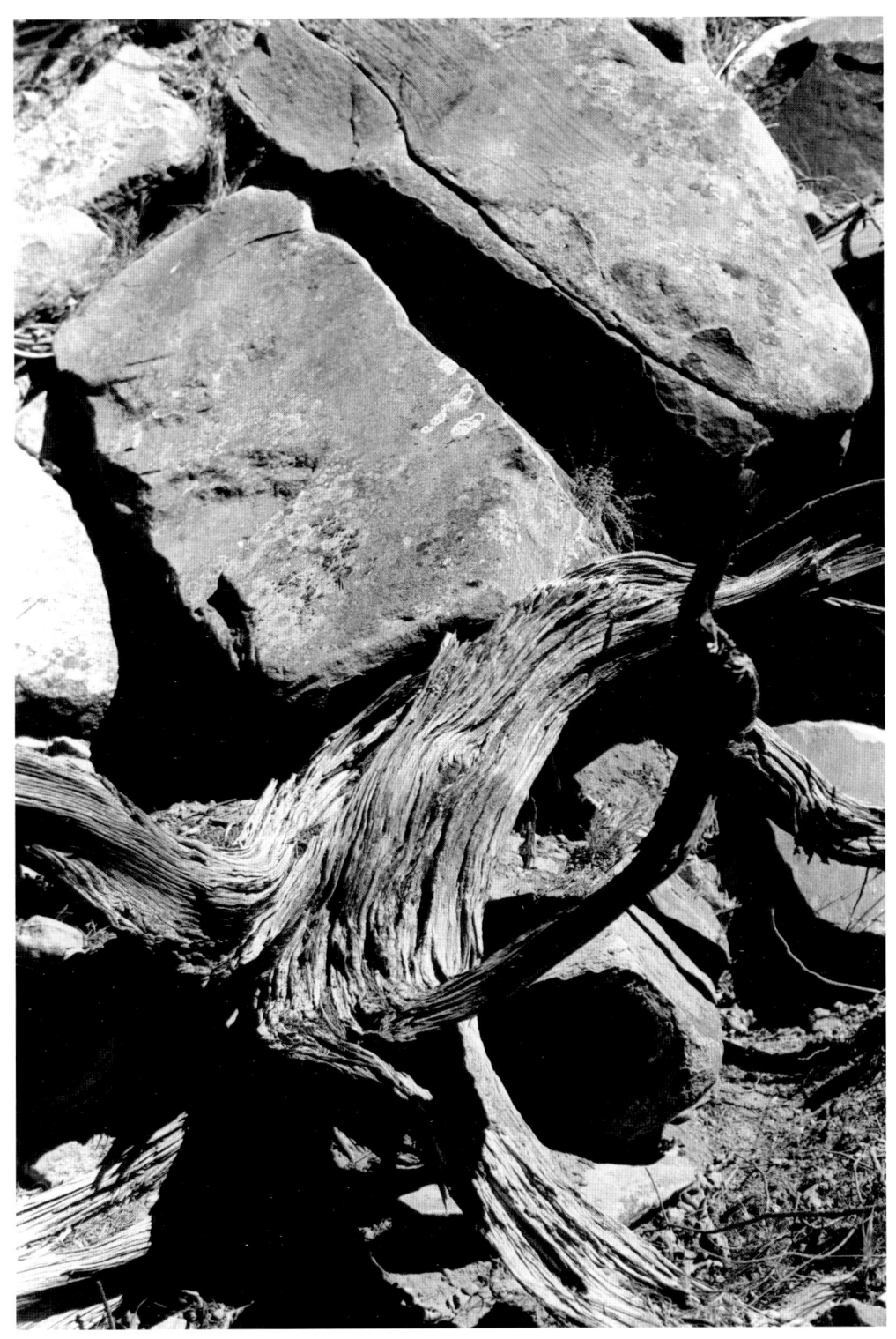

A HIDDEN WHOLENESS ||| 111

Root

At the center of our being is a point of nothingness which is untouched by sin and by illusion, a point of pure truth, a point or spark which belongs entirely to God...this little point of nothingness and of *absolute poverty* is the pure glory of God in us.[28]

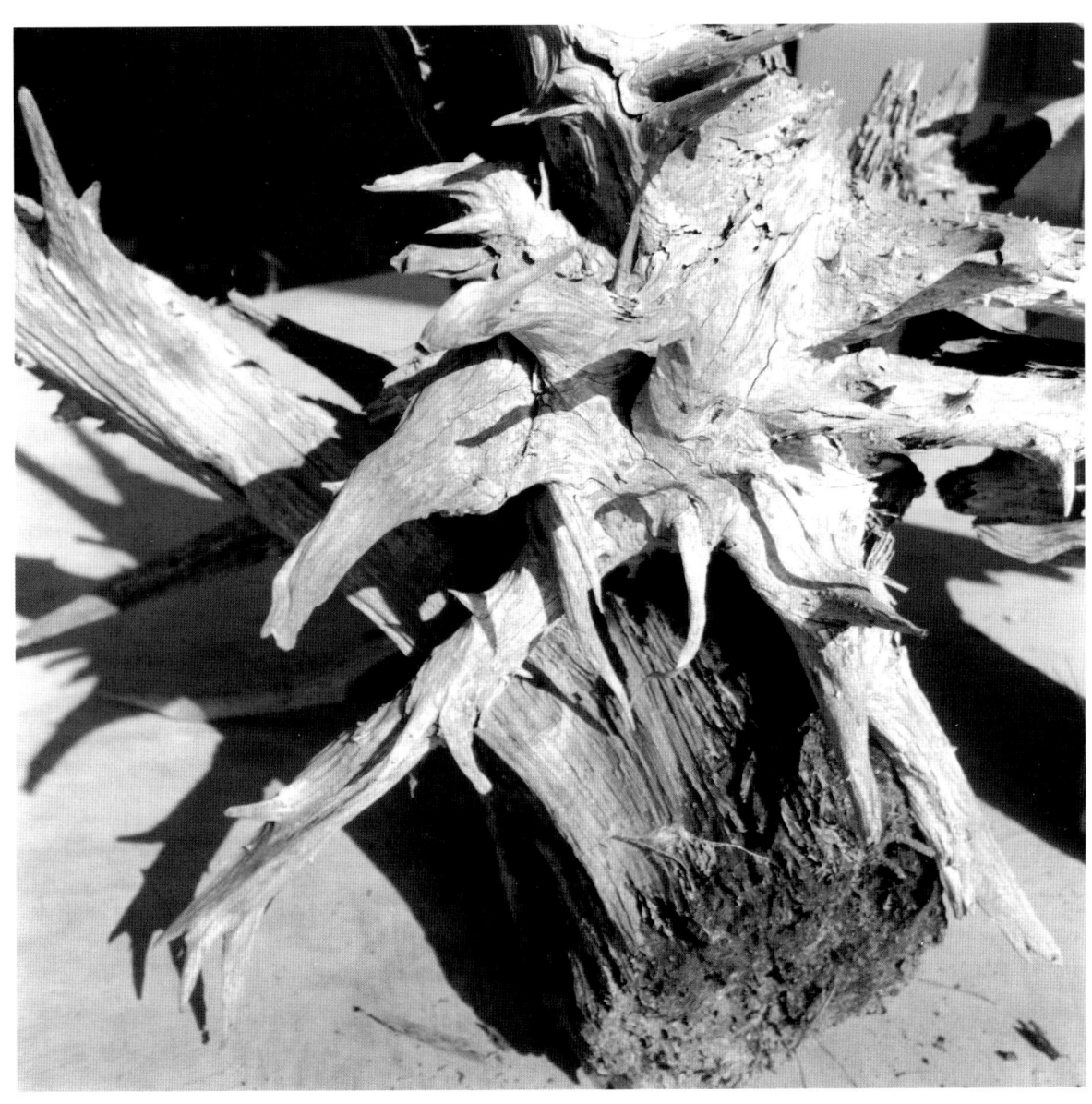

Root

Nirvana: perfect awareness and perfect compassion. *Nirvana* is the wisdom of perfect love grounded in itself and shining through everything, meeting with no opposition.[29]

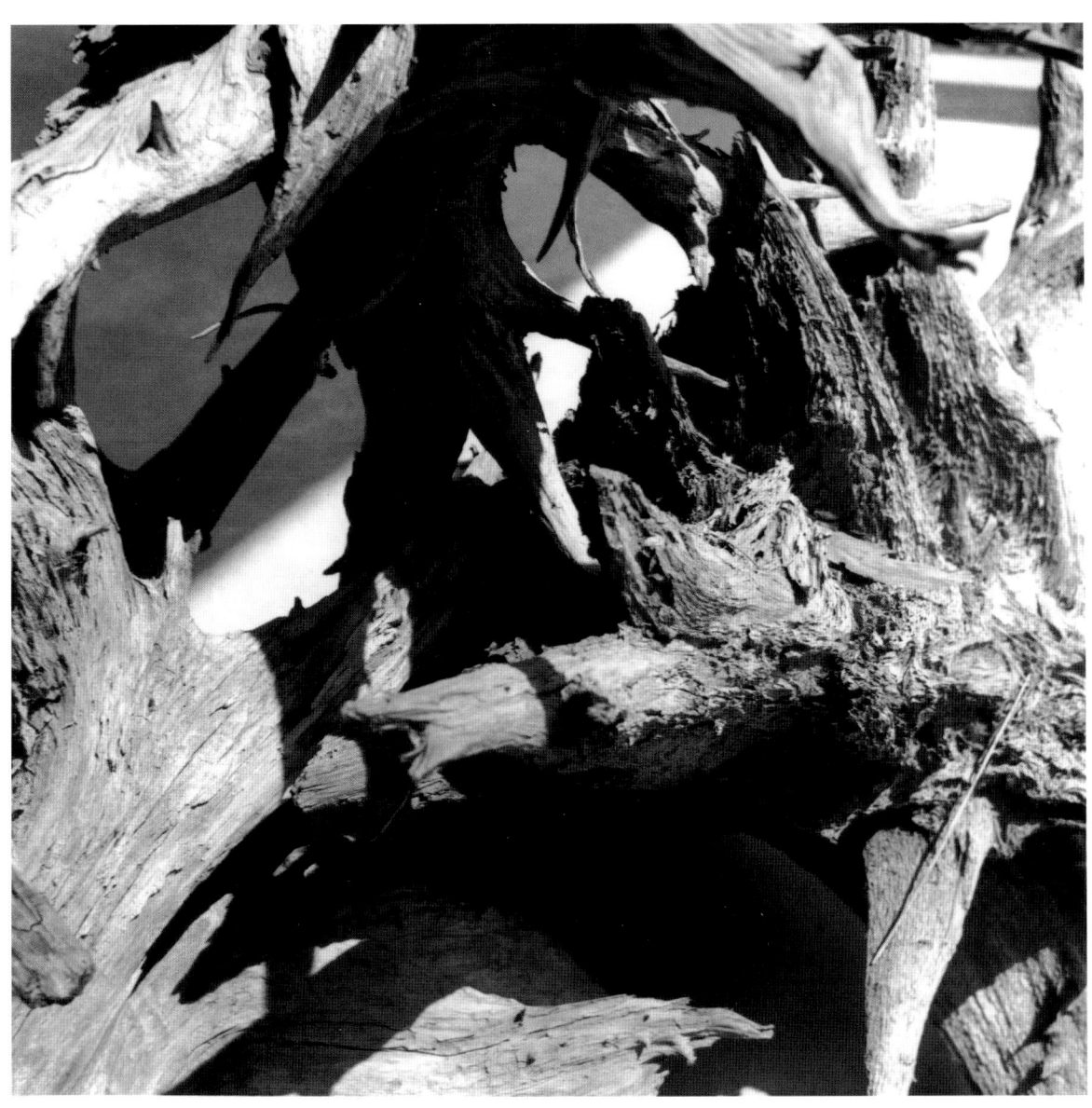

Root

My love is darkness!

Only in the Void

Are all ways one:

Only in the night

Are all the lost

Found.

In my ending is my meaning.[30]

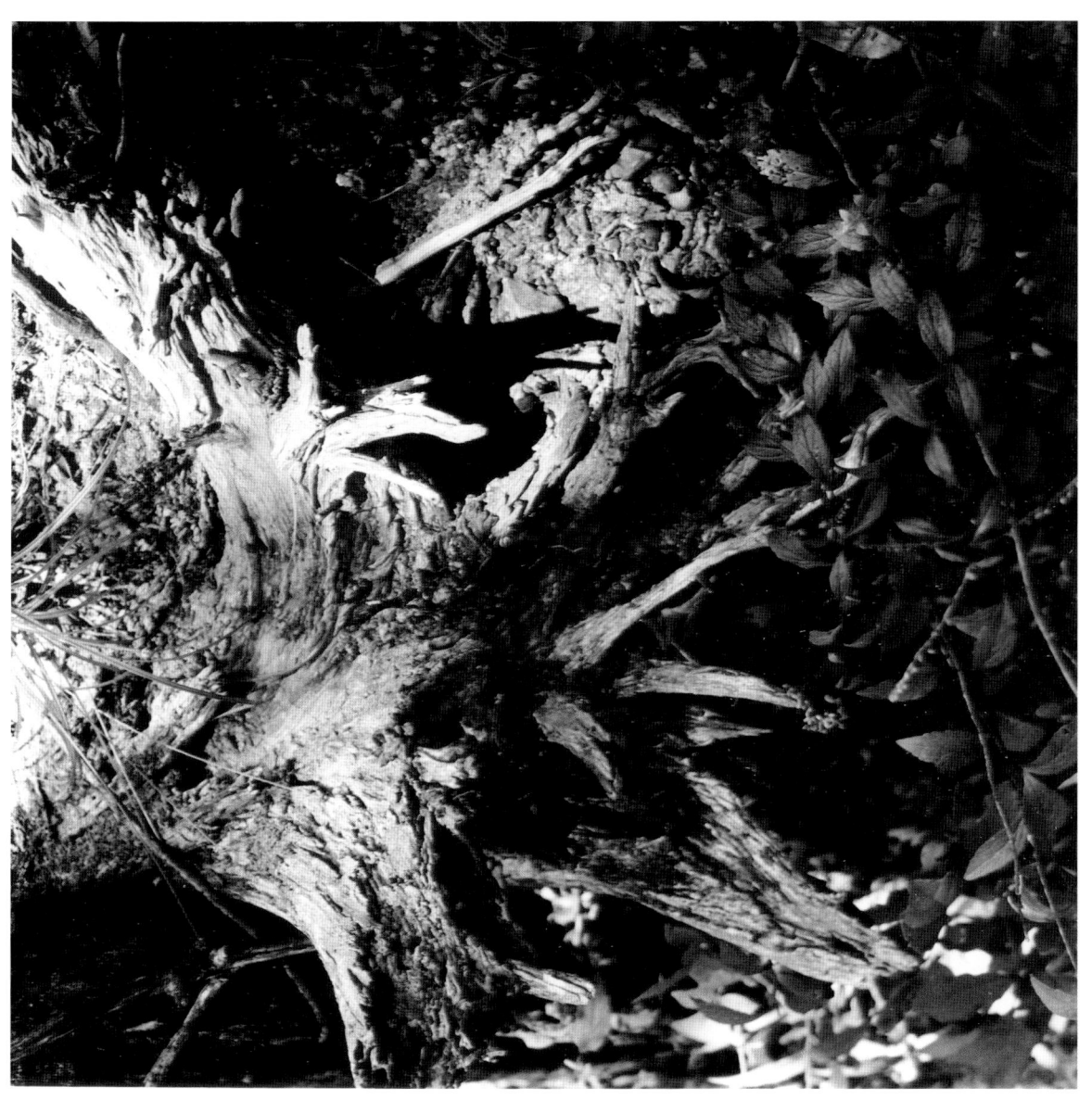

Window in Side of Barn

We are exiles in the far end of solitude,
living as listeners

With hearts attending to the skies
we cannot understand:

Waiting upon the first far drums of
Christ the Conqueror,

Planted like sentinels upon the
world's frontier.[31]

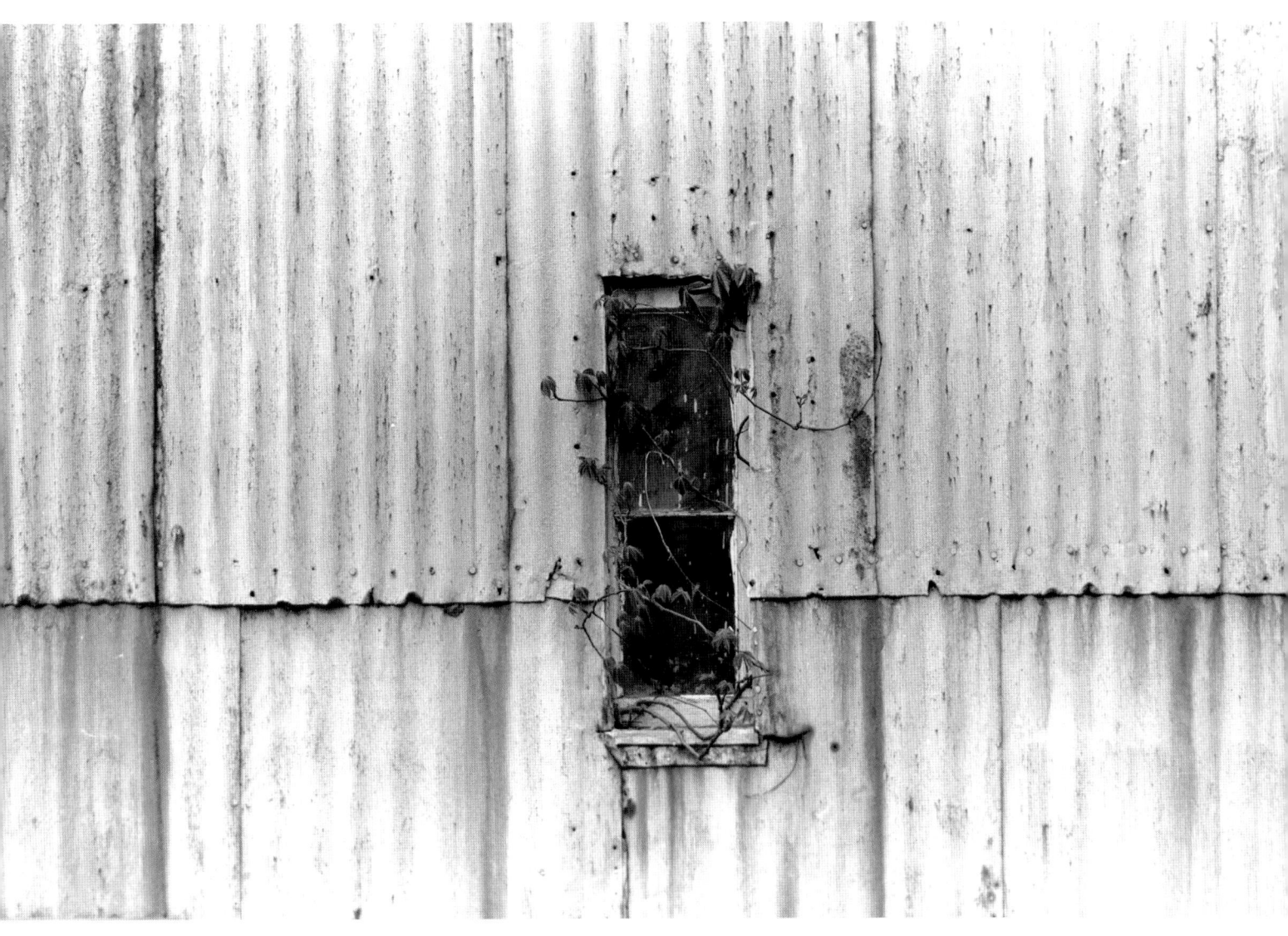

Watering Can at Hermitage

Zen seeks not to *explain* but to *pay attention*, to *become aware*, to *be mindful*.[32]

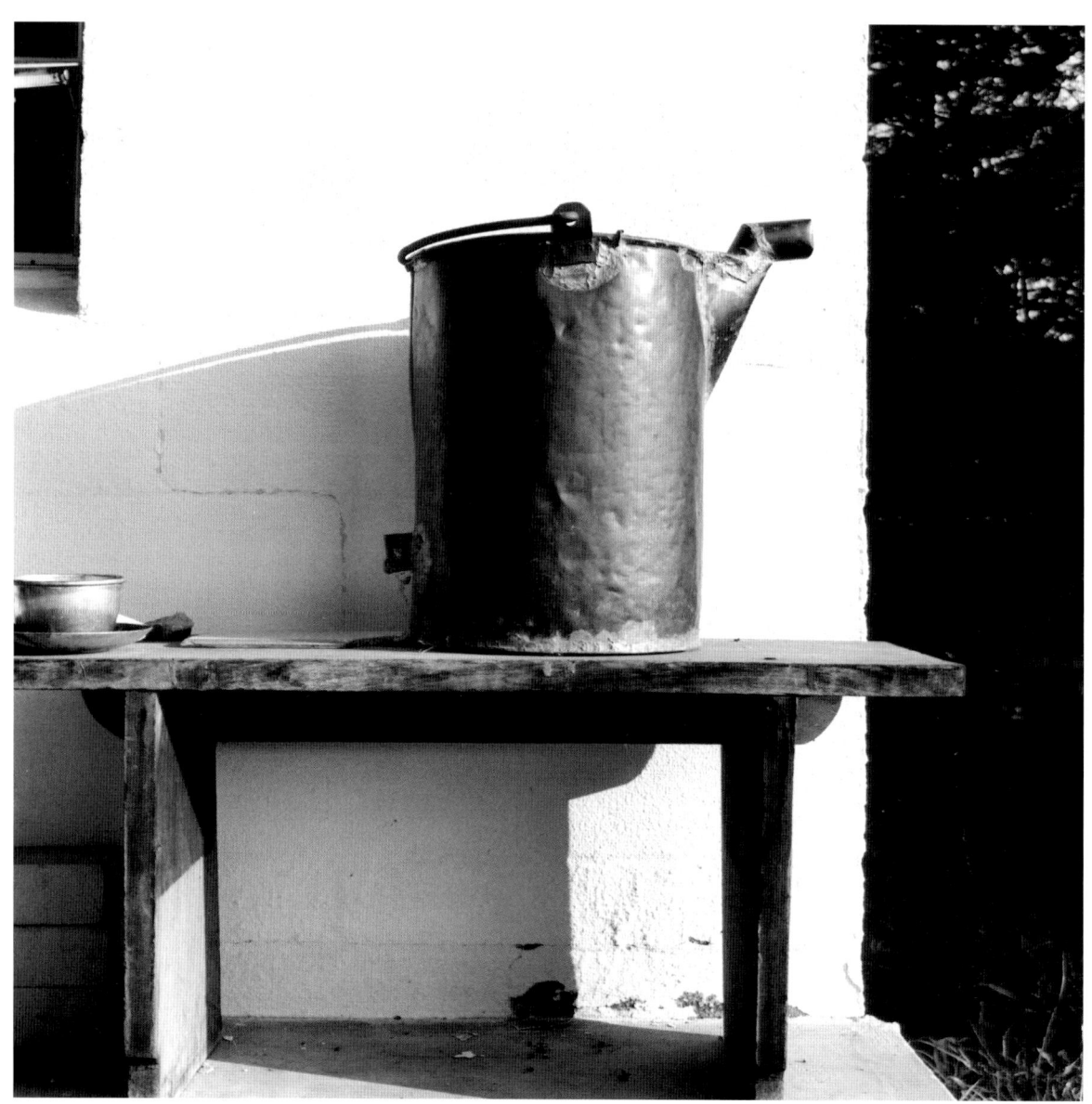

120 ||| *Beholding Paradise*

Ladder and Chair

This is the land where you have given me roots in eternity.[33]

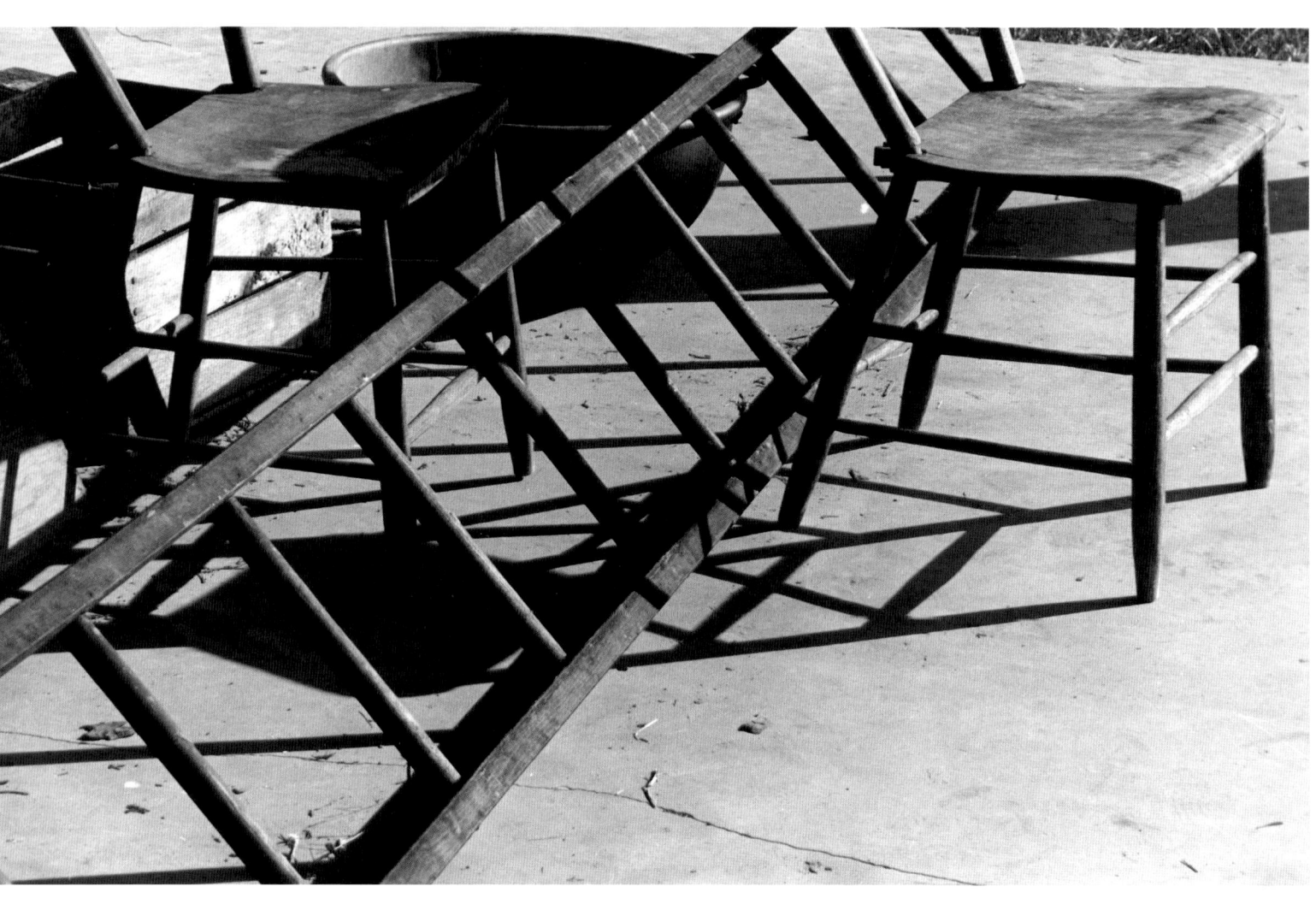

122 ||| *Beholding Paradise*

Wheel Barrow and Work Tools at Hermitage

In a Zen koan someone said that an enlightened man is not one who seeks Buddha or finds Buddha, but simply an ordinary man *who has nothing left to do.*[34]

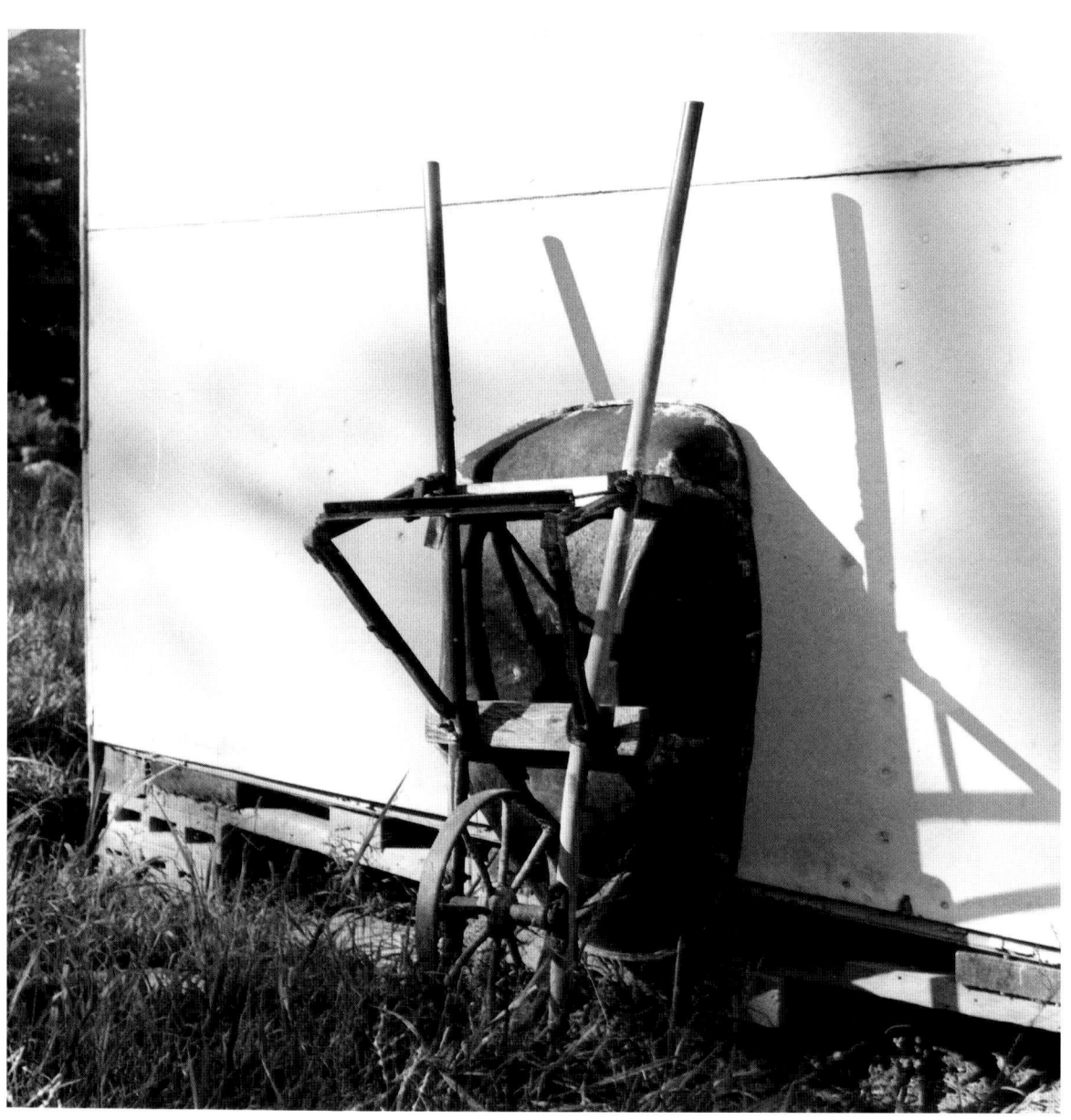

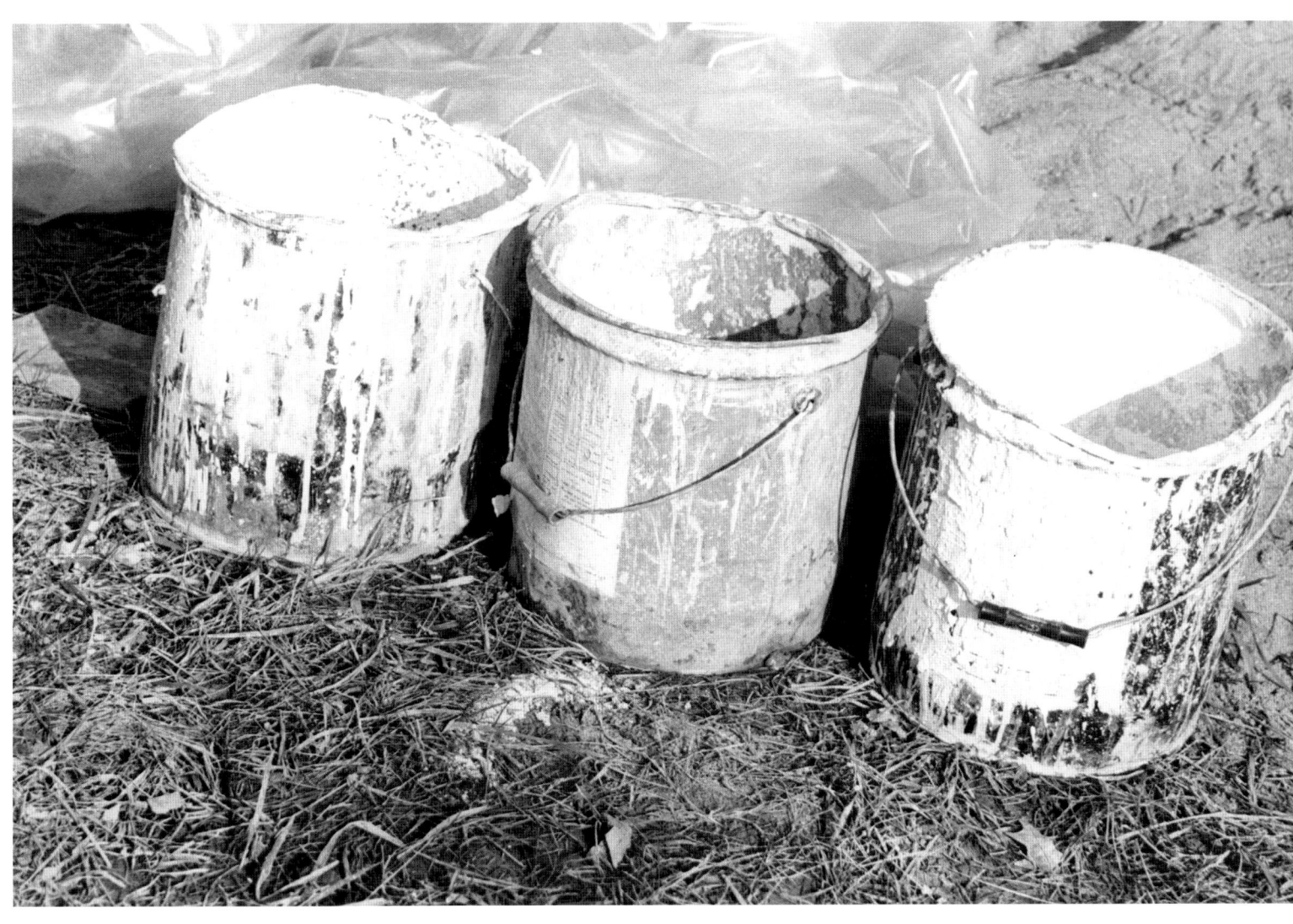

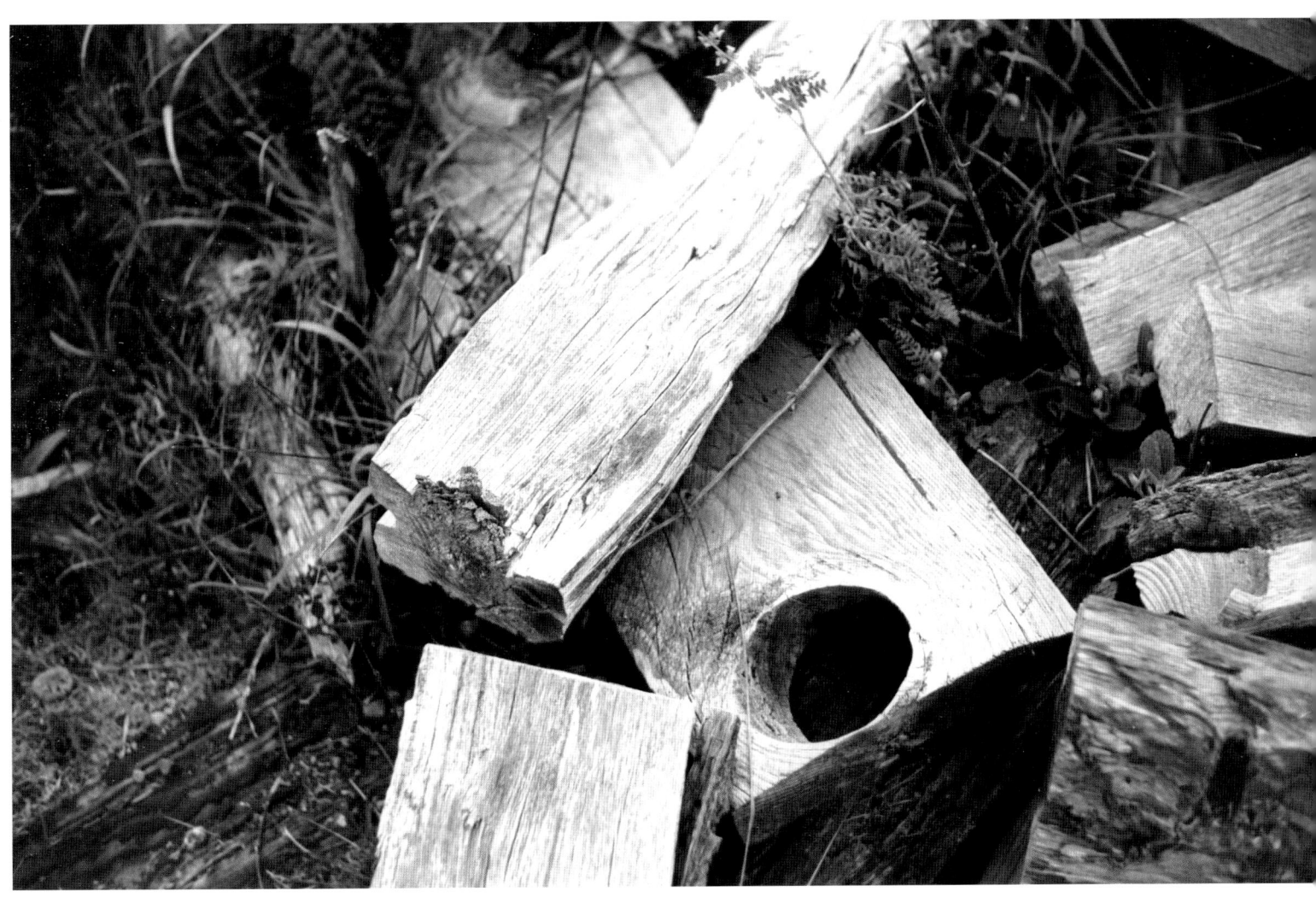

Tracks in Snow

Before the first step is taken,
the goal is reached.

Before the tongue is moved the
speech is finished.

More than brilliant intuition is needed

To find the origin of the right road.[35]

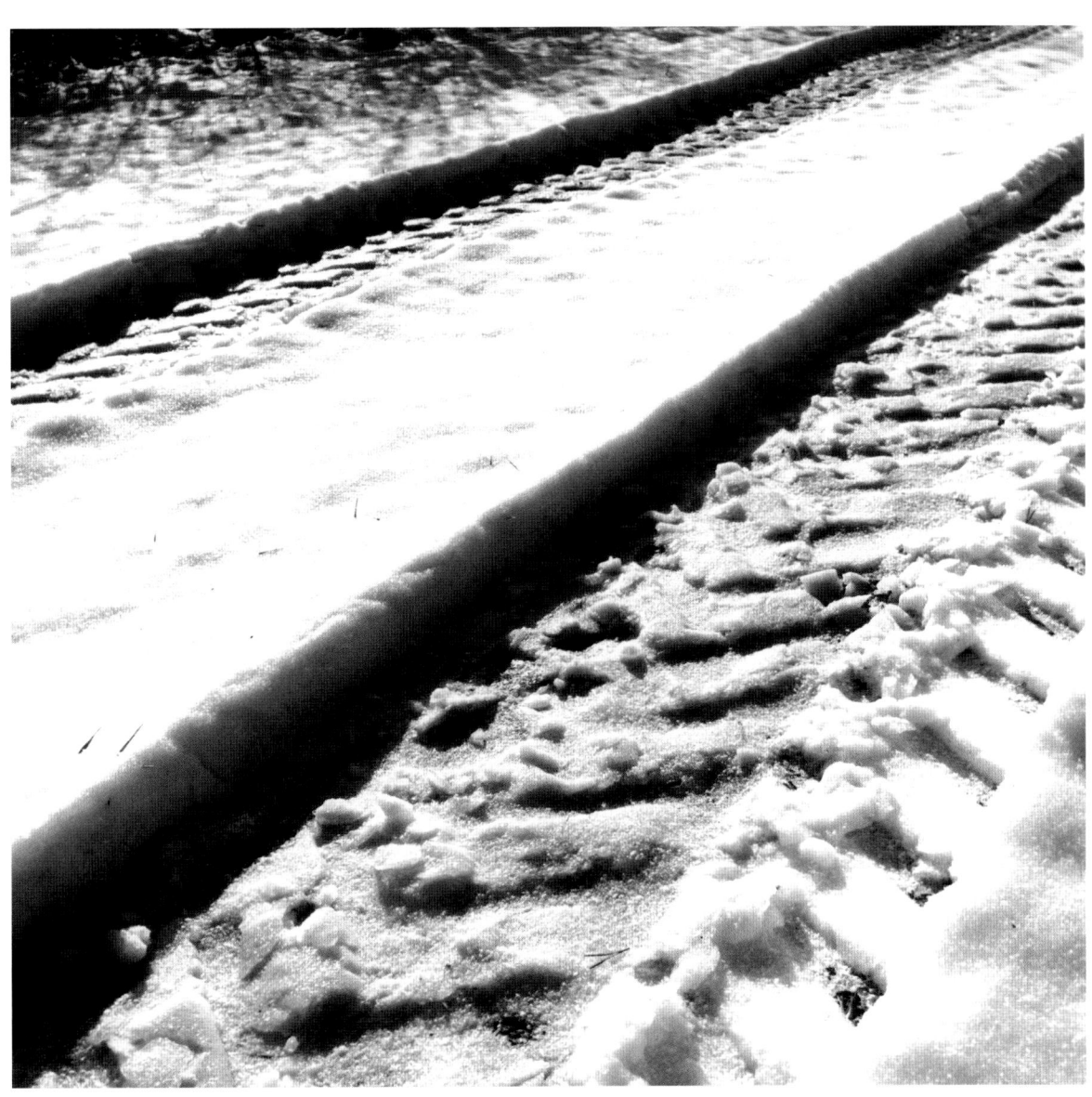

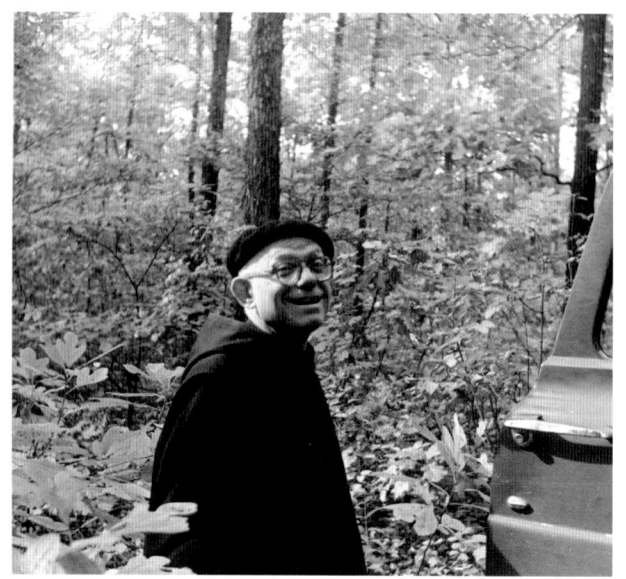

III

SHINING LIKE THE SUN

FRIENDS AND FACES RADIATING THE SPARK IN THE SOUL

In "Firewatch, July 4, 1952," the epilogue to *The Sign of Jonas*, Merton's thoughts are introspective as he patrols the monastery at Gethsemani at the beginning of the nineteen fifties and relate to the events of his own monastic life and spiritual development. In contrast, the fire watch included at the end of the pivotal section of *Conjectures of a Guilty Bystander*, "The Night Spirit and the Dawn Air," penned approximately a decade later, is vastly different. As Merton passes through the novitiate, it "no longer speaks to" him of his "own past" but "more of the present generation of novices." He writes that he found their

> *love and their goodness had transformed the room and filled it with a presence curiously real, comforting, perfect: one might say, with Christ. Indeed, it seemed to me momentarily that He was as truly present here, in a certain way, as upstairs in the Chapel.*[1]

Merton's entry in *Conjectures of a Guilty Bystander* is reworked from an entry in his personal journal for November 27, 1961:

> *On the night watch, hurrying by, I pushed open the door of the novices' scriptorium, and flashed the light over all the empty desks. It was as if the empty room were wholly full of their hearts and their love, as if their goodness had made the place wholly good and rich with love. The loveliness of humanity which God has taken to Himself in love, and the wonder of each individual person among them.*[2]

His reference to the presence of God in the novitiate appears in this passage from his personal journal, but it lacks the later emphasis he would add to the passage as he prepared it for publication in *Conjectures*. So that, with a few more years of hindsight, Merton could refine his perception of God's presence in the novitiate and write, "Christ was as truly present here as upstairs in the Chapel."[3] [It is in the same section of *Conjectures* that Merton records his experience, his well-known epiphany, as mentioned in the introduction.]

Merton's insights are reflected in the smaller number of portraits he took of his visitors, friends, and contacts. Although in the late fifties Merton had complained of the "awful instantaneous snapshot of pose, of falsity, eternalized,"[4] when he came to take portraits himself, there is certainly no suggestion in his subjects of "pose, of falsity, eternalized," quite the opposite. The shining visages Merton experienced in downtown Louisville he also captured in many of his portraits. Though the portraits do not appear posed, their settings are frequently complimentary to the subjects and the subjects' nature, perhaps what Merton would call their "true self." His subjects' innocence and, not infrequently, their joy shine through.

The "true self" has often been compared to a shy wild deer. Only in the right conditions will either the deer or the true self allow itself to be seen. Merton's journal *A Vow of Conversation* contains numerous references to the deer that inhabited the woods at Gethsemani and who were frequently Merton's closest neighbors during his final years as a hermit at Gethsemani. In an entry in *A Vow of Conversation* where Merton reflects on the "'deerness' that sums up everything and is sacred and marvelous"—a reference reflecting Merton's intuition of Zen and his reading of Rainer Maria Rilke—Merton describes this "deerness," saying,

> *The deer reveals to me something essential, not only in itself, but also in myself. Something beyond the trivialities of my everyday being, my individual existence. Something profound. The face of that which is both in the deer and in myself.*[5]

Rilke's poetic view of reality, "inseeing," is clearly influencing Merton here. In a conference on Rilke, Merton describes the way Rilke gets into the very center of the thing he is describing. Taking a dog as an example, this inseeing involves, Merton explains, getting into

> *the dog's very centre, the point from where it begins to be a dog, the place in which, in it, where God, as it were, would have sat down for a moment when the dog was finished in order to watch it...and to know that it was good.*[6]

In writing of the deer in *A Vow of Conversation*, Merton is inseeing in the same way as Rilke, an inseeing that is "an inner event in the person who sees it, and it takes place in this encounter with something else, not just a subjective thing." Merton goes on to add that in this encounter with reality, "our own existence" is revealed to us, along with "the meaning of our own life."[7]

The same deep encounter Merton writes of in Rilke's poetry, or his encounters with the "shy wild deer" at the monastery, or his experience of the sacramental nature of other people, experiencing them as Christ and seeing them "shining like sun," can be seen too in Merton's portraits of his friends and visitors, as well as in the more casual encounters that took place in his final weeks in Asia.

Jonathan Greene,
Gethsemani Woods

Robert Lax, Monk's Pond, Gethsemani

Shining Like the Sun ||| 137

Jacques Maritain, Gethsemani Woods

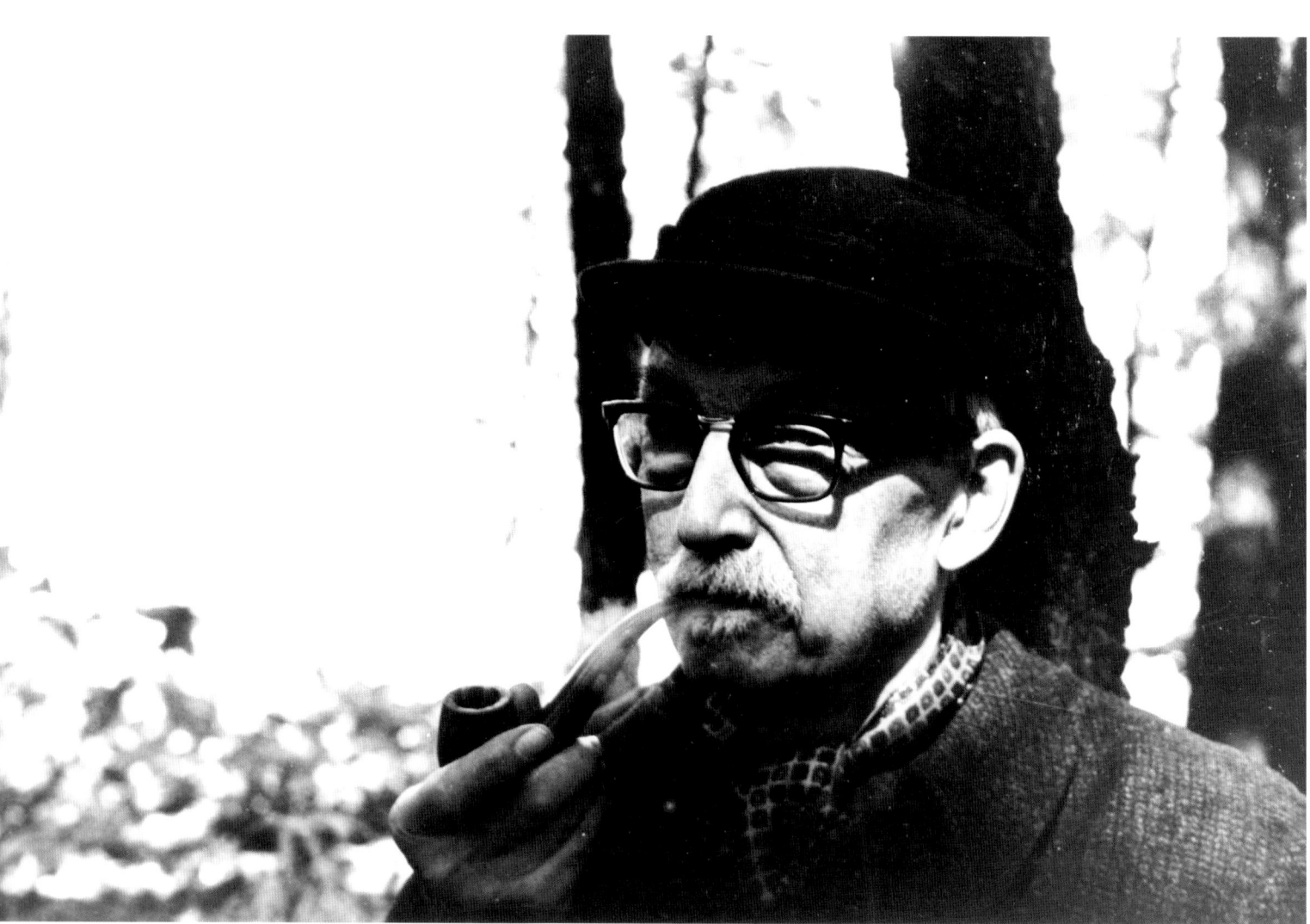

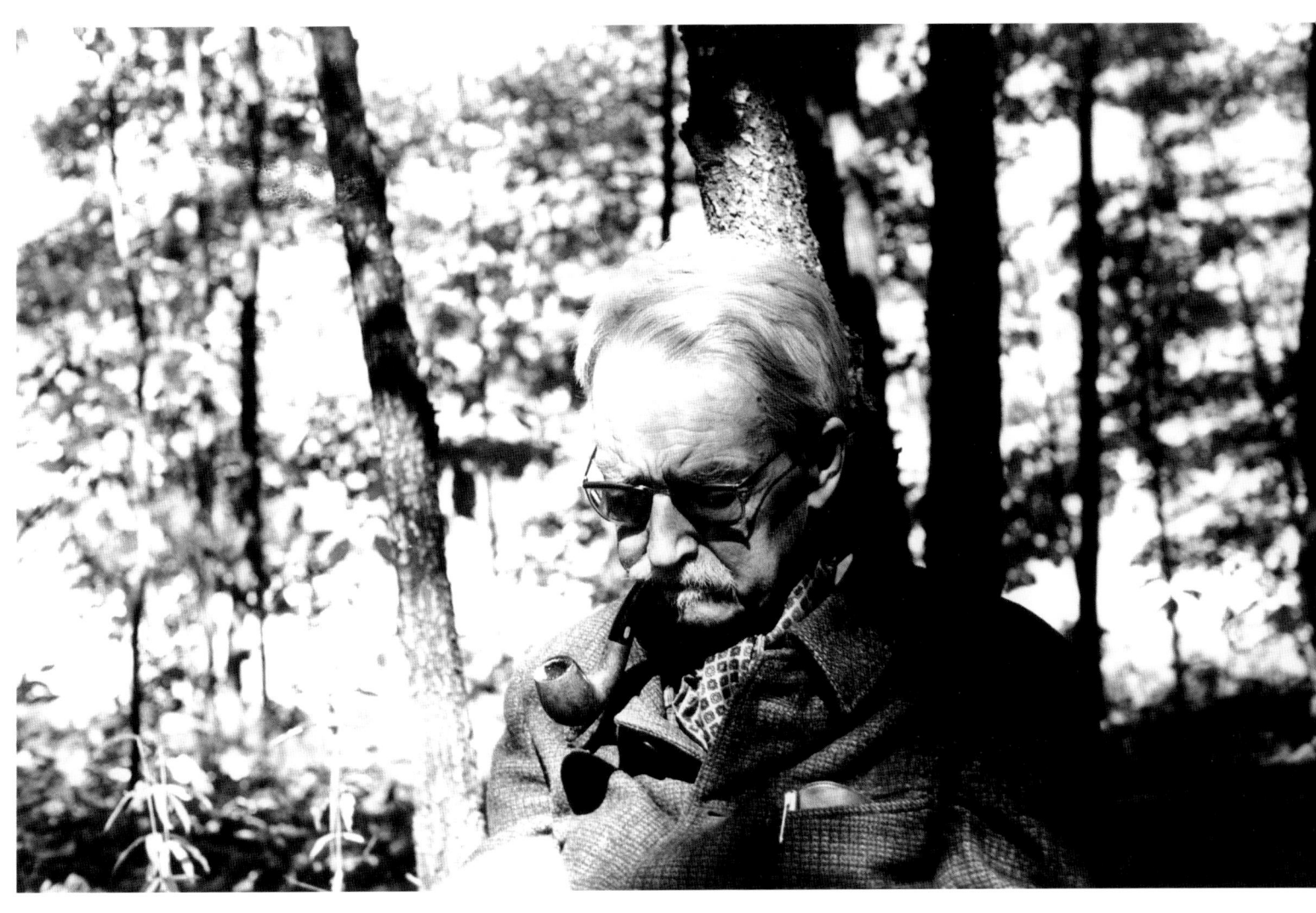

Jean Leclercq, OSB, Gethsemani Woods

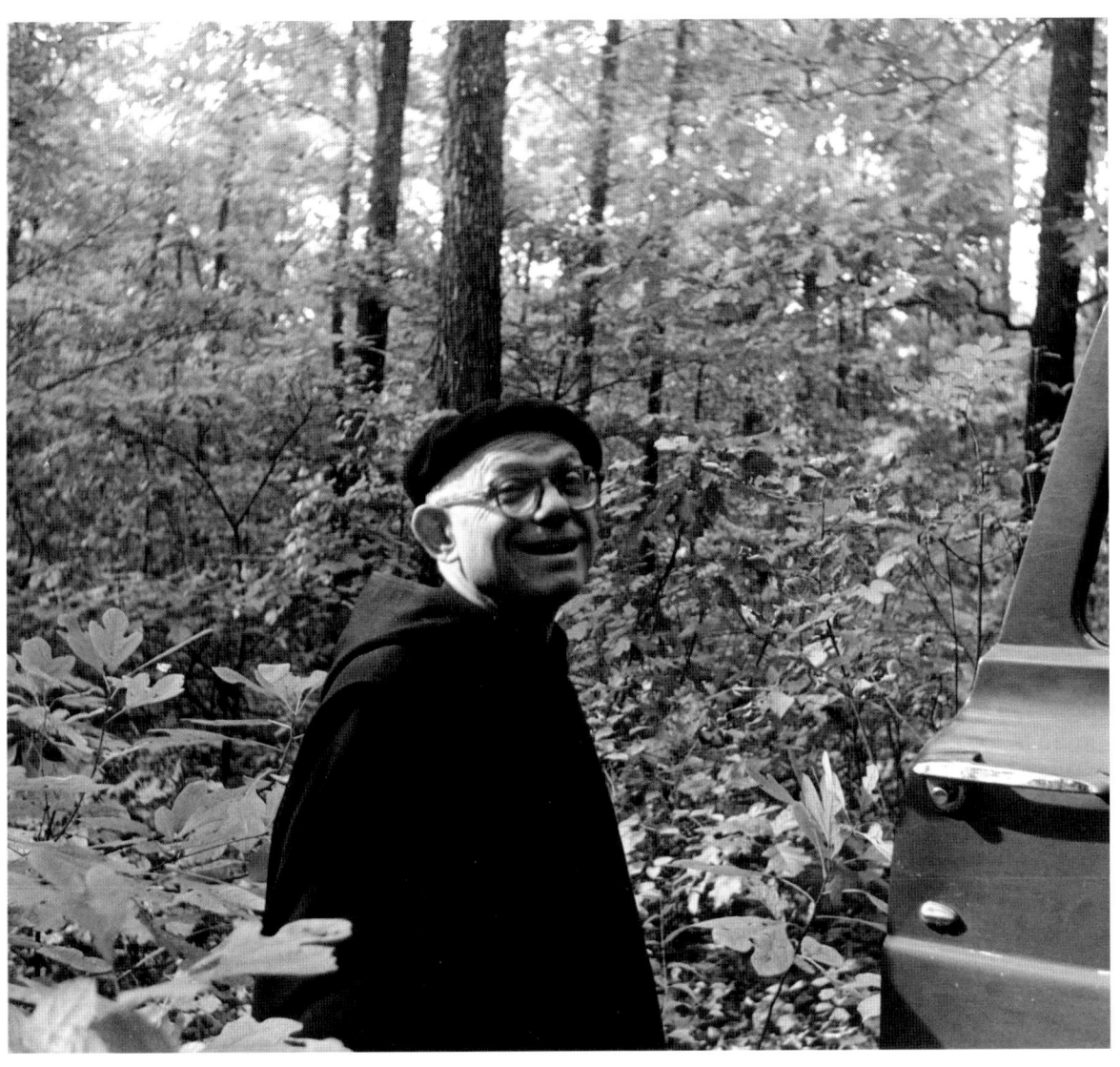

Madeleine Meatyard, Hermitage, Gethsemani

Patrick Hart, OCSO
and Phil Stark, SJ

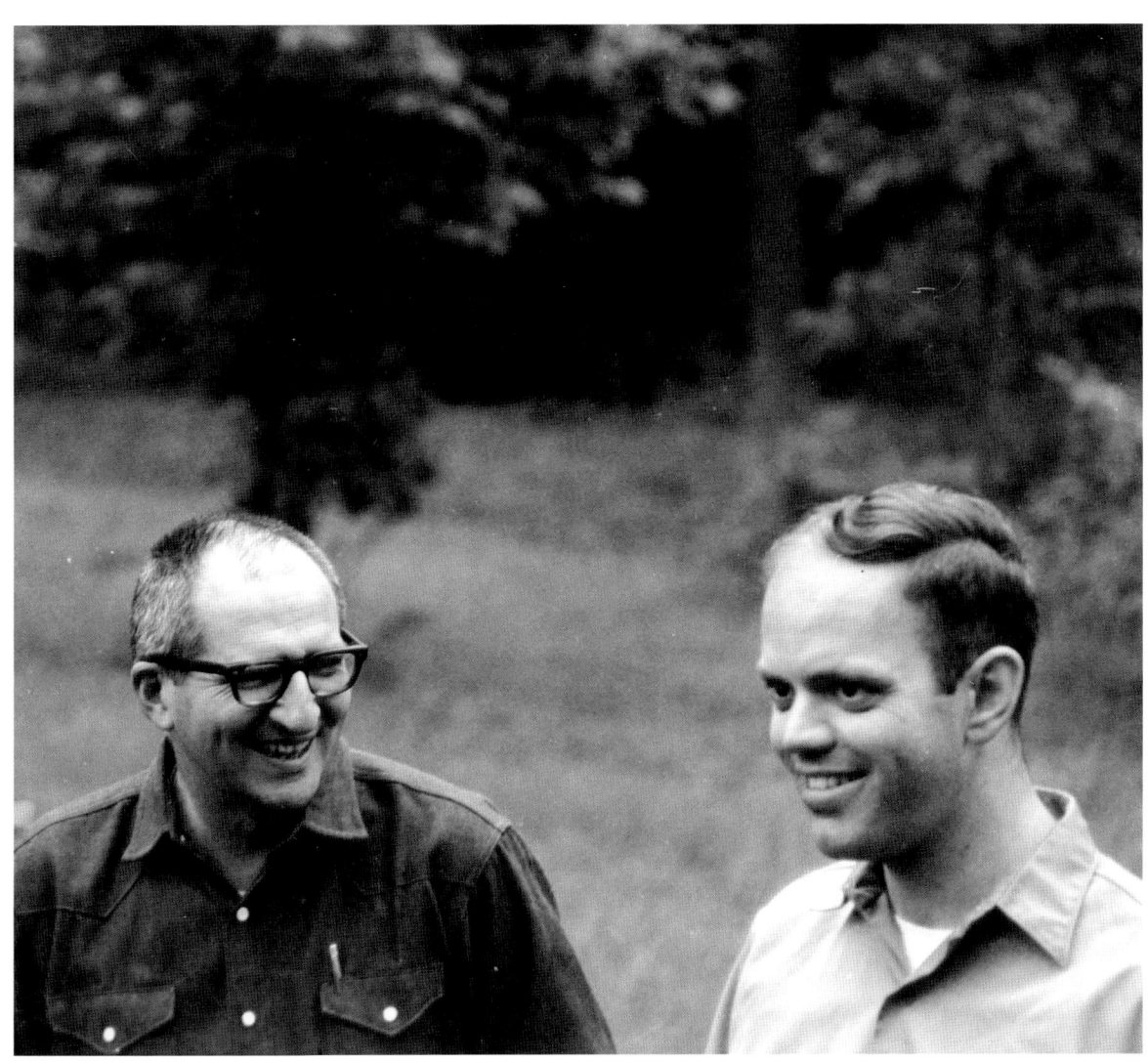

Maurice Flood, OCSO

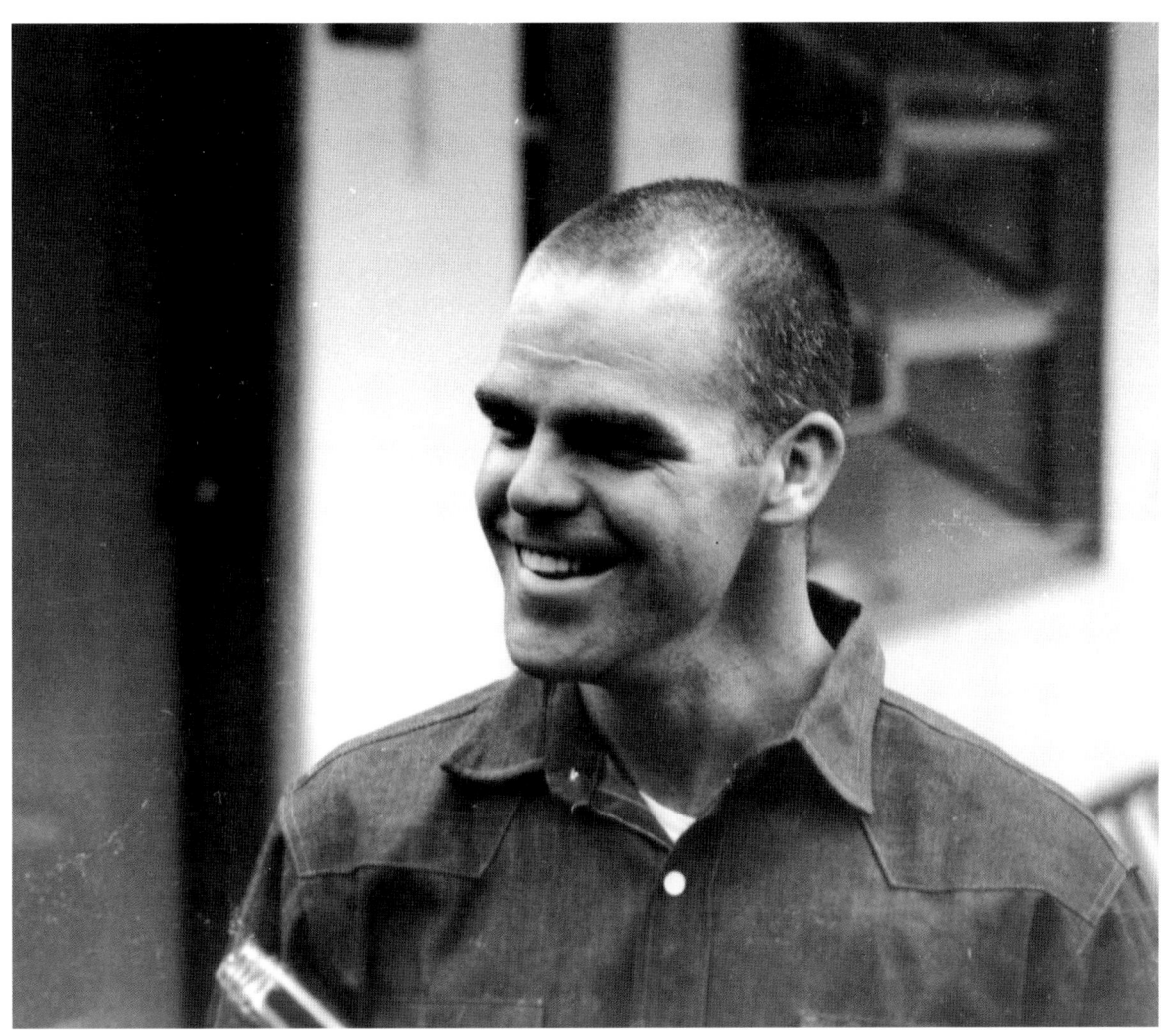

Faces from Asia

How does one take pictures of these streets with the faces, the eyes, of such people.... Yet the people are beautiful.[1]

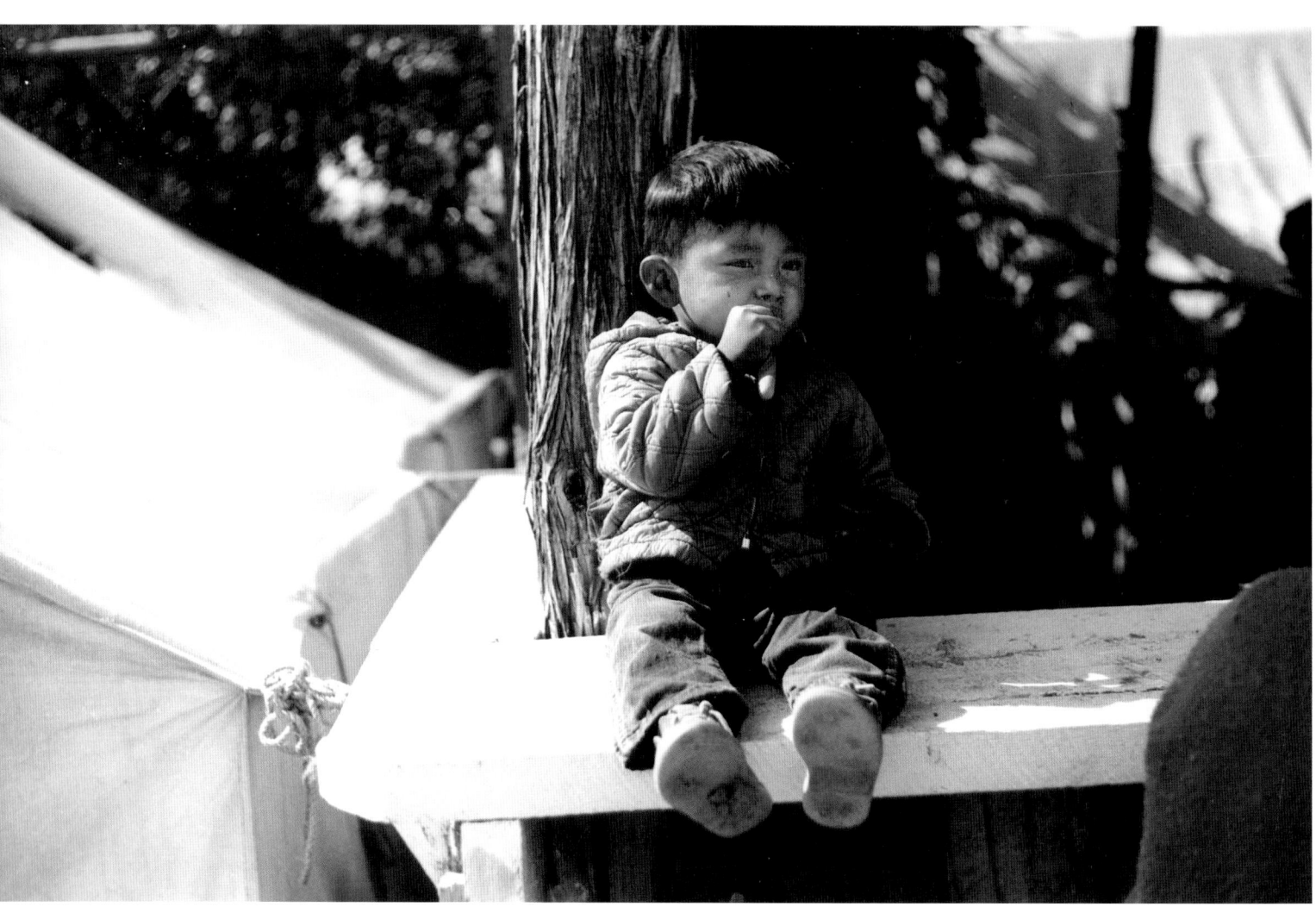

148 ||| *Beholding Paradise*

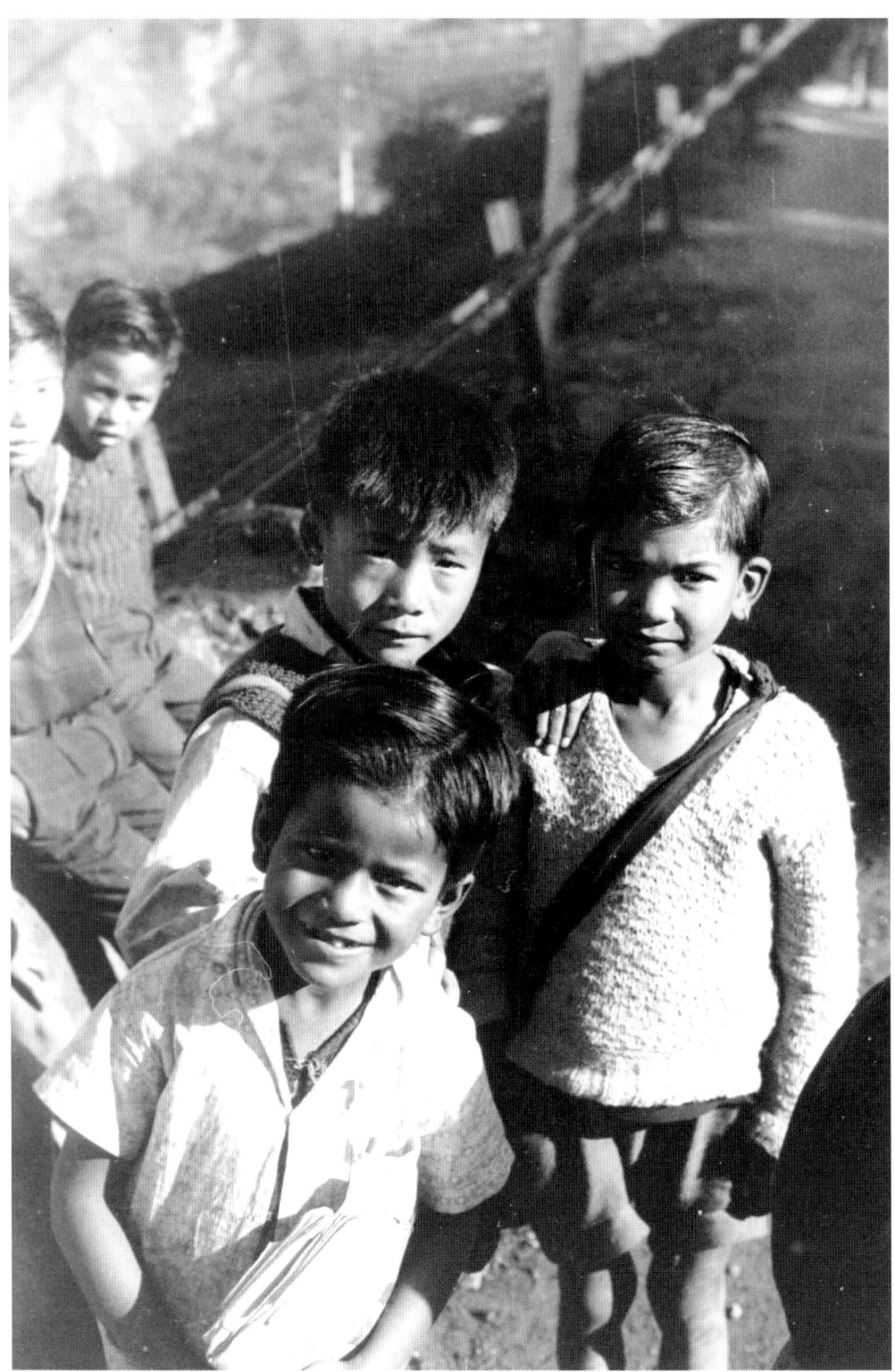

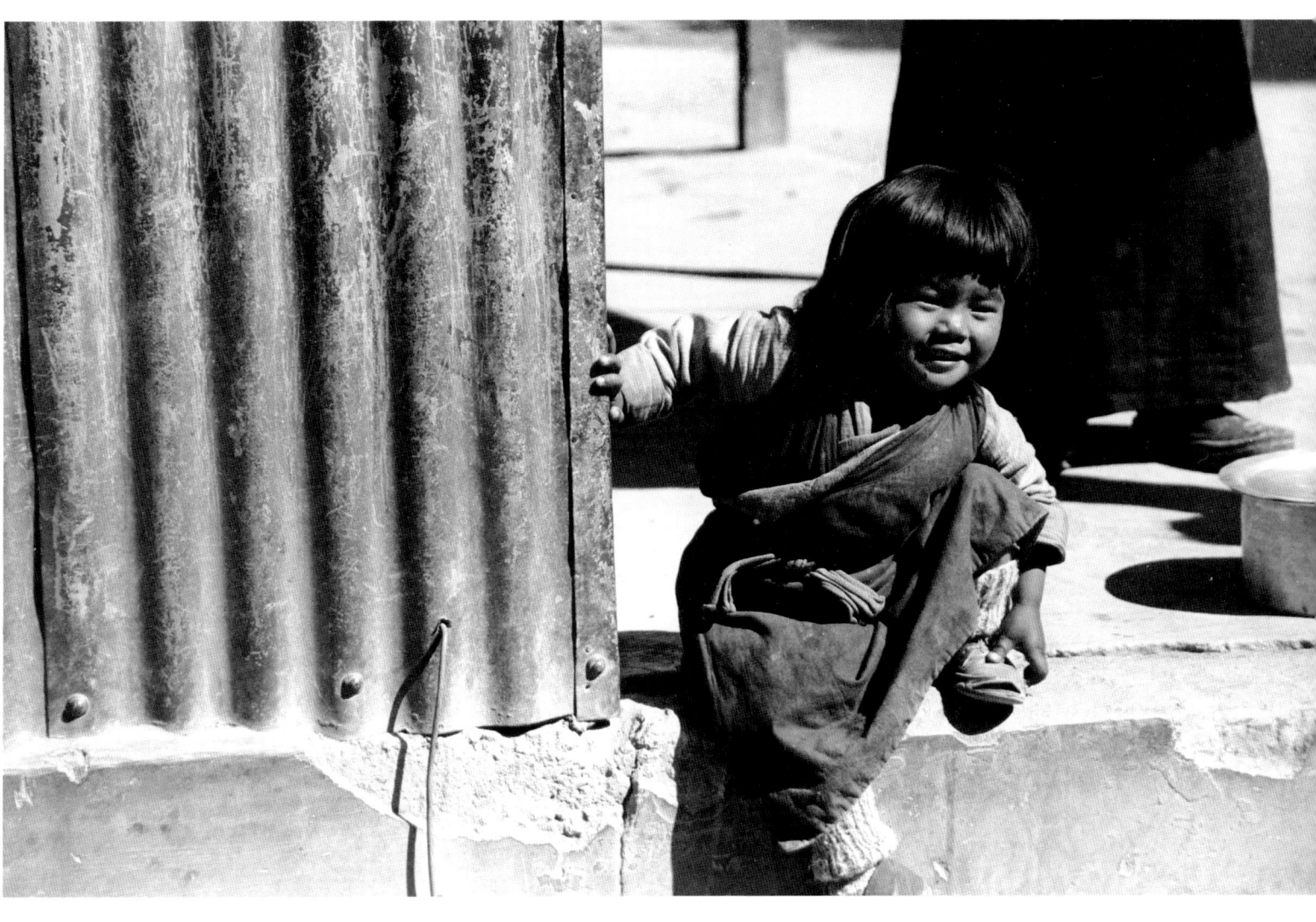

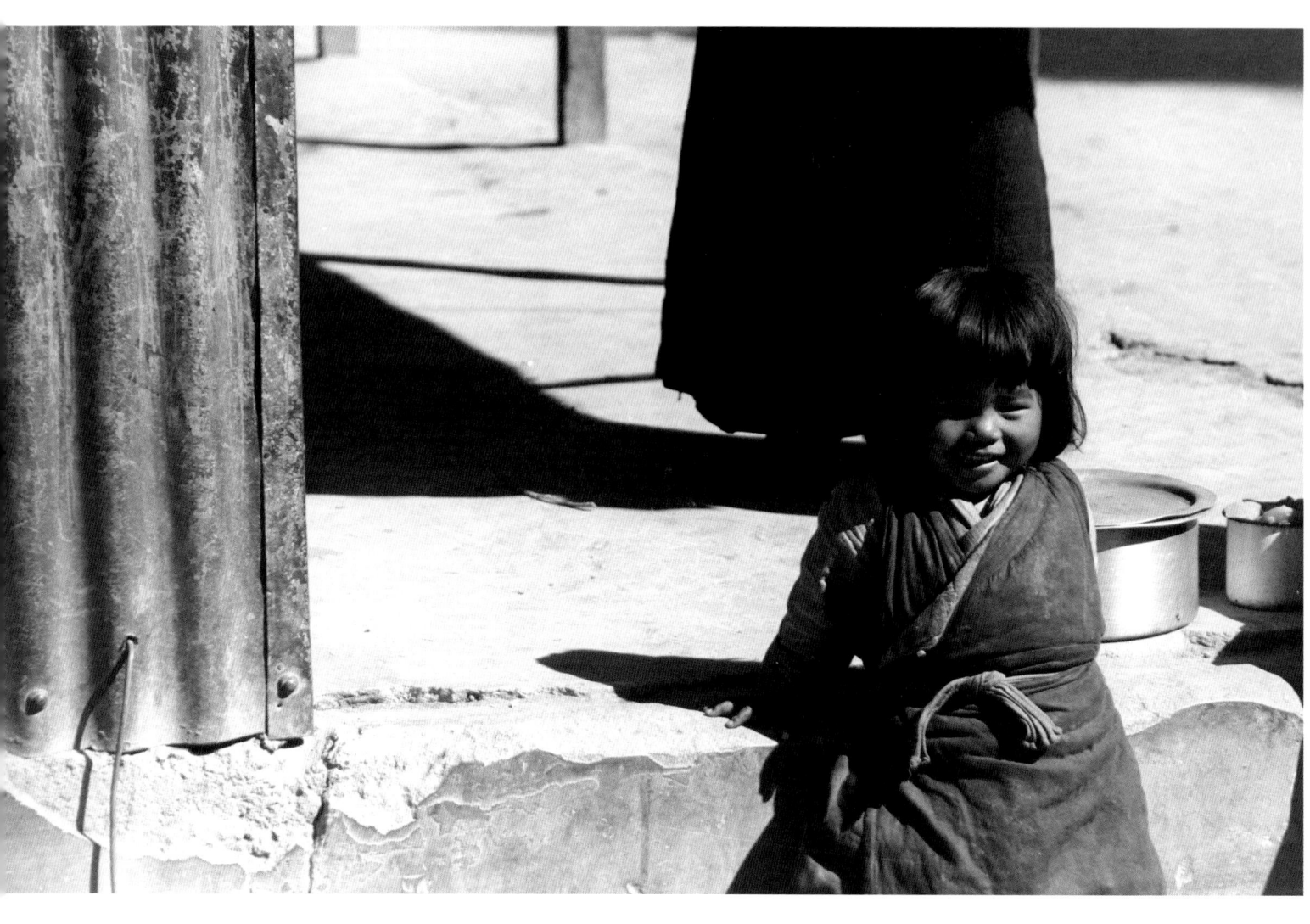

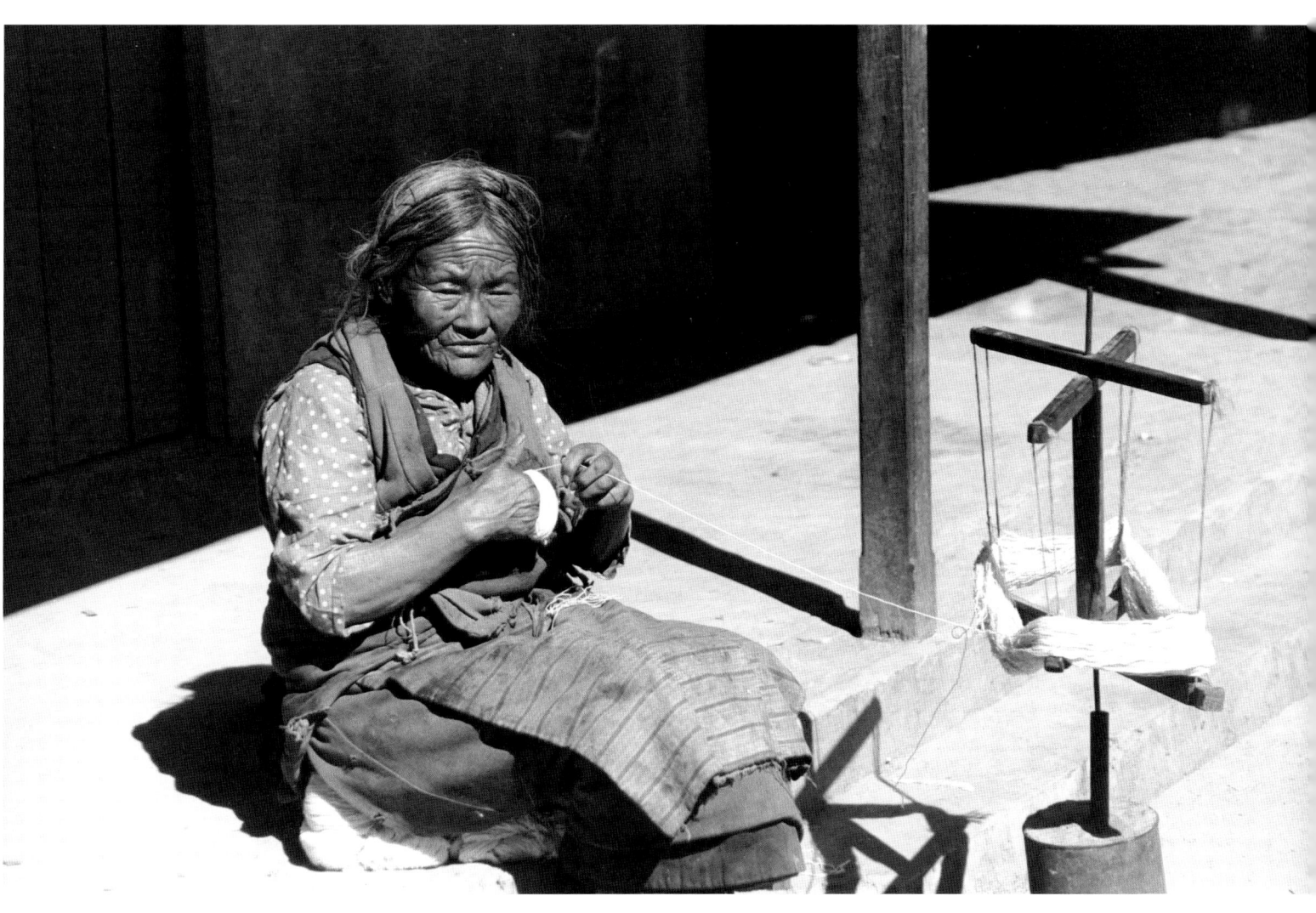

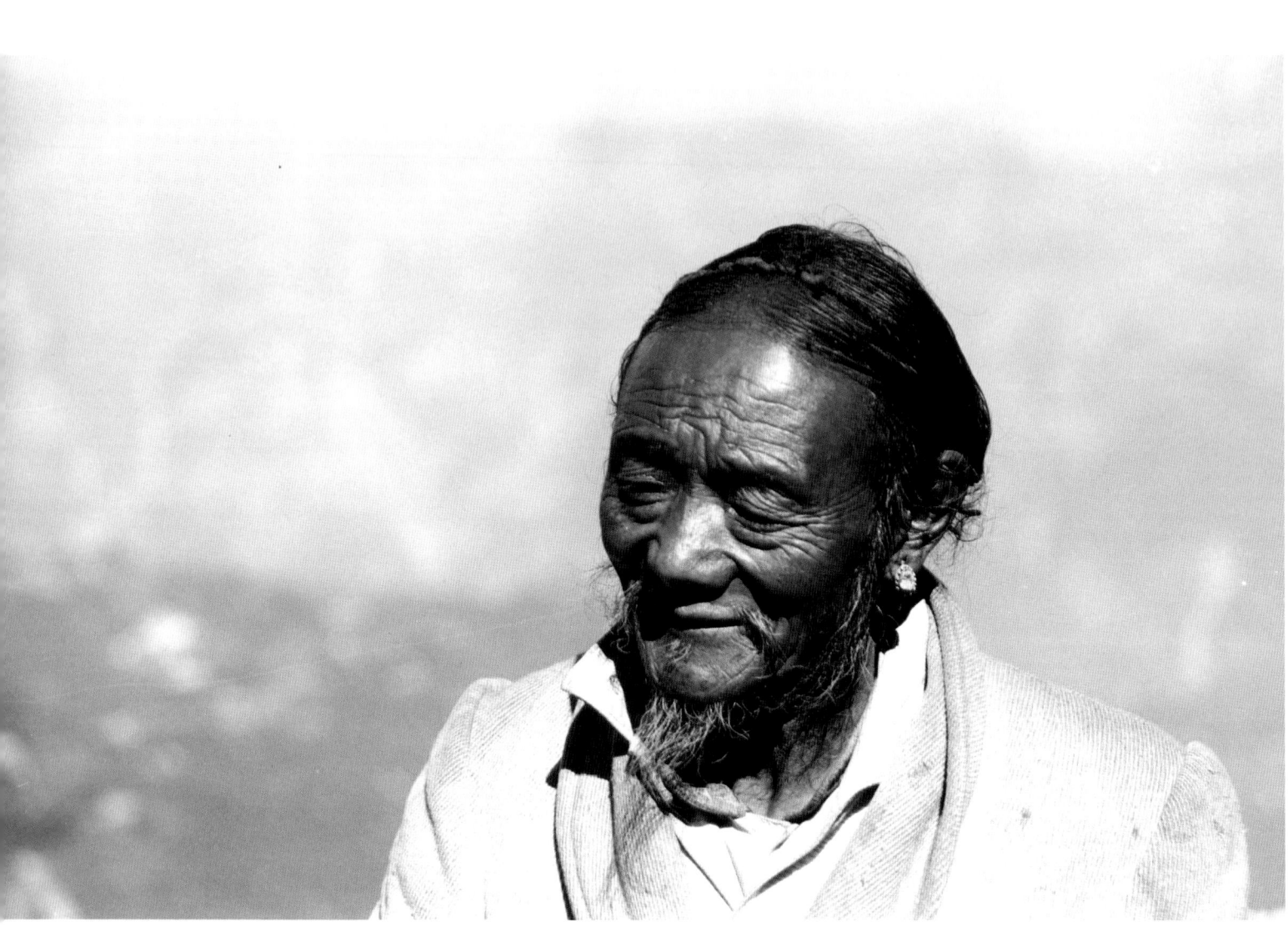

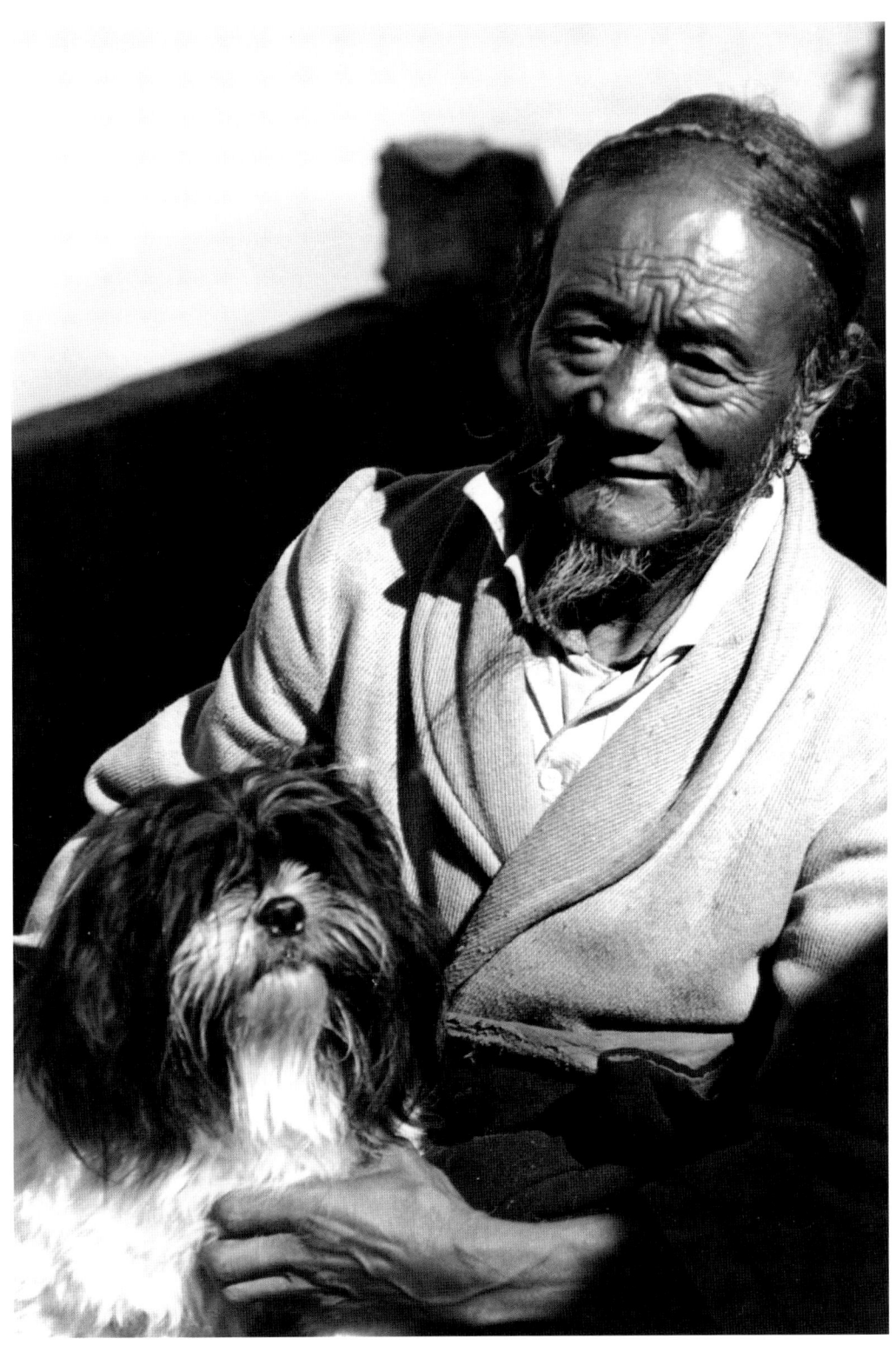

Khamtul Rimpoche

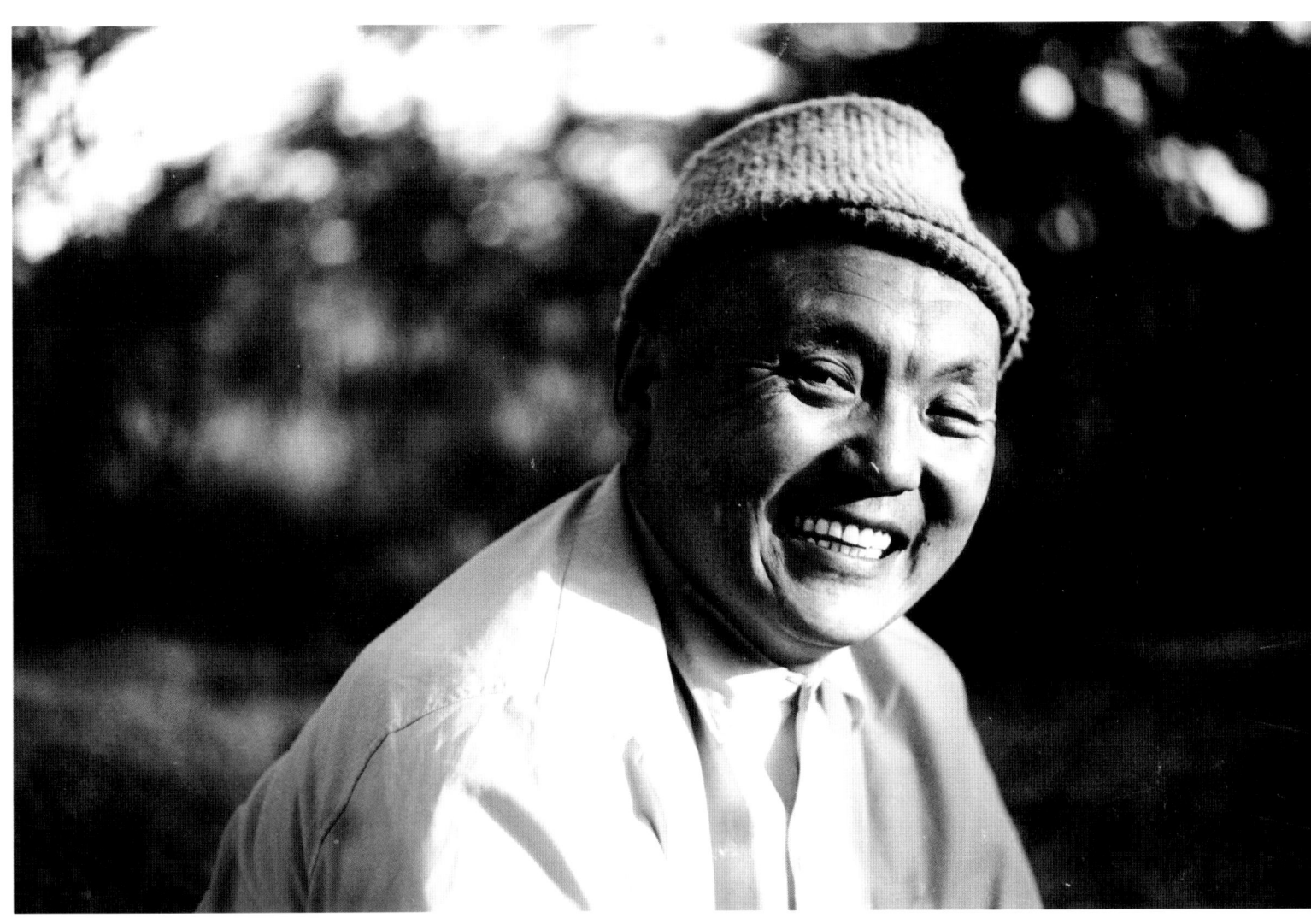

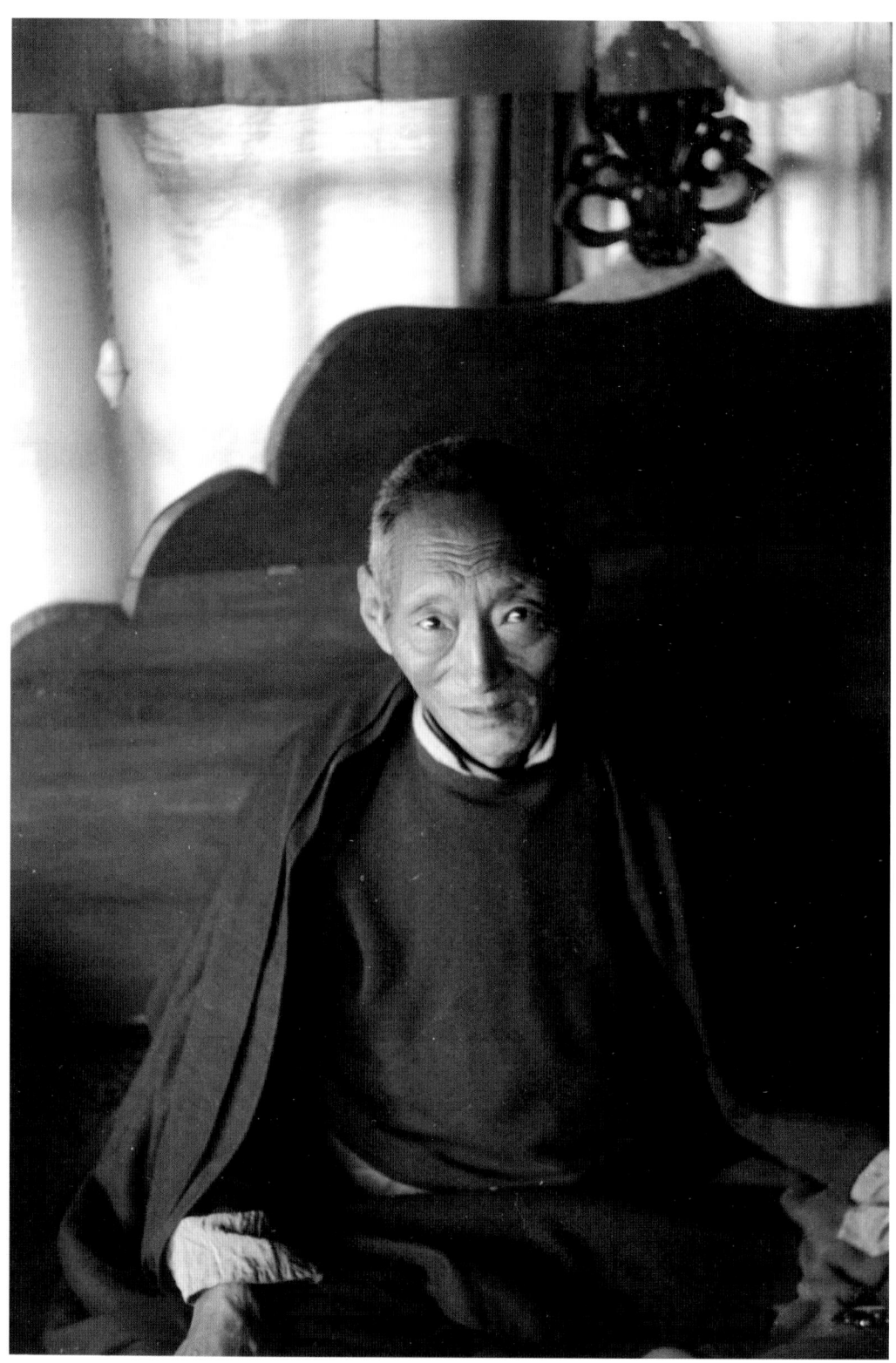

Chatral Rimpoche

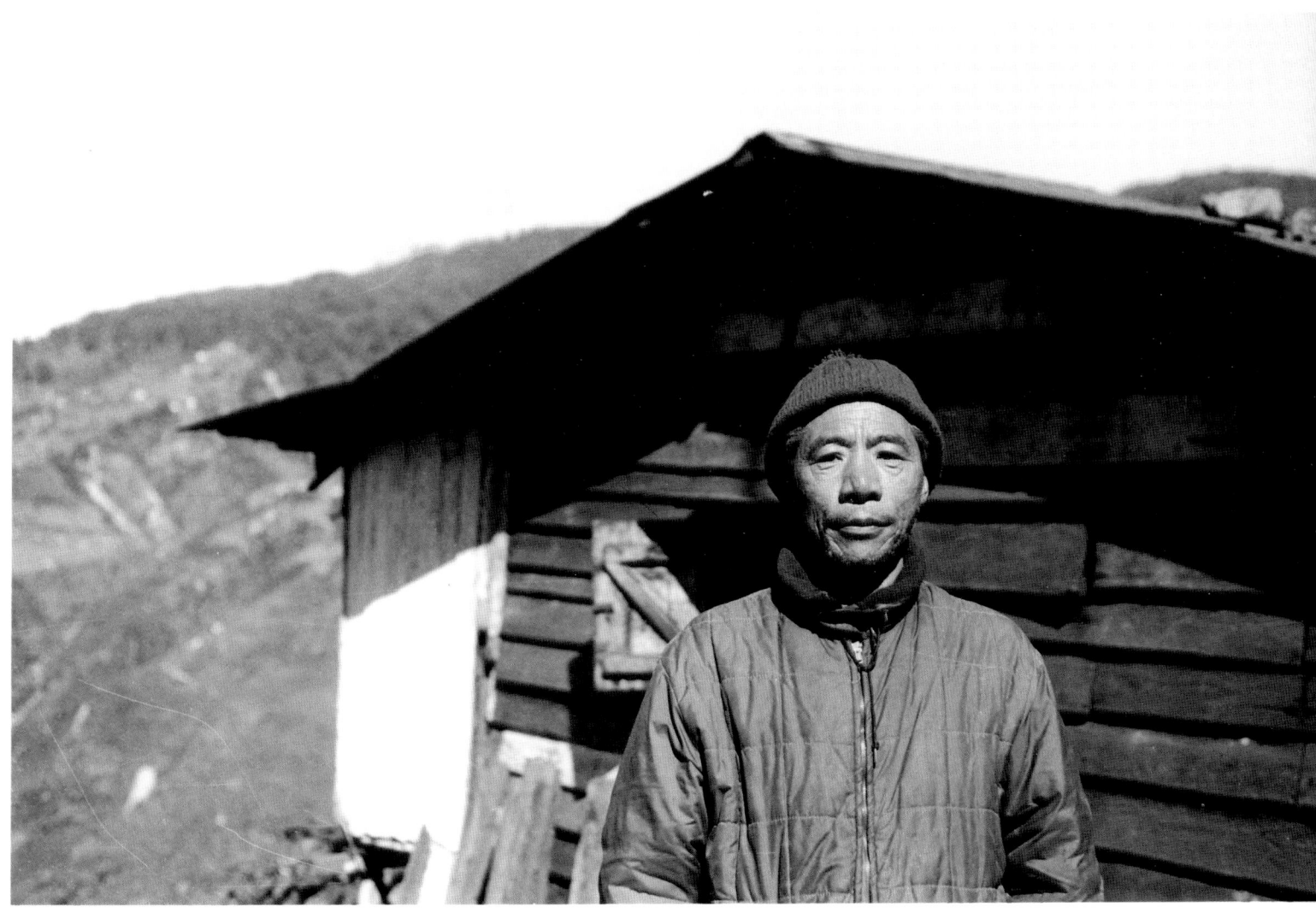

Ratod Rimpoche

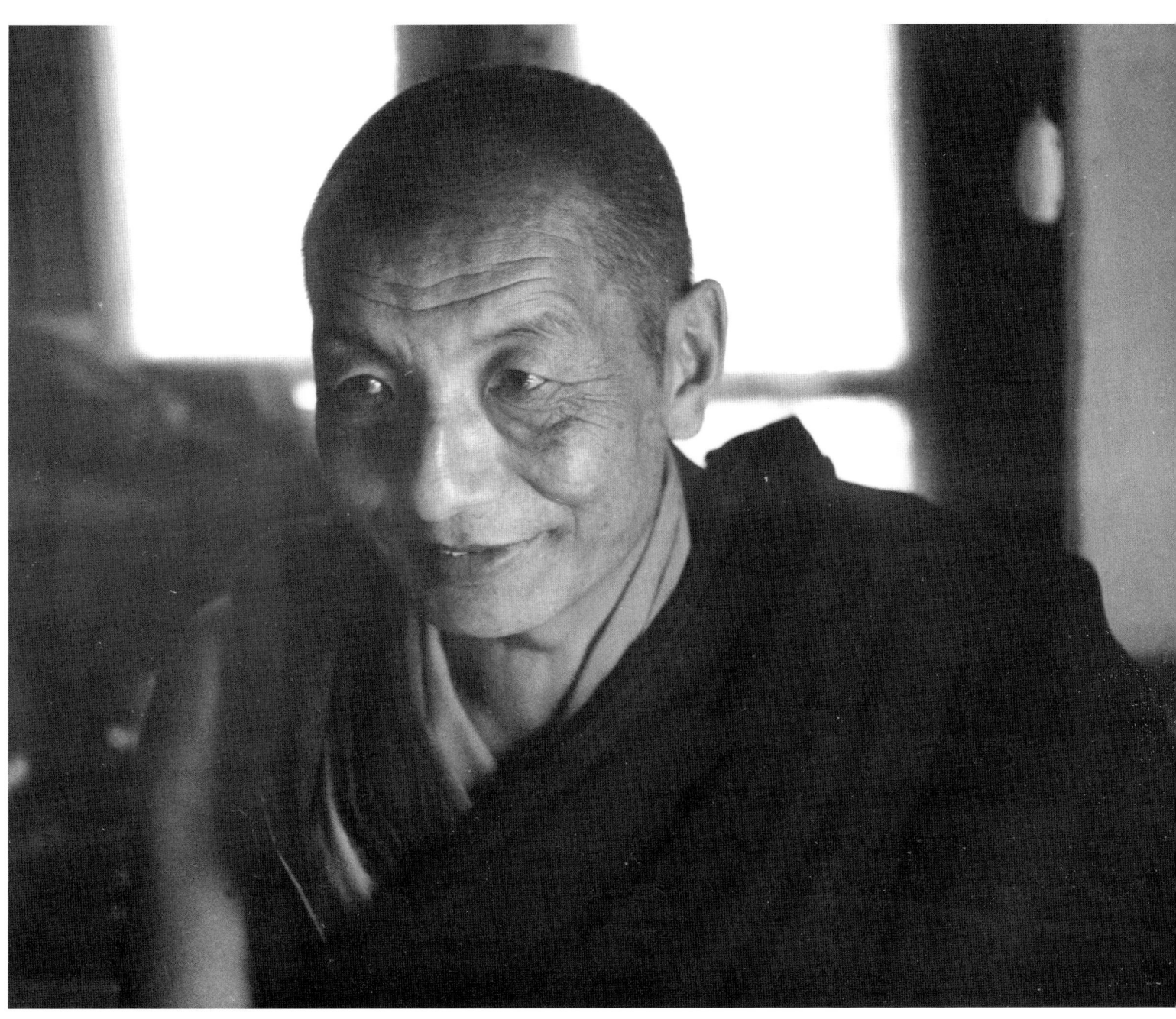

His Holiness
The 14th Dalai Lama

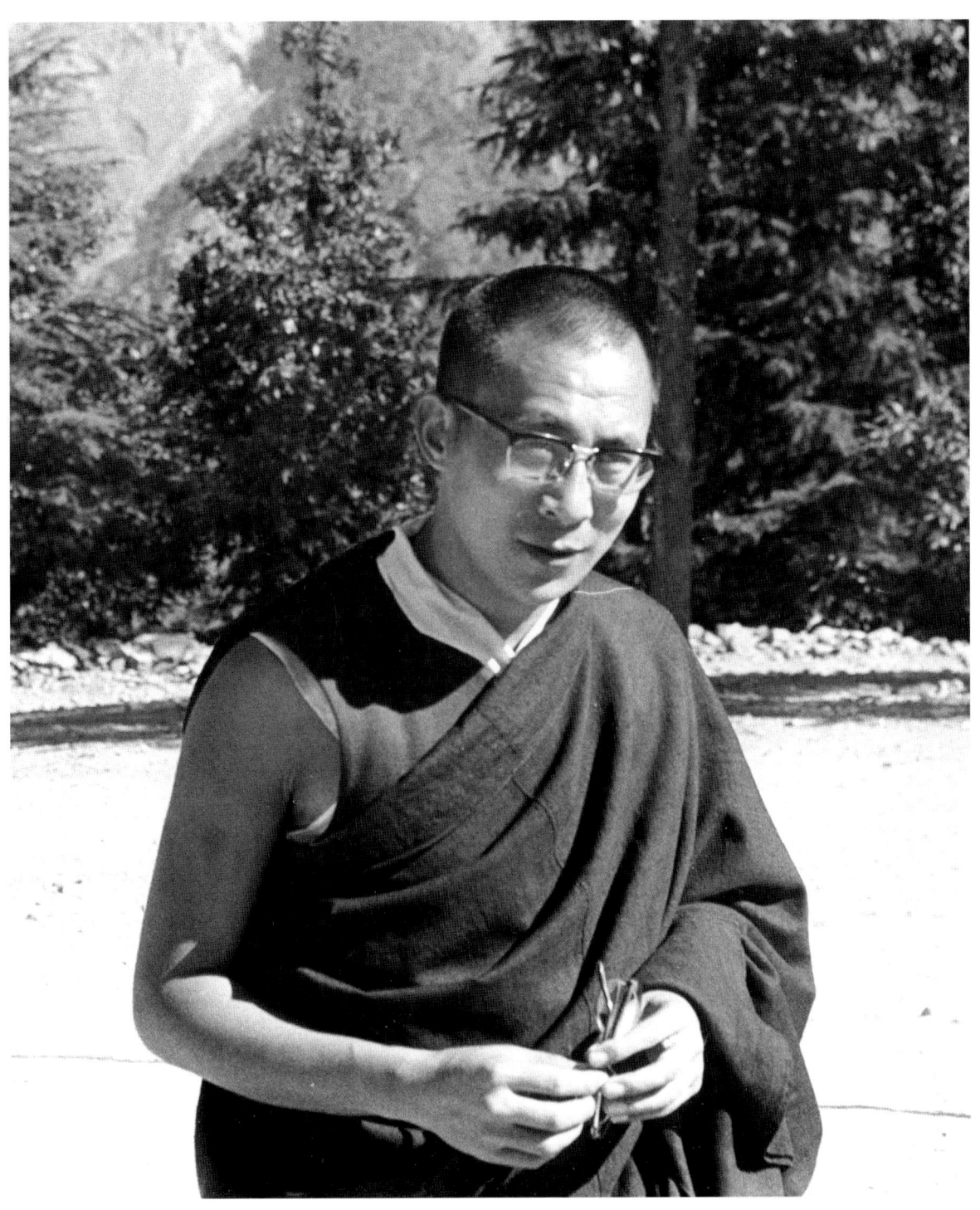

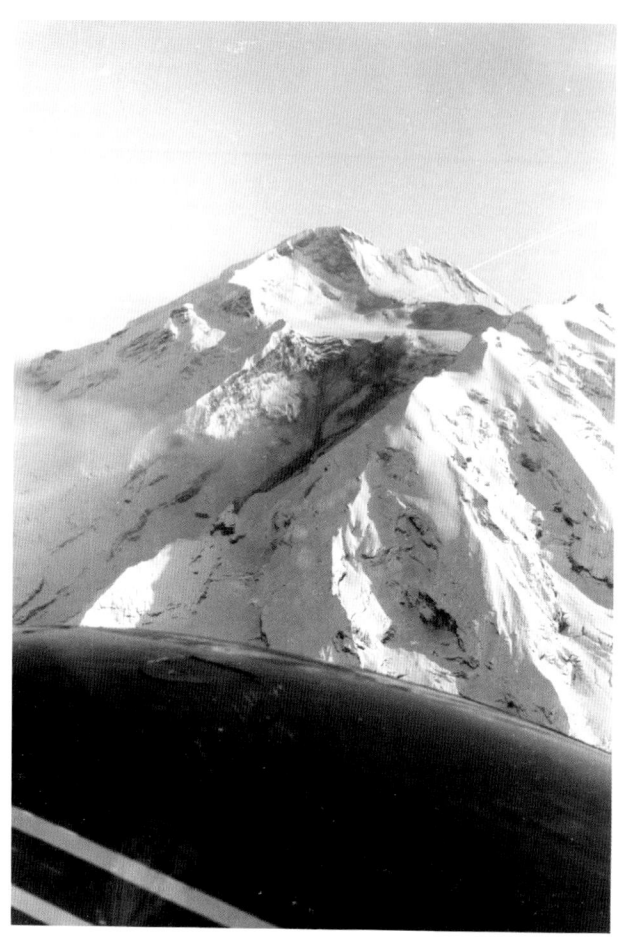

IV

WOODS, SHORE, DESERT, EAST

THE PILGRIM

IN 1968, after twenty-seven years in the monastery enclosure, twenty-seven years in which the world was turned on its head, Merton was once more out and about exploring this vastly altered world—enjoying Bloody Marys on airplane flights, meeting religious leaders and writers, gazing at ancient religious sites. As he humorously noted,

The old monk is turned loose.
And can travel!
He's out to see the world.
What progress in the last thirty years![1]

His first major trip of 1968 was to the convent of Our Lady of the Redwoods in California and then to the Monastery of Christ in the Desert in New Mexico. Merton kept an impressionistic diary of these visits, and this was the last journal he prepared for publication.[2] Its title, *Woods, Shore, Desert*, reflects the places Merton visited: the woods are the giant redwoods of

California where the Trappestine convent was situated; the shore was the coastline near the convent; and the desert referred to his visit to Christ in the Desert. In this journal geography, place and nature, as seen in the title, continue to be of great importance to Merton as they had been at the monastery. On his return to Gethsemani, in the final entries in *Woods, Shore, Desert*, Merton's thoughts return frequently to the "desolate shore" to which "I must return,"[3] and to the "immense silent redwoods."[4] The West also occupied Merton's dreams at Gethsemani, and in pictures he took out on the coast of "the great Yang-Yin of sea rock mist, diffused light and half hidden mountain," he recognized "an interior landscape," an inner geography in which "what is written within me is there." There was a sense he had discovered a place that was right for him when he described Needle Rock and Bear Harbor as "more nowhere" than his hermitage at Gethsemani. He added, "The country which is nowhere is the real home."[5]

In *The Asian Journal,* place, geography and journey are central motifs, and a number of times, Merton's spiritual journey and his physical journey come together in an important way for him, which he describes in considerable detail. This integration of the inner and outer journeys happens four times, each time related to a specific place.

First, at Dharamsala, where many Tibetans were living in exile around the mountain on which the Dali Lama had made his home, Merton "instinctively [saw] the mountain as a mandala. Slightly askew no doubt, with a central presence and surrounding presences more or less amiable," he described it as a spiritual mountain and as "the 'mandala awareness' of space."[6] Up until Merton's visit to Dharamsala in November 1968, he had been pondering over the meaning of the mandala concept, reading what others had to say about it and contemplating over the idea in relation to "the drama of disintegration and reintegration," "the axis mundi," yet feeling "all this mandala business is, for me, at least, useless."[7] By the end of October, Merton's understanding of the mandala is changing. He sees everything he thinks or does as entering "into the construction of a mandala"[8] and records advice given to him by Sonam Kazi that "one meditates on the mandala in order to be in control of what goes on within one instead of 'being controlled by it.'"[9] Gradually, Merton had moved from an approach to the mandala that was theoretical to one that touched on his own personal development until, with his experience of the Tibetans at Dharamsala, he came to

an experiential understanding of the mandala through the geography of the mountain on which the Tibetans were living, "clinging precariously to a world in which they have no place."[10]

Second, there is Merton's fascination with the mountain Kanchenjunga when he is in Darjeeling. Merton had come across pictures of Kanchenjunga before he had left for Asia and he saw it for the first time from a plane in October 1968. In mid-November, when Merton was at Darjeeling, Kanchenjunga was also visible, or not visible, depending on the clouds. He found the sight "incomparable" saying he needed "to go back for more,"[11] and for the following ten days, he made frequent references to the mountain in his journal. He found himself tired of it, "tired of icebergs 30,000 feet high"[12] and of a "28,000-foot post card." For a few days at the Mim Tea Estate, within sight of Kanchenjunga, Merton had the use of a bungalow for a time of quiet. As he argued with Kanchenjunga, he also had time to reflect on his Asian trip up to this point and felt he was not called to settle in Asia but in either Alaska or near the Redwoods, writing of his desire to remain a part of the Gethsemani community. In this time of quiet, Merton could reassess his Indian experience as "too much movement. Too much 'looking for' something: an answer, a vision, 'something other.' And this breeds illusion." In his bungalow at the tea estate, Merton realized he could be anywhere; everything he had found in Asia, so far, he could have found anywhere except for one thing, his own "illusion of Asia" that, he questions, "needed to be dissolved by experience? Here?"[13] After having made this entry in his journal, Merton dreamed that night of Kanchenjunga, realizing "there is another side of Kanchenjunga and of every mountain."[14] In Kanchenjunga, Merton sees an answer to his questions: the mountain holds paradoxes together, a theme central in Merton's own work. It has a side that is seen and a side that is not seen, it is a "palace of opposites in unity," "impermanence and patience, solidity and non-being, existence and wisdom." Developing his reflection on the mountain Merton added,

> *The full beauty of the mountain is not seen until you too consent to the impossible paradox: it is and is not. When nothing more needs to be said, the smoke of ideas clears, the mountain is SEEN.*[15]

After this passage Merton appears to have resolved his argument with Kanchenjunga and only makes a couple of minor references to it.

Third, Merton is impressed with a visit to Mahabalipuram near Madras, and he found

there "a sense of silence and space."[16] A few days later, Merton refers back to Mahabalipuram after his visit to the fourth important place for him, Polonnaruwa, and says of them both "surely, with Mahabalipuram and Polonnaruwa my Asian pilgrimage has come clear and purified itself. I mean, I know and have seen what I was obscurely looking for." At Polonnaruwa, Merton experienced the ancient giant carved statues of the Buddha at the Gal Vihara as a "Zen garden," a place of unity in his life, where stillness and movement, geography and journey, came together: "the great figures, motionless, yet with the lines in full movement." As described in his *Asian Journal*, Merton's visit to Polonnaruwa reads like a moment of illumination for Merton. Only a couple of days later did he feel he could write about his experience there in which he found "all problems are resolved and everything is clear, simply because what matters is clear. The rock, all matter, all life, is charged with dharmakaya...everything is emptiness and everything is compassion."[17] A week later, Merton was dead.

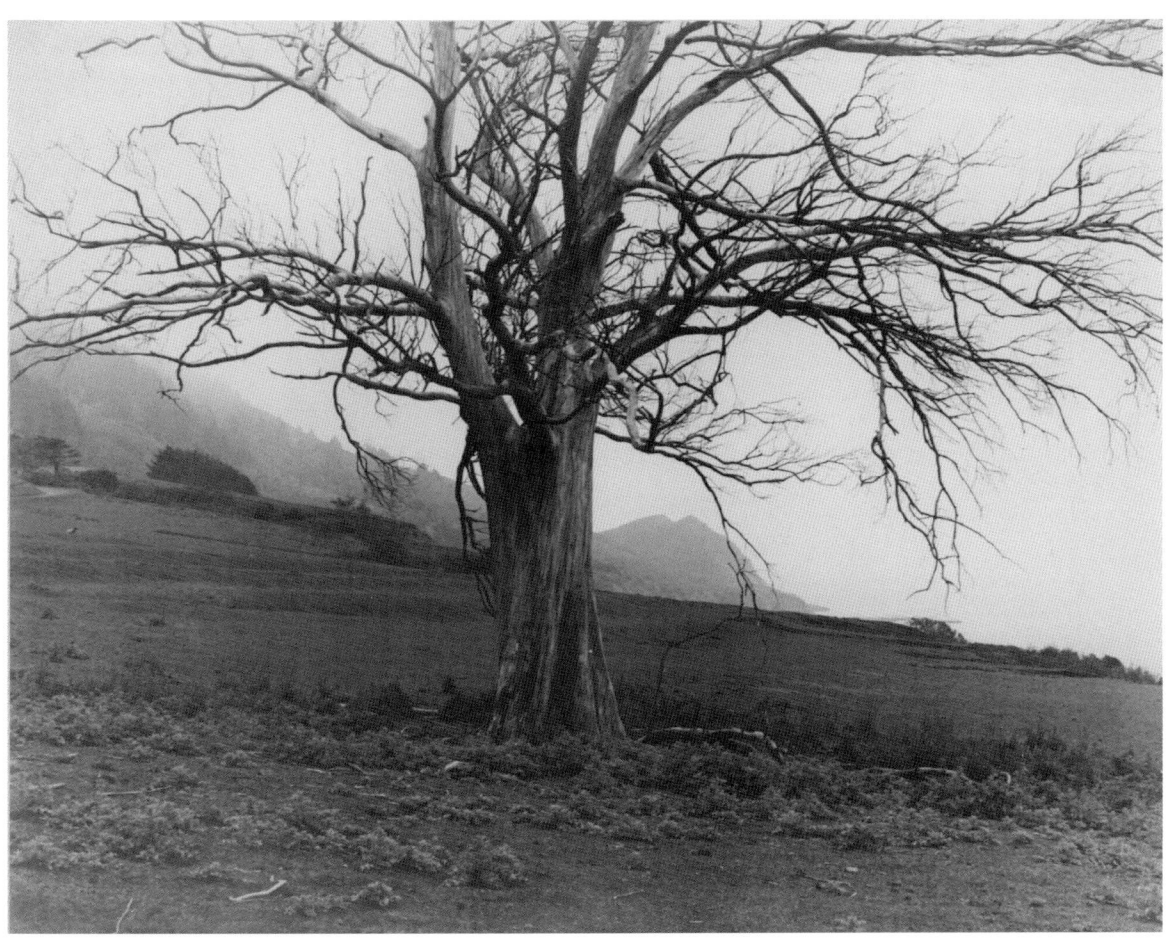

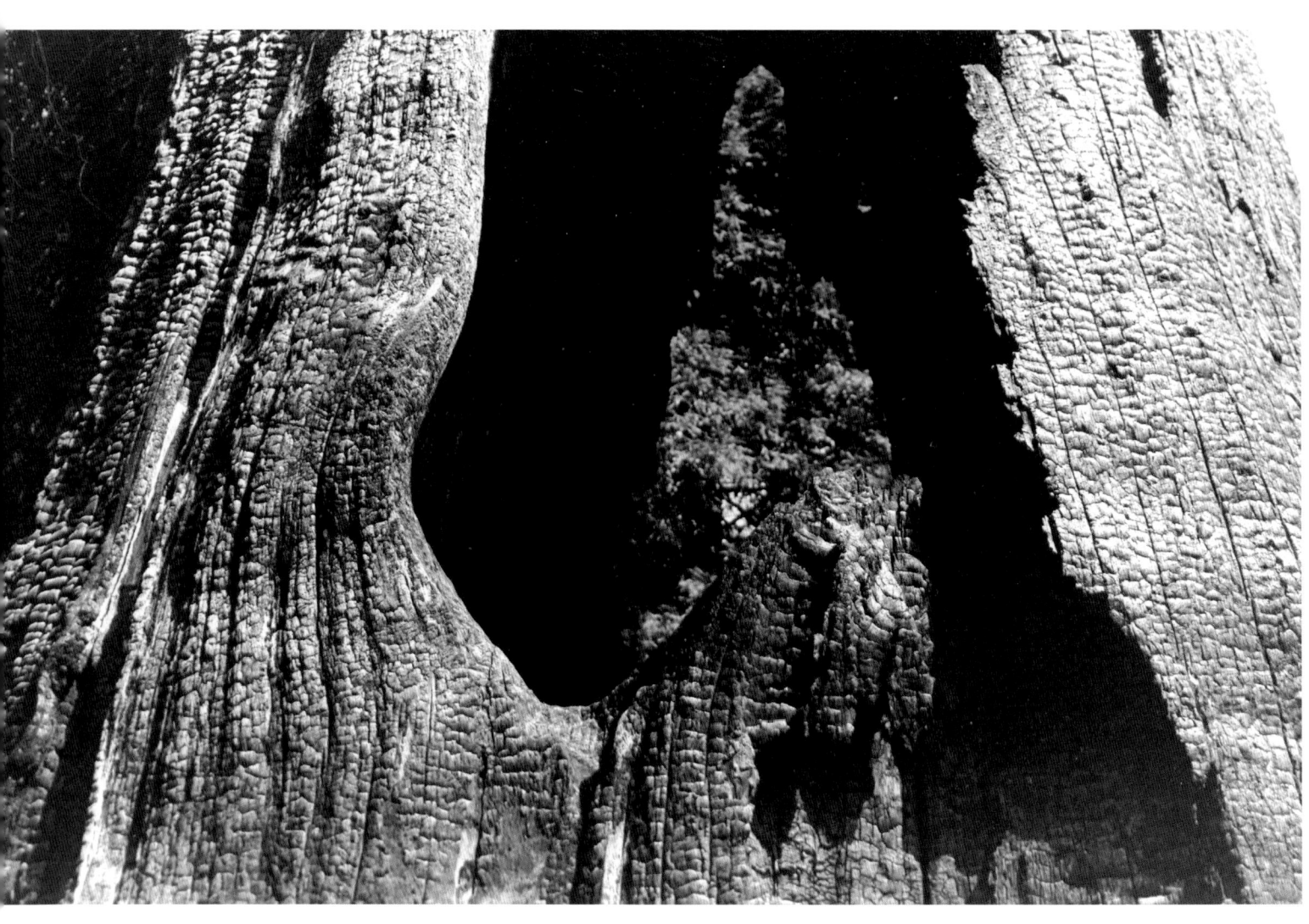

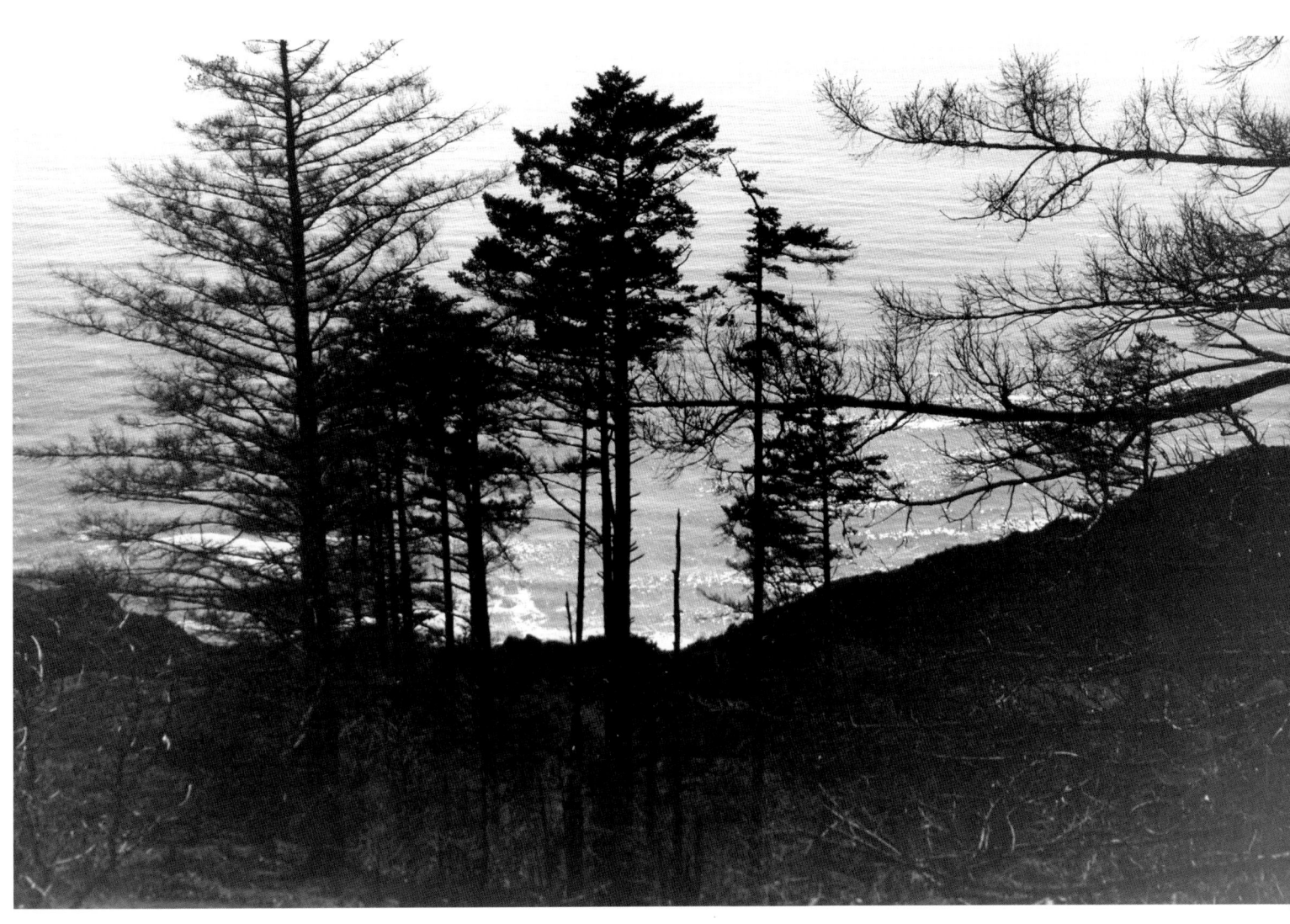

Sea Shore Driftwood, California

My desolate shore is Mendocino.
I must return.[1]

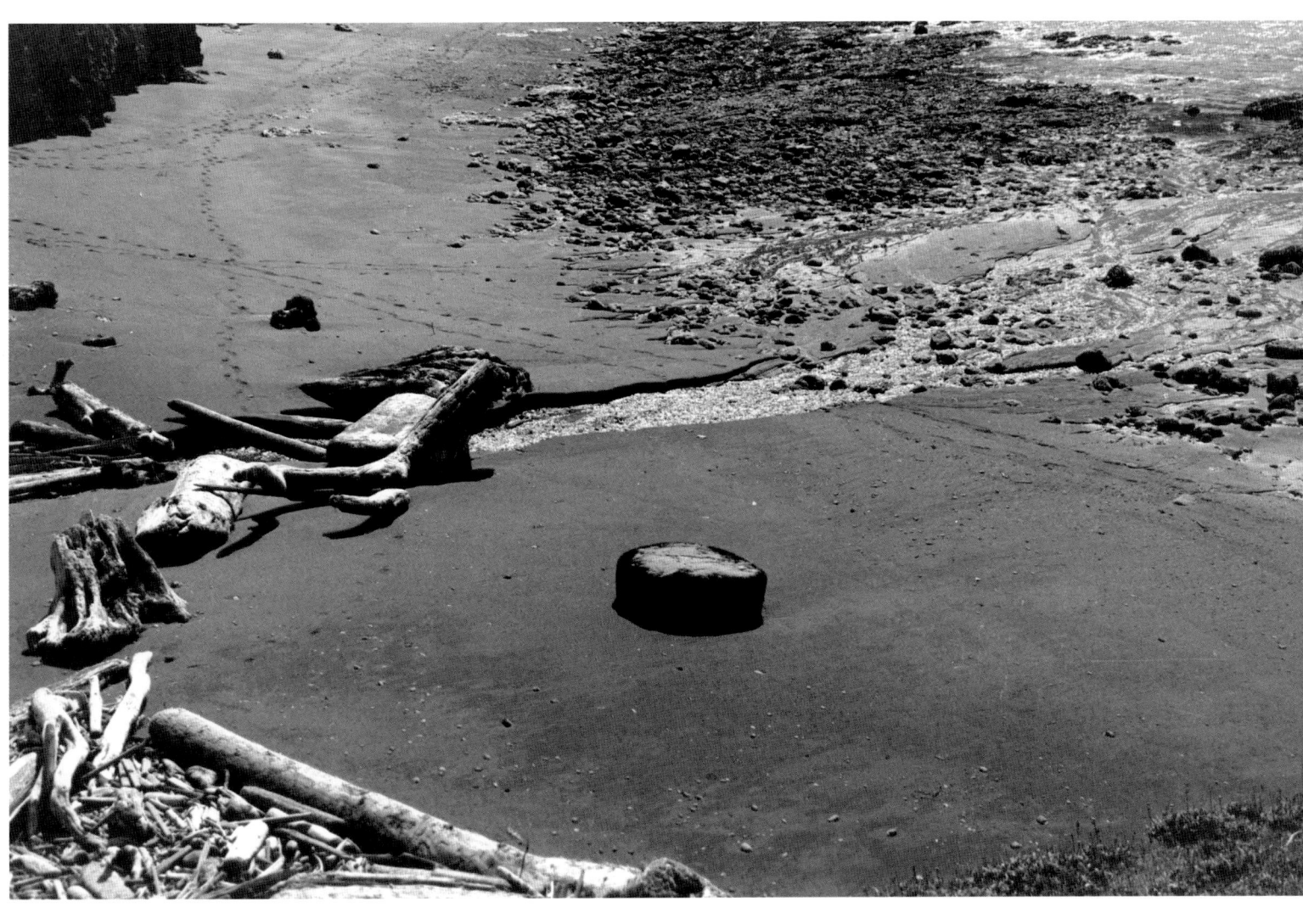

Sea Shore, California

...the great *Yang-Yin* of sea rock mist, diffused light and half hidden mountain... an interior landscape, yet there. In other words, what is written within me is there. "Thou art that."[2]

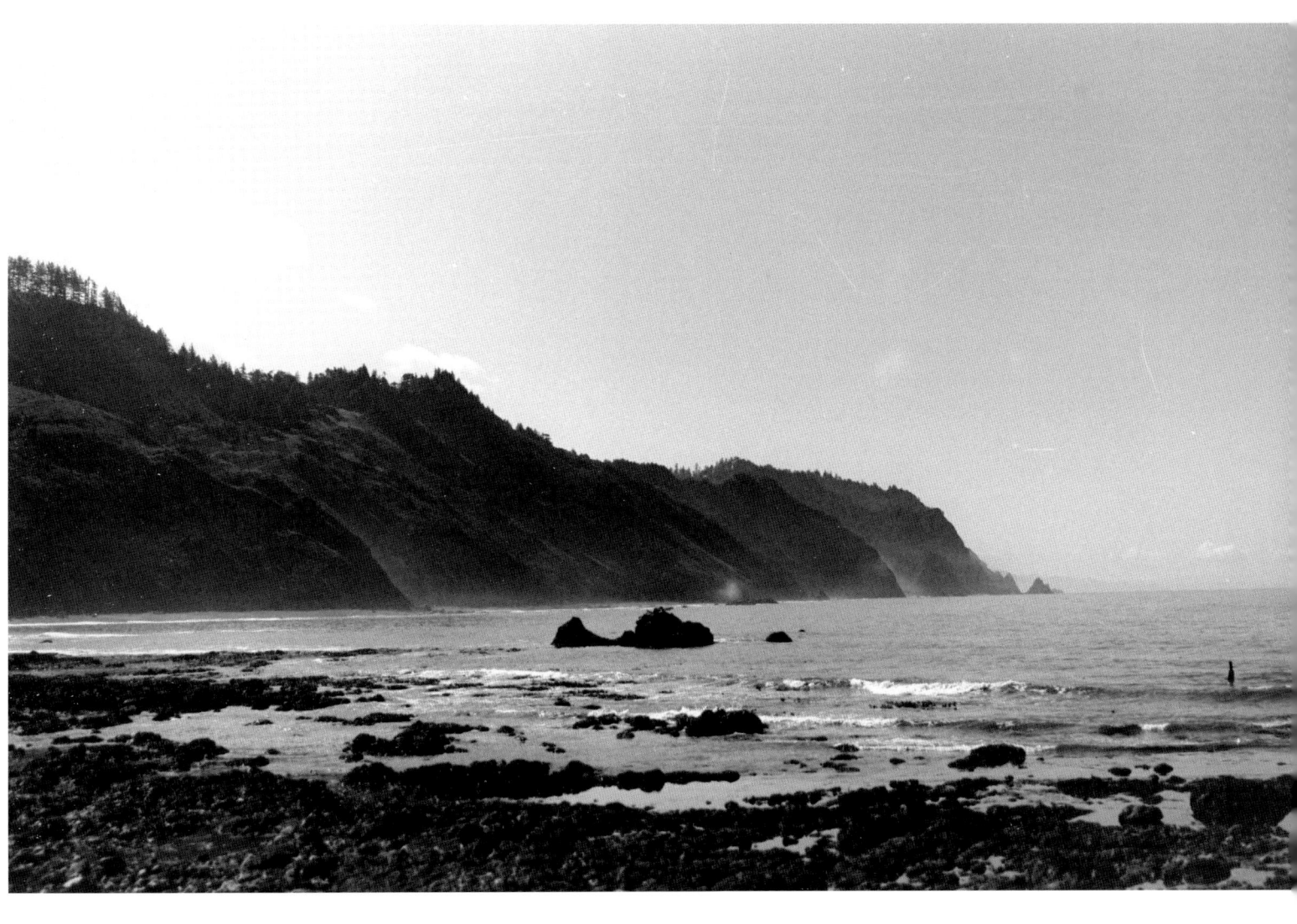

Christ in the Desert, New Mexico

The important thing for me is not acquiring land or finding an ideal solitude but opening up the depths of my own heart. The rest is secondary.[3]

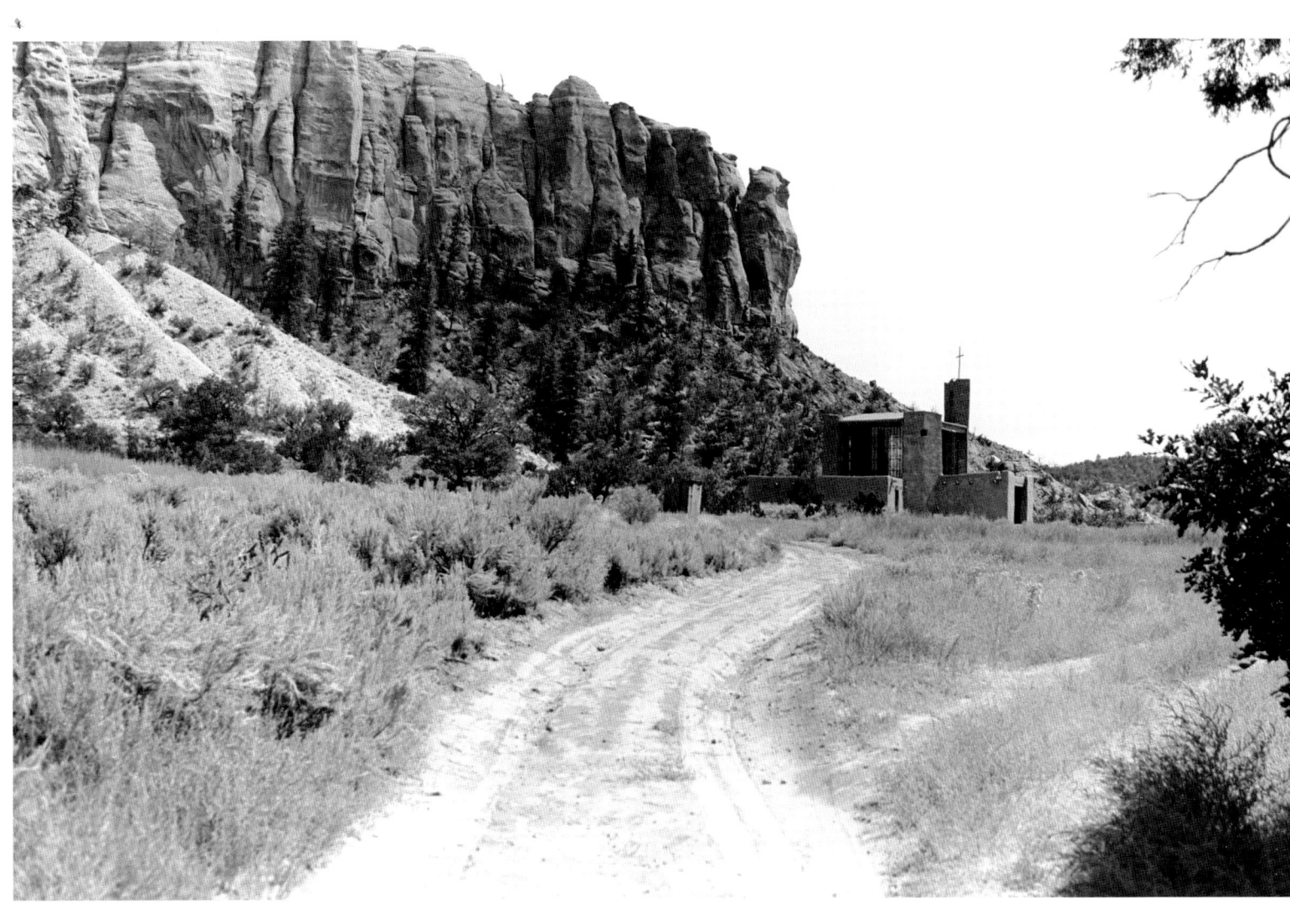

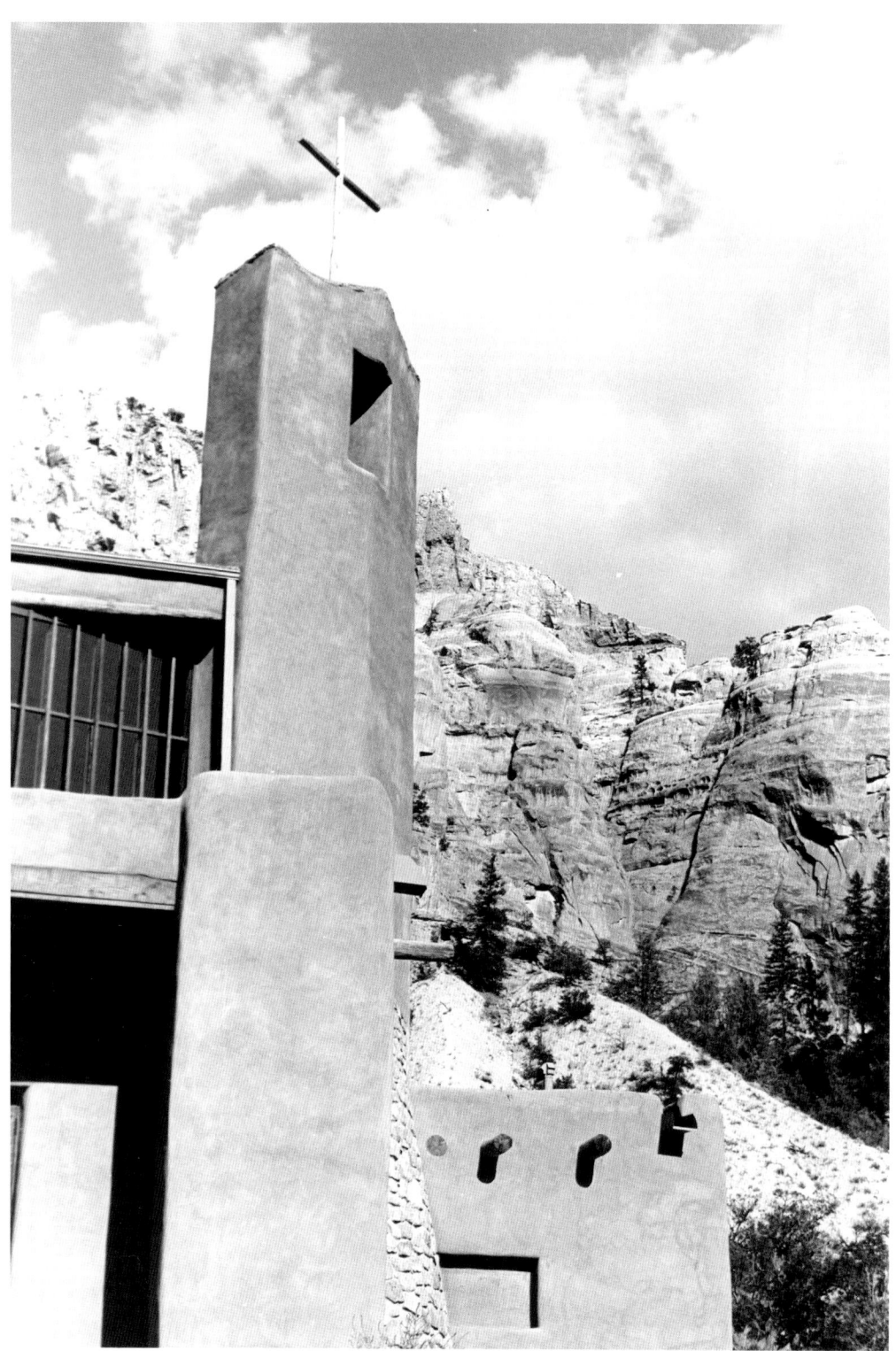

178 ||| BEHOLDING PARADISE

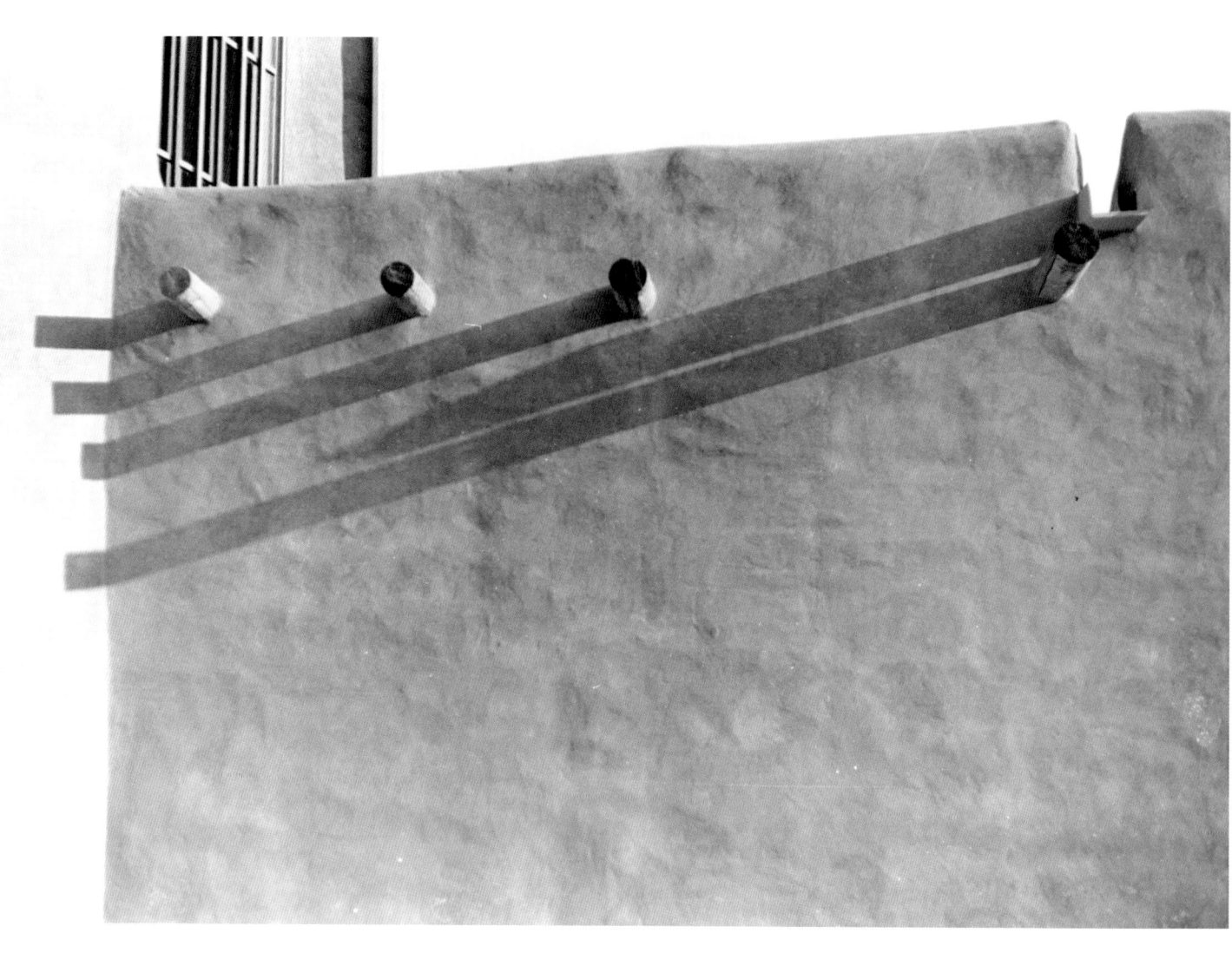

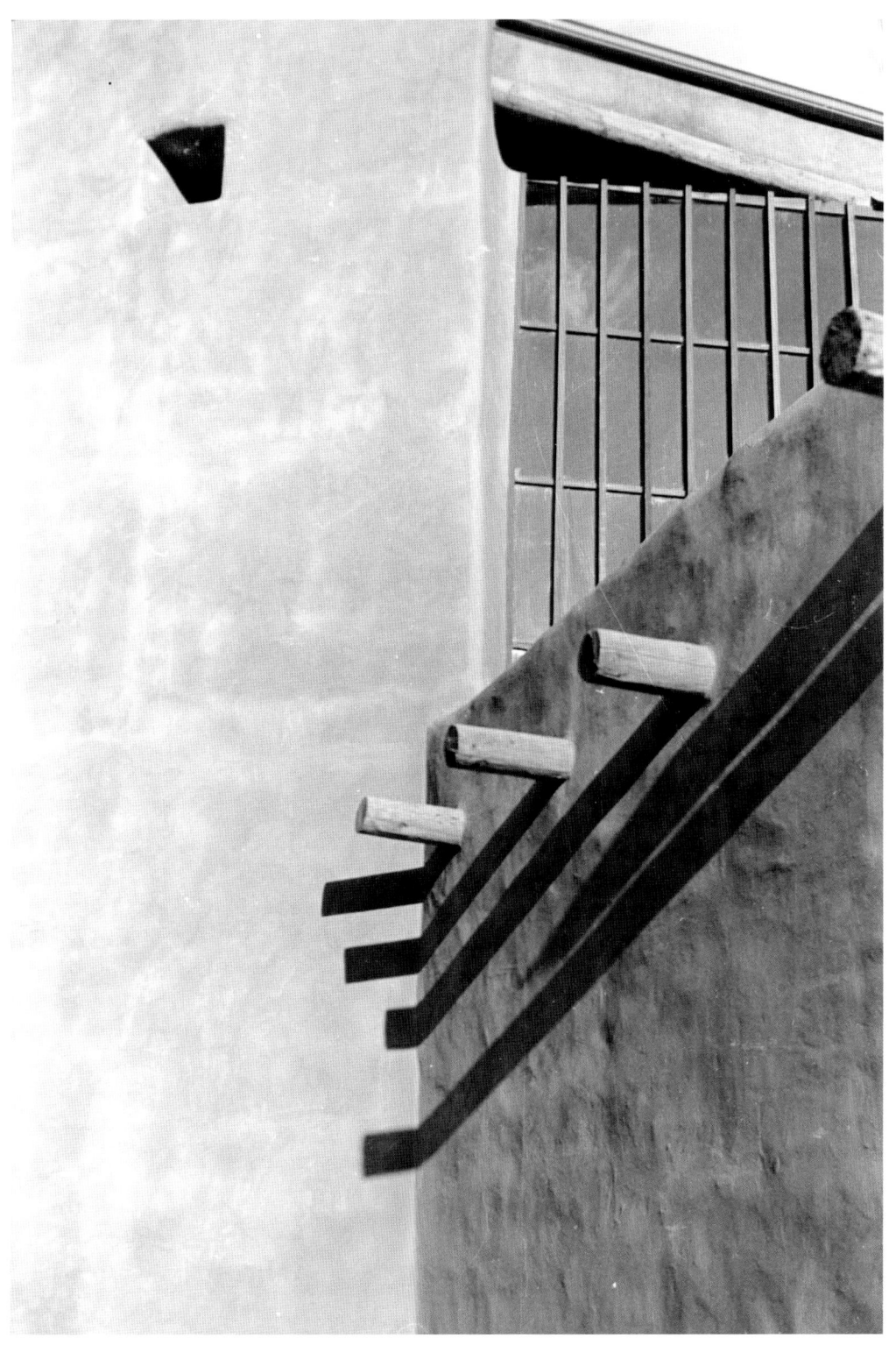

Desert Outhouse, New Mexico

Rituals...approaching the outhouse with circumspection on account of the king snake who likes to curl up on one of the beams inside. Addressing the possible king snake in the outhouse and informing him that he should not be there. Asking the formal ritual question that is asked at this time every morning: "Are you in there, you bastard?"[4]

WOODS, SHORE, DESERT, EAST ||| 183

Alaskan Mountains from Plane

Fine snow covered mountains lift their knowledges into a gap of clouds & I am exhilarated with them. Salute the spirit dwellings. Spirit-liftings come up out of the invisible land.[5]

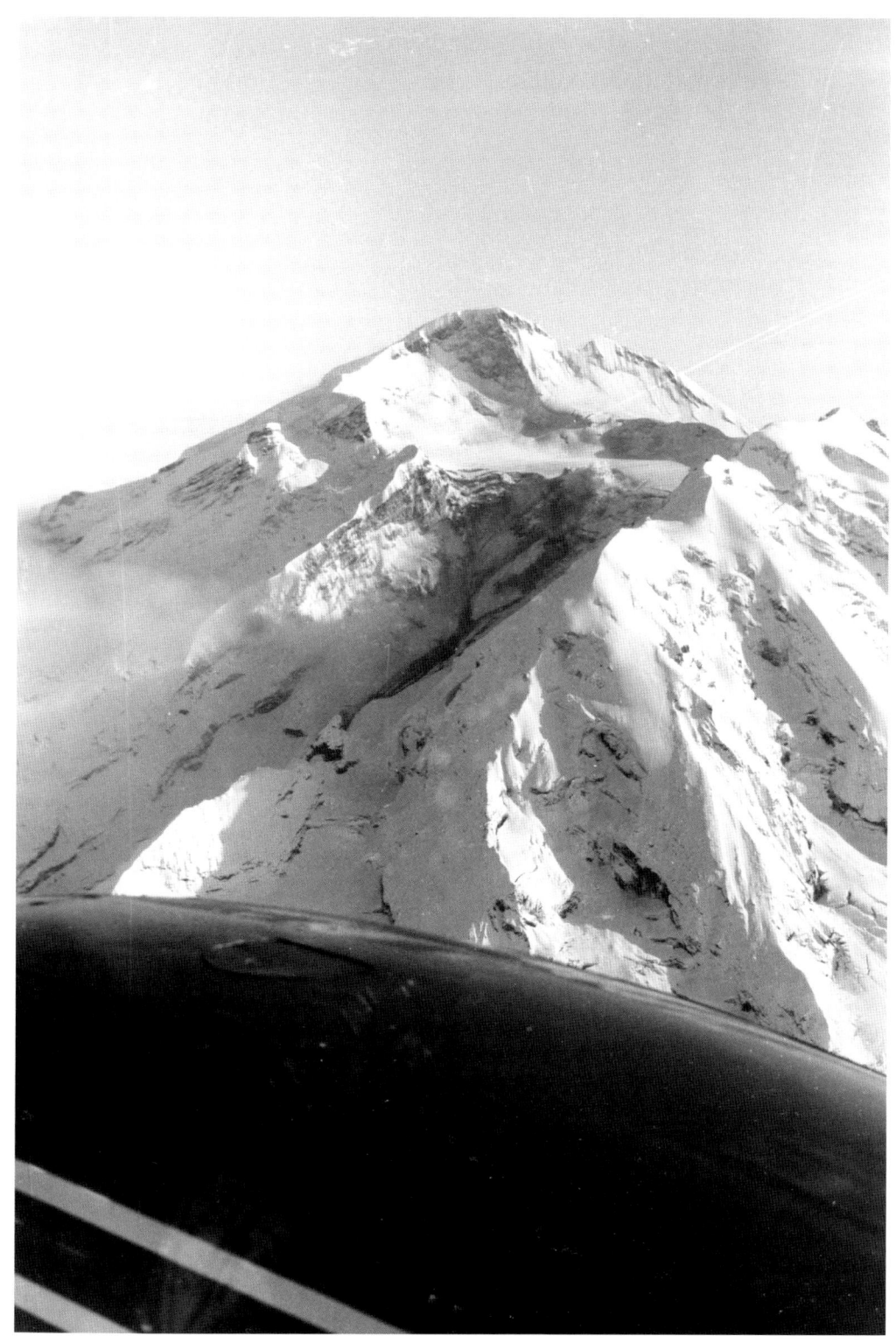

Road with Mountains, Alaska

Our real journey in life is interior: it is a matter of growth, deepening, and of an ever greater surrender to the creative action of love and grace in our hearts.[6]

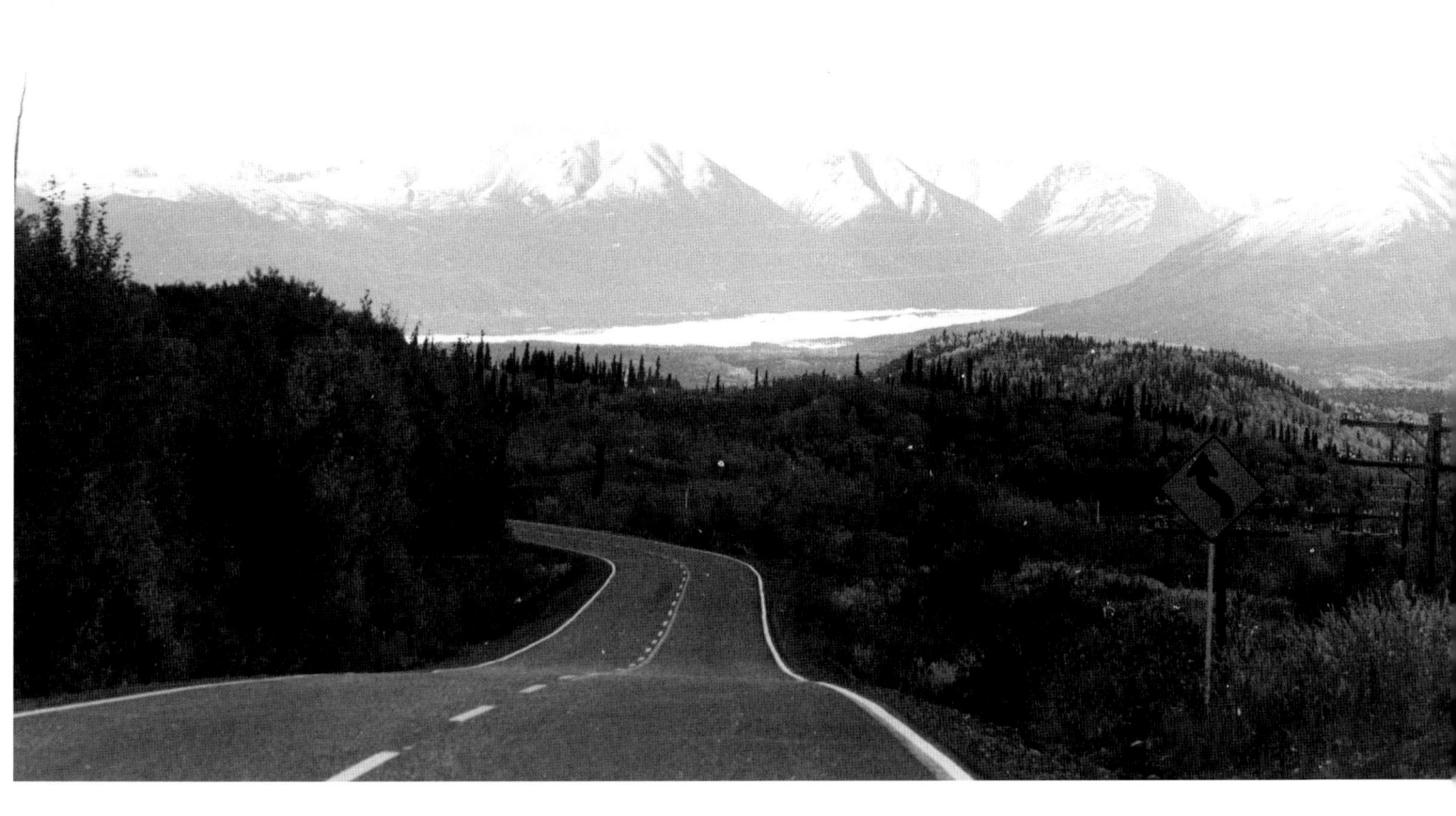

Fishing Boats,
Juneau, Alaska

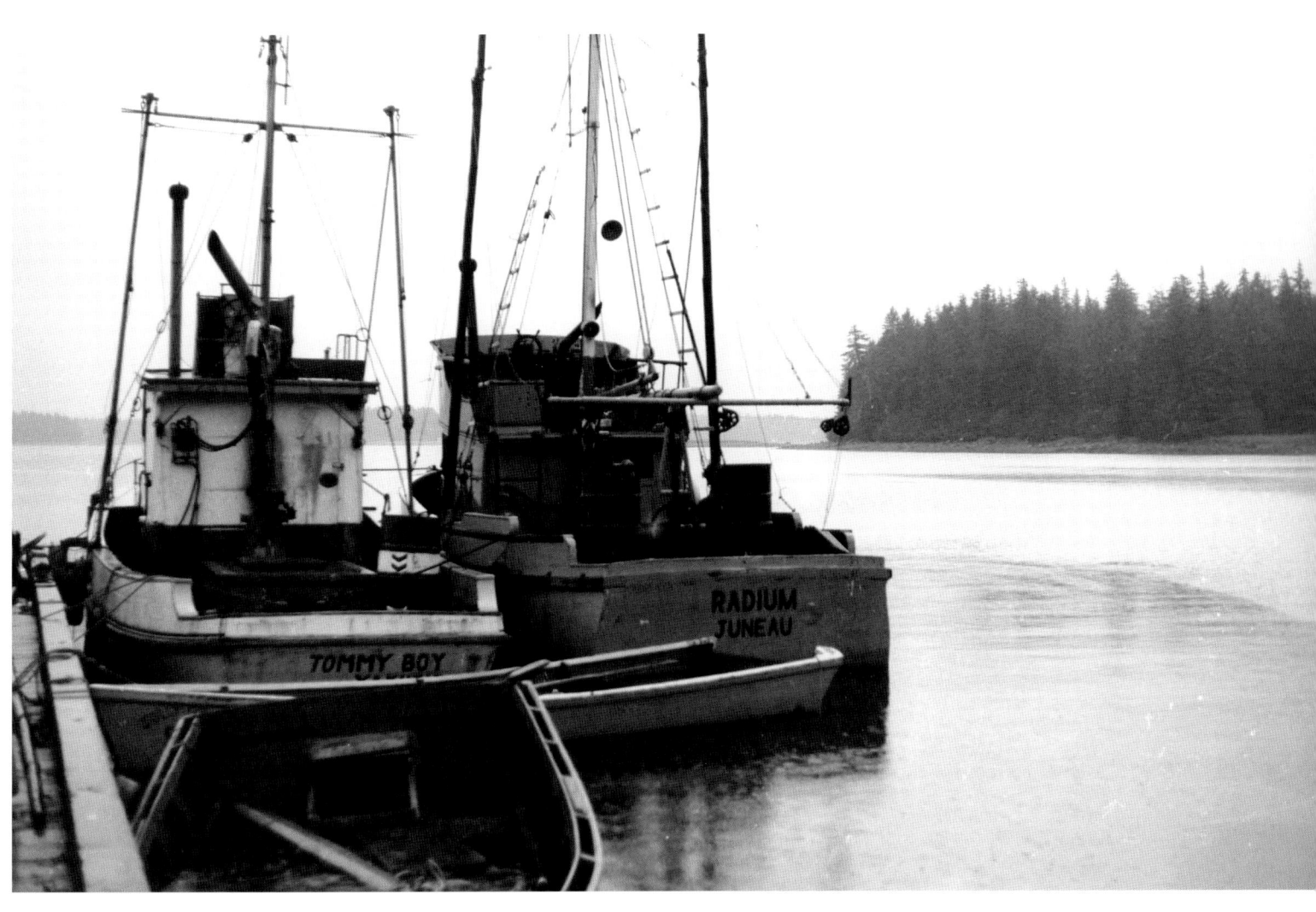

Truck, India

The old monk is turned loose.

And can travel!

He's out to see the world.

What progress in the last thirty years!

But his mode of travel

Is still the same.[7]

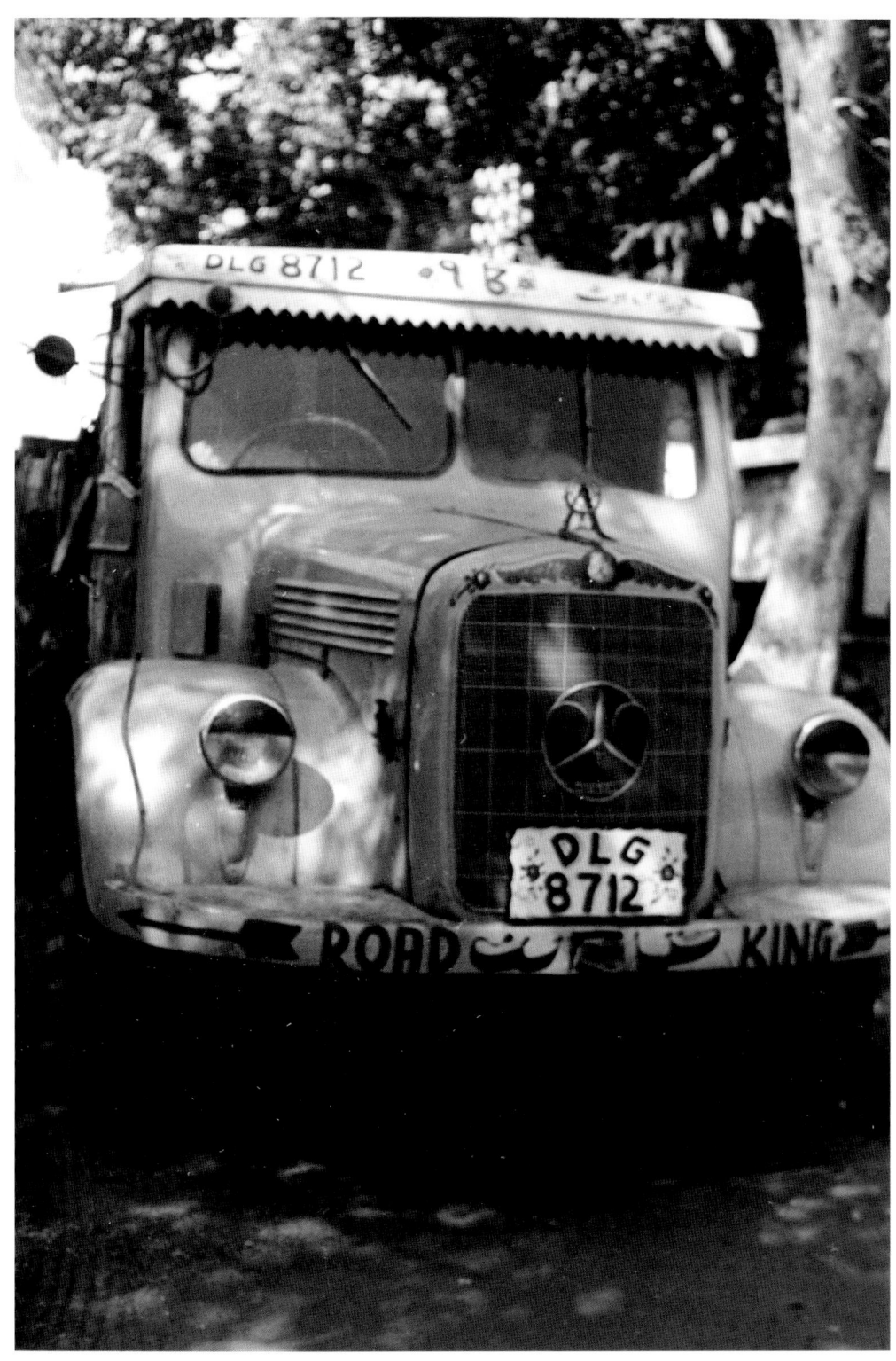

Temple of the Emerald Buddha, Bangkok, Thailand

The temple itself was impressive in a dark, ornate, spacious way and the small, precious, green Buddha enshrined high up in a lighted niche was somehow moving. The buildings and sculptures of the temple compound I thought precious and bizarre rather than beautiful. They are saved by a kind of proportion which is very evident as soon as you get away from them a little.[8]

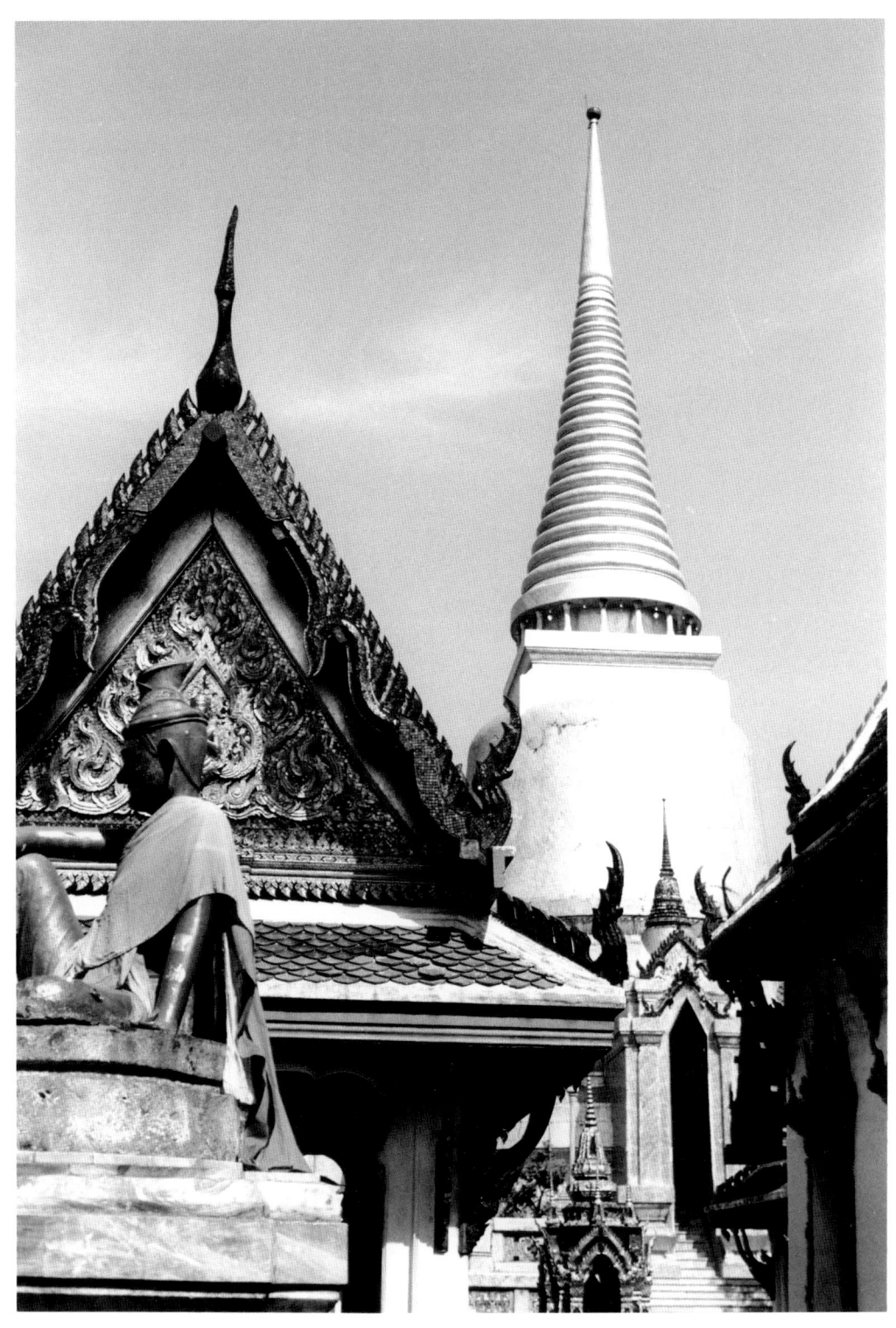

Phra Pathod Chedi, near Bangkok, Thailand

I circumambulate the stupa with incense and flowers...sweating with my camera around my neck.[9]

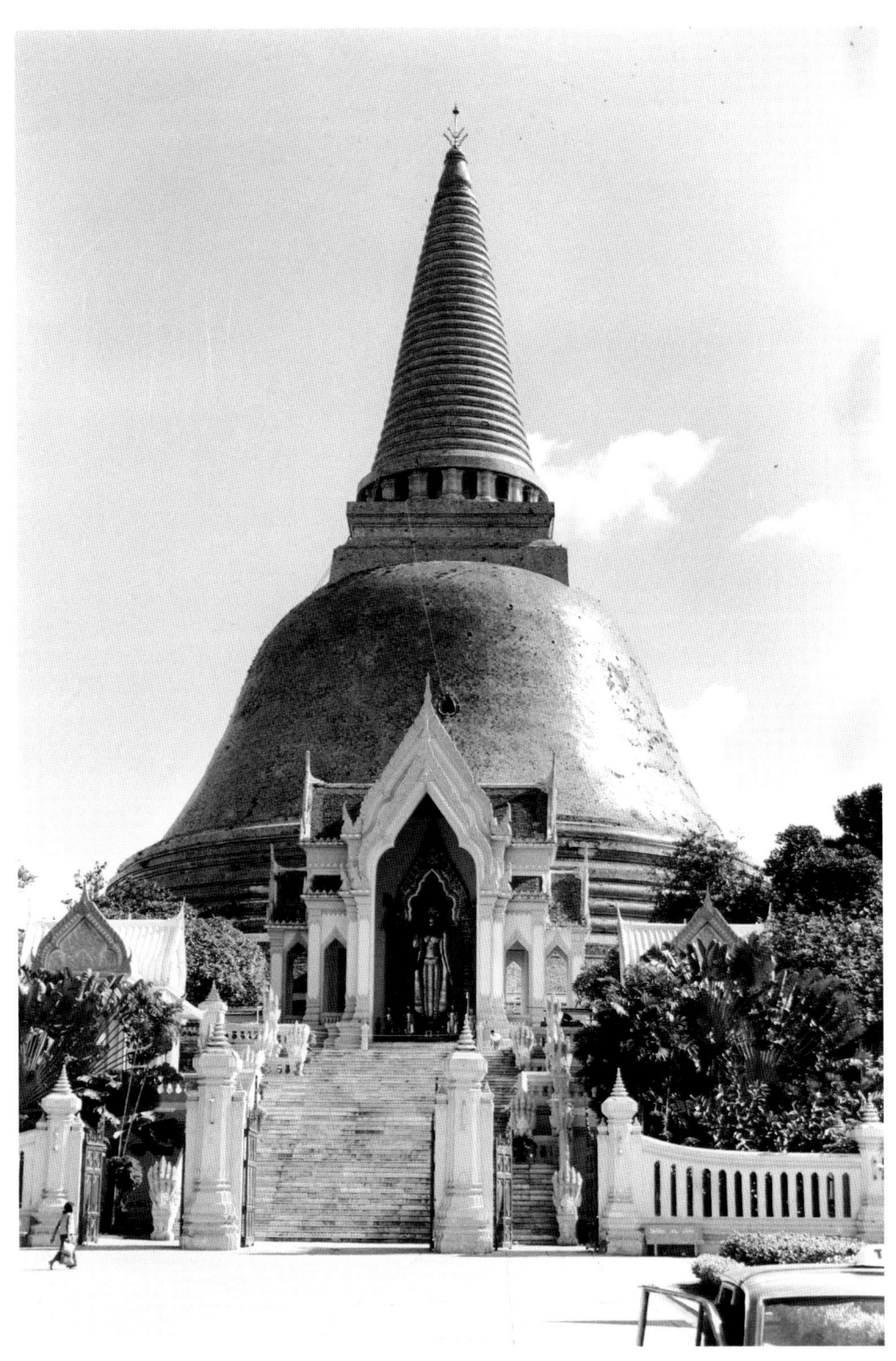

Mountain Path, Himalayas

Geography comes to an end,

Compass has lost all earthly north,

Horizons have no meaning

Nor roads an explanation.[10]

Mount Kanchenjunga

The full beauty of the mountain is not seen until you too consent to the impossible paradox: it is and is not. When nothing more needs to be said, the smoke of ideas clears, the mountain is SEEN.[11]

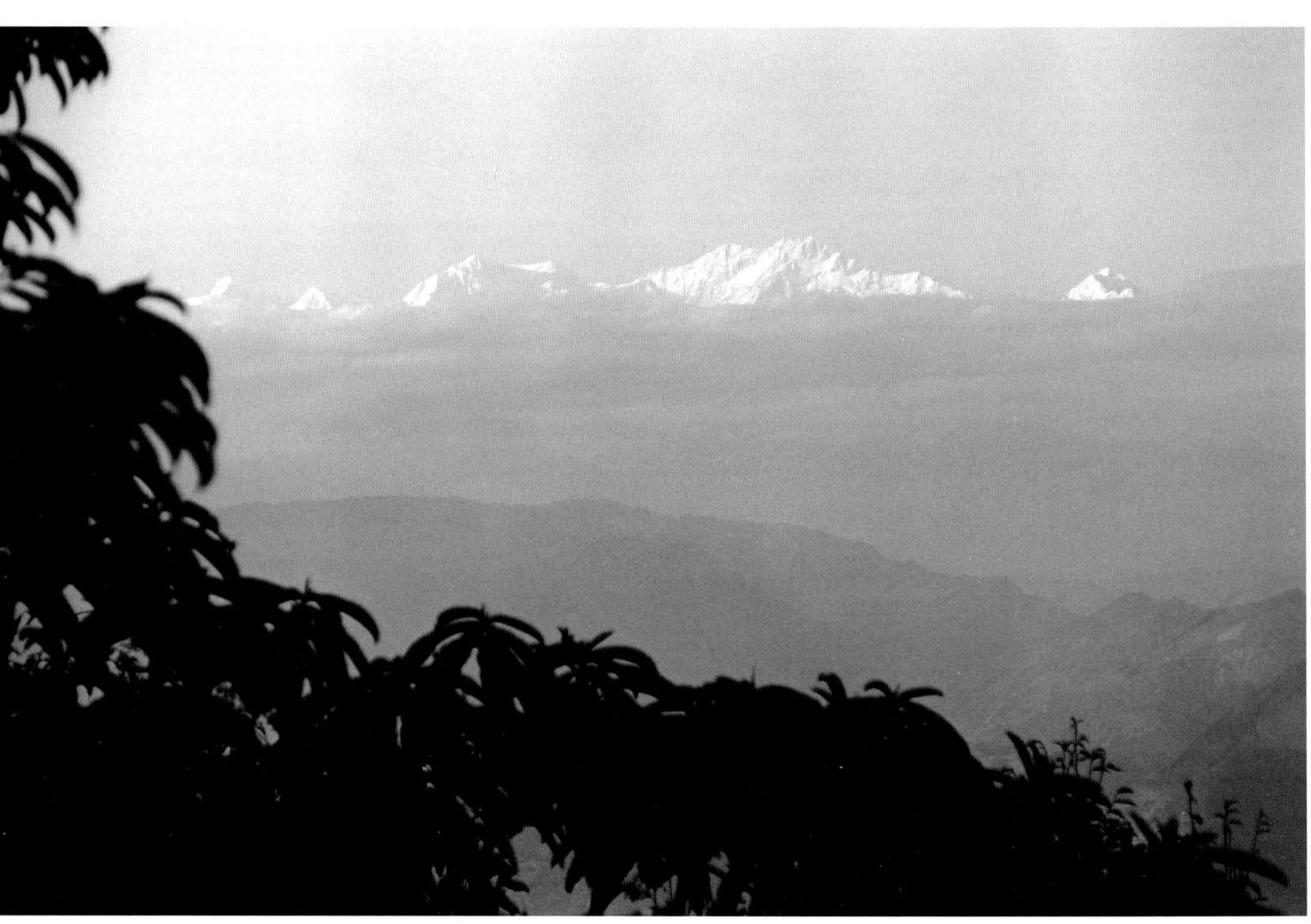

198 ||| *Beholding Paradise*

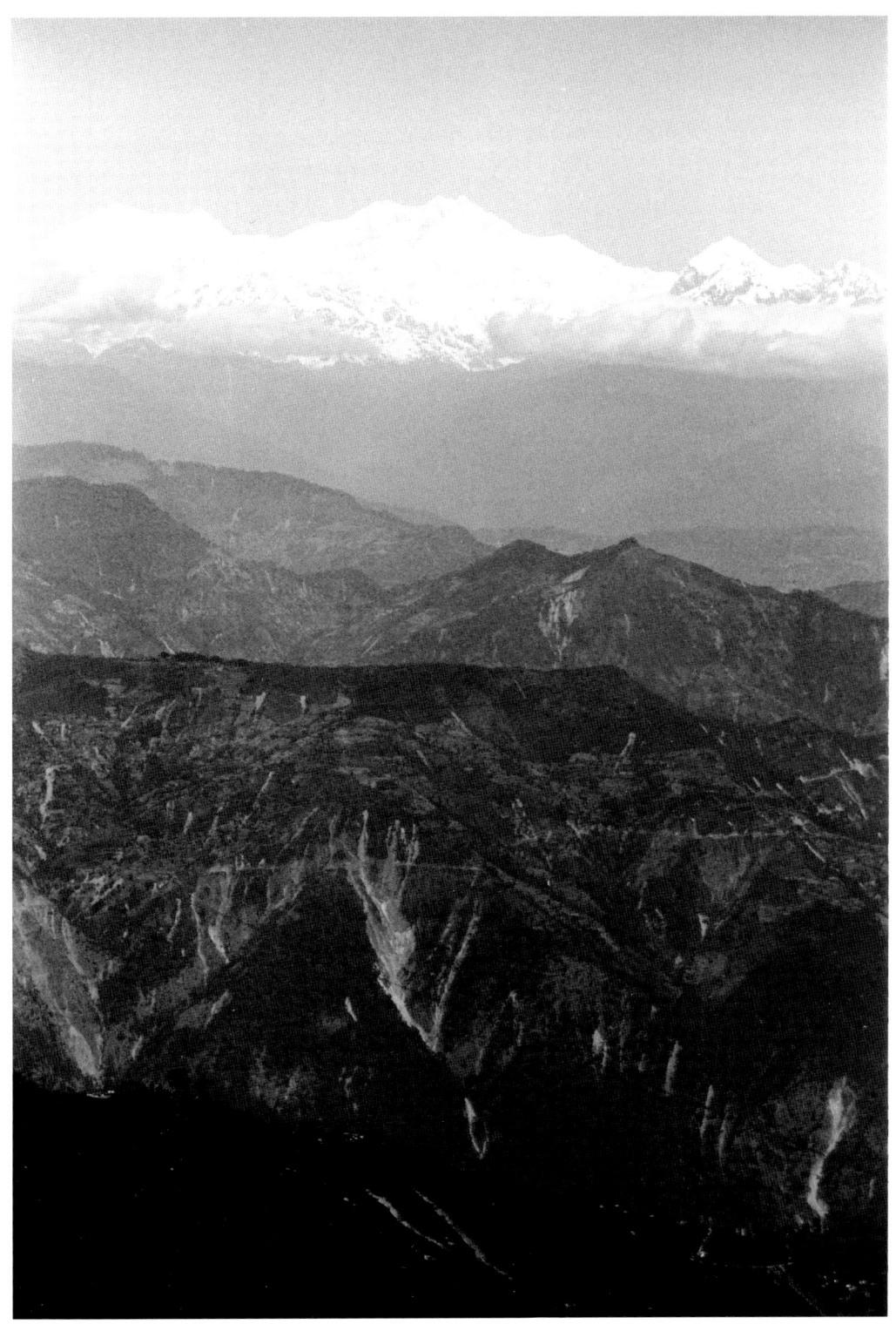

Terraced Village, Himalayas

Morning. Good for foliage to resist the faithful wind. Lean into the new light. Listen to well-ordered hills go by, rank upon rank, in the sun....The sound of the earth goes up to embrace the constant sky. My own center is the teeming heart of natural families.[12]

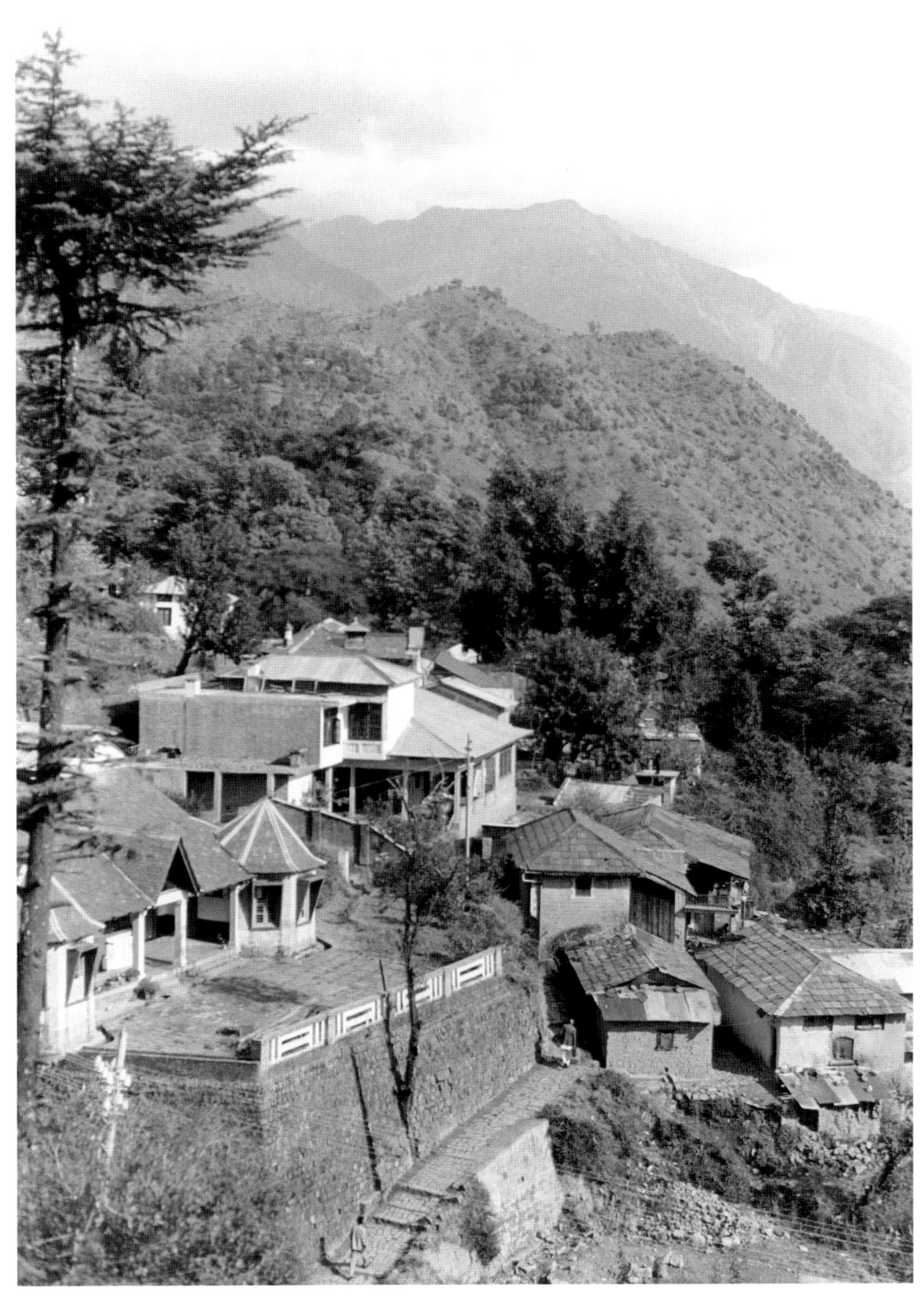

Jantar Mantar Observatory, Delhi, India

The first thing I did...was to go to the 18th-century observatory, Jantar Mantar, with its endless abstract shapes and patterns. In a few minutes I had run out of film.[13]

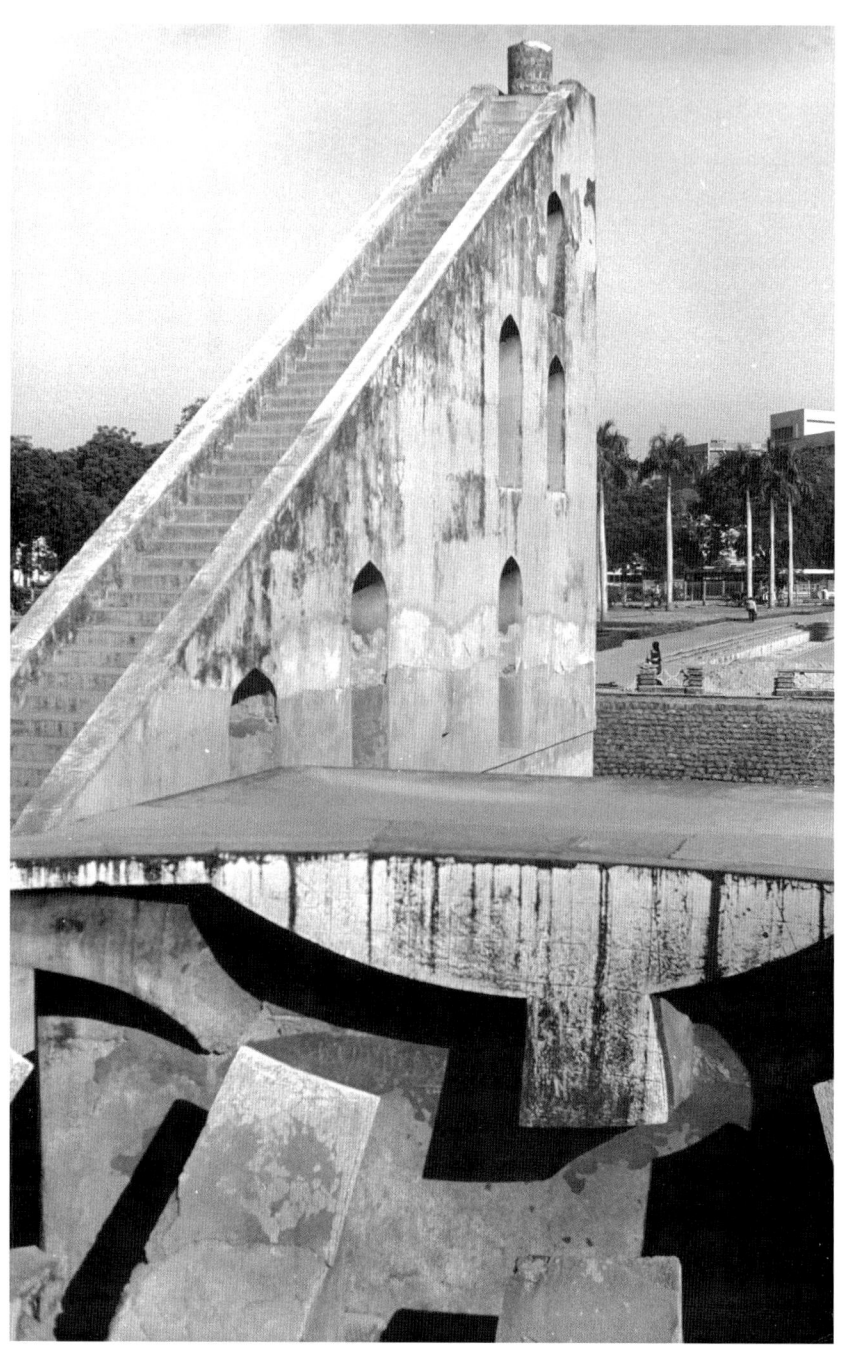

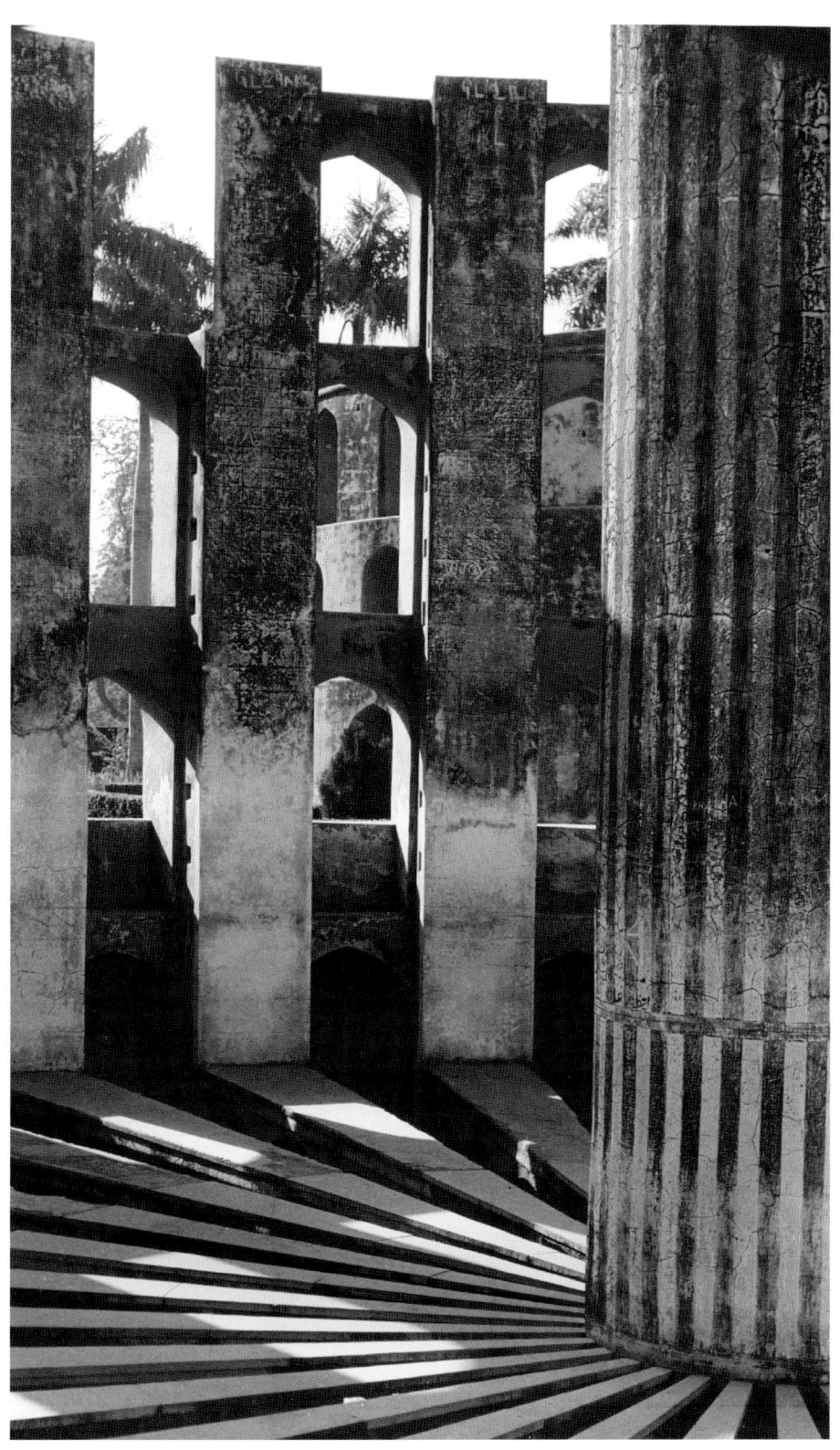

Sea Temples, Mahabalipuram, India

Surely, with Mahabalipuram and Polonnaruwa my Asian pilgrimage has come clear and purified itself. I mean, I know and have seen what I was obscurely looking for. I don't know what else remains but I have now seen and have pierced through the surface and have got beyond the shadow and the disguise.[14]

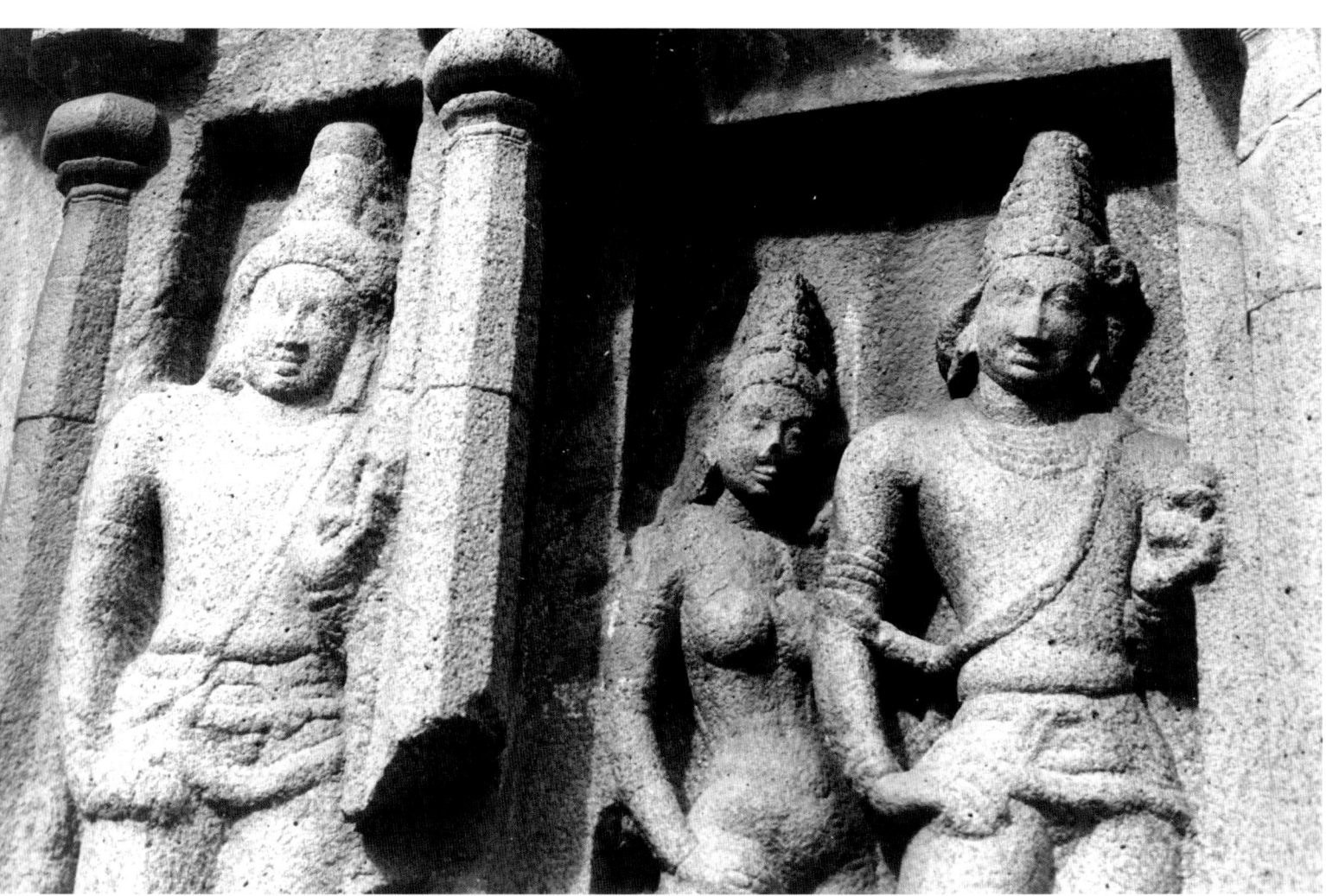

204 ||| BEHOLDING PARADISE

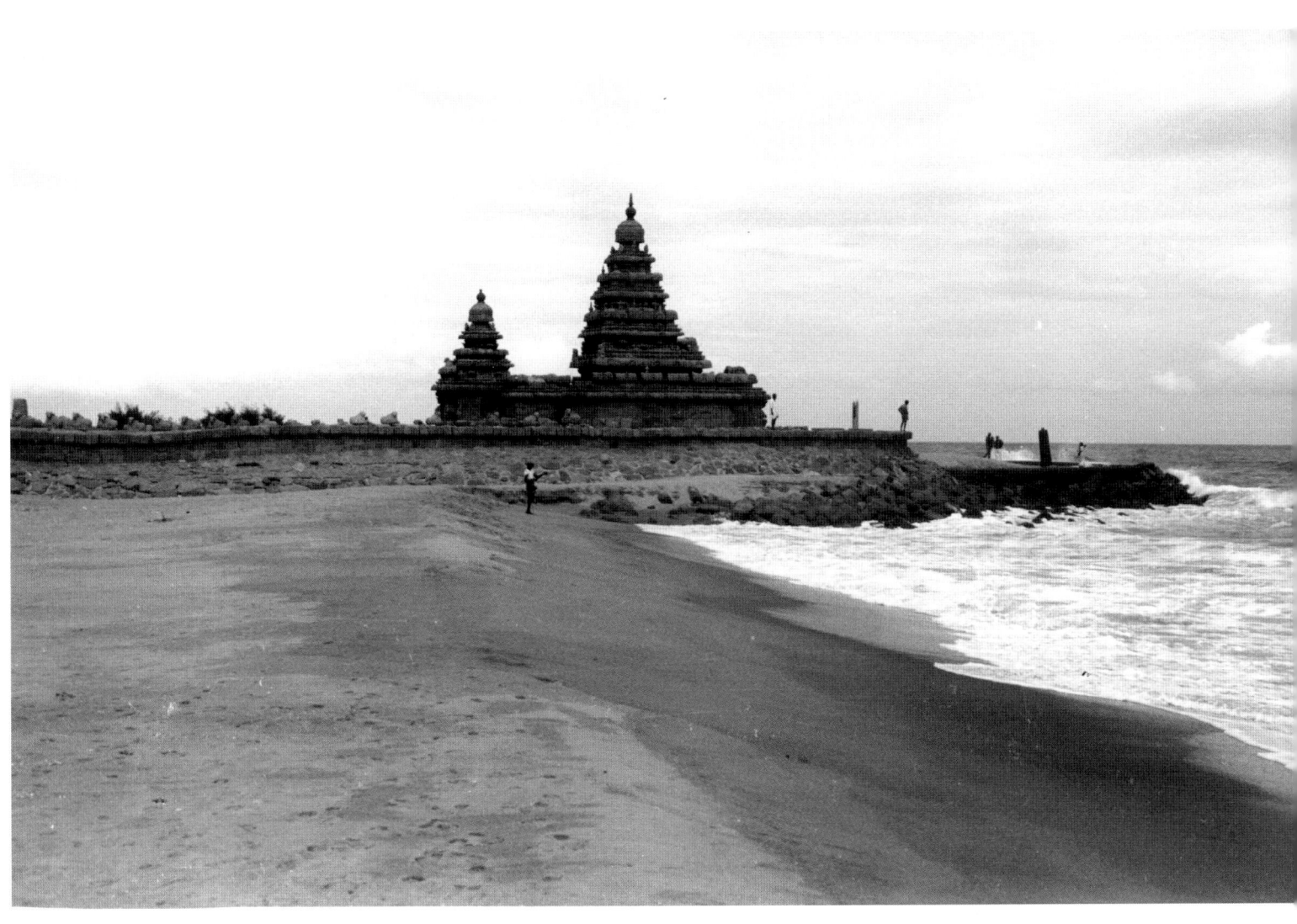

Shiva Lingam, Mahabalipuram, India

I'm curious to read again after so many years Lawrence's "Virgin Youth" when today I have seen the Shiva lingam at Mahabalipuram, standing black and alone at the edge of the ocean, washed by spray of great waves breaking on the rocks.

> He stands like a lighthouse, night churns
> Round his base, his dark light rolls
> Into darkness, and darkly returns.
>
> Is he calling, the lone one? Is his deep
> Silence full of summons?

There is no "problem," however, in the black lingam. It is washed by the sea, and the sea is woman: it is no void, no question. No English anguish about Mahabalipuram.[15]

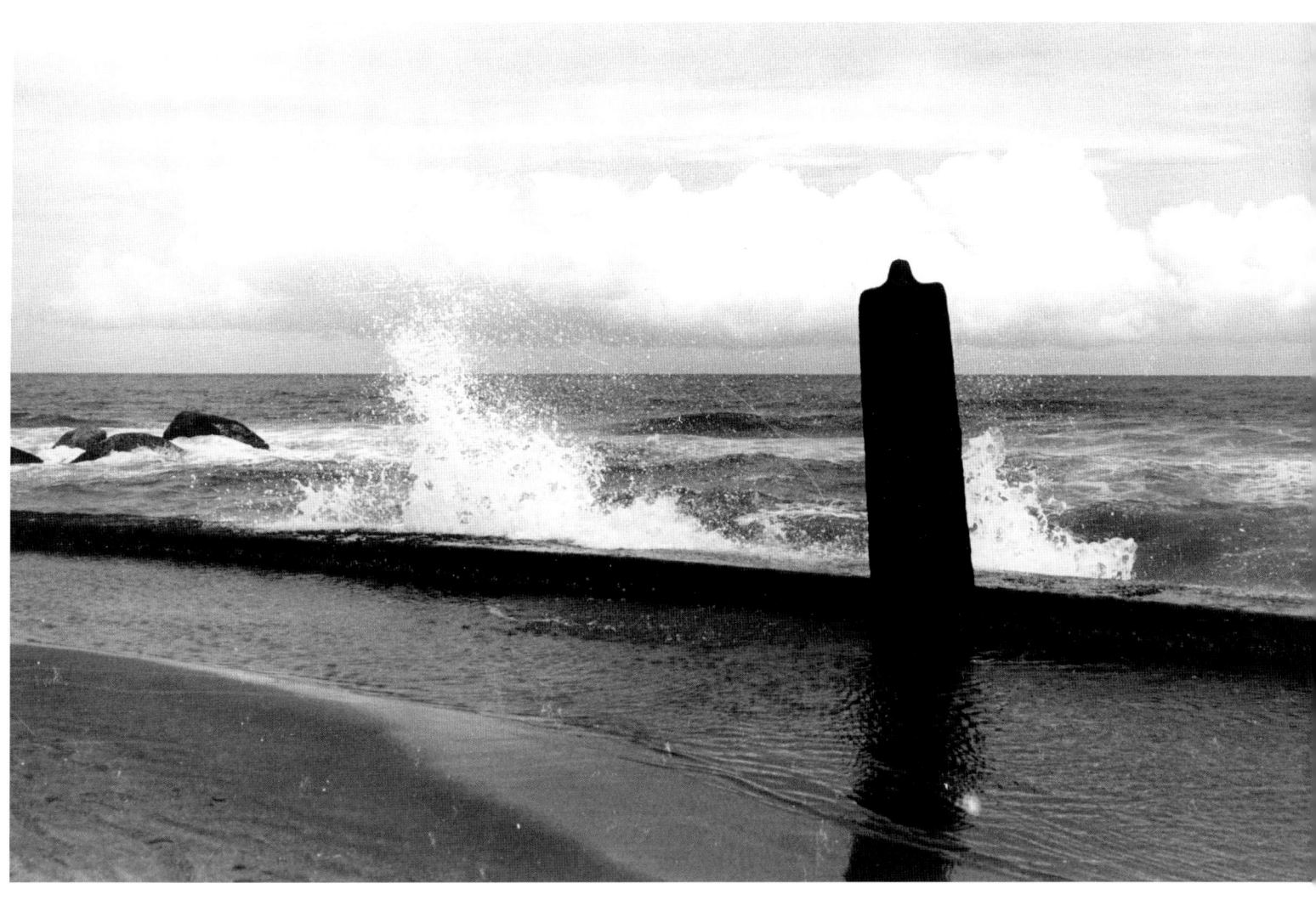

Reclining Buddha, Polonnaruwa, Sri Lanka

The vicar general, shying away from "paganism," hangs back and sits under a tree reading the guidebook. I am able to approach the Buddhas barefoot and undisturbed, my feet in wet grass, wet sand. Then the silence of the extraordinary faces. The great smiles. Huge and yet subtle. Filled with every possibility, questioning nothing, knowing everything, rejecting nothing.[16]

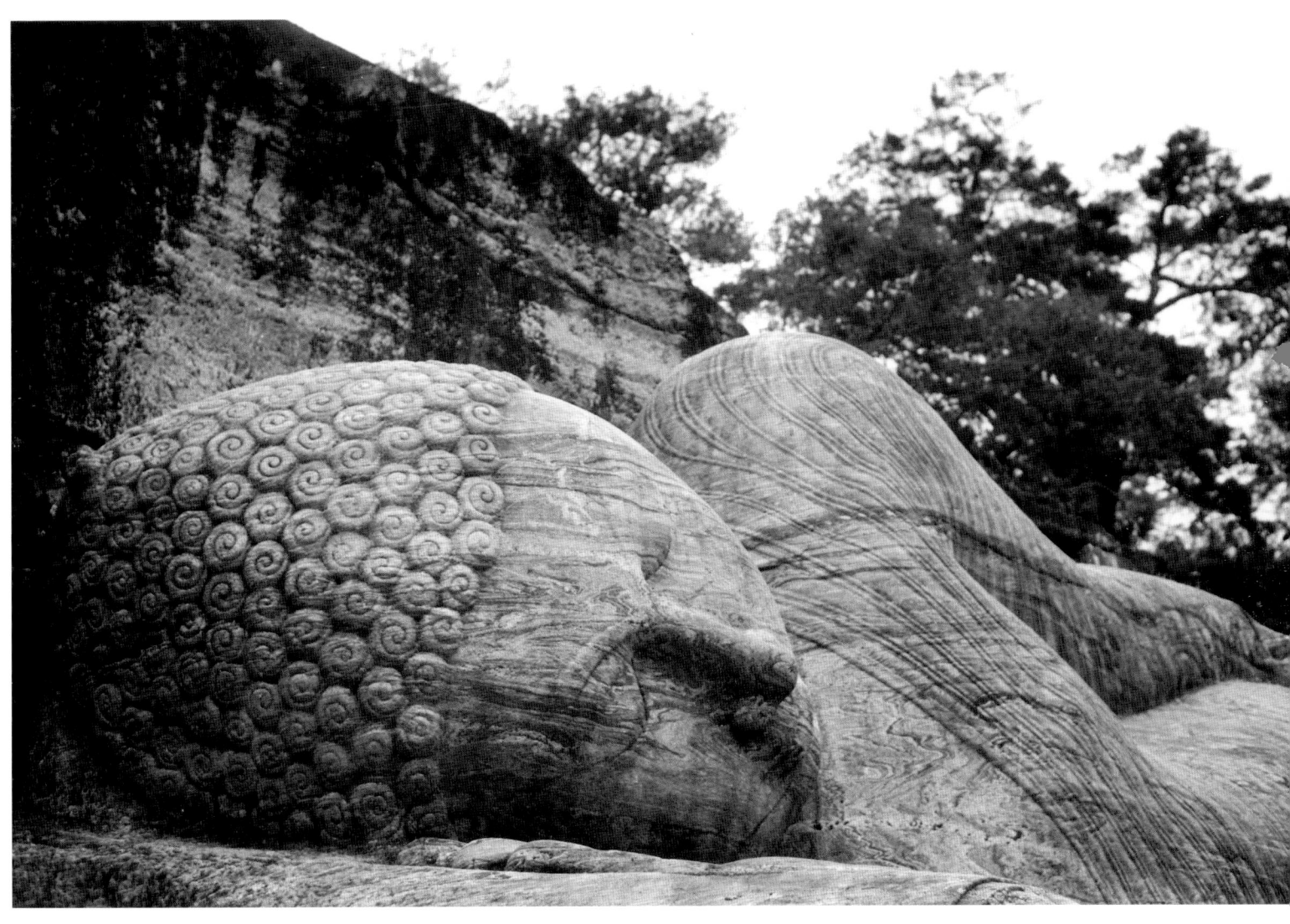

Reclining Buddha, Polonnaruwa, Sri Lanka

Looking at these figures I was suddenly, almost forcibly, jerked clean out of the habitual, half-tied vision of things, and an inner clearness, clarity, as if exploding from the rocks themselves, became evident and obvious.[17]

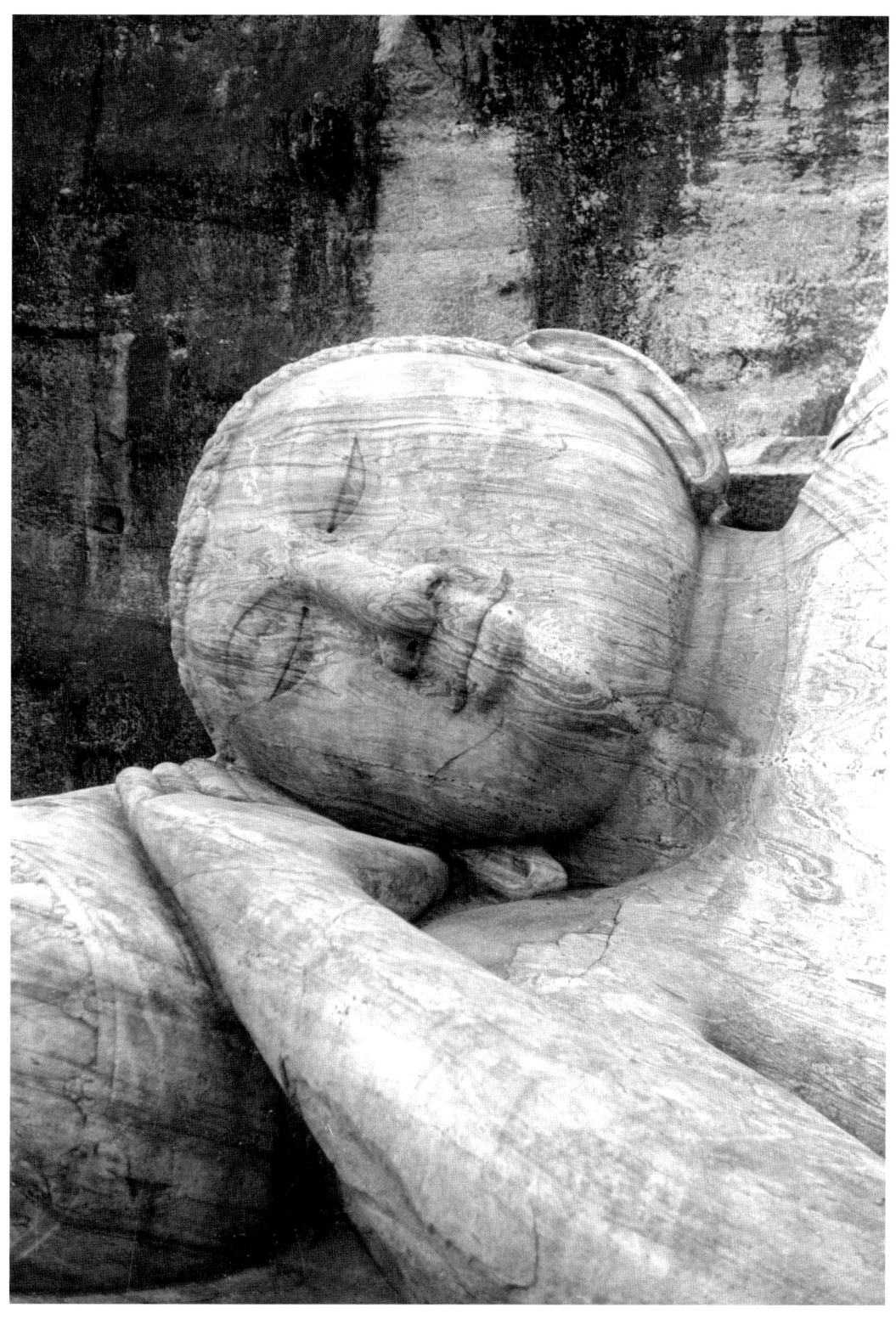

Reclining Buddha, Polonnaruwa, Sri Lanka

All problems are resolved and everything is clear, simply because what matters is clear. The rock, all matter, all life, is charged with *dharmakaya*...everything is emptiness and everything is compassion.[18]

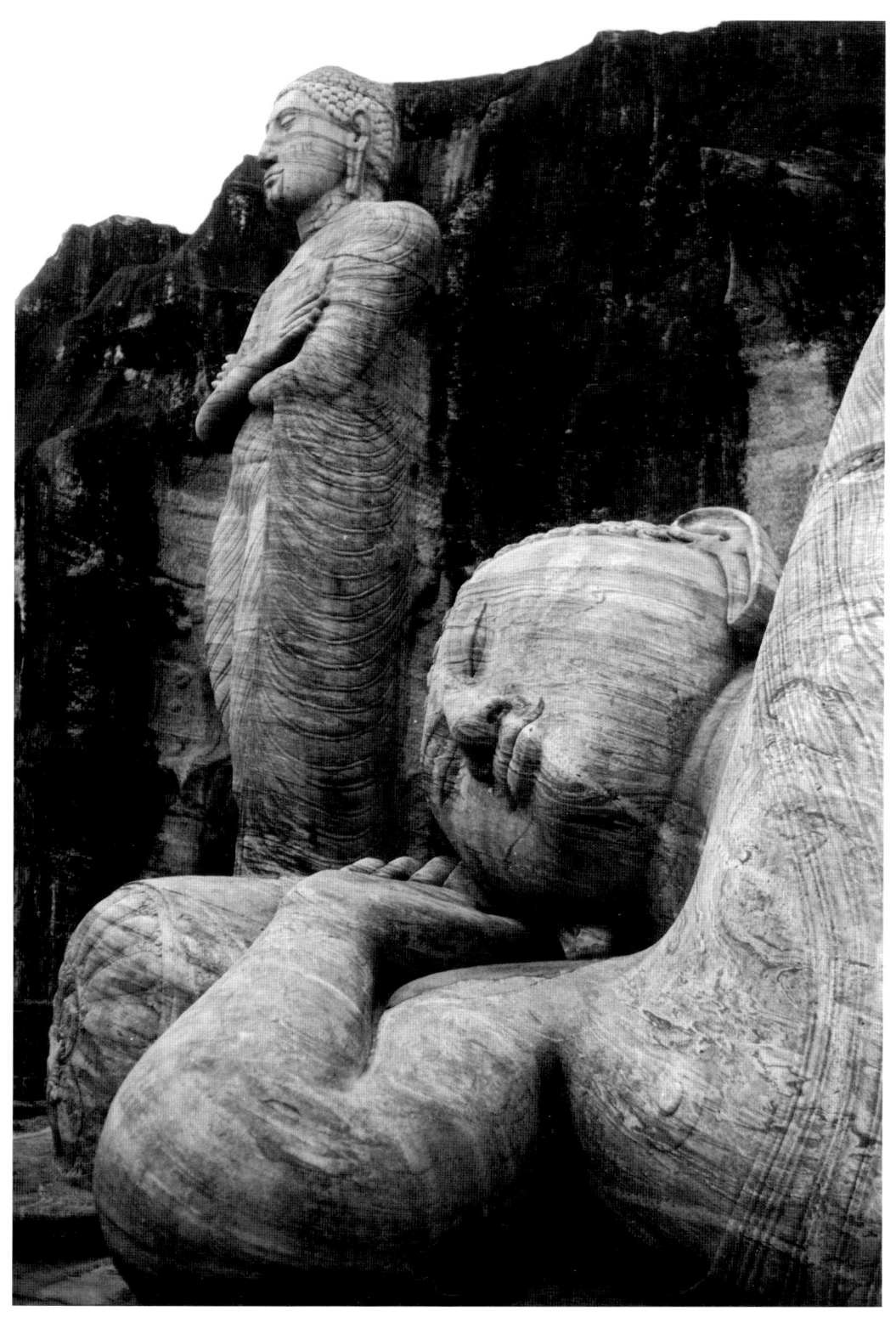

Merton outside Gethsemani Hermitage, September 1968

I shall certainly have solitude but only by miracle and not at all by my own contriving. Where? Here or there makes no difference. Somewhere, nowhere, beyond all "where." Solitude outside geography or in it. No matter.[19]

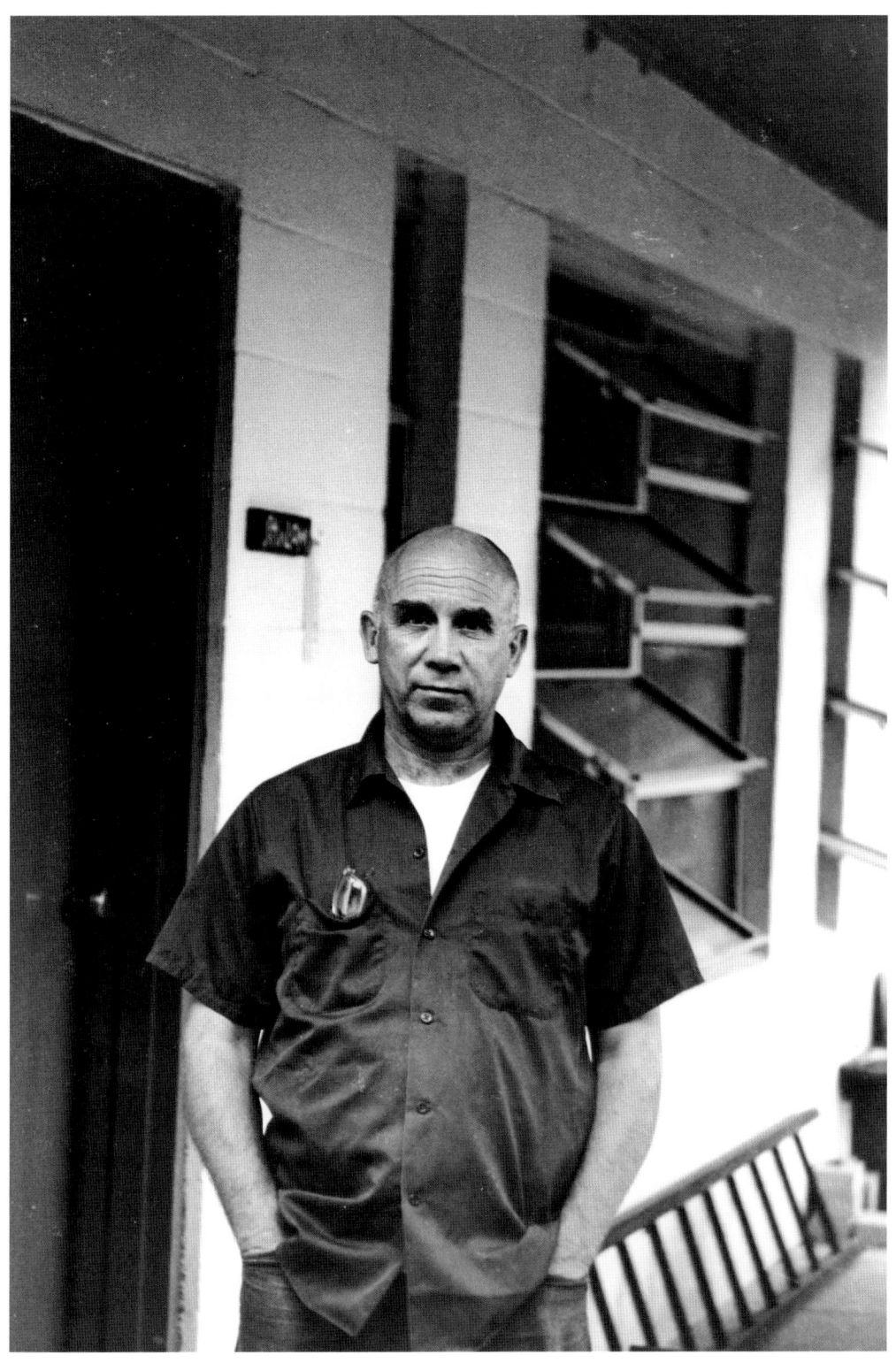

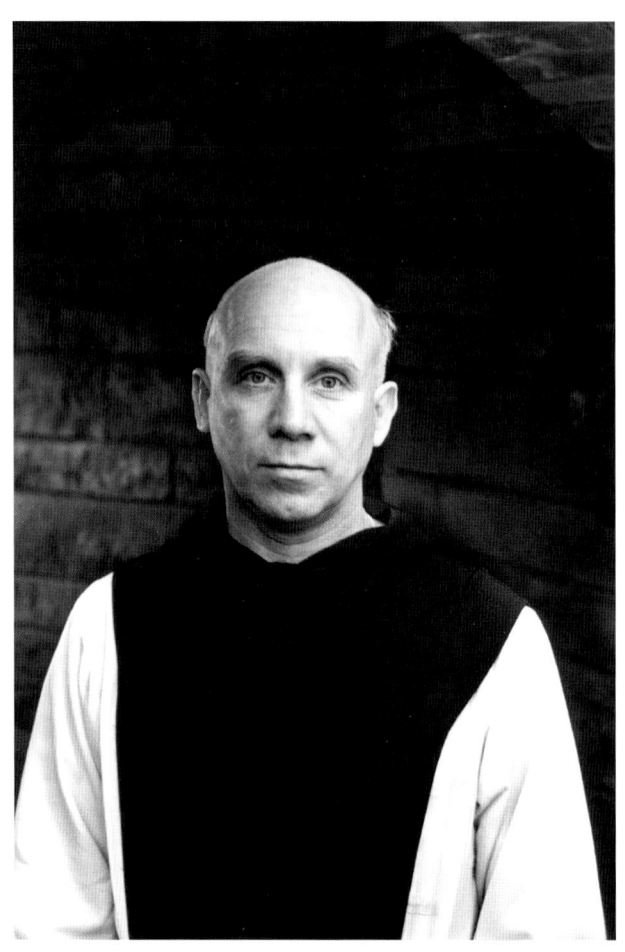

V

THE JOYFUL FACE BEHIND THE CAMERA

IMAGES OF MERTON

IT SEEMS FITTING after having seen the world through Merton's eyes—through the eye, the lens, of his camera—to conclude by turning the camera on Merton with a small selection of some of the photographs of Merton himself, drawn mostly from his "photographer" friends and contacts who ignited his own interest in photography from the late fifties onwards. Many of these photographs have been published over the years in biographies of Merton or in other publications, most notably the collections of their photographs published by John Howard Griffin,[1] Edward Rice,[2] and posthumously by the estate of Ralph Eugene Meatyard.[3]

Most of the photographs of Thomas Merton in existence date from the final decade of his life. Very few photographs, just a handful, have survived from his childhood and youth. With his mother dying when he was just six, his father when he was fifteen, and growing up mostly separated from his brother and maternal grandparents up until his return to the United States in 1934 after his disastrous year at Cambridge University in England, there was really no one to save photographs from his early years. Some photographs have survived from his years at Columbia University and at St. Bonaventure. However, after his entry to the Abbey of Gethsemani in December 1941 until his contact with Shirley Burden and Sibylle Akers in the late nineteen fifties, and then his friendships with John Howard Griffin and Ralph Eugene Meatyard in the sixties, there is a further paucity, with some photographs from the time of his ordination in 1949 and a very limited number of occasional photographs.

In 1963, after Griffin's first photo shoot of Merton, with the permission of Merton's abbot, Griffin recorded in his personal journal on March 2 his experience of preparing to take photographs of Merton:

Spent much of yesterday with Father Louis (Thomas Merton). A cold, drizzly day. We talked at great length of the two subjects that most concern us—racism and war—or more exactly, peace.

Odd, Father Louis has a most difficult face to photograph—it changes completely with different moods. I studied this carefully yesterday, since I am to photograph him today. Will I be able to capture him? I rather doubt it. Certainly it will be difficult. His face in laughter is all alight and such a joy to see that I found myself trying again and again to provoke him to mirth. It tends to blank in repose, but it comes alive flickeringly and I must try to catch him in such moments.[4]

From the small selection of photographs of Thomas Merton that follow, the difficulty Griffin speaks of in photographing Merton is evident and obvious in Merton's instantly recognizable though endlessly changing, at times impish, face. This is never more noticeable than in some of the photographs of him in which Merton is "clowning around" for the camera. In the same way, we see his humor in some of the comments

Merton would write on photographs of himself taken by his friends—in one photograph, looking slightly over his shoulder and slightly skyward, Merton writes, "Will it drop the bomb?" or again, on a photograph of him standing in front of the monastery, he writes, "How'd you like to buy this joint?"

Merton's humor, an aspect of him yet to be studied in great depth, is evident throughout his life and is palpable in a *curriculum vitae* he wrote in 1967 to accompany a poem, "Ceremony for Edward Dahlberg," that was to be published in *TriQuarterly*.[5] In those author notes, he touched a little on the elusiveness of his face, writing how he was "proud of facial resemblance to Picasso and/or Jean Genet or alternatively Henry Miller (though not so much Miller)"[6]— an interesting choice of characters in anyone's book, let alone that of a cloistered Trappist monk!

Brother Paul Quenon of the Abbey of Gethsemani, a novice of Merton's who would later use Merton's camera after his death for his own photography, once wrote of the "joyful face behind the camera," and many of the photographs of Merton do indeed capture his joy, his exuberance, his *joie de vivre*. Though perhaps none did more so than one of Ralph Eugene Meatyard's photographs—the last photograph he ever took of Merton—taken of Merton's joyful face as he lowered his camera after having himself just taken a photograph.

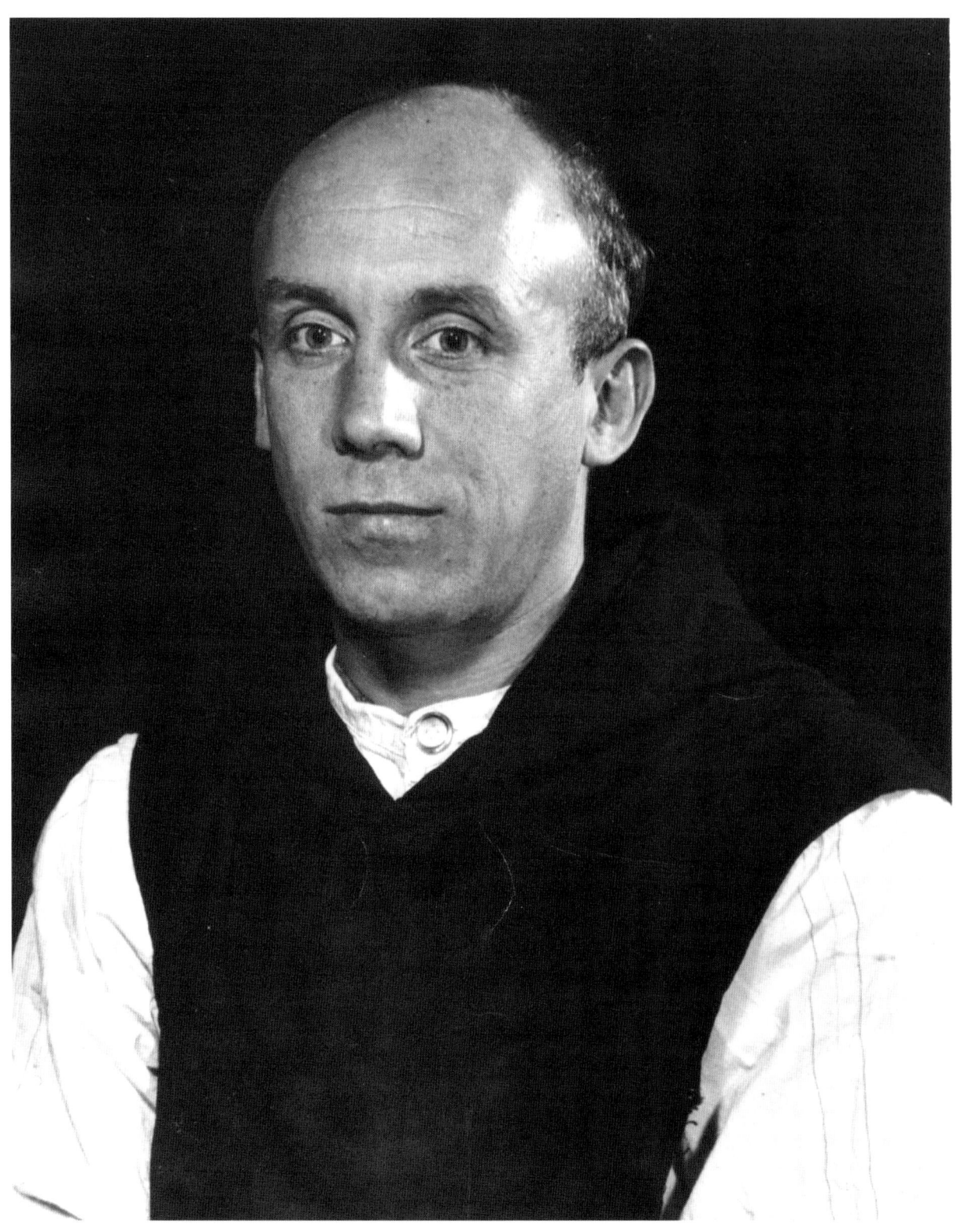

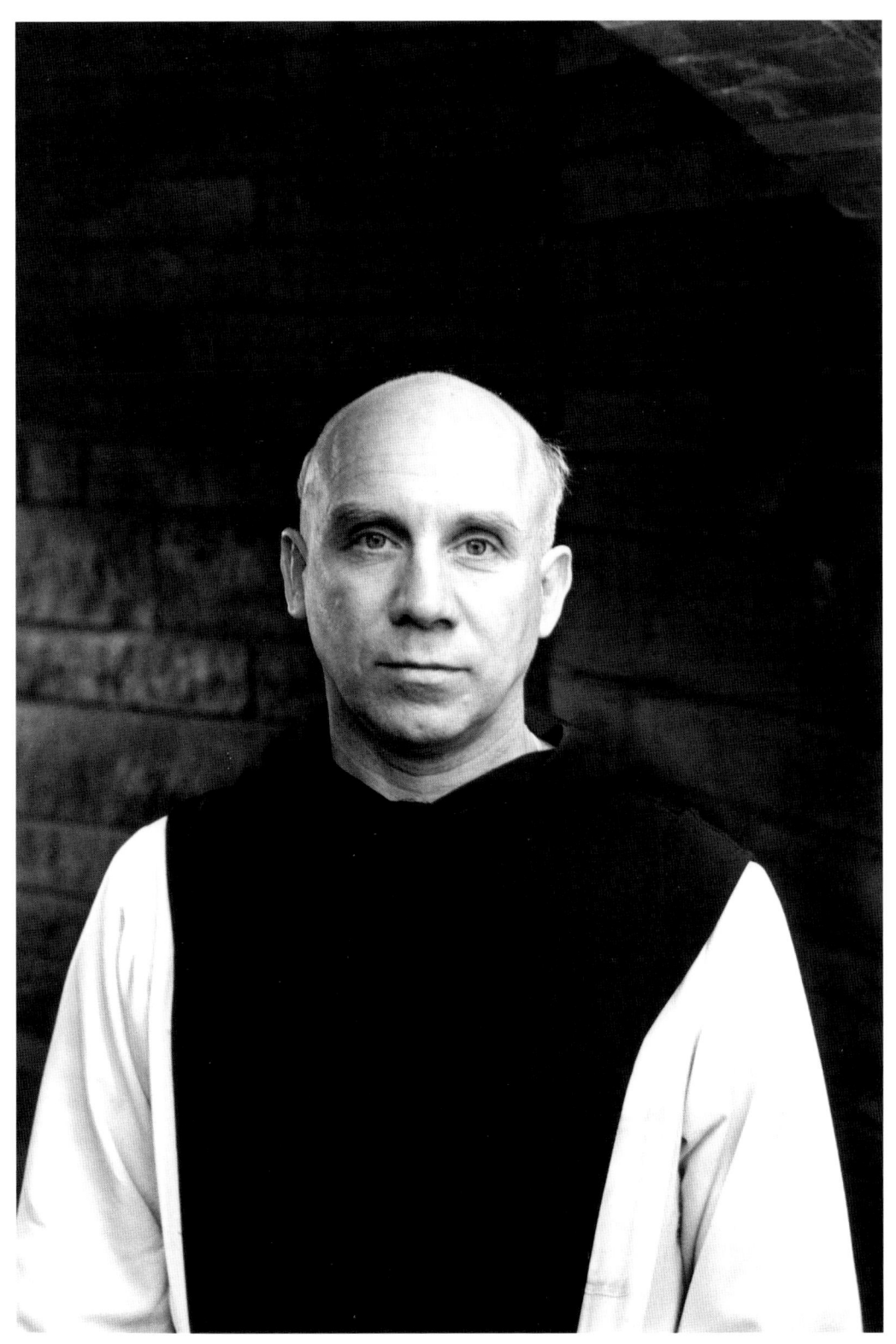

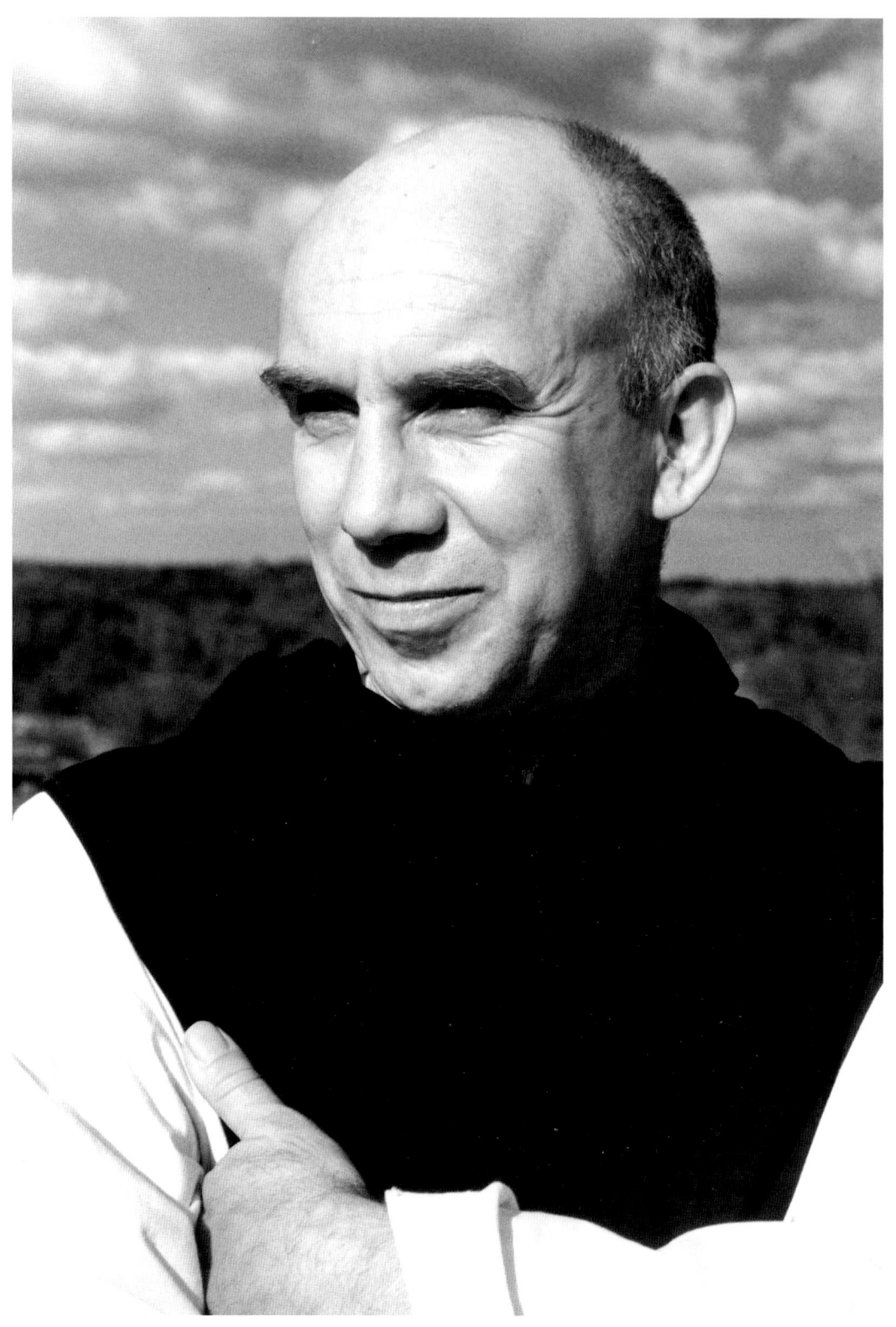

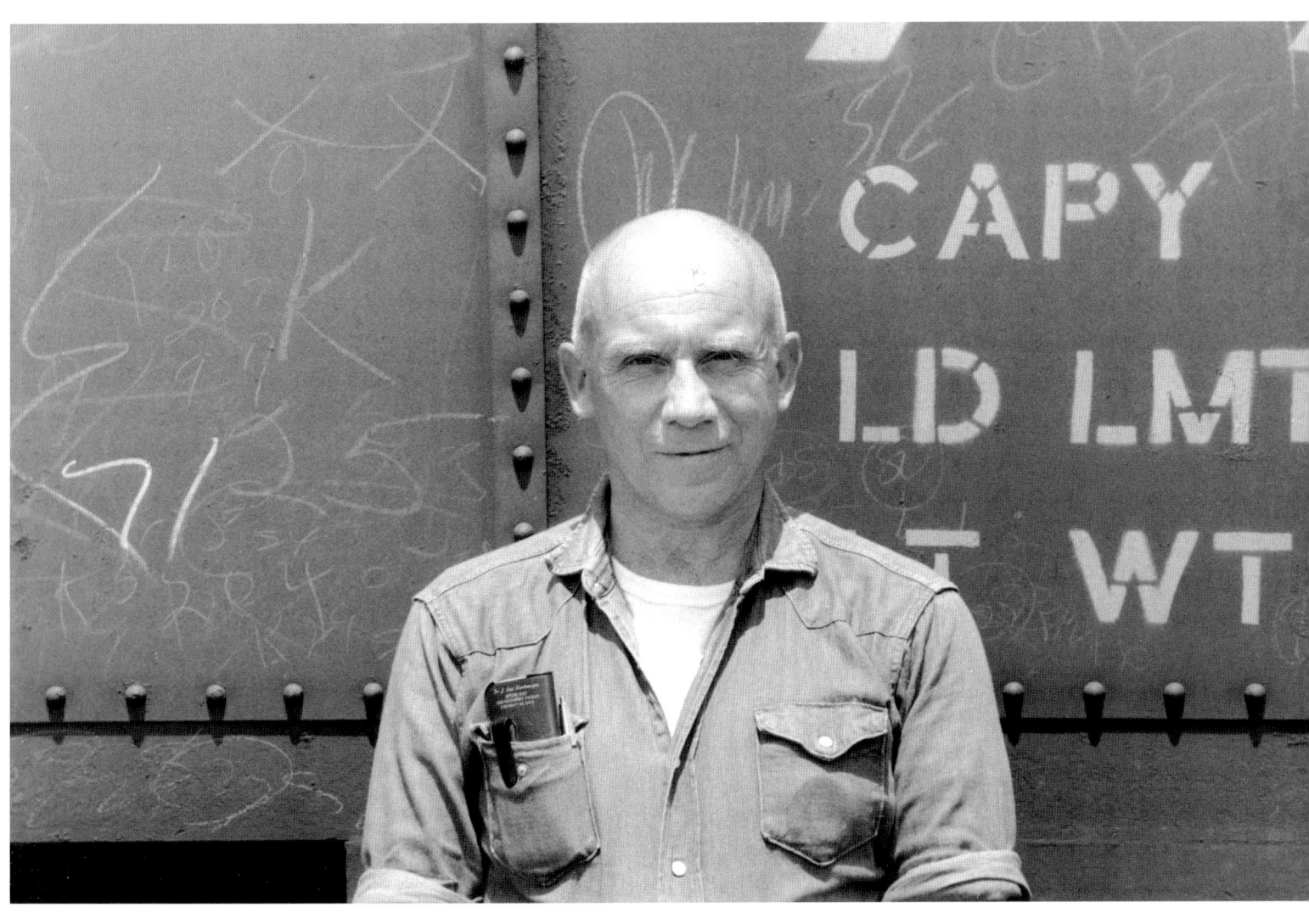

THE JOYFUL FACE BEHIND THE CAMERA ||| 223

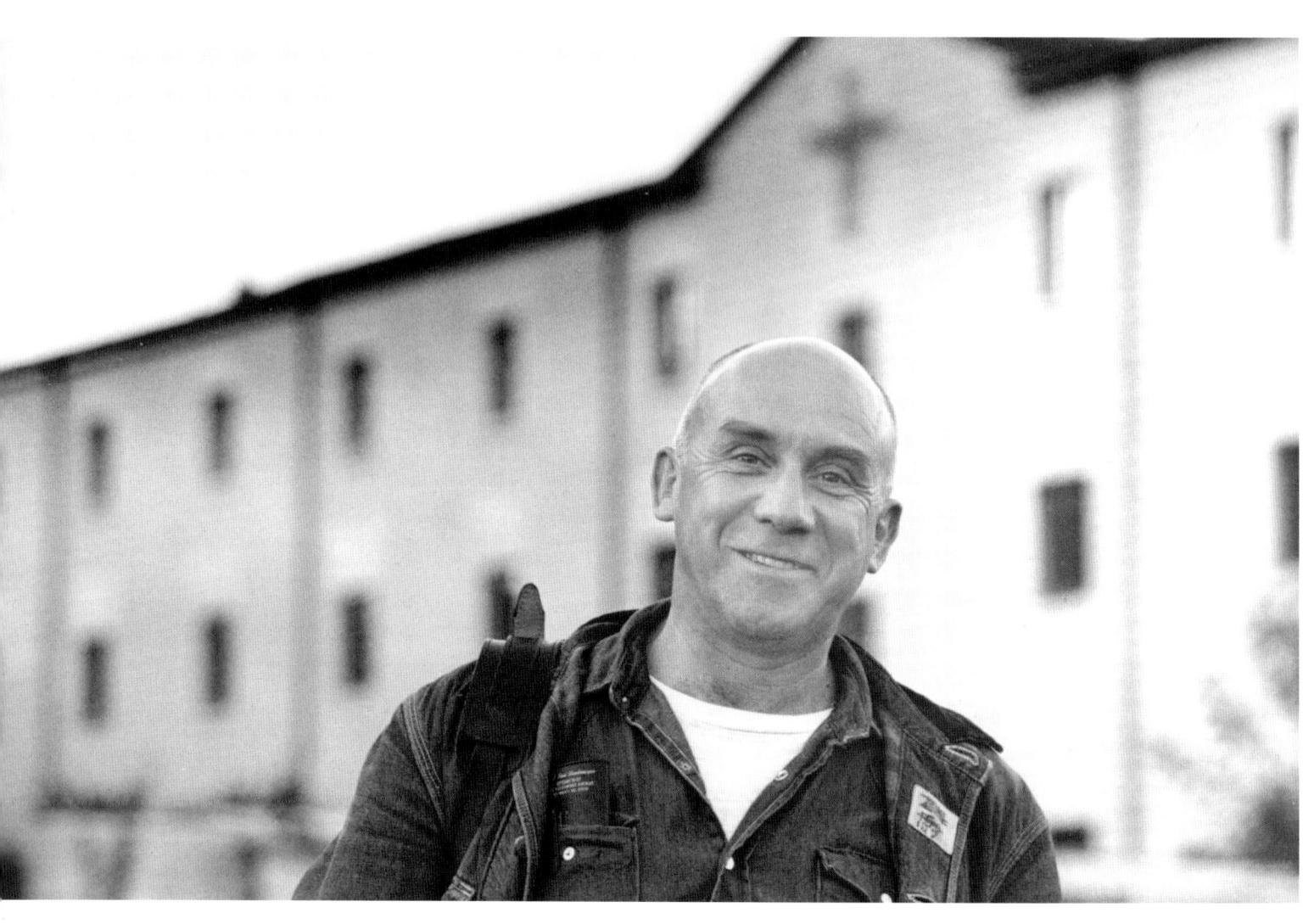

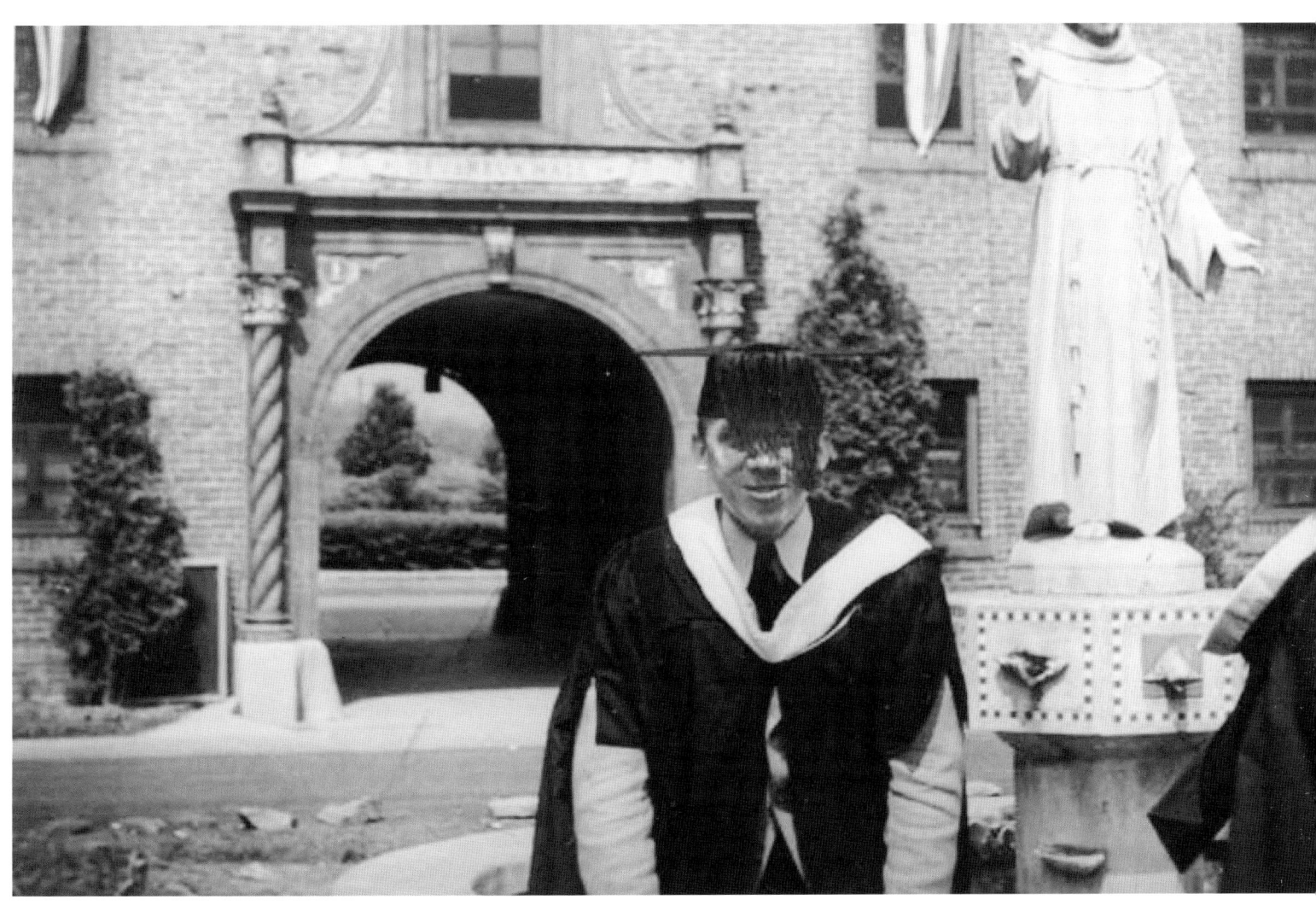

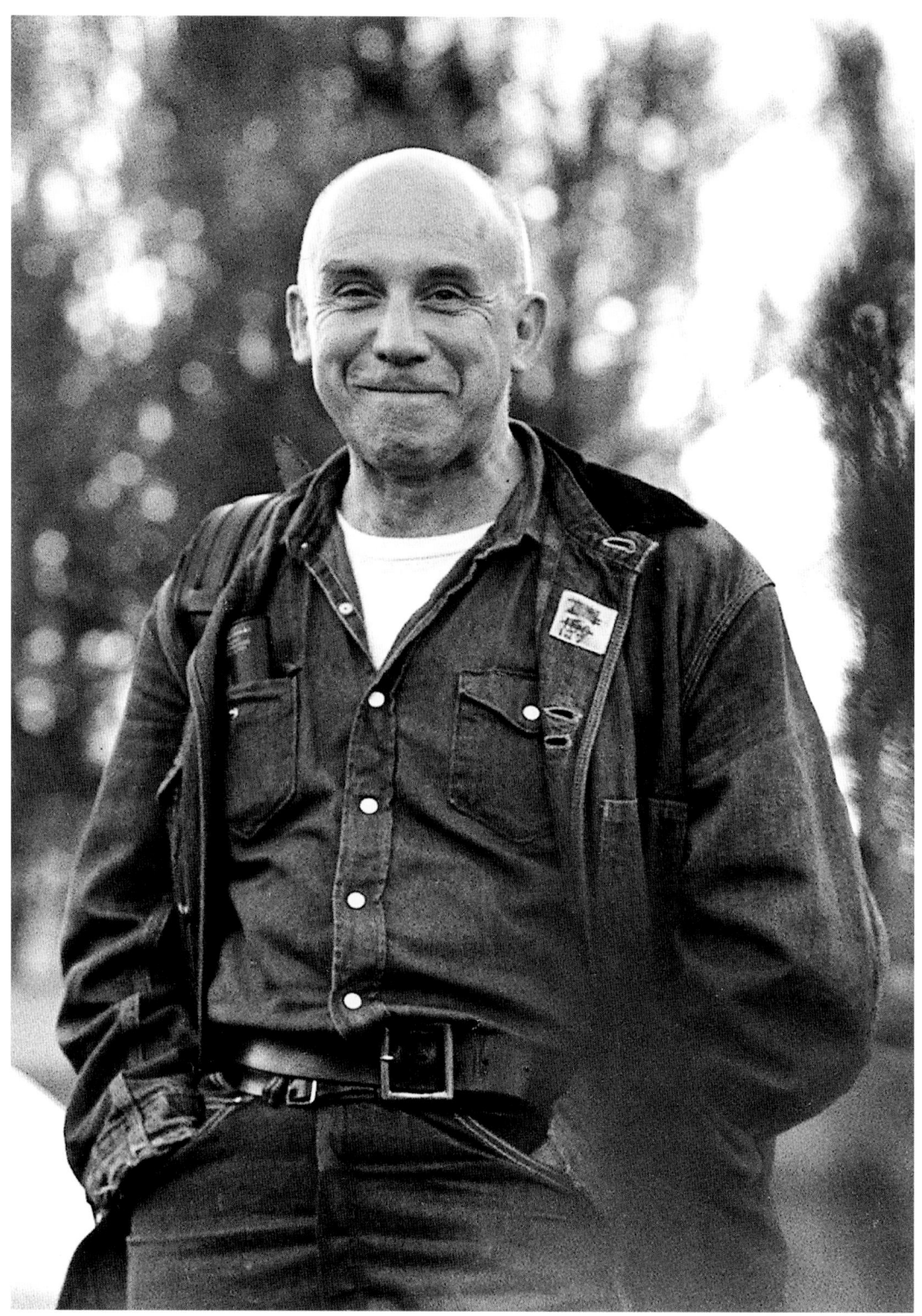

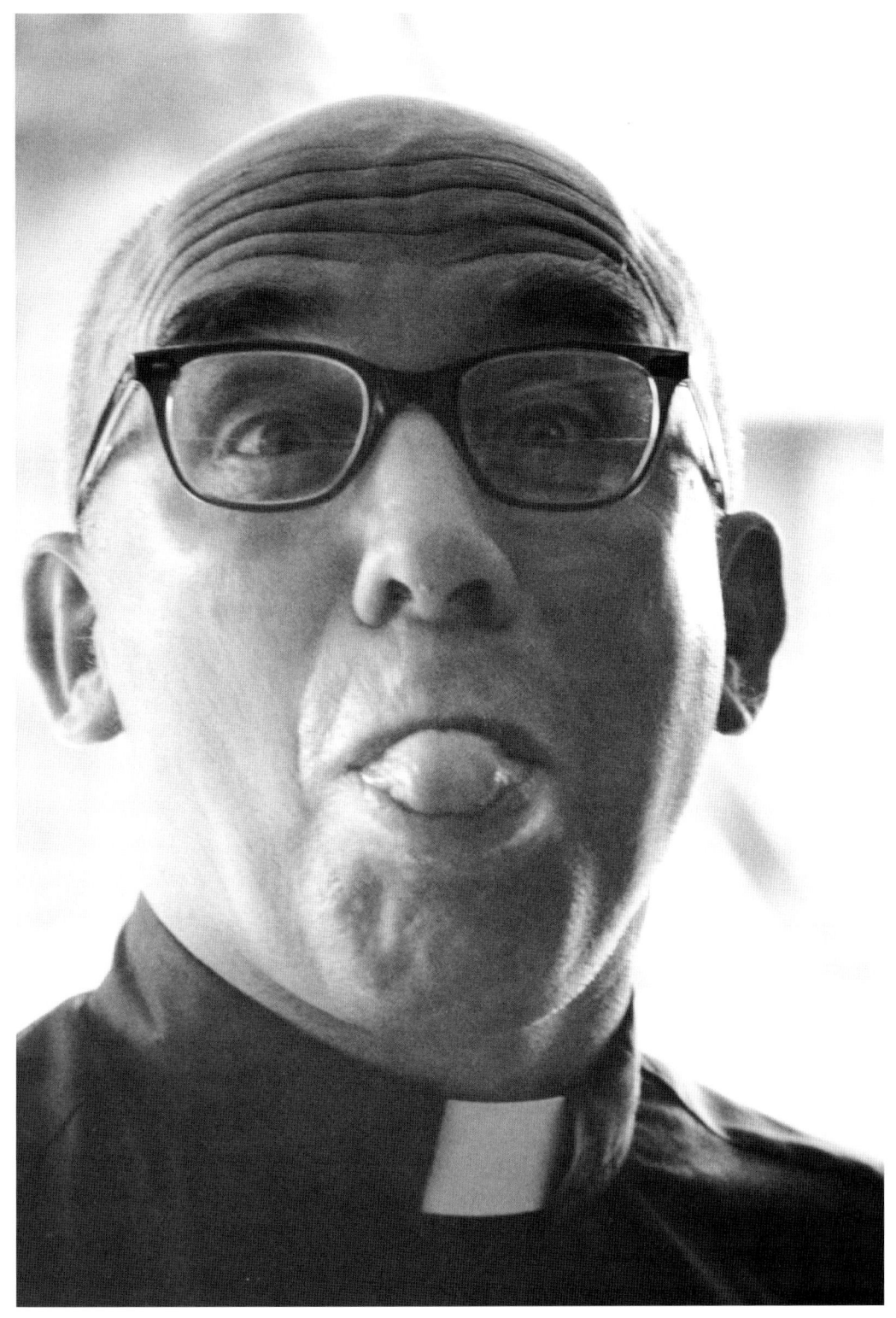

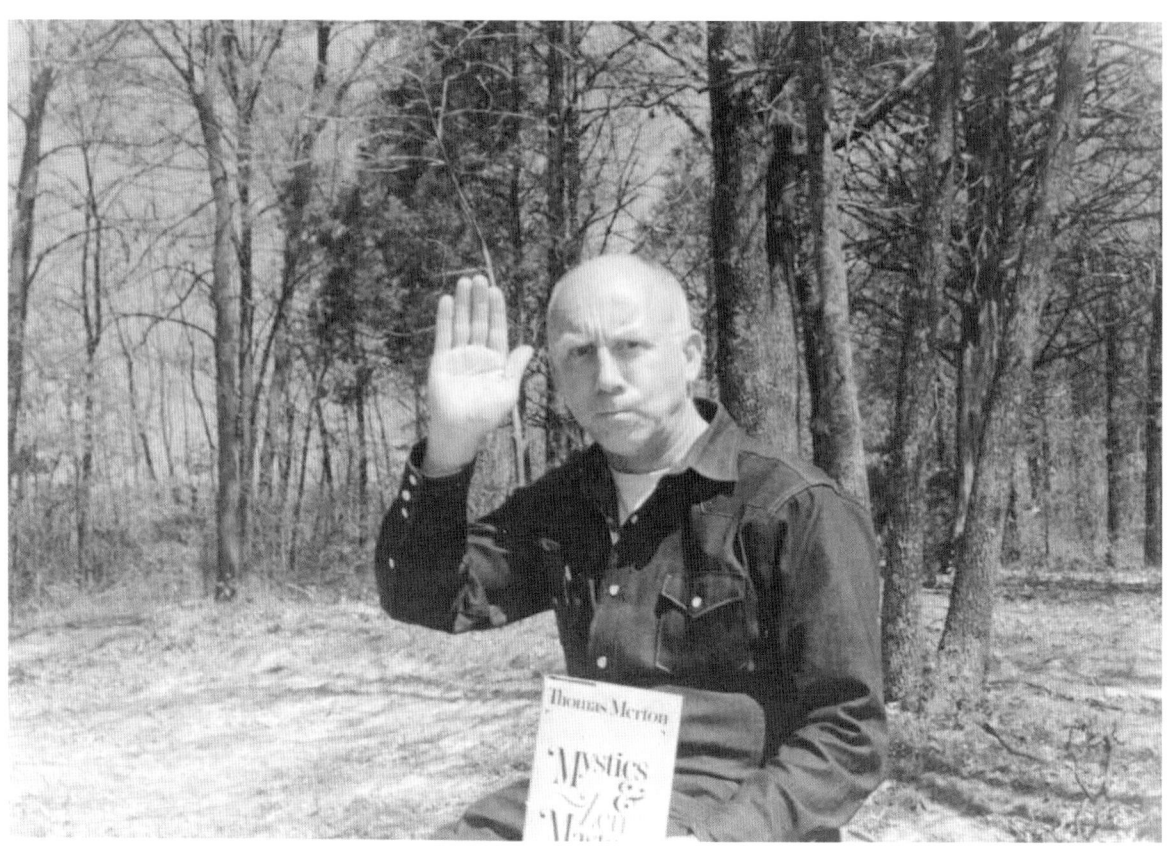

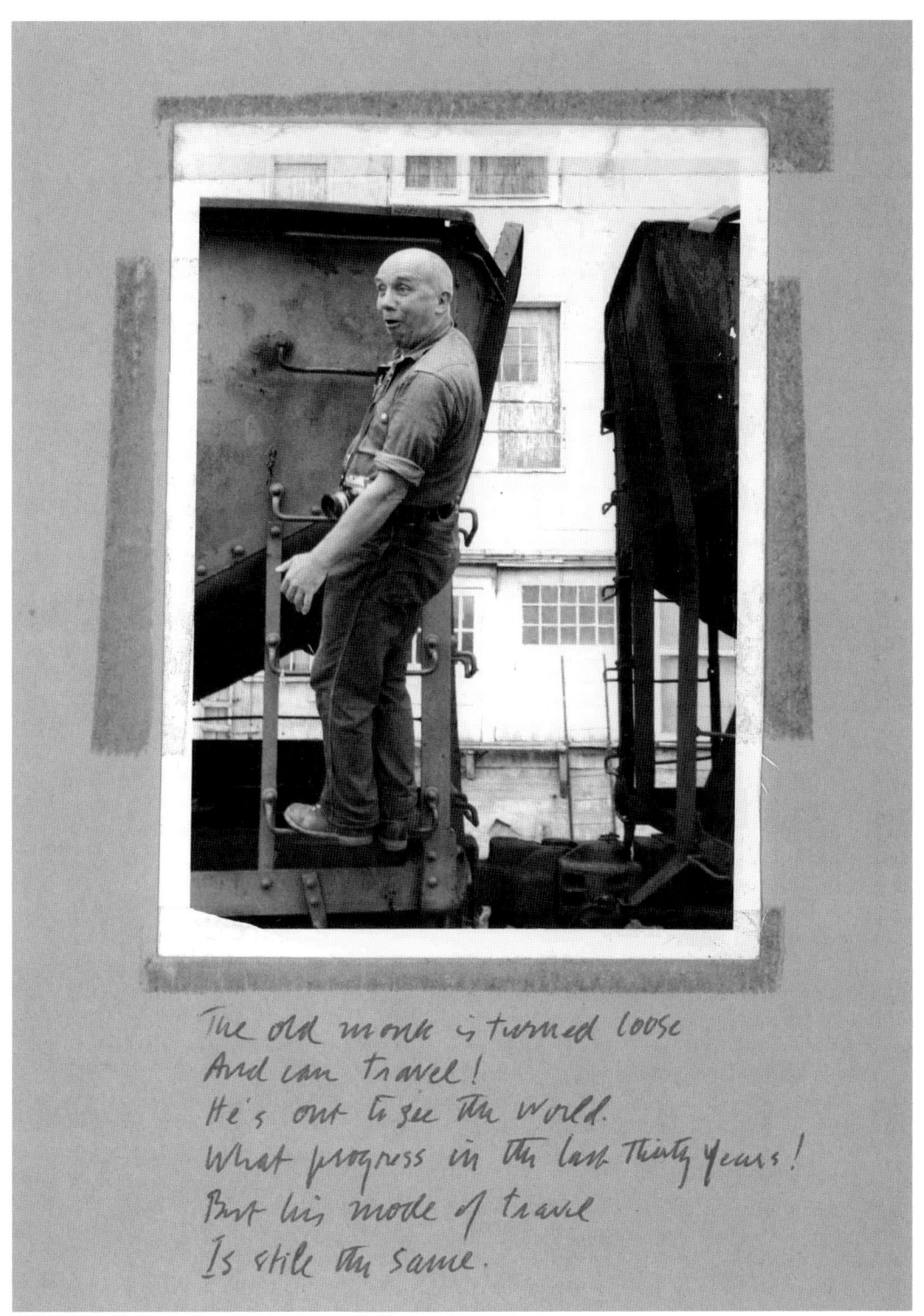

The old monk is turned loose
And can travel!
He's out to see the world.
What progress in the last thirty years!
But his mode of travel
Is still the same.

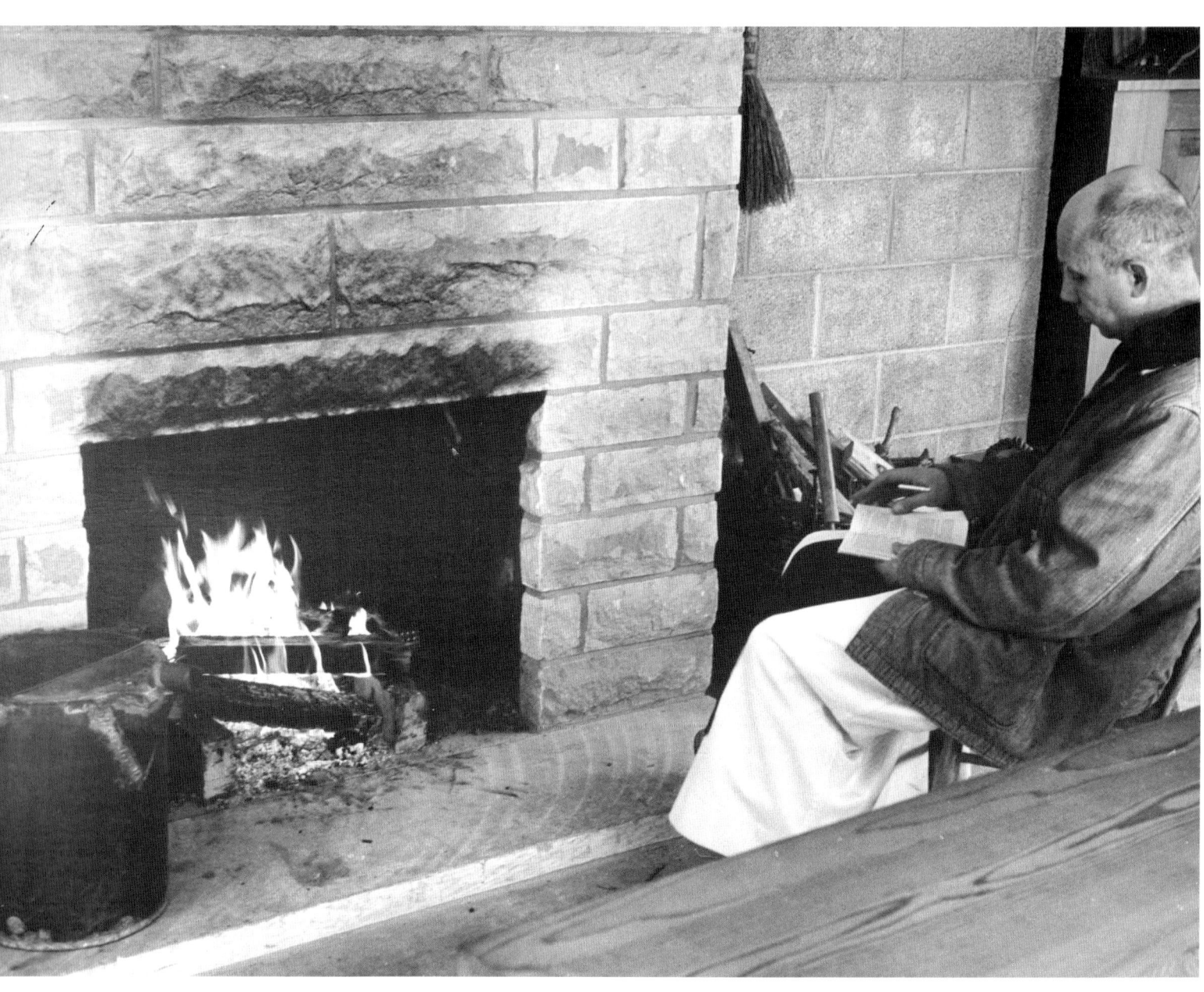

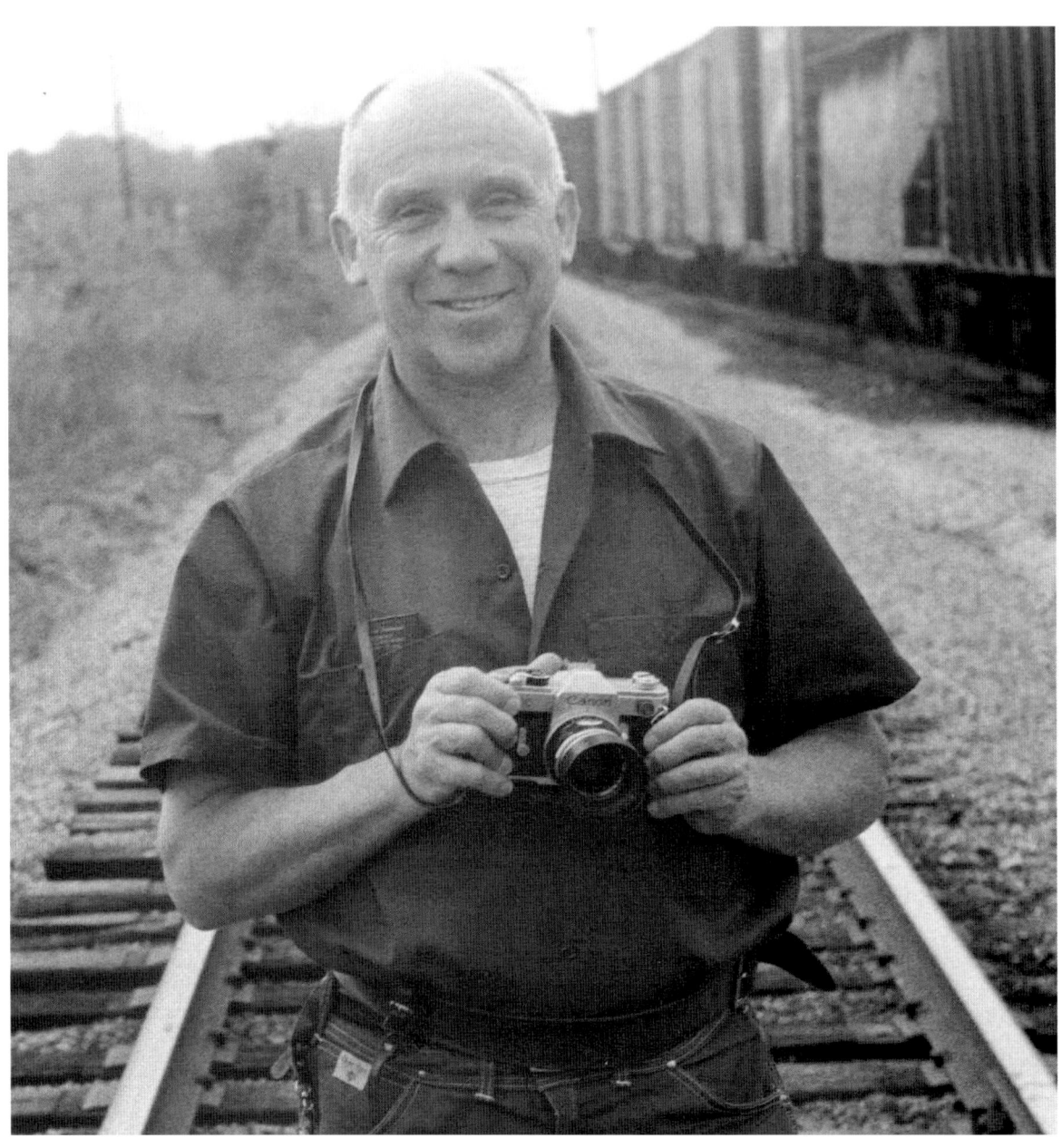

232 ||| *Beholding Paradise*

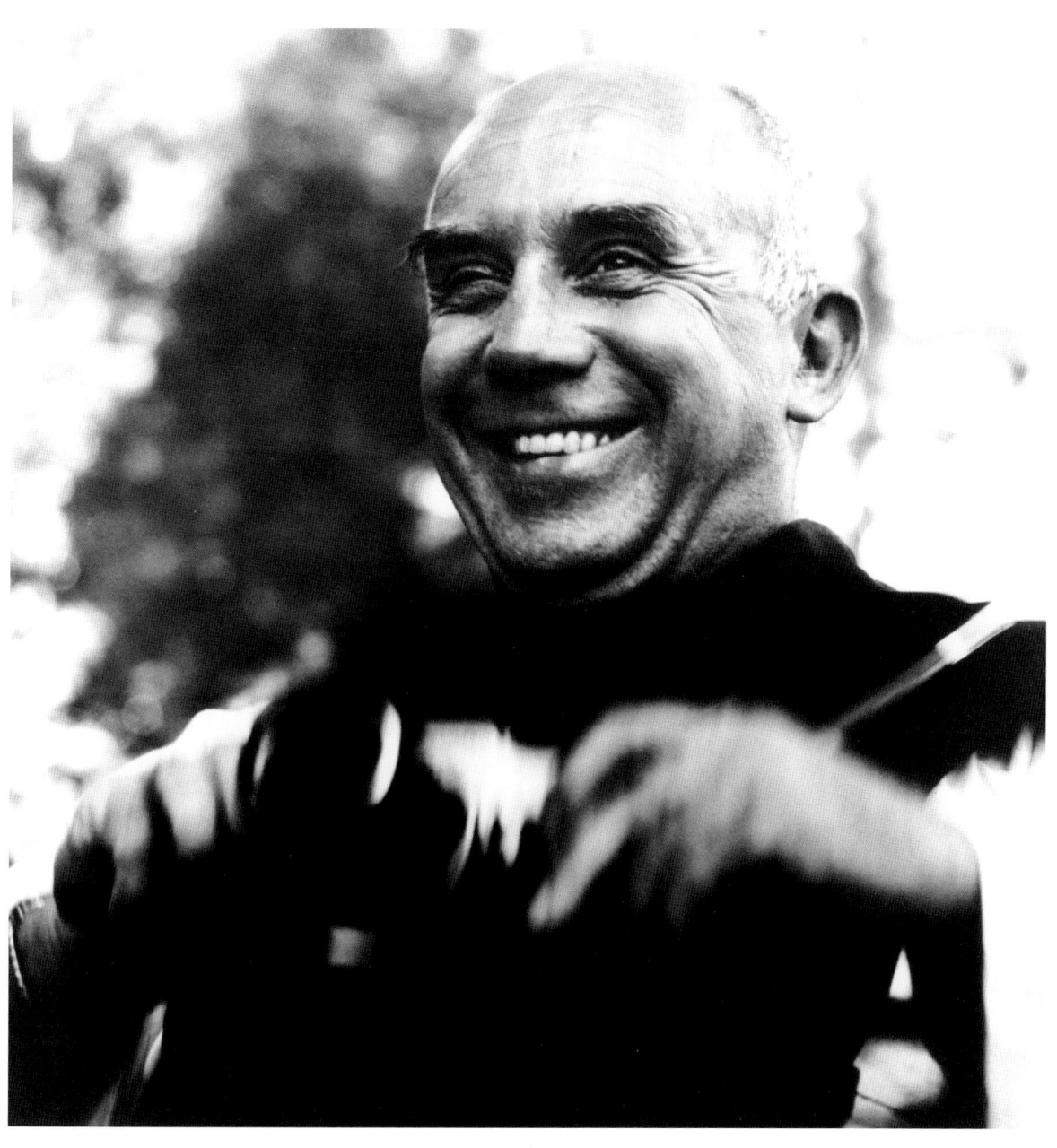

NOTES

INTRODUCTION

1. Thomas Merton, *The Seven Storey Mountain* (London: Sheldon Press, 1975), 3.
2. Owen Merton's obituary, *The Times*, January 21, 1931.
3. Archives of the Thomas Merton Center at Bellarmine University, Louisville, KY. (Subsequently referred to as TMC.)
4. Thomas Merton, "The Haunted Castle," *The Merton Seasonal* 19 (Winter 1994): 7–10, dates back to Christmas 1929.
5. TMC.
6. Thomas Merton, *Turning Toward the World: The Pivotal Years*, ed. Victor A. Kramer (San Francisco: Harper Collins, 1996), 60.
7. Michael Mott, *The Seven Mountains of Thomas Merton* (Boston: Houghton Mifflin, 1994), 83.
8. Thomas Merton, *Run to the Mountain: The Story of a Vocation*, ed. Patrick Hart (San Francisco: Harper Collins, 1995), 68.
9. Thomas Merton, *Entering the Silence: Becoming a Monk and Writer* (San Francisco: Harper Collins, 1996), 153. Similar references can be found in entries in *Entering the Silence* for January 27, 1947, and for February 7, 1950.
10. Thomas Merton, *Monastic Peace* (Trappist, KY: Abbey of Gethsemani, 1958).
11. Thomas Merton, *Selected Poems* (New York: New Directions, 1959).
12. Thomas Merton, *God Is My Life: The Story of Our Lady of Gethsemani*, photographs by Shirley Burden (New York: Reynal, 1960).
13. Thomas Merton, *A Search for Solitude: Pursuing the Monk's True Life*, ed. Lawrence S. Cunningham (San Francisco: Harper Collins, 1996), 282.
14. Ibid., 385.
15. Ibid., 283.
16. Merton's essays and correspondence about the Shakers, along with his photographs of Pleasant Hill, can be found in *Seeking Paradise: The Spirit of the Shakers*, intro. and ed. Paul M. Pearson (Maryknoll, NY: Orbis Books, 2003).
17. Merton, *A Search for Solitude*, 182–83.
18. Thomas Merton, *Conjectures of a Guilty Bystander* (London: Burns & Oates, 1968), 140–42.
19. Merton, *A Search for Solitude*, 332.
20. Ibid., 339.
21. Thomas Merton, *Turning Toward the World*, 180.
22. Thomas Merton, *A Search for Solitude*, 346.
23. John Howard Griffin, *A Hidden Wholeness: The Visual World of Thomas Merton* (Boston: Houghton Mifflin, 1970), 37.
24. *Jubilee* 11 (January 1964): 36–41.
25. Thomas Merton, *When Prophecy Still Had a Voice: The Letters of Thomas Merton and Robert Lax*, ed. Arthur W. Biddle (Lexington: University Press of Kentucky, 2001), 354.
26. Thomas Merton, *Learning to Love: Exploring Solitude and Freedom*, ed. Christine M. Bochen (San Francisco: Harper Collins, 1997), 186.
27. Ralph Eugene Meatyard, *Father Louie: Photographs of Thomas Merton* (New York: Timken, 1991).
28. Minor White was certainly familiar with Merton's writings, but I am not aware that Merton was familiar with Minor White's work. The connection through Meatyard to Minor White is, at best, tentative. Having said that, there is some similarity between the work of White and Merton.
29. Meatyard, *Father Louie*, 34.
30. Merton, *Learning to Love*, 206.
31. James Rhem, *Ralph Eugene Meatyard: The Family Album of Lucybelle Crater and Other Figurative Photographs* (New York: Distributed Art Publishers, 2002).
32. Meatyard, *Father Louie*, 34.

33. John Howard Griffin to Thomas Merton, January 13, 1967, TMC.

34. John Howard Griffin to Thomas Merton, September 17, 1967, TMC.

35. Merton, *Turning Toward the World*, 169.

36. Ibid., 194.

37. Ibid.

38. Thomas Merton, *Dancing in the Water of Life: Seeking Peace in the Hermitage*, ed. Robert E. Daggy (San Francisco: Harper Collins, 1997), 23.

39. Thomas Merton, *Ascetical and Mystical Theology: An Introduction to Christian Mysticism (From the Apostolic Fathers to the Council of Trent)*, mimeographed copy of lectures given at the Abbey of Gethsemani, TMC.

40. R. H. Cravens, *Edward Weston* (New York: Aperture, 1988), 84.

41. Merton, *Turning Toward the World*, 135.

42. Merton, *The Seven Storey Mountain*, 3.

43. Merton, *Dancing in the Water of Life*, 147.

44. Ibid.

45. Ibid., 149.

46. Merton, *Learning to Love*, 221.

47. Griffin, *A Hidden Wholeness*, 37.

48. Thomas Merton, *The Road to Joy: The Letters of Thomas Merton to New and Old Friends*, ed. Robert E. Daggy (New York: Farrar, Straus, Giroux, 1989), 134.

49. Thomas Merton, *The Other Side of the Mountain: The End of the Journey*, ed. Patrick Hart (San Francisco: Harper Collins, 1998), 6.

50. Merton, *Learning to Love*, 274.

51. Merton, *The Road to Joy*, 140.

52. Ibid., 141.

53. Merton, *The Other Side of the Mountain*, 267, 326.

54. Merton, *The Road to Joy*, 134.

55. John Howard Griffin to Thomas Merton, January 13, 1967, TMC.

56. Merton, *The Road to Joy*, 134.

57. The Merton Center has over 1,400 of Merton's color and black and white photographs with negatives, along with many other photographs without negatives. The photographs were taken on a variety of different cameras including a Kodak Instamatic, a Rolleiflex, and the Canon loaned to him by Griffin.

58. John Howard Griffin to Thomas Merton, August 28, 1967, TMC.

59. Merton, *The Road to Joy*, 140.

60. John Howard Griffin to Thomas Merton, January 8, 1968, TMC.

61. Thomas Merton to John Howard Griffin, September 2, 1967, TMC.

62. Griffin, *A Hidden Wholeness*, 90.

63. Merton was even sending contact sheets to and fro between himself and Griffin during his time in Asia. Merton, *The Other Side of the Mountain*, 326.

64. Thomas Merton, *Monk's Pond: Thomas Merton's Little Magazine*, intro. and ed. Robert E. Daggy (Lexington, KY: University Press of Kentucky, 1989). Examples of Merton's photographs can be found on pp. 1, 23, 113, 171–74, 211–12, 231, 276.

65. John Howard Griffin to Thomas Merton, October 2, 1967, TMC.

66. John Howard Griffin to Robert Bonazzi, October 3, 1967, TMC.

67. Griffin, *A Hidden Wholeness*, 49–50.

68. Thomas Merton, *The Hidden Ground of Love: The Letters of Thomas Merton on Religious Experience and Social Concerns*, ed. William H. Shannon (New York: Farrar, Straus and Giroux, 1985), 551.

69. Thomas Merton, *New Seeds of Contemplation* (New York: New Directions, 1961), 297.

70. Thomas Merton, *The Collected Poems of Thomas Merton* (New York: New Directions, 1977), 280–81.

I. The Paradox of Place

1. Michael Mott, *The Seven Mountains of Thomas Merton* (London: Sheldon Press, 1986), 205.

2. Merton, *Run to the Mountain*, 456–58 (see intro., n. 8).

3. Merton, *The Collected Poems*, 24 (see intro., n. 70).

4. Monica Furlong, *Merton: A Biography* (London: Collins, 1980), 129.

5. Charles Cummings, *Monastic Practices*, Cistercian Studies Series 75 (Kalamazoo, MI: Cistercian Publications, 1986), 177. For a more detailed exploration of the relationship between journey and stability in Merton's life see Paul M. Pearson, "The Whale and the Ivy: Journey and Stability in the Life and Writing of Thomas Merton," *Hallel* 21 (1996): 87–103.

6. James McMurry, "On Being 'At Home': Reflections on Monastic Stability in the Light of the Philosophy of Gabriel Marcel," *Monastic Studies* 4 (1966): 82.

7. Merton, *Conjectures*, 161 (see intro., n. 18).

8. Merton, *Turning Toward the World*, 79–80 (see intro., n. 6).

9. McMurry, "On Being 'At Home,'" 82.

10. Merton, *Conjectures*, 234 (see intro., n. 18).

11. Cummings, *Monastic Practices*, 177.

12. Merton, *Conjectures*, 200 (see intro., n. 18).

13. Many of the qualities Merton admired in the Shakers and the early Cistercians were also qualities he saw in his father, Owen, whose "vision of the world was sane, full of balance, full of veneration for structure, for the relations of masses and for all the circumstances that impress an individual identity on a created thing." Merton, *The Seven Storey Mountain*, 3 (see intro., n. 1).

14. Merton, *The Hidden Ground of Love*, 32–33 (see intro., n. 68).

15. Thomas Merton, *The Waters of Siloe* (New York: Harcourt Brace & Co., 1979), 12.

16. Ibid., 13.

17. Thomas Merton, *Mystics and Zen Masters* (New York: The Noonday Press, 1988), 198.

18. Merton, "Ascetical and Mystical Theology," (see intro., n. 39).

19. Thomas Merton, "Introduction," *Religion in Wood: A Book of Shaker Furniture* by Edward Demming Andrews and Faith Andrews (Bloomington and London: Indiana University Press, 1973), viii.

20. Ibid., xiii.

21. Esther de Waal, *A Seven Day Journey with Thomas Merton* (Guildford, UK: Eagle, 1992), 29.

I. Photograph Section

1. Merton, *The Collected Poems*, 155 (see intro., n. 70).

2. Thomas Merton, *The Sign of Jonas* (New York: Harcourt Brace & Co., 1953), 262.

3. Merton, *Conjectures*, 234 (see intro., n. 18).

4. Merton, *The Sign of Jonas*, 337.

5. Thomas Merton, *The Courage for Truth: Letters to Writers*, ed. Christine M. Bochen (New York: Farrar, Straus, Giroux, 1993), 29.

6. Thomas Merton, *Honorable Reader: Reflections on My Work*, ed. Robert E. Daggy (New York: Crossroad, 1989), 40.

7. Merton, *The Collected Poems*, 240 (see intro., n. 70).

8. Ibid., 151.

9. Thomas Merton, *The Courage for Truth*, 225.

10. Merton, *New Seeds of Contemplation*, 297 (see intro., n. 69).

11. Thomas Merton, *A Vow of Conversation: Journals 1964–1965*, ed. Naomi Burton Stone (New York: Farrar, Straus, Giroux, 1988), 185.

12. Merton, *A Search for Solitude*, 287 (see intro., n. 13).

13. Merton, *Turning Toward the World*, 194 (see intro., n. 6).

14. Merton, *A Search for Solitude*, 362 (see intro., n. 13).

15. Thomas Merton to Edward Deming Andrews, December 12, 1960, TMC.

16. Thomas Merton, "Introduction," xii (see chap. 1, n. 19).

17. Merton, *A Vow of Conversation*, 19.

18. Thomas Merton, *Woods, Shore, Desert: A Notebook, May 1968* (Santa Fe: Museum of New Mexico Press, 1982), 26.

19. Merton, *The Collected Poems*, 280 (see intro., n. 70).

20. Ibid.

II. A Hidden Wholeness

1. Merton, *Dancing in the Water of Life*, 147 (see intro., n. 38).

2. Merton, *The Road to Joy*, 141 (see intro., n. 48).

3. Philippe L. Gross and S. I. Shapiro, *The Tao of Photography: Seeing beyond Seeing* (Berkeley, CA: Ten Speed Press, 2001), 6.

4. Ron Seitz, *Song for Nobody: A Memory Vision of Thomas Merton* (Liguori, MO: Triumph Books, 1993), 133–34.

5. Merton, *Turning Toward the World*, 123 (see intro., n. 6).

II. Photograph Section

1. Merton, *Turning Toward the World*, 123 (see intro., n. 6).

2. Merton, *New Seeds of Contemplation*, 135 (see intro., n. 69).

3. Merton, *The Sign of Jonas*, 334 (see chap. 1 photo. sec., n. 2).

4. Merton, *The Collected Poems*, 452 (see intro., n. 70).

5. Merton, *A Search for Solitude*, 45 (see intro., n. 13).

6. Merton, *New Seeds of Contemplation*, 1–2 (see intro., n. 69).

7. Merton, *The Sign of Jonas*, 340 (see chap. 1 photo. sec., n. 2).

8. Merton, *Dancing in the Water of Life*, 99 (see intro., n. 38).

9. Merton, *Conjectures*, 118 (see intro., n. 18).

10. Merton, *A Search for Solitude*, 232 (see intro., n. 13).

11. Merton, *The Collected Poems*, 188 (see intro., n. 70).

12. Thomas Merton, *Zen and the Birds of Appetite* (New York: New Directions, 1968), 57. Merton is here quoting D. T. Suzuki, who is quoting from Eckhart.

13. Merton, *A Vow of Conversation*, 127 (see chap. 1 photo. sec., n. 11).

14. Merton, *The Sign of Jonas*, 263 (see chap. 1 photo. sec., n. 2).

15. Merton, *A Search for Solitude*, 16 (see intro., n. 13).

16. Thomas Merton, *Day of a Stranger* (Salt Lake City: Gibbs M. Smith, 1981), 41.

17. Merton, *The Sign of Jonas*, 109 (see chap. 1 photo. sec., n. 2).

18. Merton, *The Collected Poems*, 341 (see intro., n. 70).

19. Merton, *Zen and the Birds of Appetite*, 54.

20. Merton, *New Seeds of Contemplation*, 30 (see intro., n. 69).

21. Ibid.

22. Merton, *The Sign of Jonas*, 262 (see chap. 1 photo. sec., n. 2).

23. Merton, *Conjectures*, 131 (see intro., n. 18).

24. Merton, *New Seeds of Contemplation*, 131 (see intro., n. 69). [The Light shines in darkness and the darkness has not understood it.]

25. Ibid., 81.

26. Merton, *The Collected Poems*, 168 (see intro., n. 70).

27. Merton, *Zen and the Birds of Appetite*, 81.

28. Merton, *Conjectures*, 142 (see intro., n. 18).

29. Merton, *Zen and the Birds of Appetite*, 84.

30. Merton, *The Collected Poems*, 635 (see intro., n. 70).

31. Ibid., 201.

32. Merton, *Zen and the Birds of Appetite*, 38.

33. Merton, *The Sign of Jonas*, 345 (see chap. 1 photo. sec., n. 2).

34. Merton, *Conjectures*, 258 (see intro., n. 18).

35. Thomas Merton, "Working Notebook # 52: Zen, etc.," unpublished manuscript in the TMC archives.

III. Shining Like the Sun

1. Merton, *Conjectures*, 193 (see intro., n. 18).

2. Merton, *Turning Toward the World*, 183 (see intro., n. 6).

3. Merton, *Conjectures*, 140–42 (see intro., n. 18).

4. Merton, *Turning Toward the World*, 180 (see intro., n. 6).

5. Merton, *A Vow of Conversation*, 208 (see chap. 1 photo. sec., n. 11).

6. Thomas Merton, *Natural Contemplation*, Credence Cassettes, AA2077, Side 1, 1988. Transcribed by the current author.

7. Ibid.

III. Photograph Section

1. Merton, *The Other Side of the Mountain*, 216 (see intro., n. 49).

IV. Woods, Shore, Desert, East

1. Merton, *The Collected Poems*, 815 (see intro., n. 70).

2. Thomas Merton, *Woods, Shore, Desert: A Notebook, May 1968*, with foreword by Brother Patrick Hart (Santa Fe: Museum of New Mexico Press, 1982), vii.

3. Ibid., 43.

4. Ibid., 46.

5. Ibid., 42.

6. Thomas Merton, *The Asian Journal of Thomas Merton*, ed. Naomi Burton et al. (New York: New Directions, 1973), 105–6.

7. Ibid., 57–59.

8. Ibid., 68.

9. Ibid., 82.

10. Ibid., 93.

11. Ibid., 135.

12. Ibid., 146.

13. Ibid., 148–50.

14. Ibid., 153.

15. Ibid., 156–57.

16. Ibid., 202.

17. Ibid., 235–36.

IV. Photograph Section

1. Merton, *Woods, Shore, Desert*, 43 (see chap. 4, n. 2).

2. Ibid., 42.

3. Thomas Merton, *The School of Charity: The Letters of Thomas Merton on Religious Renewal and Spiritual Direction*, ed. Brother Patrick Hart (New York: Farrar, Straus, Giroux, 1990), 402.

4. Merton, *Day of a Stranger*, 53 (see chap. 2 photo. sec., n. 16).

5. Thomas Merton, *Thomas Merton in Alaska: The Alaskan Conferences, Journals, and Letters* (New York: New Directions, 1989), 10.

6. Merton, *The Asian Journal*, 296 (see chap. 4, n. 6).

7. Merton, *The Collected Poems*, 815 (see intro., n. 70).

8. Merton, *The Asian Journal*, 248–50 (see chap. 4, n. 6).

9. Ibid., 16.

10. Merton, *The Collected Poems*, 24 (see intro., n. 70).

11. Merton, *The Asian Journal*, 156–57 (see chap. 4, n. 6).

12. Merton, *The Collected Poems*, 443 (see intro., n. 70).

13. Merton, *The Asian Journal*, 126 (see chap. 4, n. 6).

14. Ibid., 235–36.

15. Ibid., 197.

16. Ibid., 233.

17. Ibid., 233–35.

18. Ibid., 235–36.

19. Merton, *A Search for Solitude*, 359 (see intro., n. 13).

V. The Joyful Face behind the Camera

1. Griffin, *A Hidden Wholeness* (see intro., n. 23).

2. Edward E. Rice. *The Man in the Sycamore Tree: The Good Times and Hard Life of Thomas Merton* (Garden City, NY: Doubleday, 1970).

3. Meatyard. *Father Louie* (see intro., n. 27).

4. John Howard Griffin, unpublished journal entry for March 3, 1963, TMC.

5. Thomas Merton, "Ceremony for Edward Dahlberg," *TriQuarterly* 19 (Fall 1970): 138–39.

6. Ibid., 190.

Photos by other photographers

p. 216 – Sibylle Akers

p. 220 – Official Monastery Portrait, Photographer Unknown.

p. 221 – Sibylle Akers

p. 222 – Sibylle Akers

p. 223 – Naomi Burton Stone

p. 224 – John Lyons

p. 225 – Photographer Unknown. Taken at St. Bonaventure commencement 1941.

p. 226 – John Lyons

p. 227 – James Laughlin

p. 228 – Naomi Burton Stone

p. 229 – Robert Lax

p. 230 – John Howard Griffin

p. 231 – John Howard Griffin

p. 232 – John Howard Griffin

p. 233 – Ralph Eugene Meatyard